THE 2ND BAIRNSFATHER OMNIBUS

The Bairnsfather Case
Fragments From His Life
Somme Battle Stories

ALSO AVAILABLE:

NON-FICTION:

'Baptism Of Fire' - by Mark Marsay
ISBN: 0 9535204 0 4 (see page 228)

'Bombardment! The Day The East Coast Bled' - by Mark Marsay
ISBN: 0 9535204 1 2 (see page 229)

'The Bairnsfather Omnibus' - by Bruce Bairnsfather
'Bullets & Billets' and 'From Mud To Mufti'
ISBN: 0 9535204 2 0 (see page 228)

'The 2nd Bairnsfather Omnibus' - by Bruce Bairnsfather
'The Bairnsfather Case', 'Fragments From His Life' and 'Somme Battle Stories'
ISBN: 0 9535204 5 5

FICTION:
Fiction/Adult Humour

'Hazardous To Health!' - An Obadiah Jones Novel (1) - by Mark Marsay
ISBN: 0 9535204 3 9 (see page 228)

'Beyond The Void' - An Erasmus Novel (1) - by Mark Marsay
ISBN: 0 9535204 4 7 (see page 229)

Other non-fiction titles under preparation:

'Yorkshires Heroes' - by Mark Marsay
ISBN: 0 9535204 7 1 (see page 229)

'The 3rd Bairnsfather Omnibus' - by Bruce Bairnsfather
'Carry On Sergeant', 'For France' and 'Laughing Through The Orient'
ISBN: 0 9535204 8 X (see page 232)

Other fiction titles under preparation:

'Under Surveillance' - An Obadiah Jones Novel (2) - by Mark Marsay
ISBN: 0 9535204 6 3 (see page 232)

'A Bridge Too Far' - An Obadiah Jones Novel (3) - by Mark Marsay

'The Love Colony' - An Erasmus Novel (2) - by Mark Marsay
ISBN: 0 9535204 9 8 (see page 232)

'Howling At The Moon' - An Erasmus Novel (3) - by Mark Marsay

THE 2ND BAIRNSFATHER OMNIBUS

The Bairnsfather Case
Fragments From His Life
Somme Battle Stories

Written and illustrated by

Bruce Bairnsfather

(with additional texts by William A. Mutch,
Vivian Carter and Captain A. J. Dawson)

COMPILED AND EDITED BY MARK MARSAY

GREAT NORTHERN PUBLISHING

THE 2ND BAIRNSFATHER OMNIBUS
'The Bairnsfather Case', 'Fragments From His Life', and 'Somme Battle Stories'

ISBN: 0 9535204 5 5

The right of Mark Marsay to be identified as the compiler and editor
of this work has been asserted in accordance with
sections 77 and 78 of the Copyright Designs and Patents Act 1988.

Original research by Mark Warby, Editor of the *'Old Bill Newsletter'*.

Cover illustration:
'THOSE BLOODY MOUTH-ORGANS'
"Keep away from the 'ive, Bert; 'e's goin' to sting yer!"
Original artwork by Captain Bruce Bairnsfather - cover rendering by Neil Pearson.
The original cartoon appeared in *The Bystander* magazine on 7th March 1917.

'The Bairnsfather Case' first published by G. P. Putnam's Sons, New York and London, 1920.
'Bairnsfather - A Few Fragments from His Life' first published for *The Bystander*
by Hodder & Stoughton, London, Toronto and New York, 1916.
'Somme Battle Stories' first published for *The Bystander*
by Hodder & Stoughton, London, Toronto and New York, 1916.

This omnibus edition first published by Great Northern Publishing, 2000.
All rights reserved.

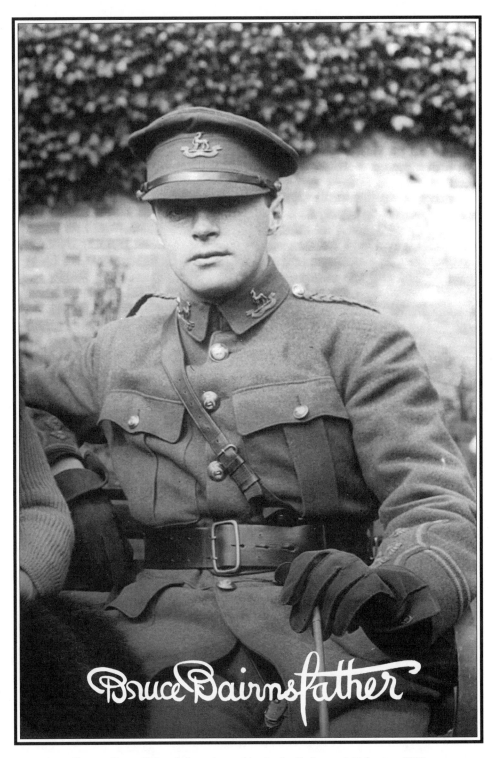

Captain Bruce Bairnsfather, pictured at the family home at Bishopton, 1916.

This book is dedicated to
Barbara Bairnsfather Littlejohn
for her continued support and best wishes.

Contents

The Bairnsfather Case

The Bairnsfather Case
- List of illustrations

Fragments From His Life

Fragments From His Life
- List of illustrations

Somme Battle Stories

Somme Battle Stories
- List of illustrations

Glossary

The BB Files

Acknowledgements

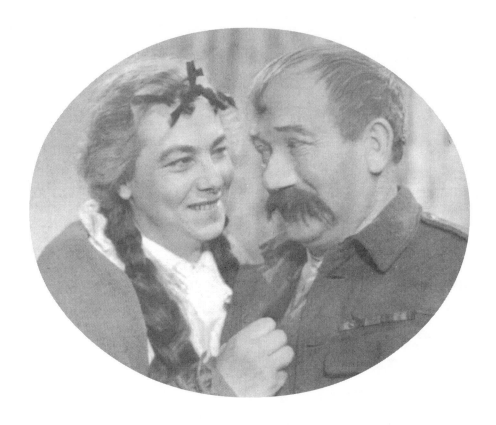

OLD BILL & MAGGIE
"Maggie! You are a one, you are!"

*Bruce Bairnsfather's most famous comic character and lifelong sidekick,
Old Bill, brought to life by actor Morland Graham in the film version of
'Old Bill and Son' released in 1941.*

*The 'son' in the film, 'Young Bill', was played by a fresh-faced John Mills,
and 'Maggie' by actress Mary Clare.*

Preface

Firstly, I have been asked, on behalf of the publisher and everyone connected to the 'Bairnsfather' project, to thank all those who purchased copies of the first Bairnsfather Omnibus and contributed so much to its success. Without your support we would not have taken the bold step to continue the Omnibus series and thus, eventually, see all of Captain Bairnsfather's work back in print and available for us all to read, enjoy and no doubt treasure once again.

Following publication of the first Omnibus we received a large number of letters from people who, if not able to remember Bairnsfather's work from the Great War directly, could well recall their parents, aunts and uncles reading aloud to them from his books and showing them the cartoons from magazines such as *'Fragments from France'*. Indeed, many of the letters were tinged with regret that what had once been prized possessions in the form of books and magazines by Bairnsfather, were now no more, having been lost in the great upheavals of life. The same letters were also suffused with a genuine warmth and fondness for this great, unassuming man, this hero of his day, so sadly overlooked in the latter part of his life. Letters bore thanks for giving our readers the chance to experience, once again, the talent and humour of Bairnsfather, for giving life and substance, to what, for many, were cherished childhood memories of their own parents and the high regard they themselves held for this wonderful man.

Many readers expressed a wish in their letters to know more, and to find out where they could obtain further Bairnsfather memorabilia, such as the original magazines, postcards, pottery and collectables. In each case we were able to point the eager 'fan' to the thriving and popular *'The Old Bill Newsletter'* (details were given at the back of the first Omnibus and appear again at the end of this one), and many have found subscribing to it has provided them with a whole new appreciation of the man and the ephemera connected with his work, whilst putting them in touch on a bi-monthly basis with like-minded collectors and fans.

However, it is true to say that of the countless letters we received, the most touching, and for everyone connected to the project, the most gratefully received, was the letter from Bruce's daughter, Barbara. I am sure she will not mind me saying that she, and her family, were delighted with the first Omnibus edition and continue to support our efforts to bring her father's work back into print and put it before the general public once more. We are proud to have Barbara's continued support and hope that, one day, Captain Bruce Bairnsfather will finally receive due recognition from this country, recognition which has sadly been overlooked for far too long.

In deciding to continue the Omnibus series a number of questions arose as to exactly what should and should not be included. Should we, for instance, include works which Bruce illustrated for other people, or simply 'plunder' them for his drawings? How should we decide on which books went into which Omnibus edition and in what order?

Although these dilemmas were not earth-shattering in their complexity, we did feel that it was necessary to 'get it right' as much for the enjoyment of the reader as for our professional pride as Bruce's publishers. In the end we consulted widely with both

There are times when jokes can be in rather bad taste.
From 'Carry On Sergeant!' - 1927.

collectors and with people who had purchased and read the first Omnibus. The final decision was practically made for us by this process and was unanimous from all quarters. Yes, we should include all work written and/or illustrated by Bairnsfather, and such works should be, as far as it was practicable so to do, in chronological order.

Before eagle-eyed readers start putting pen to paper to query the order in which the three works appear in this Omnibus edition as not being strictly 'chronological', we have endeavoured to place together books from the same or similar period, but have positioned them within the Omnibus in the way we felt best represented them and their importance. A full list of all the works to be included in the Omnibus series is given at the end of this preface.

It was also agreed that as the first Omnibus had carried a comprehensive biography of Bairnsfather, it was not necessary to repeat it in each subsequent Omnibus edition, thus allowing more room for his own work.

Therefore we have great pleasure in presenting, in this second Omnibus edition, the following three works; 'The Bairnsfather Case', 'Bairnsfather; A Few Fragments From His Life' and 'Somme Battle Stories'.

The Bairnsfather Case was published by Putnam's in 1920 and was written jointly by Bruce Bairnsfather and W. A. Mutch. It was illustrated throughout by Bairnsfather. The book was subtitled, 'As Tried Before Mr Justice Busby' (perhaps better known to you and I as Old Bill) and took the form of a court case in which Bairnsfather represented his defence and Mutch represented the prosecution, both penning alternate chapters in the book. The original preface to the book, written by Mutch, explains how the idea for the book originated and why it was decided to produce it in its final form. It is important to remember that at this stage in his career Bruce Bairnsfather was an undoubted, top-drawer celebrity, known and loved around the world and that his publishers and agents were continually inundated with letters demanding information about him. Today we would probably expect such a star to 'reveal all' in the tabloids or an up-market glossy, after being handsomely reimbursed for the trouble. But back in the 1920s the only way open to Bairnsfather and his publisher was to produce that information in book form. It also meant that they maintained control over what was written and stood to earn from their own labours.

The whole premise of the book hinges on both parties, Bairnsfather for the defence, and Mutch for the prosecution, explaining for the reader how Bairnsfather arrived at the position of celebrity he then enjoyed. The book, again autobiographical (as were 'Bullets & Billets' and 'From Mud to Mufti') seeks to provide the inquisitive fan of the time with as much information about Bruce's evolution from a struggling, would-be artist, earning his living as a boiler-suited engineer, to his meteoric rise to stardom on the world stage.

To be fair the idea of a 'defence' and 'prosecution' immediately becomes redundant, as Mutch proves himself as much a devoted fan of Bairnsfather as many of the readers who clamoured for the book on its original publication.

However, although a portion of the ground had already been covered in Bruce's two earlier books ('Bullets & Billets' and 'From Mud to Mufti') this work does provide some delightful insights into Bairnsfather's evolvement and his eventual championing of the ordinary soldiers' cause during the war, and his empathy with what is often termed 'the common man'. That he had to actually work for a living, and very obviously struggled hard to achieve what he did, without benefit of silver spoon or 'inside' contacts, speaks volumes for the integrity of the man. That he sees the various obstacles and hurdles

From 'From Mud to Mufti' - 1919.

From 'From Mud to Mufti' - 1919.

From 'Bullets & Billets' - 1916.

Leave !!!

Old Bill with a new-fangled pipe!
From 'Laughing Through the Orient' - 1932.

throughout his young life as challenges to be overcome in order for him to reach his final goal of becoming an 'artist', and that he stuck at it when many would have crumpled under the strain, again tells us much about his resolve and huge strength of character. The same resolve and strength which saw him through the bloody hell of the trenches.

My own favourite passages in the book are those where Bairnsfather (and Mutch to a lesser degree) veers aside from his autobiographical narrative to provide us with an anecdote or two on a particular subject dear to his heart. These are by far and away the wittiest parts of the book and allow his obvious talent for humour and comedy to show through. Likewise, perhaps the most touching and poignant part of the book is that in which Bairnsfather invokes his Great War companion, Old Bill, who stands before the Cenotaph in Whitehall and relates a story from the trenches to the 'Capting'. A very touching moment, contrasted heavily by what we may consider, today, to be the absurd inclusion in the book of almost an entire chapter written by Mutch describing Bruce's home at Waldridge Manor, including its history and various refurbishments! Certainly not something we are used to seeing in books these days, and perhaps more at home in the pages of *Hello* magazine than a biographical account. But again, given the context - and Bairnsfather's celebrity status - one can imagine fans clamouring for just such information at the time.

One also has to bear in mind when reading 'The Bairnsfather Case' that at this time Bruce was very big in the United States, and the book was published with a distinct 'American' bias and flavour, and that much of the biographical detail British fans had already experienced in his earlier works was being presented to a much wider American audience for possibly the first time (by the time this book was published in the United States 'A Few Fragments from His Life' - also featured in this Omnibus edition - had already been well received by a substantial portion of the American public). So, where we would perhaps regard it as repetitive, the Americans were experiencing it fresh and unsullied. And, as was always the case with Bruce's work, for many the first stop was to leaf through the pages to get a first glimpse of those wonderful original drawings and illustrations which are his hallmark, the text often incidental to the pleasure they gave.

Eagle-eyed collectors of the original edition of the book will no doubt note that, during our editing, we have re-established the correct numbering sequence for the chapters.

For those of an inquisitive nature a short biography of Mutch appears at the back of this Omnibus - unfortunatly it is 'very short' as, despite the best efforts of our researcher, Mark Warby, we could find almost nothing about the man. Perhaps his main claim to fame was his association with Bairnsfather and his collaboration on this book.

In 'Bairnsfather: A Few Fragments from His Life', published in the UK in 1916, Bruce and Vivian Carter, then the editor of *The Bystander* magazine (responsible for publishing 'Fragments from France'), collaborated on a work again intended to answer questions and provide information, in a jocular vein, to an eager and voracious general public. Again the work is biographical and covers much of the same ground covered elsewhere. Although by no means the 'best' book involving Bairnsfather - indeed, it is considered among many collectors as being one of the poorer books, produced by the publisher simply to 'jump on the Bairnsfather bandwagon' at a time when his popularity was soaring to its zenith - it does have some redeeming qualities. The book has huge appeal simply for its many original drawings, and for the inclusion, for the first time, of working sketches culled from Bairnsfather's sketch pads and letters. These rough, unfinished sketches show his brain at work as he develops his ideas for a finished piece of work. Also featured is a 'genuine' letter regarding Bairnsfather's work from a German officer

"No, we're standin' on the Palais de Justice. That there is the Café de la Paix ..."
From 'No Kiddin'!' - 1945.

who had served in the trenches. If it is indeed genuine, and we have no reason (except perhaps the hype of the publisher) to believe otherwise, then again it provides a remarkable statement about Bairnsfather's ability to reach not only his own brethren and comrades in arms, but those of all nations stuck in the gruesome Flanders mud.

A short but relatively detailed biography of Vivian Carter - *'the man who discovered the man who won the war'* - appears at the back of the book.

The final book in this second Omnibus, *'Somme Battle Stories'*, was written by Captain A. J. Dawson and illustrated throughout by Bairnsfather. The collaboration between Bairnsfather and Dawson extended to three books (all of which will appear in this and future Omnibus editions) and this was the first. Not much survives in the way of detail about the pair's collaborations. However, we do know that Dawson, the elder of the two by several years, worked out of the same Intelligence Department offices as Bairnsfather the 'officer cartoonist'. Whether the department brought the pair together, or publishers or agents were involved is unknown - though *The Bystander* figures prominently in both men's work at the time. What is perhaps significant is that the illustrations Bairnsfather contributed to Dawson's books were among some of the best of his more 'serious' studies and one cannot help but wonder if Bairnsfather would have gone to so much trouble had the pair not had some form of friendship, or at least a certain amount of respect between them. Indeed, on reading the Dawson books for the first time, one is inclined to think, for an instant, that perhaps the author was indeed Bairnsfather writing under a pseudonym. But further research has shown us that Dawson did in fact serve and one, single, solitary photograph of the pair (published in the *Daily Graphic*, part of the same group as *The Bystander*) walking in the street together, survives. Whatever the truth of the matter, it is quite obvious that Dawson and his publisher traded heavily on the name of Bairnsfather to sell the books in what was rapidly becoming an overcrowded market-place as more and more veterans and survivors penned their stories and memories of the Great War. Indeed, the precedence afforded Bairnsfather's name, which is almost twice the size of Dawson's on the original cover, confirms Bruce's 'celebrity' status and huge public appeal.

The book comprises a number of anecdotes and stories gathered by Dawson from wounded combatants arriving back in Blighty aboard hospital ships docked at Southampton who had experienced the horrors of the Somme battles of the summer of 1916. Unfortunately, because the book was published in 1916, shortly after 'the great push', a number of passages have been edited - whether by the censor or by Dawson is unclear, and is perhaps irrelevant. In compiling this Omnibus edition the decision was taken, largely through a lack of additional information, to leave many of the 'censored' paragraphs as they appeared in the original publication. However, in some places we have used editorial control to tighten up and very lightly rework various passages where we felt the changes made would have no fundamental effect on the overall structure of the narrative being provided. These very minor changes have been made to provide the reader with a 'smoother' narrative than otherwise would have been the case with so many 'censored' names, places and events appearing haphazardly throughout the text.

Whether the book, dealing as it does with the Somme, had quite the same impact in late 1916 as it may today, when the very mention of the Somme is often enough to strike a coldness into most men's hearts, is unclear. What is evident is that the book, though describing, often in quite vivid detail, the actuality of the Somme, still retains an almost 'Boy's Own' adventure story feeling to the general narrative. If the reader can overcome this and delve deeper into the text, the book offers a good handful of rather objective

Billiards up at the château.
From 'Carry On Sergeant!' - 1927.

and vividly descriptive first-hand accounts which are well worthy of note. That the book is illustrated - in quite a serious fashion - by Bairnsfather, makes it, in my view, quite a little gem to add to one's Great War collection.

Again, a short but detailed biography of Dawson appears at the back of the book.

So, there you have it! The three books which form 'The 2nd Bairnsfather Omnibus'.

Thanks to everyone who has helped us along the way (detailed thanks can be found at the back of the book), with extra special thanks to my good friend and official 'Bairnsfather Researcher' Mark Warby, and to those who continue to support our efforts to bring Bruce's work back into print, especially you, the reader. We hope you enjoy and treasure them as much as we do and I look forward to greeting you again at the beginning of the third Omnibus edition, when we will be including, what for me is far and away Bruce's best book; the incomparable *'Carry On Sergeant!'*.

Cheerio chums!

Mark Marsay
Author in residence
Great Northern Publishing
Scarborough
November 2000

The Bairnsfather Omnibus editions:

1: *Bairnsfather Biography*
 Bullets & Billets
 From Mud to Mufti

2: *The Bairnsfather Case*
 Fragments From His Life
 Somme Battle Stories

3: *Carry On Sergeant!*
 For France
 Laughing Through The Orient

4: *Back to Blighty*
 Old Bill Looks at Europe
 Old Bill Stands By

5: *Old Bill and Son*
 Old Bill Does It Again
 Jeeps and Jests
 No Kiddin'

THE 2ND BAIRNSFATHER OMNIBUS

The Bairnsfather Case

Written and illustrated by

Bruce Bairnsfather

1920

(with additional text by William A. Mutch)

Dedication

DEDICATED TO CEAL, WHO KNOWS THAT IT WASN'T ALL LUCK.

Bruce Bairnsfather

The original dedication to his future wife, Cecilia, by Bruce Bairnsfather.

Preface

I t was very soon after the appearance of *'Fragments'* that the idea of this book was conceived. Letters asking all sorts of questions began to arrive in such numbers that it became utterly impossible to deal with all enquiries individually and conscientiously.

I, therefore, suggested to Captain Bairnsfather that since there was such a real demand of this sort, it ought to be met in some definite way. I was able to persuade him that this should be done, and was still more happy in securing his promise to illustrate the book with original drawings, and to contribute alternate chapters dealing in his own inimitable way with the various subjects demanding exposition.

Hence, *'The Bairnsfather Case'*, in which we have tried to explain faithfully and analytically how Bairnsfather started as an artist, the enormous obstacles he overcame before he achieved success, and what personal elements in himself and in his work seem to have contributed most towards making him known throughout the world.

It is my special hope that the young artist will, in these pages, find some guidance and encouragement.

I am greatly indebted to Mr F. C. Wellstood, MA, for the account of the historical associations of Waldrige.

William A. Mutch
London
3rd August 1920

The original foreword by W. A. Mutch.

A cross marks the spot where the body was found.

Chapter 1

A WORD TO THE JUDGE IN WHICH I PLEAD FOR MERCY
~ BAIRNSFATHER, FOR THE DEFENCE

My Lord, and Gentlemen of the Jury, in the year 1887 the birth rate in India went up by one - that was me. The last Himalayan glacial age was drawing to an apex when I was evolved, in other words, I was *Homo Damnuisensis*, or Sub-Man (Pub-Man according to some).

Anyway, there I was, born at an altitude of umpteen thousand feet in the Himalayas.

I think my mother hid me from my father for some time, but my presence leaked out later, and they gave me a name to put at the bottom of my drawings.

My father is Scottish on the Scottish side, and my mother is English on the English side, so I am Esperanto. Our ancestral home is somewhere on the Tweed, so that we can back our trouble both ways.

I remember little of my life in the Himalayas. I can only dimly picture my father leaving our cavern in search of food; I can scarcely vision my mother beating off the monkeys as they swarmed about me. In fact I must let this nebulous portion of my career pass until I reach those sections of the dawn which I can remember. My later memories of India are very strong. I can recall a host of incidents during my life with my parents in various parts of the country, all filled with the sleepy, romantic and mystic charm of India. Even now, the smell of a bonfire on a summer's evening carries me away with ease to some hot city on the plains of India, bathed in that unique atmosphere which stands for India and nothing else.

In due course I was brought home to England. All white children are brought home at a certain time - if not, the sun affects them - I think possibly I was brought home a bit late, as I followed it up by being nothing but one big nuisance at school.

For many years I was a skeleton in our family cupboard.

As this disastrous period was the age during which my subsequent profession started to show signs of origin, I will describe what happened. Before I go further, however, I want to state that Mr Mutch is conducting the case for the prosecution. I am pleading 'Guilty' to this first phase in my drawing career, and therefore (at enormous expense) have persuaded Mr Mutch to keep his indictment for succeeding chapters, leaving me to plunge boldly and truthfully into the wild disorder of my life at school, in order to show what pain I caused my parents, how I could scarcely ever sit down in comfort, and how drawing pictures became at once the cause of my father's grey hairs, and my subsequent fortune. (In pleading for clemency, I may say now that for quite a time I have been trying to restore those grey hairs, but more of that later.)

My father comes from a martial family. (The first of the line was on Hengist and Horsa's staff, or something like that.) Old albums have shown me that his father, grandfather, uncles and cousins were all warriors. My mother, also, has an assortment of mail-fisted relatives in her family, the result being that I was 'destined for a military career'.

My Lord, pardon my waking you.

I was sent to an army college. A

school dedicated entirely to manufacturing army and naval officers. For this purpose they gave one an entirely 'Service' education; Latin, Chemistry, and Roman history.

There is nothing like Chemistry for an army officer. Think of the enormous advantage of being able to say over to yourself in the middle of a battle, $Zn + H_2SO_4 = ZnSO_4 + H_2$.

You can't think what a comfort it is.

Or say the dreadnoughts are all in line, and the rival fleet is putting twelve-inch umbrella stands through the port jib, or the conning tower. Think! Just think for a moment, the aid you get in this hour of dire need, by being able to mutter, $MnO_2 + 4HCl = MnCl_2 + 2H_2O + Cl_2$.

It's incalculable!

Well anyway, I was to get an army education. I got it. I was sent to Westward Ho! A school which has been immortalised by an immortal - Rudyard Kipling. It was here that I first began to draw, and it was here that I caught the insatiable desire to go on drawing. A wild and woolly life it was. Full of 'ups' and 'downs'. Down at the bottom of the class mostly and being turned up afterwards. I struggled in the Latin tongue with the dull successes of Caesar. I writhed with unique powders and smells in the laboratories. I sucked sweets in the French class and attended morning prayers in the gymnasium with the fervour which only a criminal can assume. My total lack of interest in Chemistry, Latin, Algebra and Arithmetic, etc., led me, ere long, to search for a means of brightening my education. The way was clear. My school books became a mass of scribbles. Caesar had to stagger, with his dull wanderings, through a mass of rude and abusive illustrations. The margins of all my books became thick with caricature. I fully realised the doom I was pronouncing on my ever passing an examination. I wallowed in degraded and hidden art of an immature kind.

It was a hard school, full of tradition and corporal punishment. (Sensations in court.)

I got quite used to my weekly thrashings and grew to looking forward to the 'star' thrashing on Saturdays for being thrashed during the week. I found my marginal scribbles helped and amused my friends. They somehow lulled them off from worrying about the properties of Hydrochloric acid and the priggish adventures of Hannibal. They dulled them to the importance of the Reformation and the Wars of the Roses. In fact, from a human point of view (though not parental) I was a great success. I won nearly all the drawing prizes, and as a

matter of fact, my school books were removed by sundry masters as scraps of amusement in their own tortured lives. (Loud and prolonged groans.)

Well, time went on, and so did the drawings. With a large geography book open vertically before me, I drew sketches behind it, in my own books and everybody else's.

Needless to say, I ultimately failed in the army examination.

However, by means of an army crammer, and the pathetic sight which my parents displayed, I galvanised myself into the necessary intelligence to pass the second time, and so was launched into a career which 'bored me to tears' as they say, but which was one day to stand me in good stead, when the Great War came along.

As I said before, the sun is not good for Anglo-Indian children after a certain age. I fear that up to this time my father was convinced that the sun had been at me.

With these words I will now leave the Prosecuting Council, Mr Mutch, to unfold the painful story.

My Lord, I trust I am not keeping you up?!

No! Not the postman. A half-Godfather of mine on the Irish side. In the Mucpuddle Volunteers (from the family album).

Chapter 2

A RECIPE FOR SUCCESS
~ MUTCH, FOR THE PROSECUTION

In any true estimate of the genius of Bruce Bairnsfather the Great War occupies a place equal to one per cent. If every other sentence I write be forgotten and that be remembered, I shall have done the Bairnsfather case a great service and contributed something towards dispelling the many amazing mythologies which have crowded round the name of 'the man who made the Empire laugh'.

It is one of the penalties of genius that the public look at the fruit - never the tree.

They do not know of the tending and training which is carried on year in year out, before any ghost or glimmer of fruit appears.

The ceaseless days of toil, forethought, and sacrifice are apt to be passed over. The apparently easy victory is too often all that catches the eye.

The development of genius is like the production of a play. There is endless endeavour and tear and wear behind that rose-coloured set that looks so beautiful across the footlights.

Don't you believe it easy! The easier it looks, be sure there is all the more sweat at the back of it.

I intend to take you behind the Bairnsfather scenes, and I can say here and now that if the Allies had gone into the Great War with but one tenth of the laboriously acquired equipment for victory that Bruce Bairnsfather took to France in 1914, the whole business

of war would have been finished in as many months as it actually occupied years.

Now, get me right once and for all, neither Old Bill nor 'Old Bill's Pa' were ever heart and soul in war for war's sake. It was their joint misfortune that they descended upon the world like a burst of sunshine when things were pretty clouded; and in order to clear my feet for more important things I propose to examine that phenomenon - the *début* of Bairnsfather and Old Bill right here and now.

At the blackest moment of the Great War, when Britain was really down-hearted about the issue, there appeared in the English *Bystander* a picture over the title, *"Where did that one go to?"* This picture was followed by another from the same unknown artist, and the title of the second picture was *"They've evidently seen me."* Soon afterwards a third picture, *"We are staying at a farm."* made the British public realise that a new star had arisen in the firmament of art.

People sat up and took notice. This phenomenon was simply incredible.

The story of the Old Contemptibles and the story of the First Hundred Thousand have been told throughout the world. It is well known that whatever else there was in France on the Allied side, there was grit, but this sort of thing was unbelievable.

Day by day, for weeks and months, previously official reports had grown more terse and despairing.

That promised Kaiser banquet at Buckingham Palace was a plain possibility.

Worse - the Allied Armies in France were living through a terrible ordeal, surrounded by mud and gas and machine guns and all the horrible mechanism employed in the modern wholesale slaughter business.

True, there were leader-writers who stayed at home and talked about the invincibility of the Allied cause, and raked out of the past such threadbare platitudes as 'Right is Might' and 'Justice must Triumph'. But all grandiloquence had long since left the front lines, although a goodly remnant might have been cherished by staffs well to the rear.

But 'up there' sitting in the mud on the edge of no-man's-land it was a hell such as Sherman never dreamt of.

And out of this massacre, from among the cannon fodder itself, came an artist who made the Empire laugh - who restored to the whole of the Allied people the gift of laughter which for months they had forgotten, who made even the neutral nations realise the inner meaning of the war, and who found appreciation in the German army. It is a remarkable fact, as showing the universality of genius, that Bairnsfather pictures were found pinned up in places of honour in German dugouts, and I have seen with my own eyes letters of appreciation of *'Fragments from France'* written by an officer of the Uhlans.

But the point I wish to make here is the highly ironical manner of the emergence of Bairnsfather.

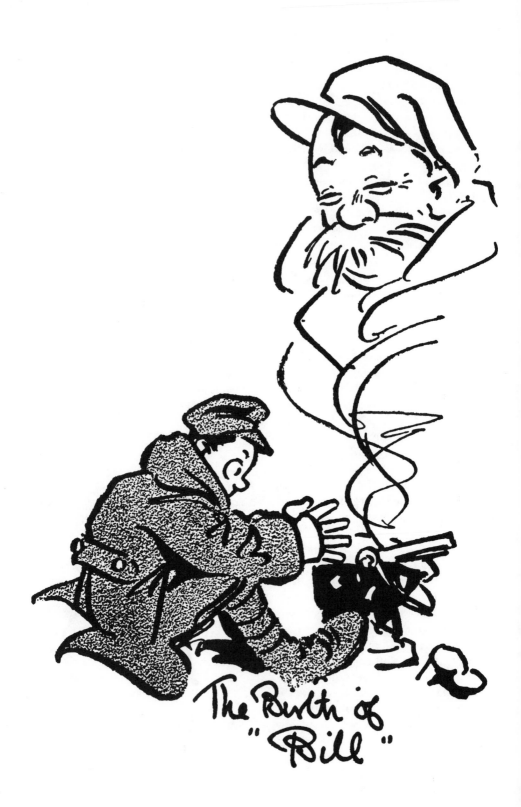

The Birth of "Bill"

The natural order of things was that the people in Britain, isolated and protected from the horrors of war by a great Navy, should have been sending laughter across the Channel to France in shiploads.

Genius upset all that.

The laugh came from the other side, and people in London, who for months had acted as wholesale gloom distributors, left off their speciality salesmanship of long faces and exclaimed, "Isn't it amazing? How does he do it? He has got the smell of the mud in his nostrils, but who is he, anyway, this Bairnsfather? Anyhow, he can't keep it up."

But the stream of '*Fragments from France*', so modestly begun, swelled into a river, and Bruce Bairnsfather, the artist, like a perfectly acting machine, has

been hitting on all six cylinders ever since. And presently 'this Bairnsfather' became a real asset in winning the war, and suffered the crowning calamity of being photographed for the press. And people looked at the photograph and said, "Now that is just what I thought he looked like. Doesn't he smile beautifully? Isn't he handsome! He must be six feet if he is an inch."

And as usual they were all wrong, because your photograph is like the men of whom David spoke in his hurry.

'The man who made the Empire laugh' is not a Douglas Fairbanks. He is not a red-faced giant laughing a carefree way through life. He thinks too deeply to live on the surface of things.

His eyes are the most arresting thing about him. They dance and sparkle. You realise at once that they see all that there is to see in life, and see it square. They are eyes that see because they are the windows of a heart that feels. They can appreciate tragedy as well as comedy. It is worth while knowing that there is a serious side of his nature because it was in a fit of profound depression that the first '*Fragment from France*' was conceived.

Although Bairnsfather comes from a military stock, he is profoundly anti-militarist. His artistic temperament in days of peace chafed at the imprisonment of barrack life. In days of war his whole being revolted against the horrors of modern battle. To him the whole business was a nauseating nightmare. He hated war as much as he loved the men who were its victims. That was why he never ceased to wonder at the unconscious heroism of the soldier.

To illustrate his attitude to war, I may quote two incidents which have clung to his memory and made a profound impression upon him. The first happened in the winter of 1914, in a small, shell-torn village on the Flanders Front.

Bairnsfather was walking alone through this village in the dusk. The wind was moaning through the broken rafters of the houses. The rain was falling without cease. He was thinking at the moment of the warm billet to which he was returning, and consoling himself with the thought that after all, even in war, there were material comforts to atone for hardships. Two officers, their caps pulled down to shelter their faces from the rain, their bodies bent against the wind, passed him on the street, and just as he realised that these two men were the Colonel and the Adjutant of his battalion, his ears caught the Adjutant saying to the Colonel in a matter-of-fact voice, "That quicklime has not arrived yet, sir."

The dream of warm billets was by that one sentence swept away in a flash to be replaced by the nightmare of no-man's-land strewn with these shapeless, broken bodies, whose last indignity it was to make life impossible for those who survived. The grim jests of death scattered broadcast on the battlefield are not congenial food for human mirth. Bairnsfather, with a soul which probes deep beneath the surface of emotion, was in point of fact overwhelmed by the mechanical horror of war.

His 'Fragments from France' are not in the least inconsistent with this innermost feeling. It is a proud Saxon quality which inspires us to cloak our deepest sorrow with our lightest words. Hence we find in all English-speaking peoples that peculiar macabre brand of humour in which the corpse and the skeleton are held up as the Aunt Sallies of our jests. The time-honoured figure of cheap fiction - the clown who gambols in the circus while death waits in his home - is not an ill metaphor to explain the Bairnsfather psychology at this period, for it was in the midst of a daily cataclysm of ideals and dreams that the first 'Fragments from France' were born.

It was not from a contemplation of war, but out of reflection on the unconcern of the soldier plunged within its vortex, that Bairnsfather found his inspiration.

This brings me to the second incident, or rather a multiplicity of incidents I want to emphasise. He used to watch the British soldier in the front line while the Germans were conducting a *strafe* and he used to wonder at the attitude of the men who followed the progress of a shell overhead with the utmost indifference and returned unmoved to their task of the moment. They would mark the trajectory of a shell without even a tithe of the wonder with which we still regard the flight of an aeroplane. Their frame of mind was identical with that of a man looking up from a plough to watch the passing of an express train - an utterly everyday incident which left not a trace of thought behind. This attitude he illustrated in a short play, *'The Johnson 'Ole'*, where two soldiers in the line are shown singing that favourite army lyric:

*"'Tain't the bird in the gilded cage
Wot 'as the sweetest notes . . ."*

when the music is interrupted by the whizz, whine and crash of a shell. The soldiers pay not the slightest regard to the interruption. They simply continue with:

*"And it ain't the girl with the pretty face
Wot loves 'er 'usband most."*

Well, now that I have done something to dispel the preconceived idea of Captain Bairnsfather as a laughing giant, you will say, "Yes, but he did make us laugh! How did he do it?"

12

That brings us down to brass tacks, because this is exactly the question I have put to myself; and before I finish this Prosecution I hope the question will be answered once and for all.

I shall ask you to return a verdict that deliberately, with malice aforethought, he made himself an artist - and what is worse, a humorous artist at that.

First and foremost let me say that success is the outcome of a curious compound of elements. I should say that of these elements ninety-nine per cent are self-contained and one per cent are external. The self-contained elements are broadly divisible into two sections - gift and grit. You know perfectly well there is material from which silk purses cannot be made. Well, you cannot take any man and make him a genius. The gift must be there first, and in this respect Bairnsfather was amazingly lucky in his choice of parents. His father, Major Bairnsfather, comes from a fine old Scottish house with proud traditions, and his mother is a sample of the most splendid type of English gentlewoman.

Bairnsfather himself has acknowledged his debt to his parents over and over again, as in the dedication of *'From Mud to Mufti' - To My Mascot Mother*.

Certainly we can see in Bairnsfather's parents the origin of his gift, but the gift would have been useless without the grit. Through the whole of his life we see grit at work. From his school days he resolved to be an artist and through adversity sufficient to daunt a hundred men, he kept the light of endeavour aflame. All through the years of ordeal he kept the ideal before him. The war gave him his opportunity as it gave an opportunity to every other artist with pen or pencil. Witness the aroma of war around the names of Rupert Brooke, Ian Hay, Boyd Cable and W. R. Nevinson.

'Success!'

13

Critics have talked of Bairnsfather as if he cornered the war. The war was simply the one big thing of the day; but Captain Bairnsfather is not a product of the war and it is one of the misfortunes of the popular conception of his work that it was created by the war. I shall endeavour to show that the war itself has occupied a very small place in Bairnsfather's life - a one per cent place - as far as his achievement is concerned.

Before the war he spent fourteen years of ceaseless effort in order to make himself an artist. In doing so he suffered all sorts of hardships before the war was dreamed of, and since the war has ended he has accomplished all sorts of achievements.

With regard to the future, I do not need to rely on speculation when I say that it will not be long before he shows the world that he can interpret the feelings of humanity in peace as brilliantly as in war.

In short, the same thing applies to Bairnsfather as to his famous character, Old Bill. Old Bill never was a soldier. He put on the khaki and went into battle because the German beast had to be crushed, but all the time he was a civilian in uniform.

I cannot emphasise too strongly the fact of the years of preparation which Bairnsfather spent before the coming of Armageddon. The war in Bairnsfather's life was simply the tide in his affairs which, taken at the flood, led on to fortune. Genius is not necessarily lucky in meeting such a tide. The tide is not as manna sent from heaven. It is not once, but several times all around us. It is there for any man to profit by, but only genius has the gift to see it.

Therefore, in the Prosecution I make, there will be merely a one per cent element of war, because the ninety-nine per cent element of peace, besides being many times more interesting, is many times more vital to any accurate estimation of the genius of Bruce Bairnsfather.

Chapter 3

ANOTHER WORD TO THE JUDGE AND A THICK EAR TO THE COUNSEL
~ BAIRNSFATHER, FOR THE DEFENCE

Before this book gets any further I feel sure everyone wants to know exactly *how* I do things. I know myself I am always bursting to know how other people do things. If I can get the sight of a 'close up' photo of how some other writer or artist works, I'm on it like a gadfly.

So many people have asked how I work, that I know I'm right in explaining this dread secret.

I also have another motive for making this explanation. As this book goes on, Prosecuting Council (curse him) is going to give all my tricks away. There can be only one verdict by the end of the book, "Guilty of loitering, with intent to commit jokes," so I am going to get in early on the readers, and explain my 'modus operandi' (a bit of Latin gives a legal touch to the explanation).

On a certain occasion long ago, in my nebulous artistic period, I somehow or other found myself being shown into Sir Thomas Lipton's office. I found myself inside trying to sell him an advertisement for tea. (I can feel the bruises now.) But amongst the things

that struck me as I left that office was that over his desk there was a large card, upon which was written, 'There's no fun like work'.

It sounds foolish to most of us. Eight hours in a rubber factory can't compare with eight hours on the river at Marlow, to my mind. But somehow, underlying that irritating phrase over Sir Thomas's desk, there is a curious truth. I've worked it out, and have so organised my day's work and my methods, that when I get an office I'm going to have a notice over my desk which will read, 'Don't talk, play to me'.

I have a studio in a wonderful garden where the sun shines down for ever, and there are no restricted hours. Across the fields I can see a brewery working overtime. It is the brewery that supplies me with inspiration. Across some more fields I see a bank, also working overtime. It is the bank I get all the money I want from. It is all nature's garden at work.

I rise at eleven and find my breakfast set out in a quiet arbour overhung with luscious flowers. At twelve I read the murders in my daily newspapers, and smoke a pipe, lulled into a delirium of tranquillity by the droning of the machinery at the brewery, and the murmuring rumble of the barrels as they are lowered into my cellar.

An Oriental comes at one o'clock, and leads me to a rose marble cabinet, where he softly and silently massages me to give me ideas. I then swim in a scented pool at the foot of the lily walk in my garden. All the while the sun is shining, the brewery is brewing, the bank is banking, and I am working.

And so the days pass in tranquil joy, and each night I open my mail and extract the cheques from various editors, with a pair of ivory paper tongs.

I read all their letters as I sit on the veranda late at night under the stars. Their letters help me in my work, they generally read like this:

My Very Dear Sir,
We are too overcome with reverence and delight at your last picture to say more than to positively refuse to pay you the mere £100 you ask for it. My firm wish me to tell you that they would be only too proud to have merely a rough scribbled idea from you, and insist on paying you £200 each for them.

We have already placed £1000 to your credit at the bank in the hopes of future work.

Yours very sincerely,
The Editor.

I understand what Sir Thomas means, but only a short while ago I didn't. I used to rise early after a night spent thinking. I would fight my moods and temperament at breakfast, and spend the next six hours in silent absorption and concentrated effort. My hours of rest were crowded with the aftermath of mental struggles, and with future

themes. I staggered with all the ills that an artist is heir to.

That method is quite wrong, yet in it there is a great joy - to my mind the greatest joy in the world - the joy of achievement: a joy which can make your playtime hours sparkle, and that's why I know that perhaps there is 'no fun like work'. I think I shall go back to that method.

It is not all method and mode of work, though, that is necessary. An overwhelming desire must be in you to be an artist. There are a terrible lot of nasty things to overcome, but if you have got the complaint from birth, nothing will be *too* nasty. Nearly every family suffers from 'an artist'.

I know I'm right, for I, too, come from a family. I have a father and a mother, also a brother; and yet I happen to be an artist. Musing on these facts inspires me to help would-be artists. I want to hand round some well-meant advice to budding Michelangelos or Bud Fishers, so I am writing from my own personal experience.

I was born with the complaint. My mother little knew the trouble she had brought into the world. I preferred pencils to rattles, even as far back as those nebulous days when I crawled about on all fours in our Himalayan home. I mention this fact because I don't think anyone can survive the devastating disappointments, and maintain the kinetic energy needed for success, unless he arrived on the globe almost holding a BB pencil in his hand. You don't notice what a pain you are to your family till your father reels financially and mentally under your reports from school, due to having done nothing all the term except illustrate your Homer or Pendlebury's Arithmetic. Then you begin to realise that to follow 'art' is going to be a sticky business. This fact strikes you more forcibly later, when *you* have been struck pretty forcibly on the part you fold at by the Headmaster, for having drawn quite a promising caricature of him.

Five or six years of disappointment and pain pass over your rapidly-ageing father's head. Your mother sticks to you and nurses you through all those years with a love that a mother always has for the mentally deficient member of her brood. Then comes the great time when you must choose your 'profession'. Your father thinks everything but 'art'. (He's heard about 'art' adversely from someone.) Professions such as civil engineering, insurance and those safe lines, Army, Navy, Bar and Church are flung at your artistic soul as 'suitable'. That wretched temperament of yours has to weather this. It will take you another five years to have tried all the lot and to have been discharged from each on the grounds of being too artistic - and consequently a failure.

Your relatives now come into full play. They have nothing whatever to do with the case. They give you nothing, they risk nothing, but have an abnormal desire to write profusely to your father or mother, incorporating in their gratuitous letters such phrases as, "It's a pity he doesn't *do* something."

You stagger on. In the wrong job which has at least become a necessity, you endeavour to earn a living. In your spare time you must persist with relentless intensity on your hidden vice - 'art'. You will be alluded to by the relatives aforesaid during this period as, "Oh, you know he draws; it's such a pity." You mustn't mind that, but carry on. Now or never comes your chance. You suddenly will get a picture accepted: a design for a luggage label, let's say. This is the signal for seeing 'RA' after your name within six months. You

must now burst all bonds and ties and go for it hard. At this juncture in your life it is impossible to formulate any rules or books of help - it all depends on incurable tenacity, relentless ambition, and some firm being weak enough to accept your first efforts, against their better judgement.

After the sale of your first picture there is generally a sickening and almost stifling pause, during which you become familiar with a little bit of prose beloved of all journals, 'The editor regrets he is unable to accept your, etc., etc.'

You are now at such a nebulous period in your career that it is impossible for me to hand out any advice just here; all I can do is to have five 'stars' set in the page. Here they are: * * * * *.

You emerge to success, and your pictures are bought with almost tiresome regularity. Your circle of friends increases in direct proportion to the rise of your income. You have no idea of the number of relatives you possess until this moment arrives. Each one of them *knew you'd be a success some day*. With your enormous fortune you can now pull your parents out of the nursing home.

Chapter 4

AT THE FOOT OF THE LADDER
~ MUTCH, FOR THE PROSECUTION

Adventure is more attractive than achievement. It is more interesting to read how a man made a million than to learn that he has it. In other words, the 'how', rather than the 'what' is the thing that thrills because, after all, the 'how' is the life and the 'what' is merely the QED (*quod erat demonstrandum - which was to be proved*) with which Euclid used to sign his propositions.

I find, therefore, in the earlier part of Bairnsfather's life, when he was striving, much greater interest than in later years, when he had attained.

From the outset of his conscious artistic efforts he aspired to the heights. His first task, at the age of fourteen, was the illustration of what unfortunately for youth is a universal classic. Certainly the invitation was not a pressing one. There were, in fact, potent arguments against accepting it. The fees were unattractive in that, instead of being paid for the job, a price was set upon the head of the artist.

Yet, it is well worth while noting that the first consistent artistic effort of Bruce Bairnsfather was the illustration of the First Book of Caesar. This, at Westward Ho! as he has already indicated in an earlier chapter, gained him intermittent doses of corporal punishment administered with the true thoroughness of the English public school in matters of this kind, in addition to the confiscation of all such illustrated editions.

Westward Ho! was in Bairnsfather's day, whatever it may be now, a typical English educational institution, owing undying allegiance to hidebound tradition. It is the fashion to lavish unlimited and even unthinking praise on the English public school on every possible occasion. The playing fields of Eton are ranked with the slopes of Parnassus.

Perhaps in the end both are equally useful.

English public school education, and English university education as well, far too often are merely luxuries, and even discounting this fault, the English system of higher education invariably suffers from an iron rigidity. For the most part it goes on the incorrect assumption that its victims are to be officers in the Army or Navy, high officials in the Diplomatic or Civil Service, or merely gentlemen of leisure. In some cases there is no distinction between any of these destinies.

Now Westward Ho! in the Bairnsfather days was given up entirely to the preparation of students for the Army and the Navy entrance examinations, and an artist was as welcome in this atmosphere as Mr Pussyfoot Johnson in a Scotch distillery.

In Bairnsfather's case prodigious efforts were for a time made to 'turn him into the right lines', because your English form master is nothing if not loyal to an ideal. Therefore, for a considerable period of his school life Bairnsfather's lot, like that of the Gilbert and Sullivan policeman, was not a happy one.

On his part he was determined to draw, and his masters, on their part, were determined that he should not.

It is a good thing for the world's supply of wit and genius that this - the first great war in which Bairnsfather engaged - ended in the complete confusion of his enemies, for the outcome of the whole affair was that this utterly incorrigible artist was shoved away into a corner and left to work out his own destruction.

For five years Bairnsfather maintained a guerrilla warfare with his masters at Westward Ho! and in the end, in 1904, they were triumphantly able to say, 'I told you so!', when he was ploughed for the Army Entrance Examination.

The subsequent year of torture was spent under an Army Crammer who stuffed him so full of Greek and Algebra that in spite of himself he passed the examination at the second time of asking, and was therefore eligible to go at once as a recruit to an army depot, to the delight of his teachers and parents, but much to his own disgust.

As a result of this unwilling triumph we next find him attached to the Warwickshire Special Reserve for a two-month period of training on the barrack square. This completed, he transferred to the First Cheshires, his father's old regiment, where he was under the command of Colonel Grove, who had gone to India with Major Bairnsfather many years before.

With the Cheshires he was stationed first at Lichfield and then at Aldershot. In both places he speedily became known as an artist with a sense of humour, and samples of his caricatures were in great demand as decorations for the officers' quarters.

The final stage of his career as a professional soldier was a return to the Warwickshire Regiment quartered at Warwick.

It is curious to note how much of the earlier Bairnsfather destiny is centred round this historic and supremely beautiful heart of England. English history makes a great appeal to him, not merely because it is English, but because it is history. There is not a hill or dale in Warwickshire he has not tramped on foot and peopled out of his imaginings with all the great men whose ghosts still haunt the land. The home which out of the earliest part of his fortune he bought for his father and mother is at Stratford-on-Avon, and although his work compels him to live in London he seldom absents

The Seat of Learning

himself long from the inspiration of the country. This is essential to his work, and Stratford is so far from London that he has been prompted to purchase a beautiful old Cromwellian residence called Waldridge in the heart of Buckinghamshire. But Waldridge opens up such a vast subject that I must leave it to a later chapter, in which I shall endeavour to show how this residence sums up the quality of Bairnsfather's gifts, and how it is in a measure a prophecy of what we may yet expect from his brush and pen.

We shall return, therefore, to the barrack square at Warwick where we left Bairnsfather occupying his time with military exercises to the least possible extent, and as far as might be by drawing libellous cartoons of his fellow officers.

It was, however, not very long before this pleasant exercise ceased to satisfy his craving to draw pictures. Even the glory of a lieutenancy failed to overshadow the call of 'art'. Life in barracks he found increasingly irksome, and he was soon begging his parents to give their consent to his leaving the Army in order to devote himself entirely to an artistic career.

The result of this unrest was that he persuaded his father to make a special journey to London in order to investigate what fortune might await an artist there. Major Bairnsfather saw a friend of his own, a distinguished member of the British Royal Academy, who said that if his son was determined to leave the Army he ought to sell something to eat. It was because of this *obvious* encouragement that in 1907 Bairnsfather resigned his commission and took up art as a serious profession.

And very serious indeed it turned out to be! He was unalterably resolved to be an artist, and at this time judged that the best was to devote his whole energies to a course of instruction in art technique which would bring his work up to a saleable standard of merit.

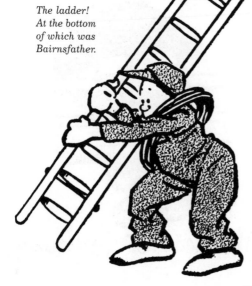

The ladder!
At the bottom
of which was
Bairnsfather.

This phase in Bairnsfather's life is full of interest to youth resolved to set out upon the thorny path which in this case was to endure for seven years before the least glimmering of success was to make its appearance.

In my association with 'Fragments' I am frequently consulted by young artists who send samples of their work and obviously hope they will get a letter in return advising them to throw up everything for art. In no case, as yet, have I been able to give such advice. The way of the artist is as hard as the way of the sinner.

The world is crowded with men of great experience who can draw just what its

magazines want. To attempt to be of their company is more difficult than getting past a pugnacious tram conductor displaying his 'full up' sign. It is taking a hundred to one chance for a youth of even the greatest merit to pit himself against the tried and expert craftsmen in the world of magazine art.

Simple human charity demands a clear statement of that caution. It is set down here deliberately because I am about to illustrate and prove it from Bairnsfather's own experience. This I shall do not to discourage youth. Rather the reverse. I shall show how in Bairnsfather's case he broke inside the charmed circle, and what is more important, I shall show that he succeeded in doing so not while he was receiving support from his parents, but after he was entirely on his own.

Before this lonely furrow period he went to London where he studied under Van Havermat, an instructor at the time in the academy known as John Hassall's School of Art.

Now, for the first time, Bairnsfather found himself in an entirely congenial atmosphere. There was no form master to recall his attention to the days of Julius Caesar. There were no orders of the day inviting his presence on the parade ground. It was art all the time - all day and all night if he cared. It was Elysium. He worked without cease and presently began

Fists: mailed: one.

counting the weeks and days to elapse before he would fare forth armed for the conquest of the world of art - a pretty picture, but not so near as he dreamt it.

Still, by his own ability and industry he soon became Van Havermat's favourite pupil and would remain at night long after less enthusiastic students had gone in order to pursue his ambition. There was no lack of enthusiasm or hard work on his part. If sheer slogging could have won success at the time it would assuredly have been his.

Neither, in the midst of the study of technique, did he neglect that equally important study of human nature which since has illumined all his work. He haunted the music halls of west London. Shepherd's Bush Empire and Hammersmith Palace saw him a regular patron for many months, watching, thinking and pondering over successes and

failures on the stage; trying to make out why one thing got across the footlights and another did not, always studying the audiences from the boxes to the gallery.

Even at this time Bairnsfather spent many of his waking hours worrying out the ways of human psychology and not so much having feelings *about* people as feeling *with* them. That is the secret of the soundness and steadiness and sanity of his outlook. He is not an analyst of humanity in the scientific sense of the word. Rather I should sum up his outlook in the most beautiful adjective in the English language - compassionate.

All this mixing with people has played a great part in the development of Bairnsfather's great gift of sympathy which is the brother to understanding. At the time he was not conscious of it.

He was in a deuce of a hurry to get that bit of training over and he was the happiest man in London when the end came and he asked Van Havermat what sort of a chance he had at making a living with the brush.

He was not so happy when Van Havermat replied, "You ought to be able to make £700 a year, but on the other hand you might make nothing." Whereupon his optimistic teacher proceeded to emphasise the nothing much more heartily than the £700 with the result that Bairnsfather left the art school with about the same cheerful frame of mind as that in which a condemned man eats his last breakfast.

Nevertheless, Van Havermat turned out to be an accurate prophet. It was not long before Bairnsfather discovered that his art school teaching was no "open sesame" to that charmed circle. He tried again and again to get his work and his name in print. Hopeless!

There was not even bread and cheese, let alone biscuits and jam, to be made out of drawing pictures. He drew until he was sick of the sight of Bristol boards and ink. He spent his little remaining allowance on stamps for the postage - and invariable return with 'editorial regrets' - of his drawings.

He had got his own way. He had had his training. He had realised his ambition to approach the gates of 'art' only to find them rigidly closed against him. He was 'not required'.

And now he was faced with the prospect of having to keep himself alive. Therefore, after a period in which hope was vanquished by despair he came to the conclusion that he would have to wander still further into the wilderness.

Yet he never for a moment lost sight of his objective and it was with the deliberate purpose of using his wages as a means to this chosen end that he apprenticed himself to a firm of electrical engineers.

Hence we find the would-be artist blossoming out as a full-blown wireman's assistant, positively wallowing in the luxury of a weekly wage envelope containing every time the sum of twenty shillings net. He had to dress the part too. Overalls and a bag of tools were as essential as the skull to Hamlet. Armed with these he wandered round the country filling the highly responsible task of holding the foot of a ladder while another man went up to do the job.

The day came, as I shall show in my next chapter, when the wireman's assistant became a wireman, was allowed to climb the ladder himself and endured the dizzy distinction of having an assistant to hold the foot of the ladder for him.

Since then Bairnsfather has climbed a few rungs of the ladder of fame, but it is well worth while for those who have an eye on the top to remember that Bruce Bairnsfather, artist, author and dramatist, started very much at the foot of that ladder.

Chapter 5

WESTWARD HO! AN ARMY EDUCATION ~ BAIRNSFATHER, FOR THE DEFENCE

To have one's school days over again is a longing that I have known many suffer from. I feel sure that time and dim memories are responsible for this desire, and that in reality, could such a transference be effected, one would willingly part with those school days after a day of the return visit.

Personally I have not even had the longing. I was fortunate in my sentence as to which school to go to, not that any other school would have made much difference. It was once a very famous college - that I first went to - Westward Ho! immortalised by the mighty Kipling in his book *'Stalky and Co.'*

When I was there it was notorious and unimmortalised by anybody.

I think I was the bar to any immortality - in fact, mortality seems to have set in just about the time I went there.

It was a school for the sons of Army and Navy officers, with here and there the son of a parson creeping in.

By that quaint reasoning beloved of English families, a son is supposed to go into the same profession as his father, hence the inevitable suction exerted on my parents by the idea of Westward Ho!

I am in full sympathy with this idea, of a hereditary profession, as you thereby get such an incentive in the opposite direction that it makes for success elsewhere.

I was a total and miserable failure at school - a great success with my friends in misfortune, but I went rotten with the masters.

To begin with, I am terribly affected by environment. For one who had recently come from the succulent scenery and mystic charm of India, to be bumped into a cheerless waste like Westward Ho! itself was enough to sow the seeds of criminality.

To those who don't know the area, let me describe this land of my scholastic incubation. It is a wild and desolate portion of North Devon. The country round about is peopled with boarding-house keepers and

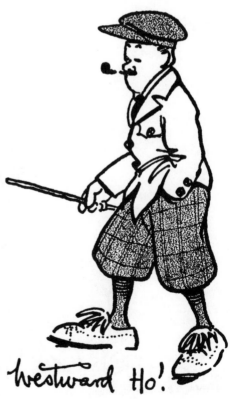

westward Ho!

Temperamentally, my father is, more or less, on these lines.

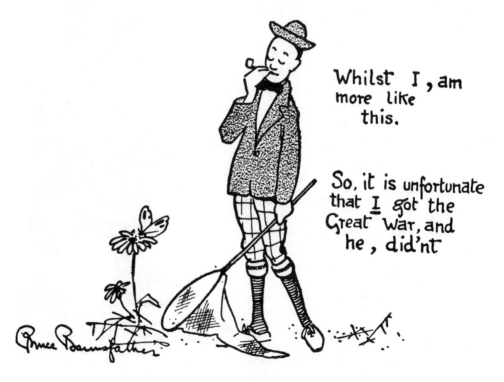

Whilst I, am more like this.

So, it is unfortunate that I got the Great War, and he, did'nt

the retired and slightly impoverished members of the upper parts of the two services. An Admiral or a General could be found there, but more often Captains, Colonels and Majors. Their sole occupation is to move dully about the locality in Harris Tweed.

It's all terribly respectable, terribly dull and terribly English.

The golf links are the great draw there. I have been chased across them by a prefect, many a time, under the title of 'There will be a paper chase for Form IV this afternoon'.

How many?

In my thin attire of a 'runner', I spurted and darted across this rush-grown wilderness on most Saturday afternoons. My view of the golf links is, therefore, possibly a little distorted.

The great thing about the college was that it gave you a really sporting education. It fitted one out with that frenzied desire to play games which (as some boob has said) 'wins our battles'.

If you didn't get the frenzied desire quickly, you were flicked around the legs with a cheap cane until you did. What could be more efficient?

Apart from that, they pumped a really useful education into you in the form of Latin and inorganic chemistry. I've used Latin once when an Italian waiter spilt a dish of spaghetti over me in Milan, and inorganic chemistry when I had indigestion, alone, in the woods of Newfoundland.

However, it was all meant very well. It must never be forgotten that all my relatives and masters saw in me a future Admiral or General. When I come to think of it, General Sir Bruce Bairnsfather, RSVP, doesn't sound at all bad.

We were a wild and woolly group, us failures at the bottom of the bottom half of the school - caned most days, but gloriously happy. We loved bird-nesting on the cliffs and swimming on our own in the pools amongst the rocks. We hated work and games simply because they were compulsory. Stealing eggs from local hen houses and cooking them in the bottom of an empty biscuit tin was an amusement of ours.

It was at Westward Ho! that I really commenced to draw presentable pictures and it was here I began practising hard. I practised all through the French class, the Latin class, and the evening preparation. On half-holidays I abstained from paper chasing, drew pictures instead, and was caned in consequence in the evening.

Dear Reader, have you ever be caned? No, then I will, if you will allow me a moment in which to change, give you a slight idea of that screaming absurdity 'a caning'.

I know my subject. I have felt my subject, so you can rely upon the following data.

You are secretly aware that a certain act which you have committed has, in certain quarters, been interpreted as a 'gross breach of discipline'.

Time alone will prove whether you will escape with writing out five hundred lines of Caesar, or whether a short, sharp term of corporal punishment will terminate your suffering.

As you are sitting harmlessly feeding your white mice in your desk at the French class, you will feel a light tap on the shoulder. It is your form master, who has come to

say, "Come to my study this evening at six o'clock, after tea."

The blow has fallen, you know you are to be caned.

I am now thirty-three, and I haven't been caned for quite a long time, but my corrugated anatomy acts like a fossil. It is a relic of the past.

'After Tea'. What a sarcastic and heartless phrase! How can you eat slabs of bread and butter and drink mud-coloured cold water, with news like that ahead?

The dread hour approaches. You know by experience the flogging ability of that particular master. Your friends announce that, "He can't biff you for nuts," and your enemies say, "I wouldn't be you for anything."

I have committed all sorts of games

The hour has arrived ... You are standing pale and resolute outside the master's door. The landing, the stairs and every nook affording concealment is alive with your school-friends, who have come to hear you through the closed door.

You knock. You enter.

Two souls meet face to face, very soon they meet hand to ...

It's all over, you've had your head under the table a minute, but it has seemed an hour. With a nice, warm, prickly, but righteous sensation you are again on the landing - one step further on the road to success in any profession except the one first thought of.

Chapter 6

VIA DOLOROSA
~ MUTCH, FOR THE PROSECUTION

We now descend to the depths. If hope be sea level, we are at least a thousand feet below the surface. Nevertheless, the stage is set in an English baronial home.

The door of the awe-inspiring library opens.

Enter a grim-faced youth bearing, as if it were made of unbreakable steel, an expensive half-watt wire filament electric light bulb.

This he throws into its socket as if he were Ty Cobb pitching a fast one over the plate.

He recites his piece, beginning, "Thank heaven that's finished."

It is to be regretted that the subsequent passages of this speech cannot be quoted here, the dramatic rights having been purchased by the Kaiser for reproduction in his forthcoming treatise, 'What I think of Marshal Foch,' after spirited competition by Bottomley, on behalf of his weekly swan song, 'Why I love America'.

Then he spies a nice white sheet of paper.

Feverishly he glances around him.

Nobody near.

The boss won't know to dock his pay. He takes up a pen and now in a fervour of enthusiasm tears it across the paper.

"I'm the man about the light, sir!"

Engrossed in his task he does not hear the door open. He does not see a stout, red-faced aristocrat gaze upon his back with a mouth as open as the door. He does not realise the approach of this parcel of blue blood as it draws near and looks over his shoulder.

"Hello! What's this? Bai Jove! Dontcher know! That's jolly good. That's me to the life. Did you draw that? What? Dimmed clever. I should love to have it. Will you have a port with me?"

Dazed, the youth drinks, or rather gulps and chokes, too embarrassed to utter a word in his own defence, but he feels like murder when his host exclaims, "You know, bai Jove, you should not be messing about with electric fittings, what? You should be a bally artist."

That, exaggerated only in detail, was the sort of incident which made Bairnsfather see red many a time during the next few months of his career when he had to walk very persistently the Via Dolorosa.

At this point it is worth while for the student of success to note the psychological dilemma in which Bairnsfather now found himself placed. He had made life a misery

About 10 years of this intensely absorbing study

Will give you such an impetus for any other profession, that you are bound to succeed

for himself and everyone around him until he succeeded in convincing those interested in his destiny that his talents justified his determination to be an artist - a success which was marked by his being sent as a student to the Hassall School of Art.

He had given up a considerable number of months to study. As far as was humanly possible he had acquired the necessary technique. He was fitted in every respect to follow the profession of his choice. Then he found that there was absolutely no opening for him. It was, therefore, as a recognition of defeat that he took up electrical engineering.

He was a failure. He had proved himself a failure. When candid friends conveyed to his parents that it was a pity they 'couldn't do something with Bruce' he had no answer.

It was strictly in accord with the irony of circumstances that no sooner had this state of affairs arisen - that no sooner had he been compelled to relinquish art for food's sake, than every second stranger discovered in him an artist. No sooner had he been sternly denied admittance to the charmed circle, than everyone advised him to give up everything else except art. And here I should say that the beginner in art should 'tread warily' where such advice is given.

The candid critic who tells the young artist to throw away his brush and sell something to eat is a much better friend.

Bairnsfather at this time was like driftwood at the mouth of a river - now carried out to sea by the stream, now carried inland by the tide.

But make no mistake here, although he was torn between masses of conflicting judgement, Bairnsfather never ceased to follow his star. He kept a stiff upper lip and his motto, even if he did not realise it himself, was that open sesame to the fairy caves of fortune - "I'll show 'em!"

Never a day passed without his having traversed another mile of that long, long road before him.

Art was seldom out of his thoughts waking or sleeping. He did not have a lot of money to invest in his ambition, but week after week he bought piles of illustrated magazines and pored over the reproduced drawings of well-known artists, always seeking to analyse the secrets of their success.

There are still plenty of critics of Bairnsfather's work who speak of it as if one day, in an idle moment, he'd picked up a brush and drawn by accident, very badly, a character called Old Bill, whereupon fickle fortune waited upon him ever more.

Possibly these will be astonished to read of days of continuous study in an atmosphere of determination and despair. Possibly they will alter their views about the alleged superficiality of Bairnsfather art.

This charge, led by a scathing condemnation in *The London Times*, I shall analyse later in the proper place, showing that Bairnsfather does not merely in the Meredithian figure, convey truth by means of split infinitives.

But I have not reached that stage of controversy yet.

I proceed therefore with my account of the days of endeavour - with Bairnsfather the engineer, and I ought to lay special stress on the fact that even in this period of trial Bairnsfather continued to work with a stern resolve, that since he had to be an engineer he would at least be a good one.

This is very important, because it throws an arc-light on his strength of character. A youth of lesser willpower would undoubtedly have lost heart in the drawing business, utterly hated and neglected the engineering business, and in consequence have made a mess of both.

Electrical engineering he never regarded as anything other than a means to an end,

but he saw very soon that if real ambition was ever to be realised, he had to make the standby a good one.

So we find him working hard at a trade which was thrust upon him - soon emerging from the stage of wireman's assistant to be a real live wireman himself.

Through industrious application to his work, aided by persistent knocking at managerial doors for wage increases, we find him rising successively from £1 a week to the comparative affluence of £2 10s., when he became an inspector of other men's work.

Following upon this we find him emerging into the higher and more delicate sphere of business known as speciality salesmanship. In this capacity he toured most of England, winning for his firm a series of remunerative contracts for electric lighting. The dungaree days were gone.

They were succeeded by days of dress and address, when, for example, he had charge of a stand for two successive years at industrial exhibitions at Olympia in London, where his task was to convince wealthy buyers that he had the best goods at the keenest prices on the market - a useful exercise in human psychology and a valuable supplement to the music hall expeditions of the earlier Hassall days.

Before we leave this period it is significant to note, in view of his after association with the stage, the fact that his first real responsible job was the lighting of the Shakespeare Memorial Theatre at Stratford-on-Avon. As I shall show later, one of the very interesting things about the genius of Bairnsfather is his intimate working knowledge of stage conditions, and there can be no doubt but that this practical introduction to the Memorial Theatre, in the capacity of a mechanic, was the first impulse which turned his mind seriously in that direction.

At this point I might also record that his very first job as a wireman's assistant was to help in the lighting of a brewery in the Midlands, hence, some will argue, the origin of that particularly anti-Pussyfoot look which appears from time to time on the face of Old Bill.

However, while he progressed handsomely in his trade as an engineer, he never lost sight of his main objective - success as an artist - and it was during this engineering period that he was first able to see himself in print.

It was natural, having come from the Hassall School of Art, that he should devote himself mainly to poster work, and for several years this occupied his sole attention.

Through his efforts at this period, the sale of several brands of tobacco, tea, mustard, pills, cocoa, face creams, and dog biscuits were materially increased.

The first poster he sold was an advertisement for Player's Tobacco. This picture was drawn at a period when, *'The Geisha'* and *'San Toy'* and various other musical comedies, giving a rose-coloured picture of life in the Far East were the rage of the British stage. Therefore, there appeared on the hoardings a huge poster of a particularly fascinating row of Chinamen, all smoking Player's cigarettes, with the words:

> *For they smoke it in the West*
> *Where it's reckoned quite the best,*
> *And you see they've introduced it into China.*

This was followed by an advertisement for Keen's Mustard - a poster which represented a boy standing on a chair before a huge map of the world. He had dipped his finger in a mustard cruet and smeared a broad line across the map. Underneath was the inscription:

> *One touch of mustard makes the whole world Keen's.*

Now, feeling he'd had enough of tobacco and mustard, he proceeded to pills.

Beecham's of that ilk displayed several Bairnsfather posters showing particularly athletic nymphs decorated with teeth, golf-clubs and tennis racquets, and positively bursting with health.

This medicinal duty fulfilled, he turned his attention to tea, and through the good

That first cheque.

services of Marie Corelli, who wrote to Sir Thomas Lipton on his behalf, he was able to get an interview in London, and as a result was sent home to draw suggestions for posters. A number of these were returned and he had despaired of giving satisfaction to the 'tea king' when he drew and sold a picture of a caddie driving off a ball from the top of a packet of Lipton's Special, with the inscription:

> *Liptons makes the best tea.*

All this happened right in the middle of the engineering period, and it was when he was engaged on a job in Birmingham that he took up a book by George Morrow and found his Lipton poster on the back cover, with the result that he felt like Lloyd George home from Spa. The book in question was a cheap edition published in those

halcyon days at a shilling net, and it is on record that Bairnsfather spent a sovereign on buying copies, which detracted considerably from the two guineas which he had originally received for the picture.

This overwhelming success was followed by a sequence of Lipton and Beecham posters, and the electrical engineer already regarded himself as an established figure in the commercial art.

He studied the magazine advertisements night after night into the early hours of the morning and was next unsuccessful with a poster design for Spratt's Dog Biscuits, which was followed by a rejected picture showing a white man sitting at a table amidst luscious palms. A Negro servant standing at the table is represented as asking, "Massa w'at tea?" To which the white man replies, "Yes, rather!"

The ease with which Bairnsfather the artist could now sell poster drawings did not tend to harmonise with Bairnsfather the speciality salesman.

As often as he saved a little money from drawing and as often as he could get away he crossed the Channel to Paris, Ostend, or Brussels in order to study the works of the great masters in continental galleries, at the same time acquiring a wide knowledge of the present day French and Belgian colour, and black-and-white artists.

It was at this time that he saw an announcement by the Quinlan Opera Company, then on tour in Canada, offering a prize of £10 for the most suitable poster submitted for use as an advertisement.

Bairnsfather submitted a drawing of Orpheus seated on the world as a symbol of the tour of the company, and with this picture won the prize.

Hope rose to uncontrollable heights. The thing was done! Success! Fame! Fortune! Goodbye to engineering. Bairnsfather's mind at this moment was a riot of dreams!

But Fate decided that her victim was not to get away with things so easily and forthwith proceeded to prepare an ice-cold douche of despair.

The Via Dolorosa had a big kick left and Bairnsfather, caught utterly unprepared, was to go down with a thud, and art as the referee once again was gleefully to count him out.

"Now, which is the 'live' one?"

Chapter 7

£1 A WEEK AND DUNGAREES
~ BAIRNSFATHER, FOR THE DEFENCE

I have nothing to say against engineering, but I feel that engineering, if the question was put to it, might have a lot to say against me. I went into the job with a full-hearted endeavour to do my best at it, but I feel somehow that engineering did the dirty on me, by starting me at a pound a week.

You can't dress well, live, and motor on a pound a week without a lot of care.

It was a terrible pound I got. It was placed in a little paper bag by the head clerk and given to me on Friday. To get more put into that paper bag looked hopeless.

The work which led to this reckless extravagance on the part of my firm was of a curious and mixed character. I was an assistant in installation work. I helped in the fixing up of electric light and petrol gas machines in factories and public buildings and private houses.

Now and again came intervals of change, in which I was in the 'shops' testing, mending, and cursing the aforesaid machines.

Every evening and every weekend I would draw and paint with frenzy, in the hopes of extricating myself into art and more than a pound a week.

As time went on I progressed in that firm, and after those dim elementary days filled with holding ladders, nailing pipes and pulling wires through tubes, I emerged into a stratum of two pounds ten shillings per week and a slightly different form of work.

It was that of travelling all over the country for orders, and inspecting faulty machinery. It is of this period that I shall speak.

I have got orders out of a variety of people in this realm of England. I became a sort of Sherlock Holmes in the summing up of my victims. I could mentally size up and knock out anything you like in type. I could almost count on getting a retired pork butcher to light his bungalow in Huddersfield, or an Indian Army Colonel to light his old manor house near Cheltenham. Sometimes I had to swim deep and lure the Dowager Countess of Leatherhead into lighting Crumbling Castle, her summer seat.

All this was weird and wonderful in its way, and interesting to a student of 'types'. I got to know how to act for each part, the sort of conversation for each particular case, and how much of an installation I could knock out of the poor souls.

I have perpetrated these crimes from Holyhead to Thanet, and from John O'Groats to Land's End. Many's the time I have arrived in a paltry, musty, strange little town on a wet January afternoon, hired a bicycle and pushed off out into the country, got out the scheme for the victim, and gone back into the town to spend the evening with the Commercial Travellers in the local hotel.

What a mass of 'Commercials' I have met, bless 'em, who have not the slightest idea that they ever met me! There was one at a town not far from Bury St Edmunds, who fastened on to me and explained Commercial Travellers' folklore, and rules of deportment for a couple of hours after supper one night.

There was another who froze on to me with full details of his travels and reductions

The man about the lights
or Tarzan of the lamps.

on weekend tickets at the Feathers Hotel, Porlock.

I have met, liked, and gained comfort from them everywhere. I have done two sea journeys with Travellers, both of whom were highly amused to remember later that the curiosity they once travelled with turned out to be me, whose pictures, plays and films they *never* expected to see, and yet which met them at every turn later on.

And now, to give you an insight into my work I am going to pick out of hundreds one case illustrating my travels, which will, I feel sure, interest students of crime.

Once upon a time there came news into our office that a certain ancient and wealthy baronet had experienced grievous trouble from his lighting installation at his castle in the Midlands. By an obscure process of reasoning, my firm decided to send me to see what was the matter, and if possible to try and remedy it.

I took out my best suit, a bag of selected tools, and set forth. It was about January, and when I arrived at the little town which was my nearest point of disembarkation, all was dark, and drear, and cold. I enquired the way to the castle and started off that night, 'Jack-the-Giant-Killer' style, to beard the Baronet in his keep. It was quite a long way that my bag and I staggered through the snow. The walk ultimately brought me to the imposing gates leading into the drive that led to the castle.

My bag and I entered, and started pounding off up the drive. On either side dark fir-trees laden with snow shivered in the light night wind. Clouds raced across the moonlit sky. My bag and I went on, up the long and winding drive. At last the castle came in sight . . . a giant dark grey building amongst the woods, on one side of which stretched a sheet of water. I floundered up to the great front door, put the bag down on the ancient steps, and rang the bell. (I've still got it somewhere, I kept it as a souvenir). The ponderous front door opened. A butler was silhouetted in the light of the mighty hall behind.

"I've come about the light," I said, expecting to be struck for my uncouth boldness in such surroundings.

"Oh!" said the butler, "well come round to the side door," and he gently closed the ponderous front one in my face.

I went to the side door. Such a small plebeian one. A footman opened it. I entered and was taken to the butler's room near a pantry. Here, after the preliminary waste of time making friends, I was initiated into the details of all the anguish which pervaded the

castle. Sir Reginald had gout, I think, and his wife delusions. The light was the worst ever and everyone was under notice to leave. In fact, one of those delectable atmospheres which are essentially associated with the idle and historic rich.

The butler and footman were hospitality itself in that pantry annex. I was thoroughly primed before passing through the green baize door to meet Sir Reginald. 'All hope abandon ye who enter here' was the invisible legend written above that door. On the other side were Sir Reginald and his Lady, living in sombre pain with no light except hurriedly recruited lamps and candles.

It was late now. Sir Reginald was in the library and the moment came for me to enter through the green baize door. The butler announced me in the library as, "The man about the light."

Sir Reginald came out of the library and clearly explained my firm to me. He shortly enunciated their chance of a future life. He even suggested ungeographical places he would like to send them to. In time he came down to the commonplace fact that I was standing before him, ready to do what I could. He agreed that I should at once try to repair his light. Having given instructions to the butler as to my being shown where the engine lay, he retired once more into his library, there I suppose to seek relaxation in *The Times Literary Supplement*, or some other mirth provider of that sort.

I retired back through the green baize door and, getting hold of my bag of tools again, was shown through the wild night and the shrubbery to the house which contained the engine.

Now, I'm not writing for the *Scientific American*, or the *Electrical Review*, so I will not launch off into the mysteries of what happened in that shed. Suffice it to say that I nearly blew myself up with a dozen tins of petrol, but cured the ailment. In a couple of hours I returned to the house and performed the miracle of turning on the light. I was a medicine man in a moment.

The butler went round the house turning on the lights, every now and again running back to Sir Reginald with the glad tidings.

I ended in the hall on the top of a ladder adjusting the historic chandelier. Sir Reginald came out to me from his library and asked me all about it. He tried some lights himself and then asked me into the library. I sat down in a giant leather chair. He rang the bell and the butler entered. "Bring two whiskeys and soda," he said.

We sat and talked for quite a time. I then went back to two pounds ten a week and a third-class smoker home.

Chapter 8

DOWN AND OUT
~ MUTCH, FOR THE PROSECUTION

One might expect from the various efforts and enterprises of Bairnsfather recorded in my previous chapter, that the time was now come when he could say without delusion that he was tasting the fruits of success.

But, for the unknown artist working on his own there is perhaps no entry to an art career more difficult than that which is concerned with poster draftmanship.

In the magazine world the market is comparatively stable. The magazine appears at regular intervals necessitating a steady demand for material. It represents a definite personality and, according to the dyspepsia of the editor, the artist can temper his approach. This in theory may sound a simple exercise in diplomacy. In practice, it is a difficult enough undertaking.

Bairnsfather tried on various occasions to sell stuff to most of the popular English magazines. At one time he had an extensive collection of 'Editor's regrets'.

The difficulties surrounding his poster enterprises, with their much more uncertain and unstable market, can therefore be all the better appreciated. The aspiring artist may be interested to know that at this period his sales averaged ten per cent of his output.

Outside poster and magazine work he occupied himself with a variety of adventures. His engineering took him round most of the cities of Britain, and if in any small town he saw an enterprising tobacconist who sold a special mixture of his own blend, Bairnsfather would immediately draw a highly attractive show card in bright colours. This he would offer to the tobacconist for display in his window - the result being that his private store of tobacco was enriched by say a couple of pounds of the self-same mixture, plus a hundred cigarettes.

There was no end to the catholicity of his adventure

at this time, and it is therefore precisely here that I find him gaining that breadth and sympathy of outlook which is the secret of his universal appeal. It was during this engineering period that his education was completed by his coming into intimate contact with all sorts and conditions of men.

True, he met them again in the comradeship of war, but had he not been able to recognise the civilian beneath the disguise of the soldier, he would never have interpreted the spirit of the trenches, he could never have discovered Old Bill.

We may sum up this period by saying that Bairnsfather was achieving a fair measure of success - a measure beyond which most aspiring artists never advance, and in consequence was considerably supplementing that weekly income of £2 10s., and gradually beginning to think that after all there would come a time when he would be able to leave the engineering period definitely behind him.

Nevertheless, there were before him several very nasty turns in that Via Dolorosa to be traversed before he was to find the sunlight of fame and fortune shining upon him.

And it is worth while to note in some detail the last great cold douche which was to shower upon him before success came his way.

Like every other British artist, he had his eyes turned on the great city of London and as ardently as he studied the art magazines, he studied the columns of 'artists wanted' in the daily press.

One day he read an advertisement in the section devoted to printers and pressmen in the *Daily Telegraph*, the effect of which was that an artist was wanted, that the artist must be accustomed to commercial designing, and that he must send samples of his work along with his application.

Bairnsfather answered this advertisement and waited!

I need not analyse the feelings of the young man who replies to such an advertisement. This species of suspense is well enough known, and it will also be universally understood that the artist's hopes went soaring away into the upper ether when he received a letter one morning saying, 'Our Directors have examined your work and would like you to call on us at your convenience.'

His convenience! His first impulse was to smash every electric light bulb for miles around and to make a bonfire of his dungarees.

But on second thoughts more cautious counsel prevailed and he compromised by asking for a half-day off. And this preposterous request, by some strange accident, was granted.

Witness therefore, this perspiring sprinter after fame arriving in London and seeing through the eyes of imagination every street paved with that mythical gold.

He walked on air. He felt he could progress even without that slender support when he saw on a prominent hoarding a huge reproduction of one of his posters.

It would be but a few days before the head waiters in every West End restaurant would be bowing at his approach and placing him at the tables reserved for honoured guests.

You will observe how Fate had worked him into just that state of ecstatic anticipation essential to making him feel the fullest weight of the rebuff in store.

It was in this joyous frame of mind that he made his way to the business headquarters of 'our directors'.

He was somewhat overawed by his first impression of the great building with its sweeping, cold stone stairs and countless closed and presumably hostile doors.

He was hushed and humbled by the grandeur of this mausoleum of British art and it was in no fit condition to argue about anything so sordid as wages that he waited in an outer room till, "our Mr Somebody-or-other," deigned to receive him.

Still, the result of the interview was generally satisfactory. But Fate had not yet done jesting with her victim.

"Our Directors," announced Mr Somebody, "have looked at your pictures and rather like your style."

An inarticulate gulp of gratitude from the victim.

"They think you could be fitted into our organisation, and we have at the moment a vacancy for a good artist."

The victim sees a mist before his eyes and threatens to swoon right off.

"Now, we should like to have some idea as to what you would expect in the way of remuneration."

At last, the charmed circle had been broken! He was actually being invited within, but those stone steps, those closed doors kept blurring his vision. It would never do to be wanting in gratitude for what the fates had sent. He would be humble. After all, he was being freed from electric engineering. He would ask just what he was being paid. The little extras would have to be sacrificed.

Very timidly he whispered, "I thought perhaps two pounds ten a week."

He glanced up in a cold sweat when no immediate assent was given.

Mr Somebody was drumming his fingers on the polished oak desk. He was pursing his lips and looking thoughtful.

His fate was in the scales. How would the balance fall? He felt like shouting out, "I'll come for nothing so long as you'll have me."

Just then Mr Somebody spoke. "Well, that is rather more than we are in the habit of paying our artists, but we might stretch a point in your favour if you will send along some further sketches."

The rest of the interview was negligible, and presently the victim found himself on the pavement, not knowing how he had stumbled down those steps.

He had not quite succeeded.

Still, he felt like a man who has just missed a bluebottle with a flick of his handkerchief. The next time would get him.

It was, therefore, in a comparatively cheerful state of mind that he took the train back to Stratford, and drew feverishly for some weeks.

The result was that he was able presently to dispatch to London, to that ancient and honourable home of art design, some poster drawings expressly intended for the advertisement of Sunlight Soap; their chief ingredients being a particularly athletic type of young woman and some supernaturally green fields.

There was then yet more waiting. Still, he did not mind that. He knew the drawings were good and he knew the end was assured.

Some weeks passed away. Suspense began to hold him in its grip, but finally the suspense was crowned with joy. A big, flat parcel, on which the name of the firm was prominently printed, made its appearance.

This was the end of engineering at last.

He tore open the parcel and picked up the letter beginning, 'Dear Sir, We are frankly disappointed with your further designs, which are returned herewith.'

And following on after this supremely encouraging beginning, 'Our Mr Somebody' conveyed to Bairnsfather that his services were not required.

Fate had got the blow home at the psychological moment.

In a state approaching suicide he wandered away among the trees of Warwickshire. He drank the cup of defeat to its dregs, deciding that art as a career, as far as he was concerned, was altogether too precarious a business and that therefore he had better reconcile himself to remaining in engineering for life.

It was exactly at this unhappy juncture that his engineering firm required the services of a desperado to go to the wilds of Newfoundland in order to examine an electrical installation at Spruce Brook, which installation was apparently, from report, capable of doing anything in the world except giving the radiant illumination it was expressly built to create.

The full and tragic story of the painful expedition is given by Bairnsfather himself in

the following chapter: but although I do not propose to enter into the technical side of the journey, I ought to say that even at Spruce Brook the itch to draw pursued him.

Bairnsfather has drawn pictures in perhaps more varied and curious surroundings than anyone else in the world.

In Newfoundland, in a log cabin, he drew a picture which, as it happened, was to mean a great deal to his future career. It was not a soaring flight of artistic fancy. It was merely a box label, but it gave such satisfaction to the man for whom it was drawn, that he advised the artist to give up all thought of engineering, to return to London and be an artist.

"I do not like the use of the word 'BLINKIN', Mr Busby!"

Bairnsfather had tasted a fair proportion of the fruits of success since the day, almost seven years before, when he had become a wireman's assistant. He was ready to receive sympathy and encouragement and therefore he returned from this expedition still more obsessed than ever with the idea of being a professional artist.

Some may find destiny in the fact that the *Durango*, the old Furness-Withy boat on which he returned, carried a load of wood pulp. But what impressed Bairnsfather most at the moment was that his cabin was directly over the propeller of the ship, and his companions, apart from a commercial traveller from Manchester, were entirely composed of rats.

Being the world's worst sailor, he was, of course, seasick on this voyage, but he found time to make friends with the cook, for which his wisdom must be commended, and he drew a picture of the lord of the kitchen peeling potatoes in his galley, much to the gratification of that potentate.

In view of Bairnsfather's attitude to the sea this picture was probably in kind the most remunerative he has ever done.

He landed at Liverpool, still having the desire to draw, but quite resigned to stay for a short period longer as an electrical engineer, because, in view of his past unfortunate experiences, he discovered that in the stormy seas of art this was the only raft to which he could cling in order to save his life.

Therefore, with a high resolve to study electric bulbs with renewed fervour, he returned to Stratford prior to reporting to his employer.

But at home another cold douche awaited him in the form of a letter beginning, 'Dear Sir, Owing to the outbreak of European war, your services are no longer required.'

Thus the Kaiser got his first blow in at England, for Bairnsfather, from buying packets of carefully straight-cut cigarettes, had now to roll his own.

He retired again to the trees and poured out the tale of his humiliation and desperation to nature.

He decided that he had been pursuing a *will-o'-the-wisp*, that in seeking success as an artist he had been trying to do something for which he was entirely unsuited, therefore he concluded that the only concern which would welcome his services would be the British Army, and accordingly he reported to his former regiment, the 1st Warwicks, with which, in a few weeks he was sent out to France, thereby joining the ever-glorious band of the Old Contemptibles.

Chapter 9

NEWFOUNDLAND
~ BAIRNSFATHER, FOR THE DEFENCE

I have already, in sundry previous chapters, touched upon my obscure life in the engineering world. I want in this chapter to give to all those who are interested an accurate portrayal of a phase of my life which perhaps marked the turning point in my career as an engineer.

The termination of the following adventure happened to be the war. Had the war not been in time to relieve the engineering world of a canker at its heart, my own inward perturbations would have procured this desirable end. However, let me hash this adventure out in the way that it occurred to me.

My firm (that group of capitalists, who from philanthropic reasons, fostered my frail talents) came, one day, suddenly to a conclusion that someone must go to Newfoundland to repair an installation at a certain remote quarter in that oldest of British colonies. Various members of the firm were approached on this score and everyone except 'yours truly' had the good sense and balance to refuse.

The job was suggested to me and I sprang at it like a tiger. Adventure minus slow consideration is my strong point (subsequent events have almost caused me to call it a weak point).

The plot was hatched. The 'Secret Society' met in a boardroom and decided that the lot had fallen on me to go forthwith to Newfoundland to repair this installation. I investigated the case. It appeared that a certain ferocious individual had been rendered almost frenzied by having purchased a lighting plant at enormous expense which had never emitted a spark of light since its transference to the remote wilds aforementioned.

I grasped the extent of his ferocity, from sundry transatlantic letters, and realised that my mission was again very similar to that of 'Jack-the-Giant-Killer' when he started out after Blunderbore.

To those who do not know, I should like to say here, that I joined the war with patriotic fervour on August 5th, 1914.

I regretted this act on August 6th, 1914.

The same trouble applies to this Newfoundland affair. I regretted my expedition as soon as I got to Liverpool. Here are the details in brief.

I left for the famous port with myself, a box of raiment and a fearsome-looking chest containing tools.

I sailed on the Allan liner *Mongolian* for St John's, Newfoundland.

I am a rotten sailor, and no words of mine can adequately convey what that passage meant to me.

There was one other man in my cabin. He was a shelf below me. He was a lace traveller, or something, from Nottingham. I have never seen him since, and I am sure he wishes he had never seen me then.

The cabin was about the size of a public telephone box.

The Atlantic had got mumps that week.

My box of weird implements was confined to the depths of the ship.

Spruce Brook, Newfoundland.

Halfway across I had about as much life left in me as a dummy at a gymkhana.

I was homesick and seasick.

We eventually arrived at St John's. The ship glided between a couple of icebergs and came to rest alongside the wharf. In due course my two boxes and I were put ashore.

My implement box had now taken the main position in the drama and I was merely a sort of clinging crustacean that had the key.

People shrank from the box. They felt that this poor, anaemic creature beside it was in some sinister way guiltily associated with its contents.

I dreaded the day when I should have to open that box and use its metallic contents for the betterment of that plant which I felt was past hope.

I interviewed a potentate in St John's about the possibilities of my journey and further work in the

island. He looked at me with a studious eye full of both scorn and pity.

"Say," he said, "haven't you heard that the only occupations in this island are fishing and flirting, and in the winter they can't fish!"

I retired crushed, but caught the train for Spruce Brook.

Spruce Brook is a station of some note on the main line, by which I mean there are a group of charred stumps at which you alight and look for residents.

A night and day on the one and only train brought me to this metropolis. I said farewell to the Negro attendant and let myself and my boxes down on to the blasted heath, to be met by three residents.

They seemed to be Anglo-Red Indian with a dash of Eskimo on the father's side.

Together this mournful procession plunged into the forest. I could clearly feel that my captors were wondering how on earth this frail spectre could be connected with the iron-bound box. Was he a medicine man? He was, if what I took on the voyage can be counted in.

Suddenly, in a clearing, I came across my destination. It was a very large log cabin. A really fine log cabin, the sort you expect William S. Hart to burst out of. So here I was, box of tools and all.

I saw the owners. I also heard the owners. I heard them describe my firm. I was their only hope, so they put off describing me. Luckily for me it was a case of 'Veni, Vidi, Vici' - 'I came, I saw, I conquered'.

I entered and examined the machinery. I saw later in the evening that everything that could be wrong *was* wrong.

The owners were most kind to me. They made me forget, as far as possible, that I had been procured at enormous expense to come out and repair their absurd plant. The sins of the firm were not visited on the employee.

I spent a first night in comparative calm, longing for the morrow when I could start in, and try and cure that miserable machine outside.

Next morning my box of tools and I examined the affair. I will not harass readers of this book with mechanical details. I will roughly indicate what happened.

The light emitted by this heavily advertised luxury was at zero. It happened to be a faulty plant. After some painful hours of investigation I had diagnosed the cause. I saw that it was absurd to wait for new parts to rectify the fault, and during the course of the next few days set to work to invent a substitute for those parts which would have the greatly desired, and already paid-for effect, *light*.

The criminal side of my brain succeeded in evolving a scheme to procure this end. With the aid of my box of tools, and a dull half-caste, I manufactured an amendment to the machine. The light shone in the log cabin for the first time.

I sat triumphantly inside, glorying in the results.

This all sounds a riotous success, but stay! There was a secret in my heart which gnawed at my braces. I had brought about light, but my cure, I feared, was only temporary.

A length of string was one of my ingredients. I felt this was bound to perish, and as I wandered at dusk amidst the silent forests, and beside the silvery lakes, I wondered how long my cure would last.

It was of course necessary for me to stop and vouch for my cure lasting. This developed into an acute calculation for me. Could I keep the light going sufficiently long enough for me to escape from the island and get home?

Day after day I watched that light with the eyes of a financier watching the tape on

the stock exchange. The day came for me to leave and still the light was going strong. I said goodbye, and with a few dollars in my pocket caught the train back to St John's.

Now, to relieve the tragedy, let me tell you a little story. One of the joint owners of this log cabin was one Captain John O'Neil Power. He knew my weakness was drawing pictures. He asked me to draw the design for a box label. I did it, and after a few other sketches he said to me, "You know, you oughtn't to be messing about with wires, bulbs and engines, you ought to go back to England and have a go at the papers."

Although several months elapsed, his prophecy was one day to be fulfilled and I never forgot it, for one day as the war progressed, I got a letter from across the sea. It was from John O'Neil Power. In it was written, 'What did I tell you!'

I stayed in St John's a week, not because I wanted to, but because there wasn't a ship going to England. One or two were advertised to be starters, but owing to fogs, icebergs and delays elsewhere, none of them showed any signs of life for a week. This was most serious for me, as at any moment that piece of string in the intestines of the machine at Spruce Brook might break, after which all the ports would be watched for my escape. "You don't leave here till this bloody light is right," was an unpleasant phrase, used by the management of the log cabin.

I hung around St John's. I lurked about the town sniffing at the cod industries, eating cod for breakfast, lunch, tea and dinner. You almost have a cod under your pillow when you sleep there. I stayed at a 'hotel' mostly filled with American commercial travellers. There we all sat in a row with a floor spittoon in front of each of us, slowly filling the room with tobacco smoke. Now and again a stranger could be seen dimly entering through the haze. He would hook out a spittoon with his foot, and shuffle it across the floor to a nice range from where he was going to sit down. There we sat like birds in the wilderness. I was the only one waiting for a boat for England. How little did I think that in a very few months I would be sitting again like a bird in another wilderness entirely . . . the Western Front!

A really good test for patience, I should say, is waiting for a ship in wintertime at St John's. Days seemed to drag past with infinite slowness. Still the bit of string held. It was a few hundred miles away, but I knew a cable could reach me when the catastrophe came. I went to the docks every day and peered anxiously into official faces as I asked about the ships.

One morning, in a fit of exasperation, I burst into a new set of offices down by the docks and asked if there was any other way of getting to England except by ship, or rather, if there was any kind of raft or something other than the advertised regular boats.

There was.

I discovered the fact that ships left Grand Falls (the *Daily Mail* paper factory) for England, and sometimes took a passenger or two. I tried to squeeze into this, but found the ship was already full up. So I was hurled back to the 'hotel' again. I glared at a spittoon and gained inspiration. I went down to the docks and found a boat that never took passengers, never had, and in fact hated the sight of passengers. Luck at last! There were three bunks available, and the officials would stretch a point and take three urgent cases to England. I felt like Robinson Crusoe when he came across Friday's *Freeman, Hardy and Willis* [footprint] in the sand.

The day came when I got my two chests dragged from the 'hotel' to the ship. It was also the day when I first saw the ship. It looked to me as if it had just been salvaged. It stood very low in the water, and what could be seen of the sides was rusty, streaky iron.

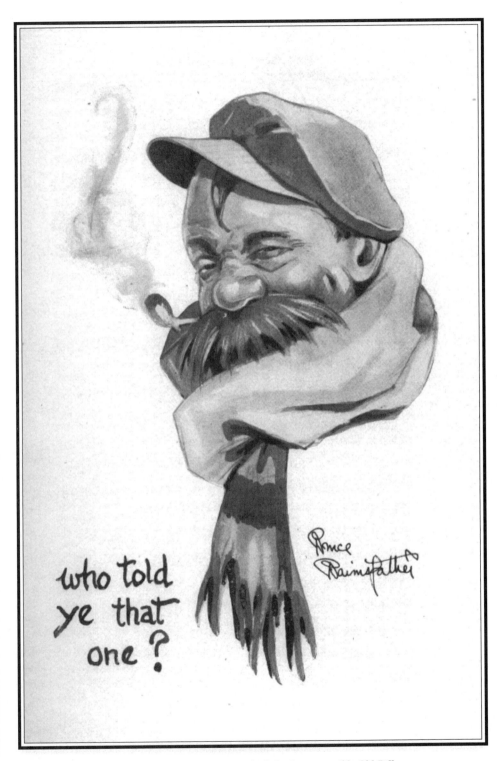

"Who told ye that one?" - Bairnsfather's irrepresible Old Bill.

The world's worst sailor.

It had no proper deck. It all seemed to be one big hold. In fact, the ship, as I afterwards discovered, was full to bursting point with tinned cod and wood pulp. I went on board over a plank, and my boxes were got across somehow and deposited on top of a lot of wooden planks lashed to the place that ought to have been the deck. The general appearance of this barque was a ship-shaped rusty metal case filled to overflowing with long planks of wood.

I found my bunk.

I smelt my bunk.

I sat down to think on my bunk.

For a student of rat life I can imagine nothing better. For a student of vibration I felt that it would have been a fund of interest; but for an ordinary and rather bilious mortal like myself, it was a failure! It was directly over the propeller, at the part where they shave a ship off to a sort of slope over the top of the rudder. I don't know much about ships, but have an uncle in the Navy and he's got on awfully well.

Rats must have been making genealogical trees there for centuries. What with rats, the propeller, and that quaint compound of smells peculiar to any ship, you can realise my bunk. Don't get thinking it was a cabin. It was more or less a cupboard with one shelf in it. There were two other hovels of this class; mine was the worst of the three.

The voyage began . . .

This ancient iron case full of wood and cod jerked its way out of the harbour, between the two cliffs, missed the icebergs waiting outside, and headed for the open sea. As to whether I was ill in five minutes from the start, or ten minutes, I don't know. My memories seem to be a jumble of vibration, rats and anguish. I was lifeless, yet painfully alive. I lay

46

in pallid loneliness on my shelf, trembling like a cheap jelly in an east wind. Bringing a rare mummy back from Egypt via Cape Horn was about the picture.

That pathetic box of tools was under my shelf. Now and again a screwdriver or a corkscrew would get loose and roll down amongst the hammers, adding to the general disorder of the surroundings.

At this dark moment of my life there entered a fairy godmother in the shape of the ship's cook. He had a kind heart, that man. He would come and sit on the box by my shelf and try to interest me with sea-faring yarns. He would also bring apples and peel them with a sea-faring knife, and bring me soup, with a sea-faring thumb holding the bowl, out of sight in the liquid.

Days and nights of anguish passed. We were slowly but surely crossing the Atlantic, and what a vast lonely place it seemed under these conditions.

I really think that if the sea was rough *all* the time it would kill me, but somehow or other there always seems to be a good patch somewhere during the voyage. Two days off the Irish coast the sea went dead flat. You could have almost sailed a paper boat on it. I carefully and slowly emerged from my inquisition and clambered up on to the planks that composed the deck. I spent the long hours drawing sketches. I varied my position by sitting with the cook as he peeled potatoes in the galley. I drew sketches of him at his work. I sat and chatted with various members of the crew who had made a sort of well to sit in amongst the planks. And so the few days passed in the last half of the voyage.

We came round the south end of Ireland at dusk and during the night proceeded up the Irish Channel.

All the joys of life came rushing back into me now - the great tingling joy of my return to England. I sat up all night on the banked-up wood and watched the flickering occasional lights of other ships; the exciting and mysterious pauses amidst coloured lights off North Wales as we awaited the pilot. I didn't mind now. Here was England again! Liverpool lying still and calm under a rosy coloured dawn. The voyage was over!

The work I went to do accomplished. I resolved to ask for a rise.

In a few days I went to the firm to discover a cable had preceded me. The light had gone out again. That bloody string had broken. No rise.

Chapter 10

THE FIRST FRAGMENT
~ MUTCH, FOR THE PROSECUTION

As far as Bairnsfather's actual achievement as an artist is concerned, the point of greatest interest is, of course, the circumstances surrounding the origin of *'Fragments from France'*.

Bairnsfather was stationed at this period at a house in St Yvon, just in front of Plugstreet Wood. This house was a very short distance behind an exceedingly lively front line. It was well within rifle and machine-gun fire, being barely two hundred yards removed from the German trenches.

Like most other houses at the Front, it was in a particularly dilapidated condition. The walls and roof afforded little shelter from the rains of heaven, let alone the fire of the Hun.

It was, therefore, as a measure of self-protection that Bairnsfather and another Lieutenant started to dig a cellar under the floor to which they could retire when the Germans chose to send over 5.9-inch shells. In the midst of this operation he started drawing pictures on the walls of the house. This was in December 1914.

When the walls were well covered with sketches he started drawing on odd bits of paper. These were seen by the soldiers and evidently enjoyed.

In the front trench, fifty yards ahead of the house, the men in the line were perpetually being harassed by heavy shelling, and owing to the continual passage overhead of chunks of German iron, the saying, "Where did that one go to?" became a catch-phrase with the men.

Bairnsfather, now that his drawing was resumed, had the idea that this phrase might be worked into a humorous illustration, which first of all he drew on a scrap of paper which now reposes at Bishopton, his Stratford home, with many other relics of the Great War.

His fellow officers who saw this original liked it, and said he ought to send it to the newspapers.

He thought very little about this advice because before the war came he had had rather an unhappy experience with English magazines. However, a week or two later his battalion was taken out of the line and sent to rest at a farm near Neuve Eglise.

This was in January 1915, and during this

period of rest he made a wash drawing of *"Where did that one go to?"* after which he discovered that he didn't know where to send it.

It so happened that among the magazines lying around at the transport farm there was a copy of *The Bystander*, and it seemed to Bairnsfather that this was the magazine most likely to accept his work. He therefore rolled the drawing up and sent it away.

Very soon afterwards his battalion was ordered to Wulverghem, before the Messines Ridge, where they were in the line for a few weeks, after which they came out to rest at La Plus Douce Farm, on the Momerin Road.

He arrived at the billets at about eight o'clock in the evening in pitch darkness and pouring rain, where everything was miserable, and in the billet he saw a Corporal sorting letters out of a sack with the aid of the dim light of a candle stuck in a bottle.

In this sack was a letter from the editor of *The Bystander*, accepting his sketch and saying that he would be pleased to see others.

This was his first real victory in the magazine world, and as such it was exceedingly gratifying to him, but his elation did not cause him to have any roseate visions of future acceptance.

There was no such idea in his head at the moment as a series of pictures which would one day be reprinted in book form and sold throughout the world literally in millions.

Old Bill drew this one.

Indeed, so far was this ambition from his thoughts at the moment that he turned his attention to poster work again and drew an advertisement for Beecham's pills, showing a square-jawed Hercules behind a machine-gun with the legend, 'Beecham's keep you fit'.

He himself was anything but fit at the time. Neither physically or mentally was he capable of proceeding with a sustained series of humorous drawings of trench life.

Following upon a fortnight's rest at La Plus Douce Farm, he returned to the front lines at Wulverghem so broken in health that he was more or less constantly in the hands of the regimental doctor.

His state of depression at this period can hardly be realised. He was overwhelmed by the horror of everything around him. There was a graveyard just behind the Wulverghem lines. To this graveyard corpses were brought back every day, and his face grew longer with the graveyard.

It was in the midst of these circumstances that he drew the picture, *"They've evidently seen me"*, a picture with which he first of all decorated the wall of an old French house, and secondly drew on a piece of paper for *Major Lancaster, one of the most courageous lionhearts who ever went into action, and who was killed in the first gas attack at Ypres.

[Major John Cecil Lancaster, 1st Warwicks, was actually killed in action on 8th May 1915. He is listed on the cemetery register at Oosttaverne Wood cemetery, Wytschaete, and commemorated on the Menin Gate Memorial at Ypres.]

49

The third drawing of the picture was made at a small farm between Wulverghem and the Messines Ridge, and sent away to try its luck with *The Bystander*.

By this time he had become well-known throughout the Army as an artist, and his pictures were in great demand for the decoration of billets.

At Wulverghem he had plenty of time to draw, because the Germans were so persistent with their shelling that the British were compelled to keep under cover by day. He was therefore quite at liberty to accept a commission from *Colonel Loveband of the Dublin Fusiliers, who asked him to come and do some 'Colonel pictures' in his room. These he drew on the white plaster walls.

[Lieutenant-Colonel Arthur Loveband, of the 2nd Royal Dublin Fusiliers was killed in action on 25th May 1915. He is commemorated on the Menin Gate Memorial at Ypres.]

It was in this neighbourhood that he first saw a reproduction of, "*Where did that one go to?*"

Thereafter he moved to Armentières, and then went to rest at Outersteene, near Bailleul, where he found a letter of acceptance for *"They've evidently seen me"*, and got a commission to draw six pictures at twenty francs each to decorate an officers' mess.

He still followed that catholicity of adventure of which I made note in the engineering days!

His billet at Outersteene was in a small farm, the presiding genius of which was Madame Charlotte Flaw, whom he afterwards introduced into the play 'The Better 'Ole', in the character of Suzette. The other characters of 'The Better 'Ole' - Angèle and Bertha - also lived at this farm, and much of the local colour of the earlier part of the play was culled from this period of rest, for which he was particularly grateful given the nerve-shattered state in which he then was.

This calm was, however, totally broken when the whole of the 10th Brigade were suddenly turned out and marched away under sealed orders.

Very soon, by a study of the map, he discovered that they were marching to Ypres, which at that time was regarded by every soldier outside the salient as the most fearful quarter on the whole of the Western Front.

That night they got to Locre, where he took his machine-gun section to the church and fixed them up in the chancel, having made a barricade of chairs to keep off stray visitors.

Thence, after a few hours rest, the 10th Brigade were marched from Locre to Poperinghe. Towards midday they rested on a dust-covered plain, every man oppressed by a sense of fear and the remorseless destiny surrounding him.

In the afternoon they were on the road again, marching through constant showers of shrapnel, and by dusk they had entered Ypres itself. The rain was now falling in torrents, and the Germans, in view of their attack, were shelling with their whole strength.

Bairnsfather sat in the middle of a field, with a waterproof over his head, watching the Cloth Hall go up in flames. Then came the word that the Germans had broken through at St Julien, and between twelve and one in the morning they left the field, marching into the inferno ahead.

At two o'clock they stopped at St Jean, again in a graveyard. Bairnsfather made for a ruined estaminet a few paces away, found a three-legged chair on which he balanced himself against the wall, and slept the sleep of exhaustion.

They were now informed that they were to join the Canadians, and again were on the march through Wieltje - a mass of smouldering ruins. The machine guns were called for, and of course one had to stick in the mud and be torn out only after Herculean labours.

At four o'clock on this terrible day the 10th Brigade made contact with the Canadians and attacked the Germans. The battle began at 4.30am. Bairnsfather's company was right in the thick of it.

The story of the first gas attack is one of the most terrible in the whole history of the war. Bairnsfather, as does every man who was there, remembers it as a nightmare of horror. In this case the nightmare was ended by his being blown sky-high by the explosion of a shell, and soon after, waking to consciousness in a hospital in Boulogne.

As it so happened, this was to be his last taste of war as a soldier in the trenches. As soon as he was convalescent he started upon his great series of 'Fragments from France'. By the time he was ready to return, he had turned these 'Fragments' out in such numbers and with such brilliance that even the war office awoke to the fact that his pictures were a tremendous morale stimulus to the soldiers of the line.

It was therefore decided that he must be kept exclusively on the making of 'Fragments', for which purpose he was sent first of all to the French Front, then to the Italian, and finally to the American Army in France.

Of these and other wanderings and of their extraordinary success I shall write in my next chapter.

Chapter 11

LUCK
~ BAIRNSFATHER, FOR THE DEFENCE

You will doubtless have noticed by now the desire on the part of the prosecution to prove: a) that I am a success, and b) that I had reasons for becoming so. Now we all know what Counsel are. We all know how things can go in there at one end and come out quite different at the other. "All is not sausage that grunts," as they say in the Chicago factories.

Well, I want to plead now, and in a short space will endeavour to explain this 'success'. I want to be quite candid, and as well as I can, describe, for those who wish to hear, all about the meteor which flashed into my existence in the year 1915. I have had so many letters and personal requests that I feel the necessary egoism in this chapter will be pardoned. I am going to do my utmost to explain the sensations of worldwide success *and* its drawbacks.

As Counsel has already explained, and as he will emphasise later on, I began at the 'O' in zero. I feel I can conscientiously say that nobody could exist who had a more frenzied desire to succeed as an artist than I had. I was a sort of 'moody Dane'. Back in those struggling, impecunious days I wanted something in art, I didn't know what. As I pursued my sorrowful way through other professions, Hamlet would have been a comedian compared to me. I shall never forget the intense and wonderful joy of my first cheque! To get a real typewritten letter from an office that wanted to pay me something for what I could draw!

That first two-guinea cheque contained more soul-stirring thrills of pleasure and achievement than two-hundred-guinea cheques received later. The fact is, I think, that if you are gifted with a great desire for attainment, you never attain. By which I mean, that having attained there is always another step ahead.

Those 'Fragments from France' pictures that have percolated throughout the globe and made thousands of pounds, left my hands mostly in moods of depression; the greatest pleasure being when I felt I had hammered home a "good 'un," or got an artistic effect which pleased me.

I will skip further harrowing details, and turn to the merry spectacle of success.

Success is largely known, by those who haven't had it, as luck. It is, moreover, thought to be the height of desirability. Both of these theories are wrong, yet both contain grains of truth.

Let me take the first theory. Luck! What a small word, and yet how much it contains! I have had a touch of its meaning, and so has everyone else in the world. It's a mysterious word, embracing a mysterious and ill-defined reality. Everybody at some time or other

has *luck* about something.

I know there are morose, disappointed mortals who would deny this, but there is no getting away from the fact that in some degree everyone has had, at least, a nodding acquaintance with luck.

Before we go any further, take only one little instance in your own career. What about the time when the 5.9-inch went under your arm as you were taking a rum jar off the parapet, and exploded twenty yards away?

Luck wants a lot of thought and study.

Is luck 'luck', or is it a definite sequence of ordained chances, which we are given to clutch, and use if possible?

Anyway, whether luck floats around uncontrolled to be caught and tamed, or whether it forms part of the irrevocable film known as one's life, that does not matter. The thing that counts is that we all know of and look out for luck, and therefore the thing is how to use it.

Just as there is positive and negative electricity, there is positive and negative luck.

Good luck and bad luck.

Both can be profitably used.

Good luck can apparently be good when first you get it, and ultimately turn out to be bad.

Bad luck can ultimately turn out to be good.

Well, so much for the different brands, but now about using it.

Luck by itself is merely a transient spark - a star shell shooting up into the sky of one's life. It will burst into a bright helpful light, then drop to earth and darkness again and go out.

You must catch it, tame it and use it.

When luck does come grasp it, hold it, and do all you can to foster it. Luck is a tender flower. If put quickly into water and nursed, it may brighten the house for many a day.

People who don't do this invariably allude to other people's luck as something undeserved.

On the whole, I think, bad luck comes off best - which is perhaps natural in a bad world. Many people don't at all mind discussing in subdued exultation somebody else's bad luck while they cynically mention somebody's good luck with ill-concealed envy.

Very few realise that luck must be turned to account by the recipient.

There is no doubt as to the existence of an invisible and unexplainable grouping of events in everyone's lives. Some good, some bad, both invisible till you come on them suddenly. The best combination of these, when they have apparently come without pre-arrangement, is called luck.

Good, lasting results which come to anyone are the results of grasping the spark of luck which has gleamed, and then kindling it into a fire of fortune.

Now, having let off that froth about luck, let me turn to the resulting complaint, 'success'.

Success is the envy of everyone. One doesn't even have to bother about luck, when thinking of success. One gets dazzled by its full meaning. Think of seeing people whispering together when you enter a hotel or theatre, all saying, "That's him - that's him over there!"

Think of the joy of getting theatre seats for nothing, and buying everything else at double the price! When maidens come and ask you to sign their autograph albums, well, the joy is excruciating.

This is not all that composes success, this is merely the fame part of it.

It's most alluring. Some people, I know, like porters at railway stations to read their great name on their luggage and be civil in consequence.

(Half-a-crown generally changes hands, but why notice that.) Some like being ushered into a smart restaurant by the head waiter, as if the Shah of Persia had arrived.

But all these things come under the fame side of success. The other side is financial.

You will notice an extraordinary and subtle change creep over the

Take it away!

demeanour of sundry people you knew, when you have got the right mixture in your success (i.e. two parts of money to one part of fame).

That wealthy man, who used to scarcely see you when you passed him, and to whose domain you were never asked, will suddenly develop an acute desire to speak to you in front of other people, or invite you to a dance . . .

But I digress. Success is all right when played carefully and slow. Its greatest drawback is that when arrived at it is not nearly so attractive as it seemed when a long way off. It's quite worth aiming for all the same, if only to show the world, and yourself, how to handle it. And after all, if you don't like it, it's easy to get rid of.

Chapter 12

IS BAIRNSFATHER AN ARTIST?
~ MUTCH, FOR THE PROSECUTION

Up to this point I have tried to convey some idea of the Herculean efforts of Bairnsfather to get a footing in the world of art. It will be seen, if I have succeeded, that he trod no royal road to fortune. He started at the foot of the ladder. He spent more than the average time given to most of us to dwell in the Via Dolorosa, and nothing other than exceptional determination and willpower saved him from passing the whole of his life amidst the shadows of defeat. His grit never lost heart in his gift for long. Even when down and out and a wanderer upon the face of the earth, he constantly kept his end and ambition in sight.

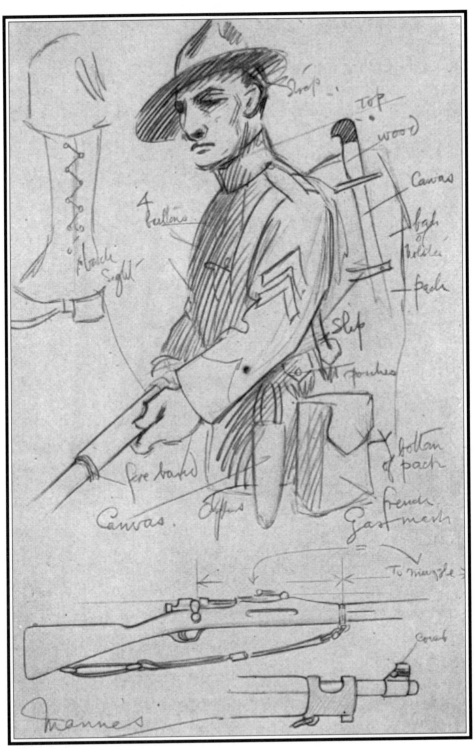

A sketch from Bairnsfather's notebook illustrating his accurate observation of detail.

'I motor' - a story without words.

Yet it was not until after seven years of ceaseless effort that the first glimmering of fame broke through the shadows. This grateful moment happened in the military hospital in Boulogne when he was waiting to be shipped to England. He had emerged with his life from the carnage of the first gas attack and like every other wounded solider was thinking only of his amazing good fortune at being alive and bound for Blighty.

The soldier in the adjoining bed heard his name, turned to him and said, "You'll be the fellow who drew those pictures in *The Bystander*."

This was positively the first appearance of that strange, intangible thing called fame.

Arriving in England he was taken to the 4th London General Hospital where he remained under treatment for several weeks with his 'mascot mother' in close attendance upon him.

It was one afternoon when she was sitting by his bedside that a representative of *The Bystander* called at the hospital, asked to see Bairnsfather, expressed the pleasure of the paper at having his drawings and asked him to send along some more.

This, probably more than anything else, contributed to the rapidity of his convalescence.

He had not thought very much about the incident at Boulogne until this moment, but the idea of a casual reader's opinion being supported by the opinion of the paper itself, lifted him into the seventh heaven of exaltation. As soon as he was able to draw he got his materials together and started in earnest on the wonderful series of *'Fragments from France'*.

On reaching the stage where he was able to leave the hospital, he went to his home at Bishopton, near Stratford, and day in and day out drew pictures for *The Bystander*.

As I have already indicated, these pictures met with some criticism from outside circles. The reason for such criticism is easily understood.

In England, journalism is curiously mixed in its appeal. The most popular papers in England are, as a rule, sensational in character and they continue to feed their readers - to the gratification of the public and themselves - with a series of highly coloured accounts of crime and scandal.

It is natural, therefore, that in this atmosphere there should arise a counter feeling intensely hostile to this type of thing - a feeling so hostile that it sometimes does not pause to consider what is common and what is human.

Bairnsfather dealt with everyday types; therefore, before people took the time or the trouble to understand him they classified him with the common, which condemnation is very well illustrated by the writer in *The Times*, who said:

It is always disappointing to be dull when others hold their sides, to be the only one who does not see the joke. We regret unfeignedly that when the Empire laughs we must remain dumb. Captain Bairnsfather's cartoons have always been looked for with eagerness by the public for many months past, by civilians and soldiers alike, who nearly all unite in a chorus of praise, that 'it is so like what trench life must be,' that 'it shows our unique British sense of humour,' and so on. Mr Kipling, one may say, 'created' the British soldier in the shape of Private Ortheris and Soldiers Three. What is the result on the public of reading those works? They think no soldier a 'real soldier' unless he uses plenty of the worst language; young soldiers model themselves on Private Ortheris, with what result? That they acquire his vices and overlook his virtues. Readers of Mr Wells's last book will remember the Cockney soldier of the New Army who could not open his mouth without using the word "bloody," not because he liked it, but because Ortheris, his beau ideal of a soldier, did so, and the disgust that he aroused in his fellow soldiers who preferred - shall we say Wordsworth's ideal? We know a battalion where a soldier such as Captain Bairnsfather takes as his type would be most summarily dealt with. Nothing so quickly lowers morale as slovenliness, and nothing is more difficult to check than the gradual degeneration due to trench life: and yet here we have an Army officer who invariably depicts his men (to whom his book is dedicated), as the very type which the army is anxious to suppress. Can it be wondered at that young soldiers try to look like a 'Bairnsfather type'? We can all remember the 'Gibson Girl,' but do we want our daughters to look like 'Eve' in another of our illustrated contemporaries. Yet 'Eve' is delightful, because she is not a degenerate, she is an impossible. Bairnsfather's Alf and Bert are disgusting, because they are so possible. It is not with Captain Bairnsfather's humour that we quarrel, for his situations are invariably amusing. It is because he standardises - almost idealises - a degraded type of face. We cannot but enter a protest against so cruel a caricature of the men who endured the first winter in France. The men we knew jested and swore like many other gallant men, but they prided themselves on being the smartest battalion in the brigade, not the one that most resembled Bairnsfather's drawings.

You would imagine this diatribe appearing under some heading such as 'The Vulgarity of Bairnsfather'. On the contrary, it appeared in *The Times Literary Supplement* of the 21st December 1916, under the title, 'The Solider who made the Empire Laugh'.

It is also worth while remarking that although the writer regards Bairnsfather's types

as 'disgusting,' he not only admits their acceptability throughout the Empire, but professes his own utmost familiarity with the Bairnsfather cartoons.

Furthermore, in a final paragraph I have not quoted, he declares that the interest in *'Bullets & Billets'* lies in the pictures, so that after quarrelling with Bairnsfather's psychology for nine-tenths of his space, the writer concludes by paying an unconscious tribute to the stuff he sets out to condemn.

This was the sort of thing levelled at Bairnsfather's head in the earlier days of his success.

The contrary of the sensationalism to which I made references is snobbery, and among the snobs Bairnsfather found not favour. He was

Mr Mutch preparing his case
. . . curse him!

regarded as an offence against good taste and in no place was this attitude more speedily and formally established than in the British War Office.

Yet it was the British War Office which first had forced upon it positive proof that Bairnsfather's drawings caused a tremendous uplift in fighting morale among the men at the Front - a fact which has been proved over and over again, although the writer in *The Times* is so blind to human psychology that he flatly contradicts it and proceeds to elaborate his thesis of this contradiction.

The experts whose duty is was during the war to see to the maintenance of Army discipline, not merely encouraged the distribution of Bairnsfather's pictures, but gave him special and extraordinary facilities to do as much work as possible of the same kind.

The writer in *The Times* is so utterly wide of the mark that I can only conclude that he wrote in ignorance of the trenches.

It was a famous General who declared that the Bairnsfather pictures were worth an Army Corps on the Western Front, but possibly the writer in *The Times* knows more about the psychological reaction of such things than a mere General.

It is quite true that Bairnsfather was not very popular with the Staff Officers behind the line, but then they themselves were not very popular with the men in the trenches whom Bairnsfather knew and loved because he was one of them and had stood shoulder to shoulder with them both before and during the war. It was their point of view - since that was the most vital thing in the whole war - that he chose to interpret.

Throughout the whole of his career his artistic effort has been directed to the translation into picture and jest of the doings of the people, so that on the whole we may conclude that if he did not find laudation elsewhere, it was because he did not look for it.

This man looks like this in the hope that something will come of it!

The War Office, however, was so sure of the uplifting effect of his art that he was not allowed to return to the trenches as a soldier, but was reserved for a time on special propaganda work in London. Then he was sent to the French Front at Rosendael, on the borders of the North Sea, and subsequently to Verdun, the result being a series of pictures illustrating the life of the French Army.

This task was undertaken at the special invitation of the French High Command, and no sooner was it completed than an invitation from the Italian Headquarters reached him, and he was dispatched to the Italian Front, where the Duke of Milan personally conducted him round the battle lines. The resulting series of pictures met with the full approval of General Cadorna and were published and circulated among the Italian soldiers as well as throughout the world.

It is interesting to note that it is in this series that the great American artist Dana Gibson finds Bairnsfather's best picture - the '*Fragment*' he chose as being the most brilliant thing Bairnsfather ever did in this series - entitled '19XX?'

The picture, it will be remembered, depicts the war as being over some little time ago and represents an Italian soldier, who has not heard about it yet, lying on the crest of an inaccessible peak and down what looks like miles below are Austrian villages frantically signalling without any visible result as he continues to snipe at them.

The Bairnsfather cartoons were extraordinarily popular with the Italian soldiers. Piermarini, the distinguished correspondent of the *London Evening News*, told me that they were displayed everywhere in Italian billets, and that he himself was pressed into service by his fellow soldiers to write translations in Italian of the caption below each of the drawings.

Following on this, just before the Armistice, he was asked to go to America to lecture on behalf of the Allied cause, and thereafter to proceed to Australia to be the central figure in a recruiting campaign on the invitation of the Australian Government.

I know one should look and feel like this if successful, but it's the hardest job of the lot!

These facts, which I record in the briefest possible fashion, are in themselves sufficiently damning contradiction to the statement made by the writer quoted above to the effect that Bairnsfather's cartoons had an undesirable influence upon the morale of the soldiers who saw his work.

Another criticism levelled against Bairnsfather's work is that even if he is humorous, he is not an artist.

This criticism arises out of the fact that most of Bairnsfather's public work has had a decided, and as I have indicated, a deliberate popular appeal, with the result that he was compelled to work in a medium which would be widely understood.

Probably if he had followed some of the so-called highbrow schools of art and developed futurism, cubism, or vorticism, or some other of the diseases which are liable to attack artists in their youth, he would have gained a reputation for cleverness and abstruseness.

It is one of the curious and fallacious qualities of certain tastes that they are inclined to gaze in wondering admiration on what they cannot understand. The simple style is the only classic style, and eccentricities superimposed upon such simplicity are often as not mere camouflage for a cleverness which does not exist.

I find, therefore, in the simple, direct appeal which is characteristic of Bairnsfather's popular cartoons, not a failing, but a virtue.

But it should not for a moment be supposed that Bairnsfather is capable only of drawing in wash or in black and white what are called 'joke' drawings. He has, as I have tried to point out, a very serious side to his nature. As I have indicated, he thinks deeply and correctly on all subjects of the day concerning humanity, and he has repeatedly found himself compelled to interpret such things on canvas and in colour. The many pictures of this description which decorate his homes in London and in the country, would, if they were exhibited, come as a revelation to those who assert that there is little or no artistic ability behind the drawings of 'Fragments'.

In these pictures I find real artistic conception, a true idea of picture composition, an exquisite handling of colour, and a perfect sense of the value of spacing - a complement to composition which is of such vital importance that it can lift any picture where it is successfully applied, from commonplace rank to distinction.

It is, as far as colour work is concerned, in landscape that Bairnsfather is most happy, and it is simply a question of time, bound by the extraordinary demands which have been made upon him since he became famous, until he will be able to free himself to do first-class work of this kind - work which he is very capable of doing and which is entirely after his own heart.

Things we had to use to win the war.

No:1 *No:2*

Chapter 13

HOW TO RUN THE NEXT WAR
~ BAIRNSFATHER, FOR THE DEFENCE

S hould we ever have the luck to be plagued by another war, why not run it on real business lines? What could be simpler and more satisfactory than to 'place' an order for a war somewhere? Anxiety as to the final result would thus be avoided, and the ultimate cost known at the outset. A glance through the correspondence below will show exactly what I mean.

John Bull & Company
OWNERS OF THE LARGEST EMPIRE IN THE WORLD

To: Bill, Burt, Alffe & Company, Universal War Providers

4th August 1928

Dear Sirs,

We are running a war shortly, and would be much obliged if you would kindly submit a quotation for 'subduing a European upstart' with a population of about sixty millions. Please let us have your quotation as soon as possible.

Yours faithfully,

John Bull & Company

~

Bill, Burt, Alffe & Company
Universal War Providers
Revolutions, Offensives, Massacres - all supplied on moderate terms.
Sole agents in Europe for Mexican Revolts. Capital, £750,000,000,000,000,000

5th August 1928

Dear Sirs,

We thank you for your enquiry of the 4th, and herewith have much pleasure in enclosing our quotation for a war such as you mention. We may say that we could begin on receipt of your order, and will give the work our very best attention.

Bill, Burt, Alffe & Company

Universal War Providers

ESTIMATE:

Estimate for war to be carried out to order of John Bull & Company.

To supply and fix complete in mud 20,000,000 assorted troops of the best quality, complete with generals, buff slips and memo forms, and all other necessaries.

To provide 500,000 15-inch Maxim guns complete with martyrs for firing same.

To provide and endeavour to use 50,000 30-inch howitzers with tetanus shells.

To advance 500 yards and to efficiently pulverise your opponents by means of explosive asphyxiation.

The whole of the above work to be carried out for the sum of £500,000,000,000 16s. 4d.

Please note; the above figure is exclusive of the supply of peace cranks; these can, no doubt, be procured locally.

Hoping to receive your order, which shall have our very best attention, we beg to remain,

Yours faithfully,

Bill, Burt, Alffe & Company

~

John Bull & Company
OWNERS OF THE LARGEST EMPIRE IN THE WORLD

To: Bill, Burt, Alffe & Company, Universal War Providers

10th August 1928

Dear Sirs,

We have carefully considered your estimate, and there is one point which we wish to raise with you, i.e., you make no mention of reparation. Will you please let us know as soon as possible whether reparation is included and if not, what your charge for same will be.

Yours faithfully,

John Bull & Company

~

Bill, Burt, Alffe & Company

Universal War Providers

11th August 1928

Dear Sirs,

Reparation was not included. The extra price for this will be £4,000,000,000, which will alter our total figure quoted to you to £504,000,000,000 16s. 4d. Hoping to receive your order, we beg to remain,

Yours faithfully,

Bill, Burt, Alffe & Company

~

John Bull & Company

OWNERS OF THE LARGEST EMPIRE IN THE WORLD

To: Bill, Burt, Alffe & Company, Universal War Providers

12th August 1928

Dear Sirs,

We have decided to accept your estimate. Please put the work in hand at once, but we wish the work carried out exclusive of atrocities.

Yours faithfully,

John Bull & Company

~

Bill, Burt, Alffe & Company

Universal War Providers

14th August 1928

Dear Sirs,

We thank you for your esteemed order, and hope to begin the war on Wednesday next.

We note what you say with regard to atrocities, and will delete same from our estimate.

There is some little delay in getting a sufficient number of Generals from our warehouse owing to the shortage of gold braid, but we are pushing the matter forward to the best of our ability.

Yours faithfully,

Bill, Burt, Alffe & Company

~

John Bull & Company
OWNERS OF THE LARGEST EMPIRE IN THE WORLD

To: Bill, Burt, Alffe & Company, Universal War Providers

22nd August 1928

Dear Sirs,

You promised to commence this war last Wednesday, and you have now wasted four valuable days.

We went over the ground this morning, and were annoyed to find that you had not yet delivered a single army corps, or a sheet of corrugated iron. All we could see was a pile of barbed-wire and red tabs, and an old man mixing mud.

Please give this matter your earliest attention.

Yours faithfully,

John Bull & Company

~ TEN YEARS ELAPSE ~

John Bull & Company
OWNERS OF THE LARGEST EMPIRE IN THE WORLD

To: Bill, Burt, Alffe & Company, Universal War Providers

24th August 1938

Dear Sirs,

We herewith send you 80% of the amount of your contract which is now due. At the same time we wish to state that we are entirely satisfied with the work.

Your advance of 300 yards, five years ago, was most creditable.

Yours faithfully,

John Bull & Company

~ ANOTHER TEN YEARS ELAPSE ~

John Bull & Company
OWNERS OF THE LARGEST EMPIRE IN THE WORLD

To: Bill, Burt, Alffe & Company, Universal War Providers

25th August 1948

Dear Sirs,

We herewith remit you the remainder of the amount due on your contract with us.

But we can on no account pass the extra amount of £600,000,000, submitted by you in respect of 'tips to neutrals'. This should certainly have been included in your original estimate.

Apart from that, however, we are entirely satisfied.

Yours faithfully,

John Bull & Company

Apart from the difficulties, which I have now cleared up, of how to run a war - there is another great danger. That is, if by chance, warfare falls into the hands of the YMCA completely.

There is a tendency in the world today to modify war. Having failed to remove warfare from the surface of the earth there is always a movement to carry out wars on 'humane lines'.

That ridiculous absurdity, the Hague Convention, once tried to make war a 'gentleman's game'. To my mind you cannot make fine differences in how to fight.

If an Empire is at war, it's a serious thing. You must win or pay for it, or lose and pay for it twice. And there is no difference in gentility between gassing a man or sticking him with a bayonet.

In order to avoid any anaemic set of rules being set up by a world which seeks to irradicate inevitable future wars let me utter a warning against wars being conducted as laid out in the following timetable:

UNDER THE 'ANAEMIC SET OF WAR RULES' THE WARRING NATIONS AGREE TO ABIDE BY THE FOLLOWING TIMETABLE

7.00am	Early morning tea.
7.30am	Short walk, then back for breakfast.
8.00am	A quiet hour with Bunyan's 'Pilgrim's Progress'.
9.00am	Battle.
9.30am	Coffee and sandwiches.
10.00am	Battle continued.
1.00pm	Lunch and dominoes.
2.00pm	A brisk walk realising as much as possible the beauties of the flora and fauna in the neighbourhood.
3.00pm	Battle.
4.00pm	If battle over - tea and dominoes.
6.00pm	Bugle call 'back to the huts'.
7.00pm	If battle hasn't broken out again - cocoa and caviar. (Special Campaign throughout the USA for funds in aid of this.)
8.00pm	A smokeless 'sing song' on ginger ale.
9.00am	All hot water bottles to be filled.
10.00pm	Bed. The Company Quartermaster-Sergeants and Sergeant-Majors to read fairy tales till all go to sleep.

Studying the 'Rules of Engagement'

Chapter 14

ACTOR AND PLAYWRIGHT
~ MUTCH, FOR THE PROSECUTION

To anyone who has studied the work of Bairnsfather as a humorist artist it will be apparent that a distinctive feature of his drawings is the invariably extraordinarily humorous captions attached to his pictures. This is a great gift which he has assiduously cultivated by observing a principle which most artists too often ignore.

You find, as a rule, that the average artist sees in 'situations', and therefore takes for his guidance the hopeless rule of thumb which is responsible, for example, for the terribly poor standard of cinematography. As a rule the cinema producer knows less about his

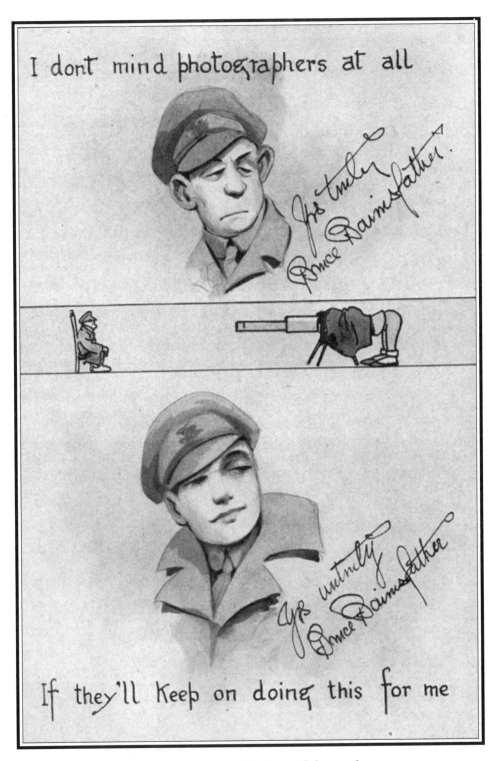

Bairnsfather's tongue-in-cheek view of photographers.

business than any other expert in trade. The reason for this is that he pictures 'situations' including action and posture, rather than ideas.

A 'situation' is seldom amusing in itself. It invariably needs a framework to which we might give the name 'context' or 'atmosphere'.

The consequence is that in drawing pictures of the best quality, especially in humorous art, you have to consider what leads up to a situation, or what results from it. Accordingly you find yourself looking not at situations, but behind them, so that what you picture is not a physical fact but a frame of mind.

Take the Bairnsfather picture *'The Better 'Ole'*, the most famous of them all. One man is saying to another, *"If you knows of a better 'ole, go to it."* I attribute much of the overwhelming success of this picture and its inspirational phrasing to the fact that the whole thing translates a frame of mind. The fact which is so delightfully absurd is the imagining of the argument which must just have taken place before the one soldier obliterates the other with this final abjuration.

Take another example, the *'Fragment'* entitled, *"There goes our blinkin' parapet again."* This derives the whole of its laughable quality from the psychological fact that the soldier in the dugout is not in the least concerned with the explosion, but feels a vast discomfort at the prospect of having to fill and place so many more sandbags.

I argue from all this that Bairnsfather's art is more than photographic.

As I have already pointed out, there is a tremendous amount of hard psychological study behind his work. I have shown in various ways how he developed along these lines in his earlier days - how he was always concerned more with what people thought than what they did, and in dealing with Bairnsfather's ventures upon the stage I think that these things are important, not only because they throw light upon this phase of his genius, but because his stage enterprise shows the full fruit and flower of these gifts.

Bairnsfather turned towards the stage long before there was any war. His first stage period is contemporary with his engineering adventures, and it will surprise many to know that he was the producer, scene painter, author and principal actor in four pantomimes at this stage in his career. Three of these were done for charity, *Robin Hood*, *Aladdin* and *Robinson Crusoe*. In each of these he took the principal part, and scored a tremendous success, especially as Widow Twanky.

These three pantomimes were so successful that he was inspired to go into the theatrical business seriously on his own, with the result that he produced the pantomime *Ali Baba*, at Stratford and Leamington, with considerable success financially, although physically he was somewhat stripped of his dignity when, on making an entrance, he fell down a ladder and had his costume so ripped and torn that he had to make a very undignified exit.

It will be seen, therefore, that when Bairnsfather turned his mind to the idea of writing a play about the war, he was not doing anything which he had not done before. He knew the sort of thing the public liked, and

by first-hand experience he had gained an intimate knowledge of the practical working of the stage.

He built a model theatre of his own, complete in every detail, and on this model stage he built the whole of his scenery for the actual production. It was because of his constant study of stage conditions in this model theatre that he has been able to master all the intricate details of stage-setting.

In most cases when authors or artists make up their minds to write a play they do so without any of this very valuable technical advantage. Bairnsfather had not only this technical knowledge of how a play is handled behind the scenes, but he had also the very valuable knowledge which comes to an actor who plays a part in his own production and learns from popular approval and disapproval the great gift of humility.

Neither should it be presumed that these

I'll give it about a week

four pantomimes and the study of the model theatre were the only training which Bairnsfather had for the stage. He was in constant demand at all sorts of entertainments and concerts, where his favourite stunt was to be either a red-nosed comedian or a female impersonator, in both of which he excelled to an equal extent.

It should be kept in mind, therefore, that when Bairnsfather came up against the war he had trained himself to look at it not only with the eye of a humorist artist, but with the mind of a dramatist, and it was very early in his career as a solider that he saw the possibility of dramatising life in the trenches in such a way as to amuse theatre-goers and at the same time represent faithfully certain phases of soldier life.

The result was the appearance of 'The Johnson 'Ole', which was a short, one-act sketch, introduced in the famous and successful London revue *Joyland*. This is the sketch from which I have already quoted the soldier classic about the 'bird' and the 'girl'.

'The Johnson 'Ole' met with such a favourable reception that Bairnsfather's name became a greater and greater attraction, and his following sketch, 'The Café de la Paix', made a tremendous hit in the London revue *See Saw*.

The reader will observe here again how slowly and systematically Bairnsfather climbed in the world of drama from the foot of the ladder to the top. He started off with singing songs and gagging at local concerts and entertainments. He followed this up by building a model theatre and making himself fully acquainted with the working of the stage, and he then proceeded to produce - on an increasingly elaborate scale - local pantomimes which met with considerable success. When his name was sufficiently big enough to command attention, he descended upon London with two one-act sketches, both of which were received with the utmost enthusiasm, and then, and not until then, he considered the time ripe to make a grand assault upon a West End manager, with a full-length play, which he entitled 'The Better 'Ole'.

The trials and tribulations which Bairnsfather underwent before any manager would consent to put this play on any stage would, in themselves, fill a book twice the size of

A story without words.

this one. In spite of the fact that he had learnt his stagecraft in a hard school, he found the theatrical producer harder still.

'The Better 'Ole' was read to manager after manager in London and turned down as a 'dud', until finally Mr C. B. Cochran decided to put it on at the Oxford.

The play had, before the first night, met with so much adverse criticism that on the fatal day Bairnsfather was in a state bordering on collapse. The greatest encouragement he had was from one or two imaginary friends, who said that he was risking his whole reputation on this mad affair, and that when he had failed he would return to the ranks of the nobodies. Even after the first night reception, which was simply overwhelming in its enthusiasm, there were plenty of people, including one very distinguished theatrical manager, who prophesied that the thing would probably last a week.

It is quite in accord with the workings of human nature that these friends and prophets now knew all along that it would be a riotous success. For it can be truly said that 'The Better 'Ole' took London by storm. It came just at the right moment, and hit just the right note. Every soldier on leave made a pilgrimage to the Oxford, and went back to France in all the better heart because he had seen 'The Better 'Ole'.

It was, in fact, so successful in London that touring companies were very speedily in the provinces in Britain, and negotiations were opened up for the sale of the play in America. American theatrical producers are usually very live men, but on this occasion they were entirely at sea because 'The Better 'Ole' was offered to practically every producer of importance on Broadway, and was absolutely turned down. Finally, when it seemed that New York would not tolerate the play in its midst at any price, Charles Coburn decided to try it out in Greenwich Village.

The thing was a riot and very soon it had to be moved to Broadway, where it remained for many months as well as touring every state of America and Canada, where even now 'Better 'Ole' companies are still playing. In addition to this, the play appeared in Australia, under the management of Mr Hugh D. Mackintosh, in South Africa and in India. Then the story of the play was filmed and shown in practically every picture theatre in the world from New York to Nairobi.

The play, which manager after manager had refused to produce, proved a tremendous success wherever it was shown, and widened Bairnsfather's audience from Stratford and Leamington to the English-speaking world. And it should be kept in mind by those who follow Bairnsfather's career, that every chapter in his story goes to show that he is not a one-play dramatist.

In 'The Better 'Ole' he caught the spirit of the times and interpreted it with a brilliance and humanity which no one else was able to equal, and it needs very little gift of prophecy to say that he will again catch the spirit of the times and give an equally brilliant interpretation for the stage.

The year following the Armistice was so nebulous and extraordinary that it was impossible to say where the interest of such a play could be found, but more recently the problems which concern all the peoples of the world have resolved themselves into more definite shape, and it is here, I imagine, that Bairnsfather will find the subject for his next play. His work as a dramatist shows exceptional powers of observation, ability to write epigrammatic English in which he invariably sums up a whole problem in a single phrase, and a tremendously acute dramatic sense which leads him to use all the stage devices which capture the attention of an audience. His theatrical work, like his pictures, combines humour with the serious things of life, with the result that while he amuses his audience, he also inspires thought.

Chapter 15

"THE PLAY'S THE THING"
~ BAIRNSFATHER, FOR THE DEFENCE

Nobody can get through this world without some pain, some less than others. I am assuming that you have been born in agony, in other words, you are a would-be author of plays for the stage (I say 'for the stage' in order to mark the important and tragic difference between that sentence and 'on the stage'). Well, this is meant as a kindly guide to those who, from an excess either of youth or ambition, are desirous of seeing a play by themselves actually on the stage.

I will treat with this malady from the earliest stages. We will assume that you have a play written. Your father, mother, sisters, brothers and cousins have had a great desire that you should part with it soon, or refrain from reading it to them again. Stimulated by this help, you set forth on your travels.

Before arriving in London to sell your play, it is as well to get a manager. A man who is more or less a cross between Joe Beckett and the United States Treasurer is the sort of one to get, if you can. When you've got him, never go out alone, take him with you - always. Now get a list of producers; this can be procured either from the telephone book, or the Criterion Restaurant. Having selected the one that you feel will be overjoyed to produce your play, get your managerial phenomenon to fix an appointment. Here, I should recommend a trip down the Nile or a little hunting in Tibet, or something of the kind, as waiting wears down your nerves.

Suddenly, one day, when you have gone back to poultry-farming, a telegram will arrive that an appointment has been fixed with Abraham Pinchwhiski, the famous producer, and owner of the Olympic Theatre. Now's your chance. You and your manager must go at once with play and terms to see the potentate in the depths of the grandeur in which he lives. It is very improbable, but we will assume that he has just returned from Paris, New York, or Maidenhead, and is in his office when you are shown in.

Don't be unnerved by the three-thousand-guinea doormat as you enter; don't let the ten-thousand-pound grand piano, inlaid with black ivory cause you to falter. Put the hundred-guinea damask curtains and the fifty-guinea inkpot out of your mind; they might make you alter your terms. Any altering of your preconceived terms will be done by the superman in whose presence you now are. A great silence will fall upon the room as you sink out of sight into the leather cushions of the thousand-pound settee. Now listen carefully. From behind the seven-and-sixpenny cigar wedged amongst the gold teeth of the producer will come golden words - probably something like, "Don't read your play, but tell me what it's about."

You must do this at once, then wait for further golden words. At this point I am going to assume that the producer likes the idea and wants that play. (Peculiar assumption this, but it makes my advice stronger.) He will put his seven-and-sixpenny cigar down on a ten-guinea ash-tray given him by the leading comedian of his last revue in the hopes of another engagement. He may then say, "Read me the first scene."

Hold your manager's hand and do this at once. If that cigar gets back amongst the

This is the place where they bring the income tax forms, the water rates, the gas rates, the electric light bill and all the other fifty-seven different varieties!

gold teeth look out for trouble. If the producer, on hearing the scene, wants the play, he will say, "In its present form it wouldn't run a week." Let us be exuberant and again assume he has said this. He will then say across your face to your manager. "What do you want for it?" This is where your financial gladiator comes in. After a twenty round verbal contest your play will be left behind and you and your manager, full of despair, will be wafted down a lift into the open street, there to seek a café.

You must now allow the sugarless coffee and cheap music to slowly revive your spirits and nurse you back to a less despairing frame of mind. Try and recall the exact words the producer used, make a rough calculation on the back of the menu card as to the absurdity of the producer's counter offer to your pre-arranged terms. Your manager will do this for you with a vigour and venom that your artistic soul will be incapable of. Make plans as to your next move. At this point in this outburst of advice I am giving, I am bound to assume a certain definite course being pursued by your play, in order to arrive at some conclusive help, which is my object. I must, therefore, presume the ridiculous and extravagant theory that the producer, after you left him, turned to his 'right-hand man' and said, "We want this guy's play." On this assumption you will not be many years older before your manager will wire you to the effect that a contract has been signed, and that details in connection with the production are being started at once. Get elated at this; don't ruin your pleasure by reading your manager's letter which follows the next day with the amended terms. Go to London if you can and start a relentless guardianship over your play. The pleasurable part of placing your play is now over; from this moment you must look out for every conceivable thing going wrong

with it. You will be compensated for this harsh period by being elevated to that charmed histrionic fraternity which refers to all its members as 'dear old boy'. The loving softness which lurks in the pseudonym will become more and more apparent as time wears on.

Now comes the actual production. The casual thinker might imagine that when a play is sold it is then put on, by means of everyone connected with it endeavouring to do his best, but here the casual thinker would be quite wrong. All sorts of peculiarities break out the moment a producer has decided to produce a play. Among the leading phenomena which are now apparent are the following:

The producer can't get a theatre. When he has got the chance of one it is not at his price. When it is at his price nobody likes the locality. The producer can never get the very man or woman for the part, at his price, and therefore probably doesn't get him or her at all. This peculiar trouble is due to a very sad occurrence. It is this. No production can take place, and no artist can be booked for it, without an inordinate and grasping interest being taken in it by things called agents, who are very rarely seen - only felt. These octopuses dart out from under cover of the shady nooks and overhanging ledges of the Charing Cross Road the moment they smell 'a new production'. The aforesaid play will only now be produced by kind permission of these agents. Judging by appearances, it is their business to prevent you booking any artist. If they could possibly prevent you getting a theatre I'm sure they would, but don't worry about them, they mean well. After all, they've probably got wives and children, and there's nothing that wives and children like better than the results of 40%.

So, here you are now, on the high road to success. You've got all the types of humanity needed for the project grouped tightly around you. What more can you want? A day will shortly come when you know what the producer has drawn out of the bran-tub, as regards a theatre and artists. Soon after this the play will begin to materialise by means of rehearsals. One day you will go to an appointed spot to see the first rehearsal; you will wait an hour and a half and find it has been moved to next Tuesday. On Tuesday a sorrowful group will assemble in the semi-darkened and shrouded bar of a theatre. The producer will probably have gone to New York, the leading actor is prevented coming by his agent, the leading lady has caught such a cold on the river that she can only sit in the stalls in a dark corner with her greatest friend, who is telling her about her own part in another play. The supers and electricians are, however, there, and are all attention.

I will gloss over a long and painful period now, during which rehearsals of all sorts and sizes take place in various parts of London. I will skip all this until I arrive at that great day, 'the dress rehearsal'. This rehearsal is supposed to represent your play as it will be presented to the public for the first time the next night. Thank heaven it doesn't. Everyone has come to this, everything is there - except the scenery, which generally comes in at half-time, thus ensuring that your 'interior of library' words are spoken in front of 'a wood near Nairobi', whilst at the end your pathetic

Possible reconstruction of my Great Grandfather, Andrew MacTrouble

'homecoming to the village inn', with allusions to the honeysuckle round the window, has to be played in front of a turbulent vision of 'Niagara Falls', being rendered still more turbulent by the carpenter making the machine that does the thunder 'loud enough' somewhere at the back. Over the dress rehearsal rests a gloom and a hopelessness such as must have oppressed England prior to Trafalgar. Nobody believes the play can possibly run more than a week. You don't yourself. If you founded your judgement on the dress rehearsal, you would be right.

The producer puts a brave front on his rash enterprise, that of having bought your play. A producer smokes most when the outlook is blackest. When you see him light a fresh Corona-Corona from the stump of the last one you know he isn't far off tears. Three o'clock in the morning comes, the rehearsal is over, you slink out of the theatre, and as you pass down the chill and empty corridor to the stage door you will probably hear a voice somewhere in the darkness mutter to another, "Call this a play?" or "I'll give it ten days." Never mind, go straight home to your hotel, but not if the way lies over Westminster Bridge - temptation is a dangerous thing.

A 'first night' of a first play is, of course, the Mecca towards which the patient is striving. The dress rehearsal is over; the doctor has stolen quietly out of your room at the hotel, and whispered to the nurse that you are now out of danger. When you awake you will realise with a galvanic start, that this is Der Tag. It is the day of the First Night! You will eat nothing except Pomeroy or Charles Heidsick. This is known in Harley Street as 'nerves'. In a starving but liquid condition you will roam, with your miserable face, up and down the hotel, and down and up streets, looking at every clock you can see, and starting violently as each half hour passes. In your mind you will have acted the play right through to an empty house, at least twelve times. The afternoon wears on. At last the zero hour approaches. You dine early off Moet and Chandon. Now's the time! You have got to go to the theatre. With a feeling much akin to that of an aristocrat in the French Revolution being taken away in the tumbrils, you will be removed to the theatre in a taxi. It's well to pay the driver to wait for you whilst a first night is on - you may want him in a hurry after the first act, and an angry crowd is a dangerous thing.

As before I am going on a preposterous assumption, i.e., that your play is going to be a success. This makes the conclusion of this chapter less painful, and more inspiring to the young enthusiast. You arrive at the theatre. You go inside. The manager, producer, commissionaires, stage managers, etc., etc., will keep well away from you; they don't know whether you are a success yet. (Never mind that, it all helps.) Enter and sit at the back of the pit near an emergency exit (you can get away quicker and safer to your waiting taxi from there). If only you can, of course dress yourself like the manager for this occasion, and risk it. A sort of George Lashwood in black, I mean, with a shirt front like a bleached skating rink. This will help you at the finish, for the audience will want to see a fair reproduction of an author.

With a crash the orchestra will burst into a tune calculated to drown the buzz of conversation and assorted noises over the crowded theatre. Somebody has whispered to you the ominous information that a lot of the press are there. Now for it. The curtain rises and you see a faint resemblance of the play you once wrote holding a great and enthusiastic audience tightly by its interest. Success!!

The first night is over! The producer, the managers, the actors, the actresses, the man in the box office, and all your friends you will now find, 'knew it would be a success'. For months to follow you will have the carnal satisfaction of seeing crowds going in and royalties coming out. You are now a successful playwright.

It will be as well, before I finish this chapter, if I try to epitomise the production of a play. For this purpose I am submitting in potted form, under the title of 'The Play's The Thing' an impression of how a play is written and possibly produced.

THE PLAY'S THE THING

In order to grasp the significance of Shakespeare's announcement, quoted above, I give a few sidelights on production, as a guide to prospective playwrights. Nothing will serve the purpose so well as a series of letters between the producer and the author.

The Web, Snatchet, Hants.

1st April

Dear Old Boy,

Very many thanks for sending me your play to look at. I like it immensely and feel sure there's pots of money for you in it. Can you come round to my offices tomorrow (you know the place, over the Babylon Grill Room) between twelve and one? We could then talk things over. It's an Eldorado for you, Old Boy.

Yours sincerely,

Adam Swindle

~

Hotel Eclipse, Warwick

2nd April

Dear Swindle,

So glad you liked the play. Right-oh! I will come to your place about 12.30 tomorrow.

Yours sincerely,

Y. B. H.

~

Hotel Eclipse, Warwick

3rd April

Dear Swindle,

I went round to your offices at twelve and waited till 2.30. The office boy then rang up 'The Web' and heard that you had gone to Brighton. He thought you would be back any minute, but I couldn't wait. So sorry to have missed you.

Yours sincerely,

Y. B. H.

~

The What's Yours Hotel, Portsmouth

10th April

Dear Old Boy,

Damn sorry about missing you the other day - thought I said Tuesday, not Monday. Anyway, have seen about the play. I think there's thousands in it and it will run for six years at least. I will put it on in the West End, on the island in Piccadilly if necessary, and have all London's leading actors in the cast.

Yours sincerely,

Adam Swindle

~ EIGHT MONTHS ELAPSE ~

Hotel Eclipse, Warwick

3rd November

Dear Swindle,

Do you want that play or not? It's now seven and a half months since you had it. You know the terms. I sent them to you over six months ago. Do let me know as soon as you can.

Yours sincerely,

Y. B. H.

~

Theatre Royal, Pontypridd

6th November

Dear Old Boy,

The terms you ask in that contract are simply ridiculous. One per cent on the extra matinee gross takings would murder the show.

The play is all right, I know, but in its present form it would not run a week.

I have been seeing about it, and I find I cannot offer you any more than one and two-thirds per cent on the gross profits obtained from the sale of the programmes.

Now do be sensible, Old Boy, and think of the manager. The expenses of putting on this show of yours are going to be stifling.

Yours sincerely,

Adam Swindle

~

The Web, Snatchet, Hants.

1st December

Dear Old Boy,

So glad you've signed the contract, my lad. You are going to roll in money over that play. I am going to put it on regardless.

I hope to get the Labyrinth Theatre for it, right in the West End. It will be on in a fortnight. Good luck, Old Boy.

Yours sincerely,

Adam Swindle

~

'Fairdeal' Convalescent Home, Bournmouth

18th June

Dear Swindle,

When is the play going to be produced? Haven't heard from you for over six months. Write a line when you can.

Yours sincerely,

Y. B. H. (Why Be Hopeful?)

~

The Web, Snatchet, Hants.

22nd June

Dear Old Boy,

The play will be on next week. Hope you can get up to see the first night.

By the way, did I tell you, it's not going to be at the Labyrinth after all - couldn't get the lease. (They have got that revue *'Let's All Strike'*, booked solid there for two years.) I am putting it on at the Corn Exchange, Pembroke, for four weeks. It's going to be a riot, Old Boy!

Thine,

Adam Swindle

~

Telegram:

Can't get Corn Exchange, Pembroke.
Suggest Pier Pavilion, Hythe, do you agree?

Swindle

~

Reply Unpaid:

Extract from private account book:

	£	s.	d.
Profits from play	46	15	0
Hotel expenses	28	10	0
Travelling	15	6	0
Specialist's Prescription	2	5	0
Balance at bank	0	14	0

Chapter 16

LECTURE TOURS
~ MUTCH, FOR THE PROSECUTION

ecture tours hardly enter into my estimate of Bairnsfather either as an artist or
writer, and, therefore, I propose to deal with this phase of Bairnsfather's activity
quite briefly. At the same time although, except in the furnishing of new ideas
and fresh outlooks in which all travel must result, these lecture tours have not materially
contributed to his success either as an artist or writer, yet they are so closely the outcome
of both, that my summary of his work would be incomplete without some reference to
his picture talks on the platform.

Bairnsfather had, of course, made his name before he was invited to talk about his
pictures and especially about one William Busby (Old Bill), whom he had lifted not
merely from obscurity, but from non-existence, to be the most popular character in
that big bother known as the Great War.

Old Bill had been received into every home and household - and some households are
not homes. He had, for many months, been a topic of table conversation like President
Wilson and Lloyd George; the only difference was that people did not quarrel about
him - except in *The Times Literary Supplement*.

Naturally out of this immense popularity there arose immense curiosity, and those
invisible beings who pull the lecture tour strings were quick to realise the existence of
that same curiosity - their job being to divine where popular curiosity is going, and to
get there first - to be ready as a sort of Cook's Guide.

In Bairnsfather they saw an ideal
lecturer, because he was not only an
object of popular interest, but he had
shown he could make people laugh,
and that, when a laugh was most sorely
needed.

It was because of this that a large
number of '*Fragments from France*'
were made into lantern slides and
Bairnsfather sat down to what he
thought the hardest task of his life - the
composition of a lecture that would
hum.

He soon found there was a harder
job still when he got stuck on a
platform before a few thousand people,
each of whom seemed to look, if not to
say - in Scotland at least - "Now make
me laugh if you can."

There is a very old proverb which

says 'You can lead a Ford to the high road, but . . .'
Lecturing taught Bairnsfather all about the 'buts'.
At first they rather wandered him. Now he can
recite them backwards.

His lecture tour in Britain opened in January
1919, at the Queen's Hall, London, and spread
outwards through the whole of the bigger cities of
England and Scotland, and the success of this tour
is shown by the fact that he was immediately
invited to do a similar series of lectures in the
United States and Canada, which engagement he
fulfilled just a year after the British tour.

The American venture was another splendid
success, which is well proved by the overwhelming
reception given to Bairnsfather by the American
Press and people.

These lectures are of interest from one point of
view. The acquiring of fame invariably brings with it a vast correspondence, ranging in
subject from the most fulsome praise to the whole-hearted abuse, from proposals of
marriage to threats of murder. Samples of the less restrained of such correspondence
would hardly look well in these pages, but a few quotations from the more moderate
will give the reader fair warning of the sort of things to expect. The more recent letters
naturally are concerned primarily with the appearance of 'Fragments', and are frequently
accompanied by photographs of the writer reading the paper in some remote corner of
the world. One, which lies before me as I write, comes from Bareilly, India. In it the
writer says:

> I should like very much to express my appreciation of your delightful little
> paper which I have read almost continuously from its infancy. The enclosed
> rough snapshot shows that 'Fragments' reaches to all corners of the earth,
> even to the Lower Himalayas. Having spent a large portion of the duration in
> our mutual mud hole of a home, Flanders, I can readily understand the humour
> of all of the Bairnsfather cartoons.

In similar strains is a letter from Sydney, Australia, in which the writer says:

> Will you accept the congratulations of an Aussie soldier, with over five years'
> service with the AIF in Egypt, Gallipoli and France, and just returned to God's
> own country - Australia - for your great and entertaining 'Fragments'. It is not
> only a bright and snappy paper, but shows you to be an editor of editors, when
> you can place such good results on the market after your trying ordeal of
> active service for your country. With regard to Old Bill, I am of course glad to
> make his acquaintance once more, as I always held a high opinion of the Old
> Bills of the British Army, because without them we would no doubt today be
> ruled by the Prussian heel. I sincerely wish you every success in your new
> venture, but a paper with such high qualities is bound to succeed every time,
> and with you at the helm it is sure to take on.

On the other hand, there is, of course, the occasional letter in which the writer sets out to express his uncontrolled wrath at some picture which has trod upon a bad corn.

Such letters are very few, but they are usually breezy when they do arrive and show that the sting, which Bairnsfather occasionally gets into his work, hits well home. This has been most noticeable in his pictures concerning Sinn Fein, and it is in this class, generally speaking, that the threats of personal violence make their appearance.

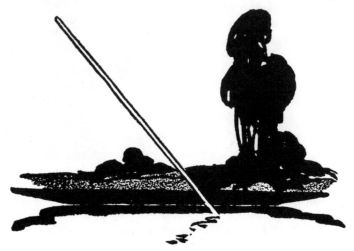

As a contrast, the following letter from New York is worth quoting.

> I hope you will pardon this intrusion. I only want to thank you for the immense pleasure you gave myself and my friends with your 'Fragments from France', your 'Bullets & Billets', and also that delightful play 'The Better 'Ole'. And now I will take the liberty of asking you what is to become of dear Old Bill. Please don't let him die or fade away; he should live for many, many years to come and bring happiness and laughter into our hearts. Please find him a new role in life. I hope to see his face again very soon in company with his old pals, Bert and Alf. Our most heartfelt thanks again for the many laughs you have given us. Wishing you as much happiness as you have given so many thousands of others.

Then there is the type of letter from the young flapper who is going on the stage and who suggests that Bairnsfather should write her a play. And in the same class comes the love letter, although the following sample is rather left-handed in compliment.

> Dear Captain Bairnsfather,
> I think your new paper is just too topping for words, and I think you are the nicest man in existence. I really am in love with you - quite. It is rather a good thing I have never seen you, or am never likely to, as perhaps my ideal would not come up to what I imagine, and what I picture you as, and I shouldn't like to lose my ideal or think of you in any other way than I do now, just as a darling.

Then, on delving further into this curious phenomenon in human psychology, I find

'Fairy Maggie' writing to wonder if 'darling Bairnsfather' would like to see her every day, and proceeds to give a timetable of her day's work, with the idea of showing that either her afternoons or evenings are quite free.

Following upon this I find 'Gypsy' hoping that if her 'dear Captain' is annoyed with 'these nonsensical notes' he will be 'kind and forgiving'. Whilst 'Julie', who has been 'contemplating writing for over two months' expresses the opinion that veneer and deception are the curse of this world, and declares that she is to make a clean breast of everything, whereupon she says that she is longing to engage in a friendly correspondence, adding that she is 'so fearfully shy, and so shocked at herself for writing this,' but concludes, 'I assure you that you will be corresponding with a perfect lady, and hoping this will be the beginning of a pleasant correspondence'.

It may be said that the letters quoted are characterised by the extremes of flattery and hatred to which I have already called notice, but in point of fact, the most interesting thing about the great bulk of them, psychologically, is their immense sincerity - a sincerity which even in the most extreme of these letters quite outweighs any seeming foolishness on the part of the writer. As I look at it, these letters are not in any instance, with the exception of what might be called the brazen epistle, a fit subject for jest. In most cases they are very much worth answering if only from the point of view that failure to acknowledge these letters is likely to injure some quite legitimate enthusiasm. As I intimated in my preface, it was, indeed, because of this consideration that the idea of this book was ever conceived or carried into execution.

The great sincerity of the bulk of Bairnsfather's correspondence, and especially the real difficulties expressed in these letters, by struggling artists, is the one thing which seemed to point to the real desire for the existence of such a book as this, and it is to be hoped that by its appearance many such difficulties will be swept away.

'Industry'

Chapter 17

"TONIGHT AT EIGHT"
~ BAIRNSFATHER, FOR THE DEFENCE

It is a long cry from drawing one's first picture to being asked to lecture on one's pictures, yet such a fairy tale came floating my way. Though I think there must have been a wicked fairy behind it all, for there are few things in life, to my mind, more soul-destroying than a lecture tour.

To lecture once is alright, but to repeat the performance round fifty cities in England and America becomes a transient hell. My fee for the next lecture is £1,000 for the first hour and £2,000 for every half hour after that.

An audience could never imagine the anguish that lies behind a lecture. They only see the lecturer, and a camouflaged edition of him at that. They don't see the cold, cheerless dressing-room behind, the group of depressing managers and the wild race to the next town in the train. I have perpetrated lectures from Aberdeen to Toronto and from Washington to Brighton.

Before I sum up and pass judgement on an English tour, let me give you a slight idea of my first lecture in America, and how I got there. Before being able to lecture at all in America it is first necessary to get there.

Ha! Ha! You'll say, of course, how obvious! But stay, gentle reader. Have you ever heard the mystic phrase 'getting a passport'? I have been through this solemn right once or twice and can therefore enunciate the complete catechism. There are, of course, reasons which lead up to one's wanting a passport. There must first have been a desire to leave this realm of England for another realm. It may be that you are going to France, Germany, or even, if you are weak enough, you may want to go to Russia.

Suppose, for instance, that you are going to Ameronia. This will enable me to give you an accurate idea of the procedure necessary to your shaking the dust of Britain from your feet, and may also convince you that the best plan is to abandon going and remain quietly at home.

Going to Ameronia begins like this. First you learn from the utterances of weary friends that it is first of all necessary to get a 'passport' before you attempt to book a passage on a ship. The idea that you have, that the shipping people want to take you anywhere, at a price, must be quickly and firmly got rid of. They don't like the idea of your leaving home at such an early age; they don't want your money; they don't, in fact, wish to know you. I suppose they suspect you of wishing to blow up their ship in mid-ocean.

Nobody wants to let you go, and nobody wants to take you. This is the first difficulty of getting anywhere outside England. Whether you are a Lenin, Trotsky, Robert Smillie, or the Duke of Coalumberland, it does not matter. They don't want you to go. You are an object of dire suspicion. In other words, you must conform to the idea of supporting a passport office in their desire to make a legitimate living. You will find out, in due course, that if you are bent on carrying out this nefarious enterprise of visiting another country, you must be photographed.

This is most important, a diagram of that growth of yours above your neck is one of the first principles to be obeyed. None of that removing of superfluous hairs by a Bond Street photographer. A clear and cruel map of your face must be made and pinned to your passport, with a truthful delineation of your father's past. Where he was born, why he dared, as an Englishman, to marry an Irishwoman, and why the hell he then had a son of your age.

After this you must fill in all your facial blemishes - colour of nose, size of mouth and quantity of hair. These details are all the more important as they will ultimately be filed by a Boy Scout in a cloister, which will probably never be disturbed till an archaeologist digs up fossilised passports in 6919AD. If you did not fill up the horrible details posterity would know nothing of its ancestors, and would have nothing to congratulate itself about.

When you have done all this, go home and wait.

Suddenly, a nicely bound volume will come to you by post - two days after the boat you wanted to catch has sailed. It is your passport! On reading it you will find that the authorities have got over their antipathy to your leaving these shores. This, in itself, is not surprising when you look at your photograph pasted inside.

Anyway, you've got your passport, but I feel it's dealt out as a warning not to try and leave the country, but to stay behind and participate in a levy on capital or any other desirable attribute which a grateful country provides.

Having got the passport the trouble, in my case, is to cross the ocean. A very important matter for me this. They don't want an invalid lecturer on the other side.

I struggled with this subject, however, and possibly others may have to struggle too, so I will take you in imagination with me closely on my last daring exploit crossing the Atlantic on the mighty All Star liner *Insomnia*. Like Sinbad the Sailor, I have perpetually vowed I would never go on another voyage, and yet here I am back after my sixth crossing of the Atlantic, which means having perpetrated about fifteen thousand miles on that sea alone. Add a few other assorted ocean trips to this and you'll find I've spent a life almost exclusively at sea; which, when taking into consideration that I am the world's worst sailor (I hold the Lonsdale Belt), will show you that the adventuresome spirit which got my ancestors into such trouble is still pulsating under my Jaeger.

I have often wondered how they get officers, crews and stewards in such amazing quantities, all looking and feeling so well. I wonder where they are brought up. I should imagine there must be a huge college somewhere on rockers or something like that, so that they can get used to the idea before they actually take to the sea. Of course, perpetually attending fairs and riding in swing-boats must be a great help in after life. Oh, isn't it terrible!

The table at which I write seems to be rocking as I think of the sea. I can walk on any sea front and throw pebbles at the water without being sick, but that's all. Without any joking, the sea is no joke to me! It's a very serious matter. I appeal to you (and all those who have ever had really ninety horsepower *mal-de-mer*), to realise that in the following words I am pouring out the heartfelt sobs of one who has worshipped at the shrine of Nausea.

I have been to the war, I have been wounded, I have lectured in Scotland; in fact, I have suffered in many ways, but for real slap-up sob-stuff anguish give me a voyage on the Atlantic. If I catch sight of the tall yellow funnels of the ship from the hotel windows, the night before we start, I reel. Then comes the great severing with the land. The moment when you take your life in one hand and your suitcase in the other, and walk

A day in the life of an artist - a) the dream, b) the reality!

up the gangway. The ship can be any tonnage for this experiment. I have done it on lightweights and heavyweights and the result never varies. There is something unique, strange and distressing about the architecture of a ship. The woodwork is never straight, but curved to suit the eccentricities of the ship. In fact, everything is ship-like and in a few day's time gets associated in your mind with basins, stewards, stuffy saloons and the ship's doctor.

To get a fine day for a start only aggravates the horror. You know, almost assuredly, that 'this wonderful weather' cannot possibly last. It doesn't.

Then it begins. A peculiar motion about your cabin becomes noticeable. Things begin to rattle on the washstand. Your clothes are swinging on their hooks on the door. Suddenly your berth seems to recede downwards away from your back, and leaves you to catch it up. Just as you are doing so, it comes up again, shudders, and slides away. You gaze at the room with glassy eyes and watch an orange roll on to the floor . . . S'truth!

Then all of that happens again!

A steward enters. It makes you feel worse to see how healthy and happy he looks.

"When do we get there, steward?" you hiss through clenched teeth.

"Another six or seven days, I expect, sir. That is if it keeps as fine as this, but it looks like a storm coming on." He shuts the port-hole and acrobatically gets out of the room.

"As fine as this. Heavens! Steward!!"

My ship was ploughing and skidding across the Atlantic not so long ago, taking me to a tour of over twenty cities. I lay in my bunk in my usual nauseated condition watching the days drag past.

My first appearance was to be at Philadelphia. Owing to business reasons a very narrow margin of time was allowed between the theoretical arrival of the ship and that first performance. The Atlantic and the ship combined to play me up and three days off New York I realised that I would not get there in time. It was hopeless. We were a day out of harbour when the date arrived for the Philadelphia outburst.

The next show was to be at the Carnegie Hall, New York.

In due course the ship arrived and amongst the throng I descended the gangway. I arrived, plus baggage, and was met by my American manager. He was delighted to see me - enormously delighted, for the Philadelphia show had been moved on to that very day, and I was down to appear at eight o'clock! One wild stampede of customs officials, boxes, tips, coloured porters and sea-sickness ensued at the docks before I was whirled off to catch the six o'clock train (I had arrived at five).

In the rocking and swaying express I changed my clothes in the lavatory and was arrayed in my lecture garments as the train arrived late in Philadelphia. A large car was waiting into which myself, my manager and my 'props' were bundled and buzzed around to the Music Hall.

Three hours before I had been on the steamer. Now I found myself in front of a large audience who had been waiting for nearly an hour. I went through my tricks on what seemed to me still to be the deck of the ship. I'm glad to say the show was a great success, but I was as tired as a bit of chewed string.

The show over, I was unavoidably incorporated in very well-meant hospitality, being rushed off to a jazz supper party at a large hotel.

This was my first appearance in America. The next night was to be New York, after which I averaged a town a day. There was only one saving grace about this wild, hard-working rush through America, and that was the wonderful and persistent hospitality

of all and sundry whom I met. I had mighty audiences, which seemed peculiar to me, as chicken pox, phenomenal snow, smallpox, influenza and indigestion seemed to be struggling for first place everywhere in the local amusements. In one place things were very bad, but both the members of the audience were most appreciative.

I will now give you an idea of a tour in England. I feel it will be a guide and help to future lecturers. Anyway, it is well meant.

It's always called a 'Lecture Tour', but in order to equip you with a full realisation of those words, I must first explain that this form of punishment only befalls those who have the misfortune to have something to lecture about. Fate may have decreed that you have become 'someone the public wants to see and hear'. And if Fate has played this dirty trick on you, then you will sooner or later be up against a Lecture Tour.

It begins like this . . .

You become aware, by a series of letters arriving, that a mysterious individual exists who is not only able, but who will arrange for you to lecture 'throughout the country'. There are several of these public benefactors; you must choose the one you fancy and come to terms. The terms will come to you pretty quick, so think them over carefully, and fix accordingly. You will find, when the tour is over, that you will think the terms over again very carefully, and probably come to some rather violent conclusions, but we needn't bother about that now.

A tour is arranged and halls to speak in are booked up all over the country. Some people, I believe, have been known to dine at a hotel first and be sent for in a Rolls Royce by the management just in time to speak, and be whirled off back to their luxurious hotel afterwards, whilst a group of officials, sent by the Lecture Agency, bring good news and press cuttings up to their suite of rooms, informing them that the first-class Pullman saloon, to take them to the next town, has been taken and redecorated in readiness. I am not in that group. I am in Class B, where one leaves the Lyon's Popular on a rainy night in a mackintosh, and can't get a taxi, and therefore walks to the hall alone, and unloved.

The hall!! Dear readers, have you ever realised the dread meaning which underlines that name? To get a true perspective view and a comprehensive grasp of the words 'Lecture Hall' follow me closely . . .

It is a wet night in January, as has been recorded by Greenwich for years. The hotel and the hall are almost invariably separated by a mile of strange streets and slush. On enquiry and observation you find that apparently no one has heard of the Lecture, but have distinctly heard that the local Amateur Dramatic Society is giving a performance of 'Charley's Aunt' the next

night, and that every seat has been sold. And the night before there was a political meeting which was so successful that they wanted the hall again for tonight, and in consequence (owing to the lecture) there is considerable ill-feeling in the town. After the first thirty-five towns you won't mind this so much.

You leave the hotel and wander off through the lamp-lit mud of your strange city to the hall. You cannot fail to recognise it, if you ever find it, by seeing the only poster advertising your lecture pasted on a board near the front entrance. Across it will be stuck two oblong labels, one which reads 'Tonight at 8', the other, *'Charley's Aunt tomorrow night'*.

You enter the hall and in the darkness grope for the dressing room. It is about now you had also better start groping for an attendant, the manager, a fire and the audience. Sometimes you will find all these accessories there and your lecture will be a success, in which case, to conclude this phenomenon, grope for the lecture management, who will be safe a couple of hundred miles away, and thank them.

After which you might grope for some money, but you'll probably be too late!

Chapter 18

AUTHOR AND JOURNALIST
~ MUTCH, FOR THE PROSECUTION

Among the major horrors of the war will always be reckoned war literature. The chief characteristic of war literature, apart from its overwhelming abundance, was that it dealt faithfully neither with literature nor with war. It was, for the most part, entirely ephemeral in character, as the reader can try out by attempting to recall the names of even a dozen of the many thousands of books which appeared in the days of Armageddon.

Yet, in the midst of this flood there stood out one or two books which, at the time of their publication, attracted exceptional attention, and are still remembered and treasured. In this class we should, without hesitation, place *'Bullets & Billets'*, which appeared in the autumn of 1916. By this time Bairnsfather was a name to conjure with, and the book achieved immediate success. In *'Bullets & Billets'* Bairnsfather set down in humorous fashion his war adventures up to the time of his being wounded in the first gas attack at Ypres and being shipped back to hospital in London. The great point of *'Bullets & Billets'*, which came as a breath of fresh air, is that it is full of Bairnsfather's wit and humour. It is, in point of fact, the exact counterpart in literature to *'Fragments from France'* in art. Both make you laugh, but at the same time present a human and intimate picture of trench life.

As far as realism is concerned, Bairnsfather has all the accurate observation of a Zola, but he is not out to shock or harrow your feelings, because he believes that pain and tragedy are generally not half so desperate as they seem at the time, and not a tenth part as deadly as they appear before they happen. He never forgets, as do the Zolas, that mankind is blessed with the gift of humour. In our little corner of the universe we are happy in having a cheerful fellow called the sun, and though we have pretty rotten weather sometimes, this sun bobs up smiling every time. Human nature has

"That's the worst of these old country houses!"

much in common with the sun. It allows wind
and fog and cloud to get in the way every now
and again, but it always comes back with a
laugh. That is the sort of thing Bairnsfather
gets away with. It is not an empty thing, but a
real thing. It is not the hollow mirth of the
cynic. It is the expression of the joy of life -
and life is a joy. The nuisances of existence only
serve to show what a joy it is.

Bairnsfather wrote another book, 'From Mud
to Mufti', in which he gave further expression
to his philosophy of Living - a philosophy which
does not fail to see the clouds, but never forgets
that behind the clouds there is the sun.

But the most remarkable thing of all in this
phase of Bairnsfather's work has been his
contribution to 'Fragments' of a weekly article
known to all its readers as 'Old Bill's Letter'.

'Fragments', the most popular magazine of
its kind in Britain, is now a healthy youngster of over twelve months old. It barged into
a field already covered and sailed away triumphantly with a seven hundred and fifty
thousand circulation. In spite of the almost insuperable difficulties of paper prices and
production costs it has splendidly kept its hold, and is now a firmly established feature
in the British magazine world.

It has, moreover, found its way to every English-speaking country on the face of the
earth. I have had letters of enthusiastic praise from readers in the United States, Canada,
Australia, India, South Africa and even from Siberia and Samoa.

A competition was run in the early issues of this magazine under the title, 'What is
Old Bill Laughing At?' I am still, at this moment, getting entries from the outposts of
the world - a fact which is worth quoting as a testimony of the enormous vitality of
Bairnsfather's work, and as a proof that it was not a Verey light, thrown into the world
in the darkness of the war, to flare and flicker and go out with the Armistice.

Bairnsfather has contributed the front-page article to every issue of this weekly
magazine, and in order to present a comprehensive impression of his ability as a writer,
I cannot do better than quote two contrasting examples of his work in this field.

The first is a humorous description of a day in the life of a King.

My Dear Old Bill,
Have you ever thought what it must feel like to be a King? Have you ever
allowed your mind to wander from your immediate, honest and humble
surroundings, up into the dizzy heights occupied by Kings?

I often have. I've thought a lot about Kings, and I've come to the conclusion
it must be simply rotten to be a King.

Supposing you are just an ordinary chap with an ordinary life, then suddenly
imagine yourself into a King's job, and you'll see what I mean. It cramps your
style right along. Let us imagine a day in the life of a King.

In the first place, Bill, you know how we like a nice, cosy little house and a
good kitchen, a tin of tobacco on the mantelpiece and a nice, handy-sized

barrel of ginger-ale standing in the corner of the scullery. Now just look at a King. There he lives in a house about the size and appearance of the British Museum. His bedroom is about forty feet by sixty-five and eighty feet high. The ceiling is crackled up all over with gold and pictures, like the top of a Christmas cake. He has to sleep in a bed that would fit one of Lockhart's elephants.

When he gets up he can't slip into a pair of flannel slacks and a shirt and pop out into the garden for a stroll before breakfast. He has to be taken down out of that bed and get dressed by a couple of Earls, whilst a third takes his crown down from the hook behind the door and runs it up with a drop of Shinio.

Before breakfast it's a hundred to one he's got to give an audience to the Peruvian Ambassador. He, therefore, has to scramble into his robes and ermine, get buttoned up the back by a Duke, put his crown on, put the elastic under his chin and hurry off down the marble stairs into a room ninety feet by seventy, and eighty feet high.

Already, Bill, I am sure you agree that being a King isn't such a joke after all. 'As happy as a King' is one of the most fallacious phrases ever invented. A king has, to my mind, one of the saddest jobs in the world. It's about as bad as a lion at the zoo.

Breakfast comes along, and then none of your cosy warm plates of bacon and eggs by the kitchen fire, Bill. Oh dear, no! He'll have to go into another gilded hall and have breakfast with a few Queens, including his own, and a few assorted Princes. His Queen is leading the same sort of life; she now and again runs across the King in the palace, but not often.

Just think what a King would give to push off after breakfast in a car by himself and go fishing, or pop down to Southend. He can't do anything like that. The Prime Minister is going to come immediately after breakfast (caviar and sole's tonsils, not bacon and eggs).

He's going to come bothering round the King about a war he suggests running or something like that. The King has to hurry off into another room, one hundred feet by thirty, put on another crown, climb up into a throne, fill a pipe, strike a match on a diamond matchbox, and light up, waiting for the Prime Minister. He's not alone now. No! he's surrounded by a whole mob of Earls, Princes and courtiers. There's the Lord High Matchbox Bearer, his Grace the Archbishop of Nairobi, the Lord High Fortune-Teller and the Earl of Tottenham Court Road, etc.,

One's best friends.

etc. He can't be alone for a minute all day. He can't take off his crown, slip on a cap, and pop out of the side door and go round to the Crown and Anchor after twelve. If he wants to have one, he just claps his hands. Instantly two doors studded with rubies are flung open and the Lord High Keeper of the 'What's Yours?', comes in on all fours, advancing along a velvet carpet, not with a small Bass (which is what the King probably wanted), but with a ten-guinea bottle of iced Farr and Farland.

And so the day wears on. By about four o'clock in the afternoon he has seen about three Prime Ministers, knighted a platoon of subjects, signed a mob of proclamations, been taken in a Pullman special train to Birmingham to review the hairpin workers, had lunch with a couple of other Kings, chosen a new crown for the Queen out of a job lot Selfridges have sent up, seen the Prime Minister again, opened Parliament, and attended the memorial service to Lord Clive.

You might think that after this he could go to the pictures - but no. There is a state banquet on in the evening. He's going to be there, but now, as I have got him to four o'clock I will leave you, Bill, to imagine for yourself a King being hurried off upstairs by three or four Earls, bathed by a Duke, and pushed into his satin evening clothes by a Marquis.

Now, then, Bill, don't let me ever hear you say, "I'm as happy as a King."

That is pure happiness, yet there is a shrewd philosophy behind it. It gets well below the froth of life, but for those who don't agree with me I shall quote another article written around the memorial erected in Whitehall, 'The Cenotaph', to the memory of those who fell in the Great War.

It was at dusk I found him, a silent kneeling figure in the gathering darkness. I crept quietly towards him to see if I could hear his words. The dear, simple old man was silent, his head bent, an old cloth cap was in his hands. I moved my feet with noise: he took no notice. Presently he rose and turned towards me. Old Bill's war and life-worn face was stained with tears.

"'Ullo! Capting," he said, in a quiet hushed voice, "what are you doin' 'ere?"

"The same as you," I said.

"Capting," said he, "it makes me ashamed to be alive."

"What does?" I asked.

"This," he said, and he pointed to the Cenotaph. "That's all that remains now . . . the memory of them blokes out yonder. I can't 'elp it, Capting, but this 'ere monument speaks to me in a way I wish it spoke to everyone. I see the old days, Capting, I see the way these chaps behaved; they didn't know there was going to be a monument. They knew in their 'earts too much about the world to think they were goin' to be remembered long, and yet, look what they did, and remember where they are now." The poor old chap turned back to look again. "I feel they're all inside there," he said in muffled tones, "and the outside seems to tell the story. Like a great big film it seems to me. Capting, let me tell yer a story, just a little one. You p'raps knows the same yourself.

"I was in a set of trenches once, a rotten lot they was, full of mud, hopelessness and danger. There was scarce a day when we didn't see someone or other stretched out on the parapet awaitin' the night when we could bury 'im. Terrible

it was. Well, we was a merry crowd in that there trench, makin' the best of it as the sayin' goes. All the young blokes 'ad their gals at 'ome, except old toughs, like me, who's always got their Maggies. Well, there was a chap in No.13 Platoon, a poor sort of bloke 'e was, red 'air, a bit of a squint and freckled somethin' 'orrible. He used to get a bit of a chippin' at times 'cos 'e was a bloke as was sort of lonely - lived in a crowd by 'isself as it were.

"Well, one night there came an extra special strafe as it were, a real scrap. It was dark and 'orrible and the machine guns was a-playin' the devil with them trenches. About midnight it was all over. I was standin' by a fire bucket 'avin a look at my rifle, and takin' the mud out of me breech-block. The sergeant passin' says ter me, 'Old 'Arry Parsons 'as copped one. Poor old bloke's mighty bad, 'e's got one just below the 'eart.

"'Arry was the feller I was tellin' yer about. I went off down the trench towards 'is dugout. Poor old 'Arry - they was always chippin' 'im about never 'avin' a gal, and I don't believe, Capting, 'e ever did 'ave a gal. 'E was that plain and quiet, I don't reckon as any gal would 'ave walked out with 'Arry, anytime.

"Well, I goes along that there old sloppy, muddy, broken trench and comes to 'is dugout. Capting, it's mighty sad when I thinks of it. There on the straw was lyin' poor old 'Arry. His boots a-stickin' out of the entrance. 'E was twistin' a bit from side to side, and as far as I could see, unconscious. I crept along the straw and watched 'is face . . . Presently 'e died. Died after 'arf a day by 'isself in that poor old dugout, died on that old straw bed near Messines, amongst the water, cold, and loneliness.

"As you know, Capting, when a bloke dies they 'as a look at what's in 'is pockets and takes 'is identification disc, so as the 'ole lot can be sent 'ome to 'is relatives. Well, anyway, that don't matter now. I liked poor old 'Arry, and 'ad 'arf a mind to write 'ome about 'im, to 'is people, like. P'raps 'e's got a girl, I sez to meself, and perhaps 'e wouldn't let on as 'e 'ad.

"I 'ad a look at 'is identification disc first. 'H. Parsons, No:45206, C of E' I saw was on it - yer know, printed round the red gutter perka medal we all used to 'ave round the neck.

"Then I looked at 'is pockets. Capting, it most always makes me cry when I remembers, and it takes a bit to shift an old bloke like me. 'E 'ad got a pile of letters tied up with a bit of old bootlace, all damp and worn they was. At the back of them was a photo, a faded brown photo of an old woman taken standin' by a bit of a rustic seat, with a sort of cuttin' behind, and across the bottom was written, 'To my darling Harry. From Mother.'

"It was all that was in 'is pocket, Capting, and this 'ere monument reminded me of it. That's all, Capting."

That, I consider, out of all the mass of literature inspired by the Cenotaph, to be the most brilliant thing written around this memorial. It is so, because it is written by one who has seen and felt deeply with a super-sensitive soul.

It is a tragic story that is told here, yet it is not without heroic belief. The clouds are black and heavy, but there is the great healing, all encompassing sun of mother love behind it. It is one of the brightest things about Bairnsfather that he has taught us to remember the sunshine.

Chapter 19

BEHIND THE SCENES IN MY STUDIO
~ BAIRNSFATHER, FOR THE DEFENCE

I feel sure that anyone who reads this book will have noticed the perpetual and increasing quantity of advertising, relative to art schools, which one finds in the papers. This, to my mind, indicates roughly the quantity of people interested in, and desirous of attaining an art career.

During the publication of 'Fragments', which I have now been editing for over a year, I have had further proof of the thousands who are interested in trying their hand at professional draughtsmanship.

I have examined countless pictures and examined the conditions underlying their possible success, with as great an interest as once I did my own. I am glad to say that I am still able to look upon the attainment of success in this field as a precarious possibility which can come to everyone, providing he has a certain chance which he can vigorously follow up with certain attributes.

I am now going to ask all and sundry who read this book to imagine me back at the starting post, also to forgive my talking in a manner which, of necessity, appears to point out my own luck.

I am writing about the intimate affairs of the would-be artist, first of all because I want, if I can, to help; secondly, because I have seen by letters and personal questioning that it is a subject which interests and vitally affects a great many.

To read about somebody else's methods provides help. I know that myself. I am a silent and private encyclopaedia on the works of other artists past and present.

Anyway, I can't be bothered doping those who will accuse me of taking up the egoisting position of a teacher any longer. I am just a-going to go right at it and tell you what I do - and what some few others may like to try too.

I have, all my life, had an insatiable desire to draw, and to draw to see it printed. I admire and love pictures such as 'Cows at Dusk, and 'In Twilight's Keeping,' and all that academy stuff - but I am now talking about drawing for the press.

There is one first principle which must be borne in mind. Your pictures must have ideas. Your work must be perpetuated by means of an overflowing stream of ideas, your work must have a literary basis. No art school in the world can give you ideas. The world is the best school to go to for them.

Art schools teach you how to draw, and how to draw for the press; they are a great technical aid, but ideas are still the basis of your future success, or trouble, as the case may be.

Very few editors can draw, and very few know anything about art, in a true and artistic sense. An editor takes pictures mainly on the idea. A presentable drawing surrounding a good idea is what he's after. He's not an artist, he's an editor and does not profess to be anything else. The pictures he chooses and puts in his paper will, if studied closely, show you his category.

But now, don't make the mistake that he is wrong. It's up to him to give the public

what it wants, and the public are about one per cent artists and ninety-nine per cent 'don't care a hang' as long as they are amused and interested. It's up to you to amuse and interest, and there's heaps of room for it.

And now to boil it all down, this is what you want, if you are bent on extracting money from press art.

Study the making and getting of a flow of ideas. One idea, or two ideas, are useless for professional purposes.

Learn to draw and paint to the best of your ability. In time a sufficient vehicle for your ideas will arrive.

Remember that the world as it loves and looks is your best art school.

Stick to it like hell.

I haven't done any of these things. The desire and perpetual thought I have given to the subject has been a birthright with me. I claim no credit whatsoever for the hours I have spent at work, or for my incessant brooding and pondering on the ever-present theme - ideas.

I have only used a tenth of the ideas that have flooded through my disordered nob. I can only describe *'Fragments from France'* as more or less the movements of a pictorial medium. The war passed before my eyes in a series of pictures. The birth of Bill, Bert and Alf seemed out of my own control. The figures, lines and laughs seemed to trickle at intervals out of my tired and depressed fingers, like ink out of a fountain pen.

I thought hard at the time and in thinking arrived at my conclusion. To show what I felt the Front and the British to be, by means of three hieroglyphics, i.e., Bill, Bert and Alf. There never has been any one, single Bill, Bert or Alf - I endeavoured to epitomise three distinct groups in our Army, and thus convey scenes and frames of mind, which by reason of mud and pain had become acutely visible to me.

Chapter 20

BAIRNSFATHER AT HOME
~ MUTCH, CLOSING FOR THE PROSECUTION

I have tried to show you Bairnsfather at work, and sought to trace the evolution of his art in such a way as to be of the greatest interest to those who are curious about the elements which make for success, and of the greatest assistance to those who are determined to follow the same road.

In this, my final chapter, I wish to present a close-up picture of the Bairnsfather behind the scenes - not the artist, the playwright, the author, or the lecturer, but Bairnsfather, the man.

We are sometimes inclined to forget that behind the public evidences of genius there is a human personality. Sometimes, indeed, we are liable to jump to the conclusion that the individual behind the scenes does not really matter, but this theory of the impersonality of genius is one which holds no more water than an inverted tea-cup. Some people go so far in this error as to excuse genius the observance of the ordinary rules of humanity. The genius, they argue, is not bound by laws, which, to put it bluntly, is purest bunk.

The genius is not a machine. He does not live outside the rules of humanity, but lives much more inside them, knows a lot more about them, and keeps them much more constantly before him than the average individual.

In fact, it is not a bad definition of the personality behind genius to say that it is most marked by a keeping in perfect tune with humanity. Or to put it another way, one of the biggest things about genius is bigness of heart.

Genius is intensely sensitive to impressions as well as being brilliantly capable of interpreting these impressions in picture, prose, or poetry - whatever the medium of interpretation may be.

It is therefore essential that the flame of genius should be fed in the right way.

Genius, in any form, is a jealous task-master. It leaves little room for frills and flummery. There is a great deal to be said for the old idea of plain living and high thinking. The more I see of Bairnsfather at work, the more I have to say for it.

A youth who wants to be a success merely in order to have a good time, had better get things straight with himself forthwith. If he does not think a job worth doing for its own sake, outside of what it may bring him, either the job is not worth doing, or he is not worthy of doing it.

No one associated with Bairnsfather can fail to be impressed by the manner in which the Bairnsfather behind the scenes supports the Bairnsfather in the glare of the footlights. He lives very simply, and prefers the country to the city, although he could not carry on without the latter. The many facets of life which shine out in London are full of inspiration for him. I find in his interest in all sorts of humanity, from Mayfair to an East End music hall, the secret of his appeal to all grades of society.

In his habits, Bairnsfather has not slipped into any one rut. His sympathies are as wide as life itself. In the ordinary sense of the word, he has little or no private life. He

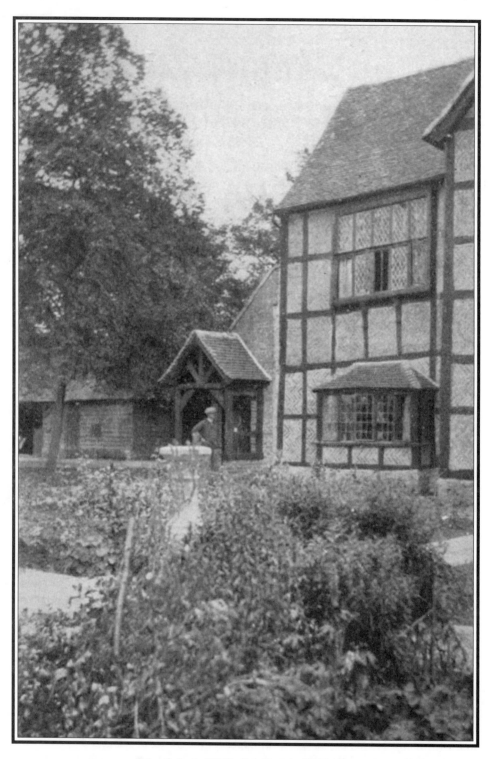

Bairnsfather's Old English Home at Waldridge.

does not work an eight hour day and hie away to a weekend diversion from business. He works often twelve or fourteen hours a day without the slightest relaxation, because even when he is not drawing or writing he is shaping and reshaping ideas until he is satisfied that they are in suitable form for setting down on paper.

Business demands his presence in London for several days every week, but it is in the country that he does his best work, and whenever he has a difficult job to finish on a deadline, he disappears from his house in Knightsbridge to his beautiful old English residence which he has purchased in Buckinghamshire.

This residence at Waldridge is of such great historical interest that I feel it essential to say something of its associations in order to give the reader a conception of the setting in which Bairnsfather now does his work.

The history of Waldridge, which is situated in the parish of Dinton, and the hundred of Ashendon, about five miles from Aylesbury, can be traced back without difficulty to the time of Edward the Confessor. After the Norman Conquest, the land, containing one hide and two virgates, was granted to the Bishop of Bayeux. It passed, together with the neighbouring manor of Dinton, in succession to the Munchesneys and the Earl of Pembroke.

After many vicissitudes the Manor of Waldridge came, towards the close of the fifteenth century, into the possession of the Hampdens, who held land there until the death of Sir Alexander Hampden in 1622, although the manor itself appears to have come before this time into the possession of Robert Serjeant who married Anne, daughter of Sir Richard Ingoldsby, Knight, of Lenborough, Buckinghamshire.

In the year 1650, Sir Richard purchased the Manor of Waldridge from the Serjeants and took up residence there.

The parish of Dinton, in which Waldridge is situated, is famous for having been the residence of two regicides in the seventeenth century; Simon Mayne of Dinton Hall, and Sir Richard Ingoldsby of Waldridge. Their joint secretary, John Bigg, also lived at Dinton, and tradition has it that he was the actual executioner of King Charles I.

After the Restoration, apparently pursued by remorse, he is stated to have become a hermit and to have lived in a cave in the parish, without ever changing his clothes. He died in 1696, and one of his shoes is preserved at Dinton Hall, the other being in the Ashmolean Museum, Oxford.

Sir Richard Ingoldsby was the second son of Sir Richard Ingoldsby of Lenborough; his mother being Elizabeth, daughter of Sir Oliver Cromwell and aunt to the Protector.

This Sir Richard Ingoldsby played a very conspicuous part in the history of the Civil War. He obtained a captaincy in his relation to Hampden's regiment, and performed many gallant services for the Parliament party, and this, together with his family alliances caused him to be greatly trusted. The City of Oxford, noted for its loyalty, was committed to his care. He was elected a commissioner of the High Court of Justice which was appointed for the trial of Charles I. He did not attend any of the sittings of the court, but he signed the warrant for the execution of the monarch, although he afterwards asserted that he was forcibly made to append his signature - that Cromwell, and others, after much entreaty and persuasion, actually laid hold of him in the Painted Chamber, pulled him to the table and, putting a pen in his hand, guided his fingers in making his signature. His seal, however, was appended to the document, and it is possible that he made this excuse afterwards to save himself from the fate which overtook his co-signatories. When the Cromwell cause had become desperate he was one of the first to join the friends of the exiled Charles II, from whose hands he alone, of the regicides, obtained any leniency,

ultimately receiving a free pardon and the Order of the Bath. His family remained as residents in the parish for many years and presumably also held the Manor of Waldridge. In 1849 it was purchased by the lord of the neighbouring Manor of Dinton, since which date it has been appendant to the main manor.

It is the old house at Upper Waldridge which Bairnsfather purchased with the land surrounding it. This house is a picturesque example of early seventeenth century design. The main feature of the plan as it now exists is a large central stack of chimneys, the shafts of which are set anglewise above the tiled roof. Round this the rooms are grouped, opening out of each other with no attempt at corridor or suite planning, the staircase being on the south side.

As the house evidently extended father to the east, it is possible that what remains is one wing and half the main block of an H-shaped house. The original work is all half-timber filled with herring-bone brickwork; but the south and west faces were refronted later in the seventeenth century with a thin skin of brickwork, with stone mullioned and transomed windows set in projecting brick panels with ribbed brick cornices and base-moulds. The north gable remains in its original state, and has a very pretty projecting gabled window on the first floor of five latticed lights with wooden mullions and a transom.

When Bairnsfather purchased this residence it was in a condition of disrepair, but he had seen the possibilities of a careful restoration which was immediately undertaken with the happiest possible results.

Waldridge is the ideal home. It is a place of peace and beauty. The dusty, traffic-laden main roads are out of sight and hearing. The approach is through pleasant byways which thread their path between sleepy meadows that seem to lead to nowhere. The country around is gently undulating, cultivated and beautifully green and gold with grass and grain in seeming careless patches irregularly divided from one another by low trimmed hedges. This on every side sweeps away for miles to a distant horizon of blue-tipped hills. There is no sign of human life, except an occasional wisp of smoke curling up from above a clump of trees. The country is not heavily wooded, but here and there a tiny patch breaks on the landscape.

Presently you approach such a miniature forest - for everything in Buckinghamshire is in miniature, and therefore all the more attractive - and just as you resolve that this is another milestone on your journey you reach the other side and discover Waldridge, nestled to the south as closely as if a swallow had built it against sunlit eaves.

A pond - a lawn - a garden - these are the things which first capture the eye. Then the house itself peeps out at you as if it had all the time been hiding there like a happy child, and smiling with a child's gladness because you have found it, and a child's confidence that you would find it.

If any north or east winds blow here the trees see to them. Your vision is south and west across the wolds of England to high noon and the setting sun. It is in this old English atmosphere that Bairnsfather does his best work, but it should not for a moment be imagined that he is a recluse. Waldridge is only the backwater in which his impressions are most easily interpreted, but these impressions are gathered by his keeping in the closest possible touch with the main stream of life. And this he does not merely for the sake of his art, but because his temperament demands it.

Whatever else may be said about him, he may well be written as one who loves his fellow man.

I live in a quaint old house.

My garden is a sheer delight!

Chapter 21

LOOKING FORWARD TO ANOTHER WAR TO GET A REST!
~ BAIRNSFATHER, CLOSING FOR THE DEFENCE

Before this book is finished I want to put in a word about wars. The late one being nearly over (in some places), I want to raise my voice in the land about the next one. I hate the sight of the darn things myself. I am only interested in a war to stop wars, and if by any means I could show up warfare I'd do it. I can't lose my temper enough to be a good soldier. I hate fighting, particularly with strangers. It's all too rough and dirty for me.

When I have chased (as I have, now and again), one of the King's enemies across a ploughed field at dawn, with a sharp knife on the end of my gun, I feel inclined to stop and stroke him. I suddenly wonder if he's got an old mother, or if he likes gardening, or something or other, which completely robs me of that venom which has made our Empire what it is today.

Apart from the actual sticky part of warfare I am filled with depression about 'Mailed Fists'.

The Mailed Fist is dead . . . or anyway, let us hope so. Perhaps we had better say, in a state of suspended animation. Anyhow, we are in a position to exult in the fact that the Mailed Fist has not come to stay. I cannot dwell too long and too deeply upon the appalling results, had such been the case, for, with a 'Mailed Fist' comes its machinery. A Mailed Fist must have its 'Military System'. It must have a War Office, and memo forms.

I want you to imagine for a few moments the stupendous disaster it would have meant to us all if a Military System had triumphed and had swamped the land with its ponderous and death-dealing ability. Selfridges, Harrods, Hope Brothers and Woolworths would all have been extinct in a week or so if run on what we have narrowly escaped - the Military System.

I want you to imagine, by way of illustration, a really large stores being run on these lines; I feel sure you will see where ruin stares it in the face.

The scene is Harridge's Stores. A man has just popped round to buy a packet of pins for his wife. He enters via the swinging glass doors, and is immediately stopped by a one-armed veteran who fought at Sebastopol.

"Have you an appointment?" he demands.

"Don't talk to me about the next war!"

The pin hunter admits that he has not.

"Well, then, fill in this form," says the veteran.

The pin hunter seizes a large yellow sheet and, with the aid of a rusty pen with a split nib, writes his age, where he was born, his nationality and next of kin.

The veteran now grabs this, and in an aggressive voice, says loudly to the pin hunter, "You want to see the DADOP."

"Who's that?" asks the pin man.

The veteran scornfully replies, "The Deputy Assistant Director of Pins, of course!"

"Oh!" says the pin man, and awaits developments.

The veteran now hands the filled-in form to a member of a group of girl guides, and, by dumb show, indicates to the pin man the advisability of following her down a forbidding stone corridor. A quarter of an hour's walk brings the pin man and the guide to a mahogany door about eight feet high and four feet wide; on it is inscribed in bold, black letters, DADOP.

The dear old DADOP

The girl asks her victim to sit on a chair and wait.

He leans against a window-ledge, because there isn't a chair.

The girl comes out again very quickly and goes off down the corridor.

Half an hour elapses.

Presently a door, fifty yards away, opens, and an official comes out. He passes the pin man and remarks in so doing, "Are you wanting something?"

"Yes, I want a penny packet of pins," answers the pin man.

The official looks puzzled.

"Pins. Pins," he murmurs in a sort of reverie, staring straight out of the window. "I think, perhaps, you had better see the OOSEFD. He's the Official Organiser of Small Essentials for Dressing."

"I see," says the pin man.

The official moves on and disappears in the dim gloom of the corridor.

"I can't hang about here any . . ." bursts out the pin man, when suddenly the monolithic mahogany door opens and a head comes out.

"Will you come in?" it says.

The pin man enters and finds himself in a room about half the size of Olympia. At the far end, behind a desk as large as a billiard table, sits an old man writing hard. He looks up and sits back in his chair.

"Yes?" he asks, interrogatively, to the pin hunter.

"I want a packet of pins, sir, just a penny packet, that's all," says our hero.

The old man looks at some papers on his desk with 'impossible' stamped on every feature of his face. "Can you give any real reason why you should want pins?" he growls, looking hard at the applicant.

The pin man explains that his wife merely wants a penny packet of pins.

"Well, you'd better fill this form in," says the ancient in authority. "Fill it in carefully; then, if you go out and get two photographs of yourself taken, one front face, the other profile - I will attach them to this form and place it before the DADOP. You see I'm merely the ADADOP, and have no power to do more than recommend you as a suitable

applicant for pins. As soon as he comes in I'll place the whole matter before him, but, of course, I can't say exactly what will happen."

The pin man takes a bottle of aspirin tablets from his waistcoat pocket and swallows four under cover of his pocket-handkerchief.

Meanwhile a long and luscious-looking Rolls-Royce is gliding along the Mall to its destination. It's four o'clock, lunch is just finished, and the DADOP will soon be back in his mausoleum, ready to give the final word to any application for pins.

And so the great universal stores would roll on in mailed prosperity.

That ought to settle Mailed Fist supporters once and for all, but I suppose it won't. I can see another war coming along somehow, somewhere, sometime. After all, it's no good keeping armies eating their heads off unless you use them.

I can see myself going to an old cupboard in my room, extracting my old uniform from the tissue paper and camphor bags. I can see myself taking my old sword and revolver down from their hooks in the hall. I can see myself sharpening the old blade on the grindstone in the back yard. I can see (curse it all, I can see everything).

I only have one hope; that my three old pals, Bill, Bert and Alf will be in it with me. My dear Old Bill, I feel you too want a rest before another . . .

"Mexico declares war on Ireland."

I can see the notice now.

I can . . . I am sorry, dear and patient reader, I *must* stop . . . the man's come round about the next war . . .

THE 2ND BAIRNSFATHER OMNIBUS

Fragments From His Life
Illustrated by

Bruce Bairnsfather

1916
(with text by Vivian Carter)

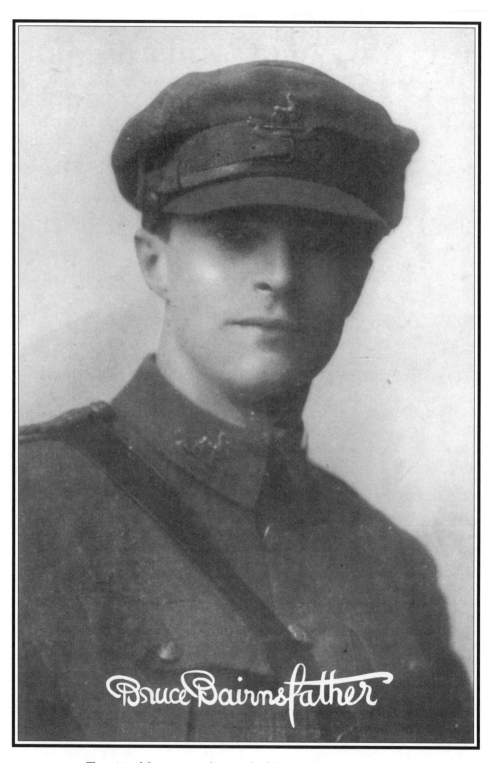

The original frontispiece photograph of Captain Bruce Bairnsfather.

Bairnsfather
A FEW FRAGMENTS
FROM HIS LIFE

The original title artwork (with replacement text for this edition).

Bairnsfather's idea
of his possible
appearance after
the war!

Vivian Carter.
Editor of *The Bystander* in 1916.
(Circa 1947.)

Top: the illustration from the original 'contents page'.

The First Fragment

THE MAN AND HIS VOGUE

If only I can get them laughing. So remarks to himself the individual who has a difficult 'crowd' to manage - a crowd out of humour, critical, peevish, bored and disillusioned. Were the affairs of the Great Nations in the hands of practical men, laughter would be one of the munitions of war, and the recruiting of humorists would be the job of a special department in Whitehall.

Instead of which the humorist has been, in our country since the war, perhaps regarded askance until - well, until the subject of this booklet appeared on the horizon, Bruce Bairnsfather, Captain of the Royal Warwickshire Regiment.

Bairnsfather has been the unsolicited and unexpected laughter-maker-in-ordinary to the forces of the British Empire at war - a volunteer laughter maker, who combined laughter-making with fighting, and extracted mirth and drollery from the most horrible situations ever endured by man, situations which have made words of profanity, for the duration of the war, the King's English.

At first, while the Army received them with unrestrained delight, the public at home received his sketches - which were originally published weekly in *The Bystander*, and afterwards in book form under the title '*Fragments from France*' - with amused bewilderment. That they were the 'real thing' so far as fidelity goes, was obvious enough, for who but a man who had been out there would have depicted trenches and dugouts, Johnson holes, battered tin pots, derelict buildings and dead cats, as did this

man? Who else would have shown, in the foreground of the devastation, an old boot resting on a candlestick on one side of a Johnson 'ole, with a cheap timepiece on the other? Who, but a man who had been there, would ever have dreamed, in his wildest nightmares, of the officer's sword being used as a toasting-fork?

Realistic as the sketches were, the 'stay-at-home' public at first found it difficult to believe that there could breathe a child, living in such an atmosphere of death, who was able to take such notes, and to print them.

Yet as the weeks wore on it became obvious that there was such a man, and all doubt as to his actual identity was speedily set at rest by men who had seen him themselves.

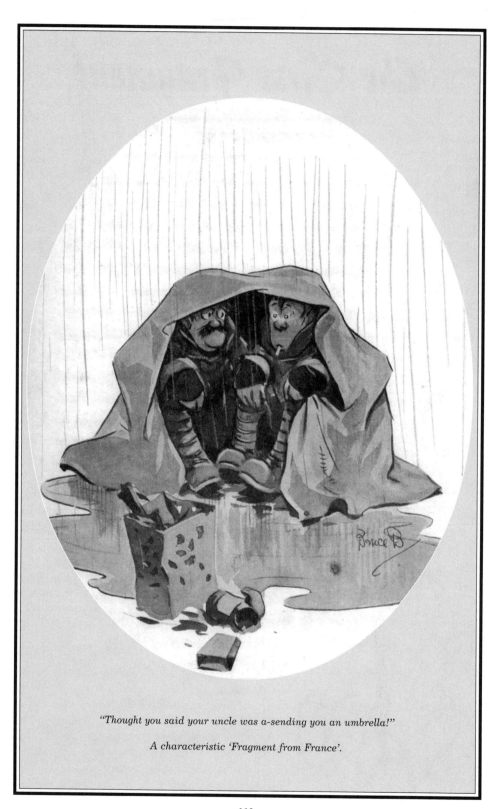

"Thought you said your uncle was a-sending you an umbrella!"

A characteristic 'Fragment from France'.

Besides, the papers published his photograph, in uniform, and at the Front.

So there must be such a man!

One knows that people at home, safely out of danger, can dig out humour from anything if they work hard enough at it, and keep their eyes well away from anything sickening.

But who is the man who has been through it - Bairnsfather was blown up at the second Battle of Ypres - that can laugh at it himself, and compel others to laugh?

For Bairnsfather has not only convulsed Great Britain and the trenches of all the Fronts, but also America and the neutral countries. He has reached a German prisoners' camp in Siberia, and received the 'thanks' of the enemy in terms that are quoted in an ensuing chapter. He has been the subject of a 'Question in the House,' and the recipient of remarkable letters from highly placed personages.

It has been said of him that he has been worth several Army Corps to the Allies by virtue of the stimulus he has imparted to the always latent good-humour of the British soldier. He has carried on, in quaint pictorial form, what Kipling originated, the tradition of 'Tommy Atkins - the man'.

Yes, but what kind of man is this who makes war - the most awful tragedy in human experience - seem screamingly funny?

That is what you probably want to know, and that is what it is the object of this little book to tell you.

First, as to the man as he is today. He is twenty-eight, and doesn't look it. He is slight of build, and his face has a refined, intuitive look, with eyes that are clearly enough noting anything there is to be noted about yourself.

A more closely observant man does not exist: his sense of detail in character is almost Dickensian. If, at an interview with a 'personality,' you have noted nine things out of ten, Bairnsfather will have got the whole ten, and the tenth will be the salient feature, the essential note.

Yet, as with most humorists, the last thing you would suspect Bairnsfather to be would

be a humorist. He is anything but a trademark of his own wares.

If a sudden 'strafe' threw you together into the same Johnson 'ole, the last person you would suspect your companion to be on the arrival of 'another hopeless dawn' would be the creator of 'Fragments'. Like all true humorists, the source of his inspiration is deep down in his nature.

His inspiration is not from the thing casually seen or heard, but from the thing constantly felt. Very few of his sketches have struck him 'all of a sudden like.'

To oblige his editor, thirsting for contributions, he is never at a loss. At a luncheon or dinner table, at the request of a fellow guest, on a menu card or in one of those awful autograph albums, he rarely fails to deliver the requisite goods. That is because, as will afterwards be mentioned, he has a stage instinct and habit, and much of the actor's desire to please and to keep ever handy the emergency gag or prop.

Yet a more naturally unaffected man does not breathe, and if he is not an obvious soldier-type, neither is he an obvious type of anything else. He possesses the magic quality of individuality; though to get to know precisely what it is requires you to have the persistency of a geologist.

To discover a humorist to be present in Bairnsfather, the best way is to conduct a conversation on the subject least humorous in the world; and to get him to give you his impressions of Tommy Atkins the best way is to start on the causes, conduct, and probable outcome of the Great War.

He will talk strategy and tactics with the usual frankness of the man who has sampled them on the spot, but sooner or later you will see a little glint in his eye, and you may register the fact that he has thought of a 'Fragment'.

Probably he won't tell you what it is, for he dislikes to display anything until it is finished. But in the course of the conversation on the war, we have talked of soldier-types, and Bairnsfather will have suddenly remembered something one of them once said to him, or some situation he was once in.

You will also realise that it is for the soldier-man himself, the private, that Bairnsfather has all his affection, and his best pictures are those which display together the two types; Bert, the novice from home, and Bill, who has been out since Mons.

Bert is clean-shaven and has a cigarette drooping from his lips and an innocent look of inquiry on his face, whilst Bill is broad, notable chiefly for his scrubby moustache and that 'fed-up' look in his eyes.

Though Bairnsfather, in his own words, is "disguised as that screaming absurdity, a Captain," it is to Bill and Bert that his heart goes out. He and his class have been through the same experiences that are depicted in *The Bystander*, but Bairnsfather regards that as the normal business of the officer, whereas he regards Bill and Bert as persons who are in the war, dug right into it, without any previous thought or intention of their own. These 'jungle-folk,' as he affectionately calls the men in the trenches, are as a sort of

army of Alices in Wonderland, doing the most marvellous things, and enduring the most amazing experiences, but all the time wondering.

The following *'Fragments'* from his life are from material jotted down by various of his friends and associates.

No serious biography is attempted - Bruce Bairnsfather is too young to be 'biographed' - but only a sketch of the career and personality, the thoughts and ideas, of one who has made his mark, in his own individual way, whilst taking part in the greatest war in history.

The illustrations have been collected from a variety of sources, and represent, on the whole, the trend of the humorist's fancy before the war brought him fame.

The Second Fragment

EARLY DAYS

Charles Bruce Bairnsfather is the eldest son of Major Thomas Bairnsfather, of the Cheshire Regiment, many years a resident at Bishopton, Stratford-on-Avon, and now acting as District Recruiting Officer in the home of Shakespeare. Bruce is towards the end of his twenties, and was schooled at the school of 'Stalky & Co.' - Westward Ho! - having been, like the earlier depicter of the moods of Tommy Atkins - the old-type Tommy - Rudyard Kipling, born in India and transplanted home to be educated.

Major Bairnsfather himself combined soldiering with painting and musical composition, and was the producer of several successful musical comedies at Simla, the best known having been the 'Mahatma,' the score of which the writer ran through recently with considerable interest and admiration.

Mrs Bairnsfather, having been herself a painter of taste, completed the hereditary influence. So that if Bruce didn't draw, or do something artistic, there was really no excuse for him. Nobody has, however, been more astonished at the precise form his art has taken than his devoted parents, and to their credit be it said, none have shown more pleasure and appreciation than they.

Any tendencies to 'art' shown in a marked form before the war were in the direction of the stage, for Bairnsfather is an amateur comedian of some merit, and was one of the

"This ought to catch your eye!"

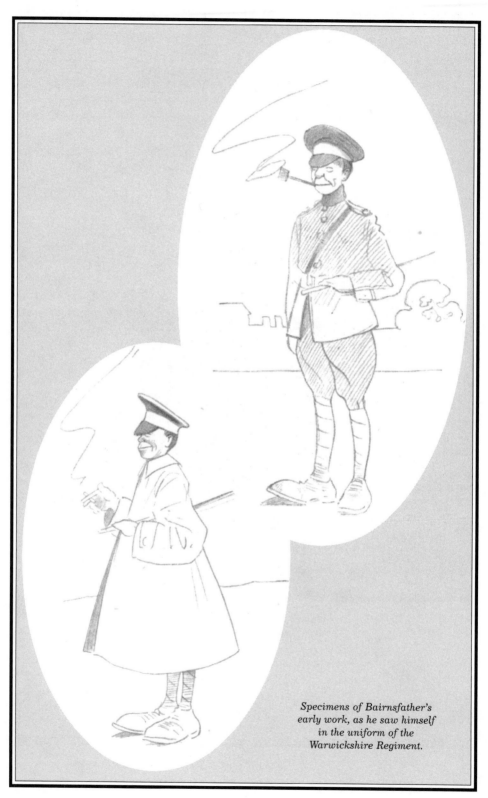

Specimens of Bairnsfather's early work, as he saw himself in the uniform of the Warwickshire Regiment.

prime successes at a famous pantomime given at Compton Verney, by Lord and Lady Willoughby de Broke. His love of the stage runs to the variety theatre rather than the legitimate, but in the latter direction he compensates for any deficiencies by a deep love of the Bard of Avon in all his moods, and an intimate knowledge of his resorts:

Piping Pebworth, dancing Marston,
Haunted Hillborough, hungry Grafton,
Dodging Exhall, Papist Wixford,
Beggarly Broom, and Drunken Bidford.

He did his bit for the 'Stratford movement' - which is unfairly the subject of a certain amount of local satire - by designing two of the festival posters.

At Stratford itself, he figured in the Aladdin pantomime; and also toured the locality with an 'Ali Baba' of his own. One of his peace-trophies at Bishopton is his 'Bishopton Empire' - a toy theatre contrived with every working detail, with cardboard marionettes of George Robey, Vesta Tilley, Billy Merson, Harry Lauder and most of the other famous stars of the pre-war period.

Bairnsfather confesses to an intimate love of the variety show. He has an intuitive sympathy with the human element 'behind it' and a most surprisingly complete knowledge of the geography of music-halldom, in London and the provinces. So that, had he chosen the stage as his profession, his neighbours would have *'told each other so'* with a vengeance. Had he even come out as a comedian himself, the locality would have had to bear it with or without grinning.

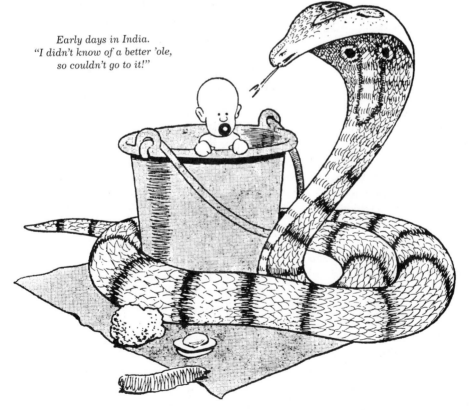

Early days in India.
"I didn't know of a better 'ole,
so couldn't go to it!"

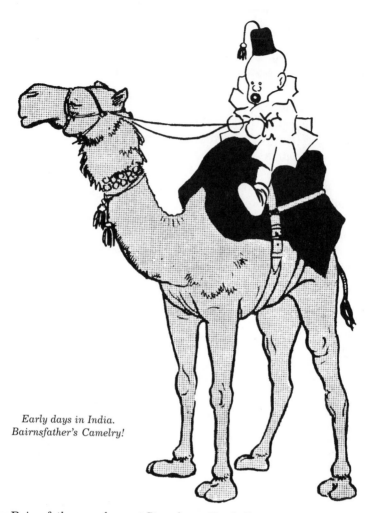

Early days in India.
Bairnsfather's Camelry!

Bruce Bairnsfather was born at Strawberry Bank Cottage at Murree in the Himalayas. A keen desire for adventure was with him from the beginning of his career. He instinctively selected for his birth a room where the roof leaked in five places. Few have given such early evidence of a predilection for 'roughing it', all of which foreshadowed the trenches, as any psychologist might detect.

Again, in his second year, he burst forth along the line of least resistance and took his mother away from Murree to Chungla Gully. There has never been a greater devotion to a parent than this. It beats Sir James Barrie's. Off he went in a 'dandy,' a sort of native sedan-chair peculiar to his mountain environment.

Strange as it may seem, of these incidents in a crowded career he has no vivid recollection; but the cholera having broken out in their midst, he was nothing loath to play the hero as readily as a true strategist, and retired for military reasons.

At Chungla Gully Bruce and his mother lived in a one-roomed 'hut,' again a foreshadow of the Great War, where he was to occupy and vacate hurriedly a villa known as Shrapnel View (though this 'hut' came with the addition of shooting).

For three weeks at Chungla Gully, with no furniture save a bed, table, and bucket, abided mother and son. Then further went they into the Gullies, where for six weeks

118

119

the terrific struggle for existence went on, and only by robbing the Government mules was life sustained. The name of his dwelling was Batungi Lodge. His life up to then was full of such Indian words.

Though in an Oriental atmosphere and speaking Hindustani better than English, there is no blot on his copy-book, nothing to cause the blush of shame to mount to the most expert cheek.

Then it was back to India again: to Umballa, where his father was Cantonment Magistrate; all of which may not be important, but all of which helped to shape the exceptional talent which has become a factor in the present European fight.

Those then were the subtle influences which began his knowledge of life, and made his outlook a wide one. Whence came Colonel Chutney VC, who, desiring to keep in touch with dugout life, sleeps while home on short leave in the cucumber frames, if he did not come from Umballa? And during these seven years there he also, accompanied by his father, went on shooting expeditions, and made the acquaintance of the elephant at its most energetic stage.

When the parents this time returned to India they left young Bruce behind at a vicarage far from towns. Thornbury Vicarage, near Bromyard in Worcestershire, was a discipline for the boy from which he could not get away. He tells how even to-day he can't read a passage from the Bible without hearing the bells of Thornbury Church tolling him to service.

The place got on his nerves; and that which gets on our nerves is discipline, and is generally good for us. Living that submerged life he was disappointed in his 'home' at first, but at length learnt to love the country and to develop a dislike of society.

To India he sent sketches of his parochial life, thumbnail snatches of humanity, just as he sent back to England those unpublished impressions of trench-life in France - for

the family to inspect - more accurate and living than any letters could be.

The interest in all these childish efforts is the marvellous power of observation, and the terse, inexplicable manner in which he dressed his ideas with humour, the way a salad is prepared with vinegar and oils. They were also blunt, but anything which is true is like a blow to one who is trained by convention to think untruthfully.

But all is seen humorously, never in bitterness, never hurtingly. Yet, even in those days, as now, he wanted to be merry. What normal boy does not? His spirit bubbled up like the air in a cushion: pushed down in one place, it came up in another. The environment could not weight him exactly, and if he dare not draw impressions in *Hymns Ancient and Modern*, he could do so in *Mrs Beeton's Cookery Book*, as witness that busy and buxom creature sketched on the flyleaf of that literary lady's contribution to *la joie de vivre*, which he found in the vicarage kitchen.

He didn't like parties in England, much as he had loved them, especially the fancy-dress ones, at Umballa. But he learnt to love the rural parts, to study its types and its features. In an atmosphere which cultivated self-consciousness, he showed no more sign of egoism then than he does today. Remember, though, that it was the cook who got his tribute, not the great lady of the manor. Sympathy and appetite are a strong combination. And once he sent to India a picture of a milk-maid!

Now we note new evidences. Family greatly agitated. He was at this time 8½ years old. Precocity! Forerunner of that dreaming soldier in *'Fragments'* who had the 'bitter' disappointment of finding both barmaid and beverage had disappeared on waking. And so, soon after, this buoyant spirit - which at Thornbury was like a kite with too heavy a tail - was wafted away to school - to 'Westward Ho! College.' See Kipling's 'Stalky & Co.,' which Bairnsfather declares got absolutely the spirit of the school. Here we find the usual things happening, an interest in everything which interests schoolmasters not at all; a gift for caricature which was, strange to say, greatly appreciated both by his associates and instructors, proof of real good humour; at games, he was rotten; at mechanical devices, expert; at entertaining in his own way, by drawing, constantly drawing, he was popular. He loved his schooldays, but for all his sense of fun and the melancholy of exile at Thornbury, he loved the country best, and longed for its milkmaids, its cooks; in short its 'types'.

From Westward Ho! he went to Trinity College, Stratford-on-Avon. His family came from India and settled in the country near the same old town; so, gradually Bruce was becoming more and more at home in England, and coming more and more into his own.

Another specimen of Bairnsfather's early work, entitled 'Student Days'.

The Third Fragment

DAYS OF ADVENTURE

After leaving Trinity College, Bairnsfather became the victim of the family inheritances, that is on the martial side, and that was, in his case, on both sides, for he sprang from stock who for a long time had considered the sword far mightier than the pen; so there seemed nothing for him to do but still maintain the family prejudices. He therefore passed the Army qualifying examinations, and after undergoing a certain amount of training with the Warwickshire Special Reserve, he was attached to his father's old regiment, the Cheshires, and went to Lichfield, where his life mainly consisted of bayonet practice with a Sergeant.

After a little time spent at lunging about trying to puncture the ever alert NCO, the whole circus migrated to Aldershot and more time passed with drilling all over that area, till at length fed-up-ness hit him so hard that he decided to take up engineering. It was a practical thing, and while not greatly appealing to him, it held out the inducement of opportunities for drawing, which the Army in peacetime did not offer.

It was while wandering up and down the country in the employ of an engineering firm that he prosecuted his quest of 'the type' in practically every music hall and byway from Wigan to Cardiff, just as later he sought it along the Johnson-pitted roads of France.

An early sketch of Old Bill.

Then it was back to Warwickshire for an interval of sketching and drawing, and then he would hit the highway again, always studying, always engrossed in those who had succeeded with brush or pencil, getting into the depths of his subject as deeply as he was able, and cultivating that spontaneous technique which was to give his work its directness and vitality, all of which things, in this case, the conventions of the peacetime Army would have stifled.

Engineering was a stepping-stone for him: his energy and sympathy did the rest. None of the artwork he did during this long period of application to his pencil and his 'type' was what might be called 'for concert purposes'. Yet they were of the same nature and led to the same end as the ceaseless piano practice which makes the virtuoso.

The ever-present 'fire bucket'.

The Taunt.
"And WHO was it sat on a golf ball for three weeks?"

By sketching on theatre programmes, producing amateur pantomimes, sauntering through slums, dining at great houses, analysing absorbingly the works of Forain, Georges Scott, Fabiano, Barribal, Tom Browne, Herouard and the rest, he kept in touch with his own talent so completely as to give us that unique thing - a humorist of the first order amid the tragedy of war.

And so, once upon a time, in that spirit of adventure and with the now well-known humorous method of attack, Bairnsfather took a voyage across the Atlantic.

During his engineering period an occasion arose for some work to be done in Newfoundland. No one else in the firm seemed keen to go, but the project appealed strongly to him. He immediately had visions of docks, forests and fishermen - in short, adventure, and was all on for it.

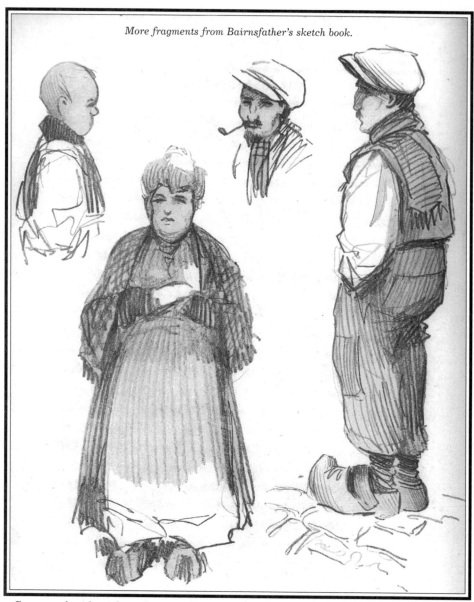

More fragments from Bairnsfather's sketch book.

So, armed with tools and instruments, he proceeded to Liverpool, determined to see the New World, or at least re-discover it. All problems for Bairnsfather have ever been solved by laughter - so he faced, with grinning determination, the ugly business of seasickness, that bane of the temperamental, for there is no surer sign of artistic gifts and great imagination than a proneness to be abnormal on the ocean wave.

To Bairnsfather trench life is a Bacchanalian festival compared with one hour at sea. So it was scarcely with a light heart, or a steady head, that he set out on an Allan liner for Newfoundland.

Prospects were grim, to say the least, and had he known how the voyage was to be protracted by the presence of icebergs and rough weather - which brought to his lively fancy vivid, ever-moving films of the then recent *Titanic* calamity - he might have thought

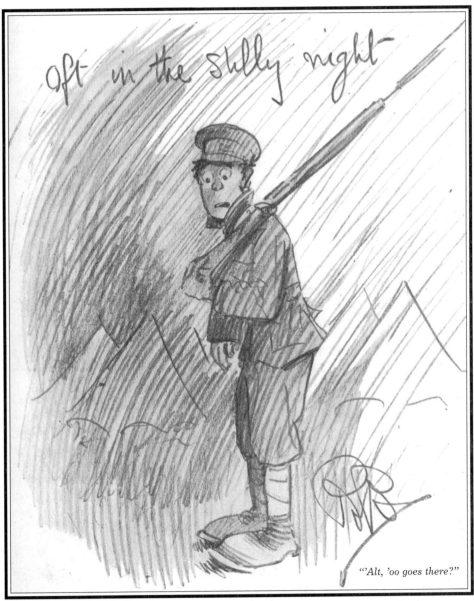

Oft in the stilly night

"'Alt, 'oo goes there?"

a third time before setting sail from Liverpool. But there is no turning back in a sea-trip, any more than from the tracks of Time, so he lazed and qualmed and retched till he reached St John's, on one of those slimy, slippery, foggy mornings when there isn't any good in any of us. Here he searched around for petrol, and soon started on his two-day jaunt by road to Spruce Brook, near Port Baques.

Under normal circumstances Spruce Brook would have meant a world of wild and woolly adventure to his mind, but under the ever-present conditions of slush he was dampened to the marrow, as one who leaves hope outside with his umbrella when he entereth in.

Very little of the alluringly artistic happened at Spruce Brook. Whilst there he explored the vastness and did his job, for he went out to fit up a lighting plant of some sort at an

hotel known as *The Log Cabin*, which was not an hotel in the ordinary sense of the word, but a lodge in a vast wilderness designed to accommodate those who might care to hunt big game: but the only big game he found there was solitude, and that proved a case of the fox hunting the hound, for it pursued him with homesickness. He longed for his studio in Warwickshire, his nights at Wigan, and the lights of the Empire and his 'types'.

The one outstanding drawing perpetrated at *The Log Cabin* was a luggage label for that hostelry, showing it to be far from the crowd, with nothing for society but a murmuring pine and a moose. The label is effective, a log cabin house, some pine trees and a deer's head, and all apparently ten thousand miles from a piece of elastic. It must, though, have served as a good advertising decoy for anyone who wanted to cultivate that sort of solitude. But to a man who liked towns there could only be one word, the American one, "Gee!" Bairnsfather did like it - for a time - but he didn't find it a wrench to break away from its fatal fascinations; and once his business there was accomplished, he was quickly back in St John's.

The shipping service is precarious in that dangerous part of the coast, and he was obliged to wait for his boat. He spent his time studying the old Newfoundland town, always sketching, busily sketching. He got to know the fisher-folk and listened to their yarns. Everybody there seemed engaged in fishing. There was nothing else to do but to fish, catching or not catching, as the case may be. Cod was the one theme of the community; and here codding - that trick of poking fun and joking at which Bairnsfather was always so adept - took on a more serious aspect in the form of fish . . . and fish and ever more fish. It was the topic and tonic of the natives. The very mattresses seemed stuffed with cod.

Cod was the parson's text and the doctor's remedy. At meals his was all cod: fried cod, boiled cod, cod cakes, cod chowder, and just plain cod. He did not get so filled up with his fisher friends and the hale and hearty folk of St John's and their manners and customs and lore, as with their cod; and so, weary of waiting for his boat, which was probably tangled up somewhere in icebergs and fogs, and not finding great scope for open-mindedness, grace and cheerfulness, he arranged to get home or bust on a species of tramp ship, which carried a cargo of wood, pulp and lobsters, and as he felt like all three of these commodities he risked the ordeal, and said farewell to St John's.

It was a boat that had made many crossings. Having been informed of Bairnsfather's fondness for the sea, we can appreciate all the more his untoward sympathy with the bad sailor in the *Bystander* cartoon, where his pure and brotherly feeling for the discomfited victims of the wave is so touchingly depicted; and we can easily imagine his cold shivers when he found that his berth on this shifting tramp was just over the propeller. It was like sleeping inside Big Ben for ten days. To him it was not so much like beginning existence over again, as living the hereafter in advance.

When able, he constituted himself the life of the ship - a drawing-room entertainer afloat - and became the pet of the crew by making sketches of them from various angles of their daily routine, and distributing his drawings like tracts. And while he sat on bales of pulp *à la* Jacobs, watching the cook peel potatoes, he thought how the county at home around its comfortable 'seven coursers' envied him his 'yachting experience'!

At last the coast of Ireland hove into view. We shall not dwell longer on the incidents of the sea. The hesitating ship: the near horizon: the far-off glimpse of home: the light in the window. Limp by limp the vessel waged its heavy bulk against the offending tide, till at length the Irish Sea clasped a million lobsters in its salty arms. Steadily the old rusty

tramp took its way for Liverpool, and Bairnsfather, like a shipwrecked hero, waited on deck, in pyjamas, for home and beauty.

No man kisses his native soil with the same gratitude and patriotism as the man who can't help being seasick. Seasickness might even be found, in some deeply-thinking Teutonic mind, to be the origin of patriotism - the beginning of nationality - the love of Fatherland and Mother Earth. It is easily understandable! And no man ever felt this emotion more fundamentally than Bairnsfather.

All of which, as anyone can see, makes England to him a land specially worth fighting for, and accounts perhaps for his patriotic presence in the trenches, where he recognised that there is another elementary illness quite as harrowing as seasickness, namely, landsickness.

Do these fighting men ever need a doctor?

"No," he said to himself, "laughter is the physic of hard lines." So he gave them laughter.

Nothing can purify like laughter, and above all laughter at one's self; for to see himself

Fragments from Bairnsfather's sketch book.

humorously is the greatest purifier a man can have. To be held up to ridicule does not cleanse. Wit, as society plays practise it, is of no physical or social value; but humour, a good-natured sympathetic joking with a man, lifts him out of the dumps - and the Slough of Despond.

Just as he cheered the crew on the *Battered Nancy* labouring under the burden of pulp and lobsters, so has Bairnsfather given stimulus to the men in France, making them forget their home-longing by showing them themselves at home in the trenches: by helping their spirits to shape so that their bodies may continue equal to their burdens.

At the same time he has visualised the war for us in England. The only way he can be repaid is for some cartoonist to find a similar jocular cure for seasickness. The strangeness of life, the vigour of hope, the immortality of good spirits among men, the

vagary of careers, the good in all of us - these are the Bairnsfather themes. He has raised pluck to a virtue, and a golden text. The soldier speaks for him and tells you this fact wherever you meet him and talk to him of Bairnsfather.

And yet, while not in any sense have his days been exciting ones, there is a kind of thrill in them, the thrill of uncertainty existing in all who live by their gifts, which is another way of living by what is known as one's wits, in the lives of all who give strength to others by means of their sympathy and imagination.

Imagine our soldier philosopher in Plug Street, somewhere in France, just a little while ago, part of a cargo of lobsters on the Atlantic, and next year, perhaps, reading the lessons in St Paul's. One never knows, and that is what makes life fascinating to Bairnsfather, and meanwhile he says, "Let's be merry." And we are.

"I am afraid the great legitimate actors, whom I admire so much, could not have taught me the frontal attack of Life so well as those fearless comedians of the Halls,'" he said briefly, when I asked him if any of his music-hall investigations had stood him in good stead as a soldier. The way they butt up against an audience takes courage of no ordinary sort. You may shake off a bulldog if you shake long enough, but you can't get free from the determined and experienced comedian whose living is dependent upon making you relax your face, because it's the comedian who is doing the shaking.

"Your laughter or your life!" is the threat which makes his success.

Fighting requires much the same method. Amid these comics, low and high, Bairnsfather found his lessons, as far as the war was concerned; so he turned them to good purpose in the cause of England.

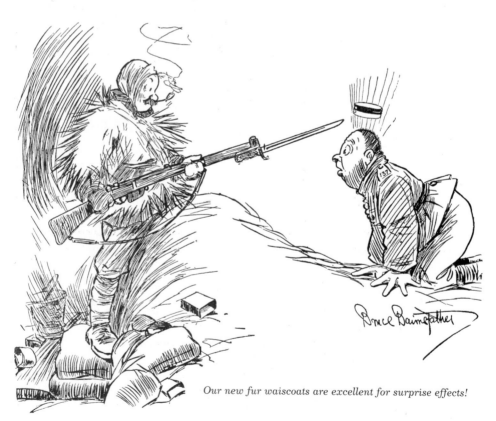

Our new fur waiscoats are excellent for surprise effects!

The Fourth Fragment

BAIRNSFATHER AS A FRAGMENT IN FRANCE

The outbreak of the Great War found Bruce Bairnsfather, with hundreds and thousands of his class and temperament, immediately at the post of duty. Naturally, it was to his old regiment that he reverted. After a short time at a mobilisation station, Bairnsfather left Southampton for the port of Havre almost before he knew what had happened, on a ship crowded with troops. Those were great days. Nothing thrills in the same way as uncertainty and determination backed up by a wrong to right. He tells now of two glad nights in Havre, which many thought would be their last plunge into the delights of this world, judging from the news which filtered through.

Whilst in England, to those favoured few who went first into the slush, broil and conflict of the thing, the spirit of knight-errantry, and a sober sense of duty had impressed them with almost religious intention.

At Havre they heard the note of honest adventure being sounded with contrasting fanfare and all the accustomed atmosphere of a military nation. Pell-mell was in the air, making a harmony of discordant elements. It, too, was a spirit derived from things we imagined in our poor knowledge of manners and men who were long dead.

Havre presented a scene which the elder Dumas would have loved and which only he could describe, with its sweeping colour, its mystery, its subtle interplay of human passion, patriotism, excitement, indignation and awe.

It was a soldiers' town, peopled by soldier souls. Cafés were like bee-hives; the streets swarmed with women of all sorts, all keen, tumultuously keen - *à bas les Boches!*

Only patriotic airs sounded from the orchestras in the cafés. Only patriotic songs were to be heard being sung above the din and confusion of the street traffic. The men in regimental equipment walked with the tread of soldiers.

It was FRANCE, the old France, the fascinating always alluring France, and the spirit of *Les Trois Mousquetaires (the Three*

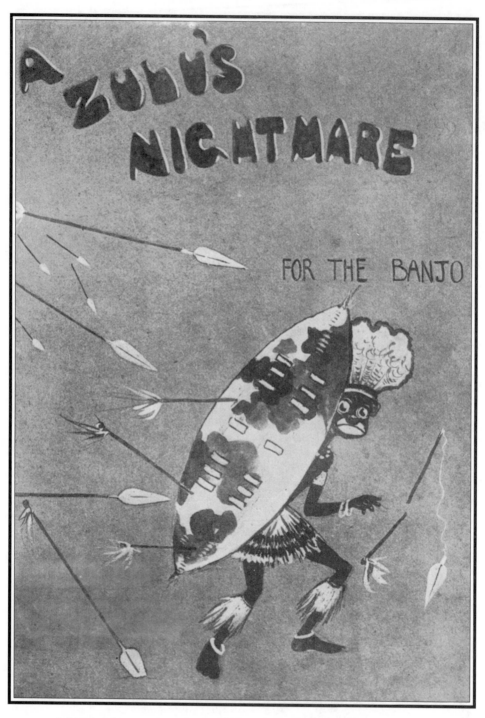

A friend of the artist, having composed a banjo march, played it to Bairnsfather,
who described it as a Zulu's nightmare, and when challenged to produce
a cover for it promptly replied with this sketch.
It was adopted - with what result to the sales is not recorded.

132

Musketeers) dominated the French world. Chivalry was also awake there, in a more martial, if not less religious, form than in England. And there they were, those among the first British who went forth, having two glad nights in Havre, thoroughly conscious of the fact that these two glad nights might be their last on this good, kind earth.

Bairnsfather, en route to 'somewhere,' noted these things and saw the irony, tragedy, and heroic fun of the situation of which he was part and parcel. This was the love of adventure which all his life he had longed to satisfy; which he had loved to read about in old books.

From Havre to Rouen in summer is a tender scene, with timid and caressing green, for no green grows old like the green of apple-tree leaves in Normandy, singing themselves to silver; in Autumn a scene red as blood and yellow as gold and as gentle as moss in those famed forests; in War, a scene brave with hurrying men from hamlet and farm, with churches busy with prayer and only silent where grass grows over graves.

At Rouen Bairnsfather secured a passport, which provided for his being dumped at a siding in Flanders; and from there he went straight into the trenches.

The Trenches!

And this was the Garden of Europe!

It is hard to imagine what he felt when he 'took to the mud.' For in dreariness and darkness and slush and water, this particular trench was the cesspool of the world: a world steeped in dereliction, dankness and despair. There was the close, unfriendly contact with Death. There was the penetrating greyness, the ugly aroma of stagnation and depression. And this was the horror which men out there actually got used to, and in which Bairnsfather saw so much with which to make them laugh.

He was billeted on a farm, a type with which his drawings have made us familiar. He was too much occupied with the business of war to think anything about drawing, although that impulse had always been a chief one in his life from his earliest youth.

Besides the monotonous or exciting routine, as the case may be, of the day, there was little in the rotten turnip field in which he was planted to rouse inspiration. Some three months passed before he could draw any pictures, and then he only sketched incidents on scraps of paper and sent them along the trench to amuse and cheer the men, or sent them in lieu of letters to friends at home.

'In Mufti'
A bit of Bairnsfather
that suggests Phil May.

I still attire myself very much on these lines.

Old Bill in trouble!

He drew cartoons of a sort on the walls of the farmhouse, and these pleased his companions mightily. All this dismalness was before any pronounced organisation had taken place, and the horrid primitiveness of the conditions of life then revolted far more than they attracted him.

It was a grey world: there was grumbling at everything - except the glorious fact that they were out to 'do' the enemy.

The guns never ceased their convincing argument night or day. There was no hate or bitterness among the men. They were all fine fellows at bottom. At length even their grumbling became picturesque to Bairnsfather: later it became humorous, and in the end excruciatingly funny, because he saw what kept them at it, steady and certain: their courageous determination and gallantry. To him, finally, they were war jesters. They sewed clumsily, but wittily; they ragged wittily; they snored wittily; they cooked wittily and if they hated the enemy at all, they hated him wittily.

"Hate," he declares, "varies inversely with the square of the distance from the Front." And these men, who at first appeared to him in this age of civilisation as a kind of aggravated savage conducting a troglodyte war with less than the dignity of moles, all brought back to Nature with a thud, suddenly struck him as getting the very best out of such a life as they were obliged to live there. They were getting, in spite of circumstances, in spite of death and appalling sadness, fun out of 'the whole blooming business'.

And while he felt sorry for the real fellow - the bloke who has to stick it out - he got much satisfaction from the fact that there was many a hearty laugh left in those tried and courageous breasts. That the enemy had wilfully

flung the world back into primitive conditions tended to embitter some of the men, but not for long, not at any rate while there was anything to make them laugh.

So months and months of mud and bully beef were grumbled through good-naturedly: and then they were moved from trench to trench, all revolting to anyone with an imagination at all. And during this migrating period, when hardships often became more than could be humanly borne, Bairnsfather noted the fearful struggle with himself which each of these men was fighting.

All were enduring the same thing, and this common battle within each of them had produced a comradeship among them which was almost beautiful and invariably expressed itself in jest, in laughter; and when things seemed to have touched rock bottom, misery some way found out its fellows and so came the pearl from the diseased oyster, the priceless pearl of fun.

Bairnsfather describes those long days in the trenches as more harrowing and devitalising than any great offensive could possibly be. To anyone with a particle of imagination they were the limitless limit, like an endless succession of funerals where you are both corpse and mourner.

There's ... so ... much ... time ... to ... think!

There you are, day in, day out, gnawed by suspense and monotony, hanging in mid-air, as it were, between sky and earth, with heaven as a possibility and war as a certainty. The curious restlessness it all produced was like wanting to scratch and having no place to scratch. In your resignation you find humour.

It is said that at his last moment a drowning man lives his whole life over in a flash like a vivid film before the mind. In the trenches one lives one's life over every minute of the day and night. Truly they also serve who only stand and wait. The absolute soldier - the absolute callousness - the absolute hopelessness - why not laugh?

It is not only a philosophical kismet, it is the British birthright. And those who have had the nastiest experiences laugh the most at Bairnsfather's cartoons. He has proved to us - as no other man of his time or any time has yet done - that a hopeless predicament can be pathetically funny. Such is the psychology of the British soldier.

It was the war which revealed these men to themselves. Why, to stare at a dead cow

135

from a dangerous 'parapet' for consecutive months *must* become funny. The cow, with legs sticking up like a four-poster, had so little concern for the diplomatic affairs in the Balkans, and yet, what a real thing the war had been to that cow!

So Bairnsfather, after months of slime and grime, came to the conclusions which resulted in his drawing his first picture, and the manner and consequences of its reception in London are the subjects of a following chapter.

The war, as well as the conditions of life it created, was getting worse and worse, for the battalion was moved into the Ypres Salient, and here, in the second battle of Ypres, our Captain came very near cracking the joke of his life.

It's not a long story, and runs in this wise. They had entered the struggle at about four in the morning. An awful din filled the air, deafening and choking. The atmosphere was venomous with bullets and the bodies of the dead were everywhere. Ypres was a mass of yellow flame. The world, clutched by the throat, was staggering and finding it hard to breathe. So it was when the dawn broke with stern greyness, bringing no light to that smoke-driven country.

Bairnsfather was doing no more than every man was doing at that moment, and they were all doing everything in their power to do their duty. He was in charge of the machine guns as usual. Two in one place, two in another position on a hill, and between them he ran frequently.

With dawn the attack began down in an expanse of field facing the Germans; one of those Hell rehearsals which no pen can describe.

Bairnsfather was hurrying along the moat of a farm when a Canadian officer dashed by him, obviously carrying a message. Bullets were falling like green fruit from an apple-tree in a tornado. About fifty yards on Bairnsfather saw the Canadian collapse in a heap. He didn't move. The battle had come to a standstill for moment, although the machine guns were busy; the world, exhausted and sore, seemed to be taking a deep breath.

On the farm behind, the bullets were falling through the roof about two a minute. There was a strange, unearthly calm over everything, mocked only by the machine guns.

Bairnsfather ran out to where he had seen the officer fall. It was not an action of any risk. It was what anyone would have done in like circumstances. It was what everybody was doing on all sides. It was the higher development of that *camaraderie* which produces humour and at length reduces the Army and at the same time lifts it to the simple term 'Man'.

He tried to drag the Canadian to a safer ditch, but finding such a tug beyond him, he cut off the equipment and cut the clothes to make sure just what had happened.

A bullet had entered under the fellow's right arm and had come out on the left side of his chest. There was the gurgling noise - worse to hear than all the perdition of a great offensive; there was the pale greenish colour in the face.

A gunner was hailed, and told to throw a water-bottle over. The gunner, Mills by name, 'an excellent chap', came himself. The wounded soldier was propped up and left in Mills's care whilst Bairnsfather ran back to the farm for a stretcher. There he found the house crowded with wounded. He spoke with a Canadian Colonel, to whom he gave the papers taken from the officer.

Could he have a stretcher?

Certainly!

A young Lieutenant was ordered to accompany him back. They returned along the

Bert in difficulties.

*More 'Fragments' from
Bairnsfather's sketch books.*

edge of the moat to avoid machine-gun fire. The wounded man on the stretcher was at length taken to the farmhouse, where all was an agony of confusion.

It was all so easy to do, this kind of thing, when everybody else was doing it. The sensations of war were to him at once so terrible and so simple, so sad, so ironical. Then Bairnsfather got back to his job, dead beat.

It was by this time 5.30am. He started along the front of the farm by the side of a ditch which went out on to the Fortuin Road, and when he had gone about forty yards one of the shells aimed at the farm exploded right alongside him. He was knocked down and

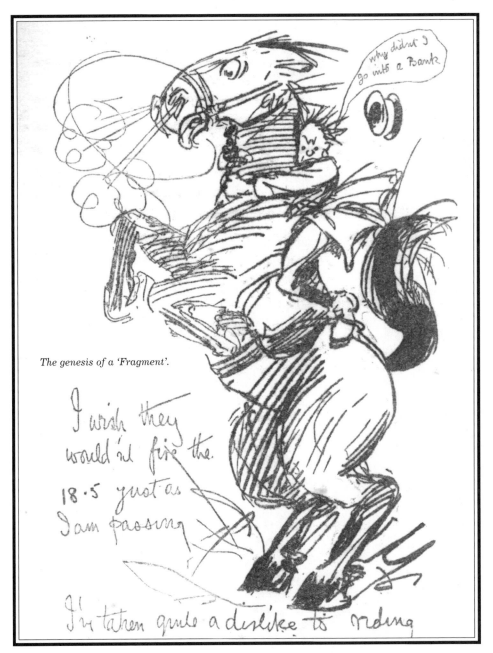

The genesis of a 'Fragment'.

lay for some time absolutely done in, but managed to drag himself to a double row of dead men, relics of previous fighting, got some water, and was helped by an orderly to a dressing station at St Jean. And so that grey dawn had turned to a grey noon; and such is the day's work *every man* does at the Front; where, before and after such bickerings, every man who can laugh becomes more and more the captain of his own soul.

Such is the psychology of the trenches; for Laughter is the invigorating handmaid of Pluck.

The Fifth Fragment

DAYS OF DISCOVERY

For a man engaged in the Great Adventure of War, in prospect of winning undying fame on the battlefield, the mere honours of publicity in so minor a thing as 'art' may seem, to the romantic-minded civilian, to be of a paltry kind. To the unromantic-minded soldier, it is otherwise. The honours of the battlefield may come, or probably may not come, in the day's march, and may be enjoyed either in this world or the next, or on the borderline between both. It has been said by cynics that the soldier in modern wars cares little or nothing about the honours in question, and that if he has any feeling for them it is rather one of distrust. This is not altogether true.

Still, it does often happen that the hero of the picture papers is not at all the hero of the trenches, and the deed not the one which Tommy himself would have selected for honour. Tommy is too much Tommy to regard war in any romantic light at all, and the thoughts of Tommy in the trenches or thereabouts are thoughts mostly of home.

If Tommy is ambitious, it is likely to be in directions *après la guerre*. Therefore, should anything written or sketched by Tommy find its way into print at home, may it be said the day of its appearance is a greater day in his life than the day on which he may have achieved some unrecorded glory at the Front?

Viewed in this light, the storming of the ramparts of London picture-journalism by 'Bairnsfather of the Warwickshires' is an achievement of which the Army at the Front is at least as proud as it would have been of his storming of, say, *Dead Pig Farm* in the battle of *Vin Ordinaire*, and the story of how it came to be may rank high in any future record of 'Great Deeds of the Great War'.

It is, at all events, one of the most remarkable feats in the whole history of journalism for a completely unknown man to have won for his own talent so instantaneous a recognition, and such universal approbation.

It has already been said that Bairnsfather had a sketching habit, for which throughout his school and professional days he was known to his friends. Also, those friends doubtless foresaw that perhaps one day he might find his way into print as some sort of a comic humorist. They did not foresee that a Great War would have to happen first, and that his arrival in print would be the result of a bomb explosion.

One of the most painfully familiar of all situations at the Front is that in which a quiet and dismal little party in a dugout are shaken out of their seven senses by something hurtling over their heads and the flying of shell fragments, when there rushes to every lip the words, '*Where did that one go to?*'

In no sense, in itself, a humorous situation: on the contrary, a tragic one. During one of the intervals between repetitions of this particular experience, Bruce Bairnsfather sketched it upon paper and handed it round. It was voted a truthful record of an actuality, and it was suggested that Bairnsfather should 'send it up somewhere'.

To 'send something up somewhere' was not altogether a thing unthought of at any time by Bruce Bairnsfather. On the contrary, it had occurred to him often that he might do this selfsame thing. In the case of this particular sketch, however, the soldier-artist

1 - Hark!

2 - Yes!

3 - I thought so!

'The Herald of the Dawn' - A 'Fragment' in the making.

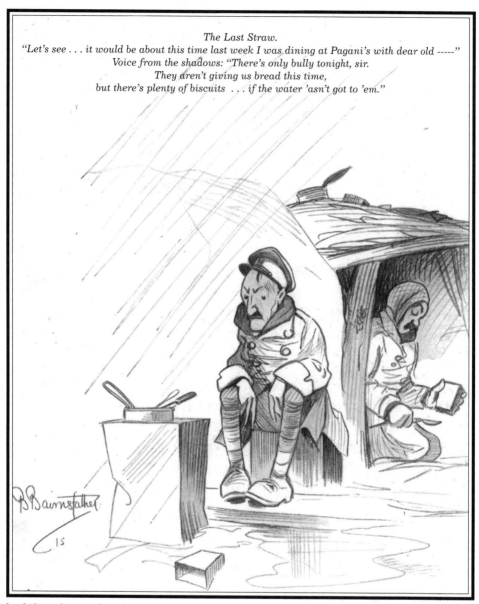

The Last Straw.

"Let's see . . . it would be about this time last week I was dining at Pagani's with dear old -----"

Voice from the shadows: "There's only bully tonight, sir.
They aren't giving us bread this time,
but there's plenty of biscuits . . . if the water 'asn't got to 'em."

had thoughts at the back of his mind. Certainly he would 'send it up somewhere,' but precisely where? To a comic paper? Well, perhaps: it might amuse the readers of one week's issue, be passed on, and forgotten.

No, reasoned Bairnsfather, this sketch shall go to London, but it shall do more than merely amuse a minute fraction of London in its tram or bus, or tea-shop. It shall make a considerable portion of London *think*: realise something, even in jest, of what is at this place they vaguely talk of as 'The Front,' and of what the true feelings of the real human Tommy are who has gone there.

An illustrated paper it had to be, and various processes of reasoning led him to decide on *The Bystander*, which had, as a matter of fact, announced its eagerness to receive humorous sketches from artists on active service.

A note thanking a friend for a pie.

The sketch was immediately accepted, and was reproduced in *The Bystander* of March 31st. On the 9th April off went another.

I herewith enclose you another black-and-white sketch entitled 'They've evidently seen me,' wrote Bairnsfather. *'I hope it will meet with your approval. Although I do not observe from a chimney myself, yet at the present time I happen to live in a house. By live I mean waiting for the next shell to come through the roof.*

This letter revealed to the editor of *The Bystander* what he had hardly dared to hope, i.e., that not only was his new and sudden 'discovery', if the word may be used without patronage, a humorist in line but also in word. Consequently a series of other transactions followed in which Bairnsfather fired each time and did not once miss the bull. The uniform acceptability of his work became a joyous monotony in the editorial office.

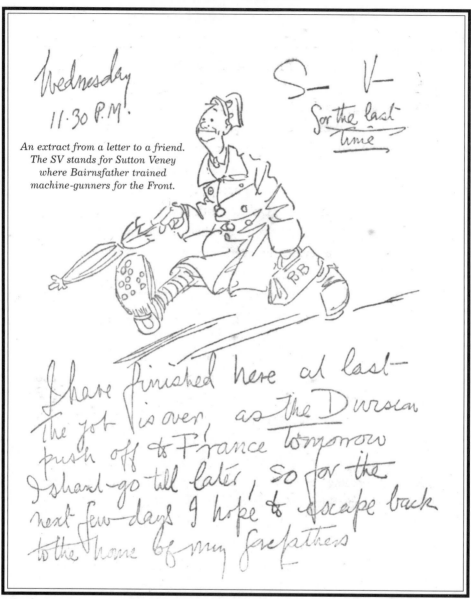

Wednesday
11.30 P.M.

An extract from a letter to a friend.
The SV stands for Sutton Veney
where Bairnsfather trained
machine-gunners for the Front.

S— V—
for the last
time

I have finished here at last—
The job is over, as the Division
push off to France tomorrow
I shan't go till later, so for the
next few days I hope to escape back
to the home of my forefathers

What was something of a revelation, however, was the instant appreciation that greeted his early sketches from the military itself. A storm of enthusiasm too rare, alas, in readers of illustrated papers, broke over the offices of *The Bystander* as a result of the first of the Bairnsfather 'Fragments'.

Every one here is talking about the pictures . . . I think they are perfect. By far and away the best and most lifelike caricatures we have seen of the war, wrote one Subaltern.

You have livened many a dull hour in the trenches, wrote another.

The best products of the war.

True to life as a dot. All details correct.

The true story of things as they exist.

We simply howled.

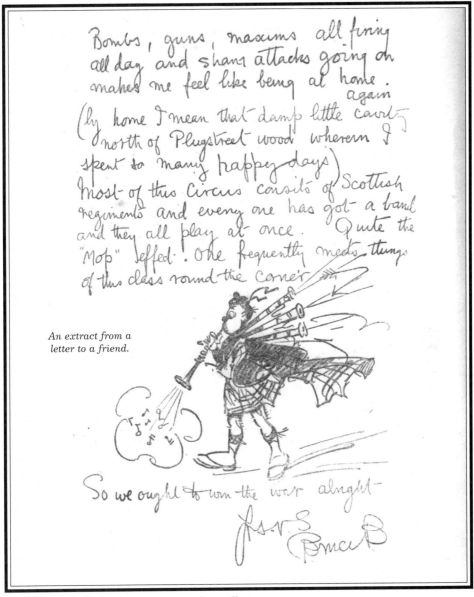

Bombs, guns, maxims all firing all day and sham attacks going on makes me feel like being at home again. (by home I mean that damp little cavity north of Plugstreet wood wherein I spent so many happy days) Most of this Circus consists of Scottish regiments and every one has got a band and they all play at once. Quite the "Mob" effect. One frequently meets things of this class round the corner.

An extract from a letter to a friend.

So we ought to won the war alright—

All Bairnsfather's pictures are on the walls in our messroom.

Absolutely IT, and so on and so forth, ran the letters that poured into the offices from 'Somewhere in France', together with applications to have first refusal on the originals when they were offered for sale.

In due course, with the usual suddenness of casualties, the feared-for thing happened to Bruce Bairnsfather - the wound described in the last chapter, which announced itself to *The Bystander* in a letter headed 'King's College Hospital, Denmark Hill.'

I was very sorry not to have been able to write and acknowledge your letter, but unfortunately we got rather busy about then, and now, as a result of the recent occurrences at Ypres, I am docked for repairs, ran the beginning of the letter, dated May 3rd, 1915, upon reading which, the editor of *The Bystander* ordered a member of his staff to proceed

forthwith to Denmark Hill and ask permission to present compliments and kind inquiries; also to notify the wounded officer that, when well enough, his presence at Tallis House (the home of *The Bystander*) would be welcome.

Bairnsfather records that the psychological effect upon him of this - to the editor a mere civility, and nothing else - was remarkable. To be actually *wanted*! That was indeed a novelty of sensation.

In Bairnsfather's case, such is his temperament, it had the reverse of the effect it has on some. Instead of self-satisfaction, he felt an intense desire to respond to the call, to justify to the full the confidence shown in him.

When he paid his visit to Tallis House, it was with as full a rough sketch book as ever was seen by the functionaries of that establishment.

It must have taken some hours to cover the whole ground of the interview, but at the end of it, Bairnsfather and his editor had established a complete mutual understanding, which was that the former was to 'produce the war,' as experienced by those taking part in it, by weekly instalments.

Bairnsfather was given carte-blanche. The sketch book, and the work already done, had been enough to convince the editor that the 'goods' were there, and that all that was now wanted was their delivery and display. The public would do the rest - and the public did.

By the arrival of Christmas, the first stage of the Bairnsfather offensive had reached its objectives, and thence onward there was no 'retirement according to plan', but only a continued pressure forward from height to height.

The Christmas edition of *The Bystander*, 1915, contained as its *pièce de résistance* the 'Fragment' which is best known to all the world. The *'Fragment'* in question was that entitled 'Well, if you knows of a better 'ole, go to it.'

The public saw it and collapsed. It was the limit. It was a funny enough picture, that of two men engaged in a furious squabble in the midst of a bombardment, but the subject of the quarrel - i.e., whether by any possible chance either of them could be in a worse predicament - seemed somehow to hit the public in its tenderest spot.

Why? Well, just this way. Christmas 1915, marked the lowest level of the Allied fortunes, and angry pessimism was the note of the day. We, the Allied nations, were in a hole and we knew it, and the question we were all wrangling about, between bombardments, was whether the future was going to show things worse, or possibly better. There was, therefore, a symbolism about the 'Better 'Ole' picture that raised it altogether above the ordinary *'Fragment'* level.

Everybody said to everybody else when a dispute arose as to *modus operandi*, 'Well, if you knows . . .' etc., etc.

The phrase got on to the stage.

It was made the subject (with acknowledgements) of political cartoons. One of them showed the married recruit and Asquith in the hole, another put Kaiser Bill and Kaiser Joseph into it.

No cartoon of the war, in actual fact, hit the public so much as that of the two desperate men in the Johnson 'ole, and the only doubt for Bairnsfather in the mind of the readers of *The Bystander* was whether he himself would succeed in finding a 'better 'ole' at any future time than this cartoon.

People feared that it might be his climax - but people were wrong. By February, he had added to it and its predecessors sufficient cartoons to justify the publishers in issuing 'Fragments from France', which was the first revelation of Bairnsfather's existence to

"fear

A terror hangs above our heads.
I scacely dare to think
Of that awful doom, that each one dreads
from which the bravest shrink

— ·· —

It's not the crashing shrapnel shell
Or yet the snipers shot.
It's not the maxims bursts of Hell
These matter not a jot

— ·· —

It's a far worse thing than that my son
with which we have to grapple
It's if we see another one——
More tin of PLUM and APPLE.

— ·· —

Bairnsfather as a versifier.

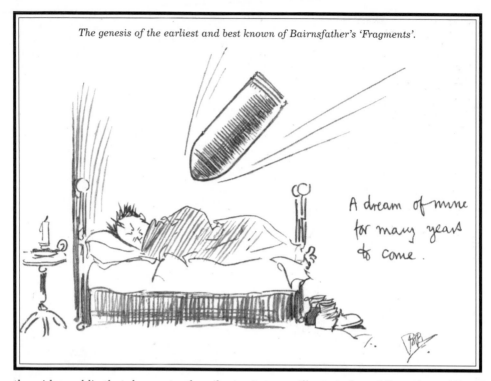

The genesis of the earliest and best known of Bairnsfather's 'Fragments'.

A dream of mine for many years to come.

the wider public that does not subscribe to sixpenny illustrated weeklies - the public of the millions. The sale of this slim volume of forty odd sketches exceeded that of any other booklet of cartoons within the recollection of the book stall clerk. Edition after edition ran out, and thousand after thousand were reprinted, until the publisher began to be seriously concerned for his supplies of paper.

The booklet found its way into the hands of everybody, from the highest downwards.

Criticism came, of course. One fine day, there came, on official paper, over the signature of an eminent political personage, a reasoned appreciation of the sketches, and an earnest entreaty that Captain Bairnsfather, who had become a factor in the situation (as was Gillray in the Napoleonic Wars), should *'avoid casting ridicule at the British Army, or giving the impression that it was less serious of purpose than the Armies of the other Allies.'*

Fear was expressed as to the way the French might regard the Bairnsfather Army, with its incorrigible spirit of levity and its complete lack of proper respect for the dignity of war.

The editor was just meditating on the best form of answer to this when there was announced another eminent gentleman, from the same department, who had called to know whether permission could be granted to a request of *the French Government* to reproduce the *'Fragments'* from time to time in the official *Bulletin des Armées*!

It was thought that such a request was the best possible answer to any doubts as to the attitude of our Allies towards the humour of Tommy as

expressed by Bairnsfather. It occurred that among our own officials there might exist a spirit described by our Allies in the phrase *'plus royaliste que le roi!'* - a tendency to be more concerned for our appearance in foreign eyes than were the foreigners; to be inclined to forget the invocation of the national Bard that 'England to herself do rest but true.'

During the months following his wound at Ypres, Bairnsfather was engaged as a machine gun instructor at home. In due course, however, he found his way back to France again, and cheered Tommy up during the whiles of waiting for the great push by some of his happiest inspirations, which went to complete *'More Fragments from France'*, and to form the nucleus of yet a third volume.

The Sixth Fragment

THE ESSENCE OF 'FRAGMENTS' - A REAL CONVERSATION

It was during his leave, after some months of this, that the writer was successful in getting Bairnsfather to talk at leisure on his way of looking at things. In the short, sharp and decisive interviews it had been possible to get on the subjects of his pictures and publications; it had been difficult to fathom the depths of a subtle nature, or to quite discover exactly what his source of inspiration was. His talent is not that of the mere picker-up of unconsidered trifles.

Active as his pencil is, and always has been, it is only the means by which accident has designed something should be given to the world. It may seem to be calling that something by a big name if one calls it the 'Psychology of the Soldier at War', but it is probable that *'Fragments'* will be regarded by historical writers of tomorrow as something more than a mere book of funny soldier sketches.

Already, the correspondence which has come to him reveals how deep is the note he has struck: and the presence of *'Fragments'* on the tables of the leaders of politics, war and society shows that it is not in the light of mere entertainment that the work is regarded.

One War Office official reported that, on the day after the publication of Volume I, the whole work of his department was stopped. Persons calling to see him on business - one of them was a very important personage indeed - found themselves turning over the pages of *'Fragments'*, with the result that the object of the call was completely forgotten.

As what follows is an 'interview,' the writer must refer to himself in the first person singular.

It was at Bishopton that I succeeded in digging Bairnsfather out of his trench of reticence, and I went prepared. He was just finishing one of the later *'Fragments'*. It was the one which figures in the third of his booklets and which bears the caption: *"Where do yer want this put, Sargint?"*

The picture depicts a Tommy, with a look of extreme perplexity on his face, carrying

a contrivance known as a tripod, that is the crossed supports of a barbed-wire section. On the horizon are the usual ridiculous Huns.

"Well," said Bairnsfather, settling on the settee underneath a huge scarlet sunshade, "it doesn't mean anything in particular. It's just a pathetic little wisp of humanity who happens to be, like millions of others, engaged in the entirely unfamiliar business of war. He doesn't want to be there, nor does he want particularly not to be there. But there he is, and at this particular moment he happens to be responsible for the disposal of a heavy and altogether repulsive thing called a tripod. He doesn't object to it on principle. He knows these things are necessary for the conduct of war. But he does very much indeed want to get rid of that tripod, and to get rid of it is the only thing in life that matters to him at the moment. His whole soul goes out in that question to the Sergeant,

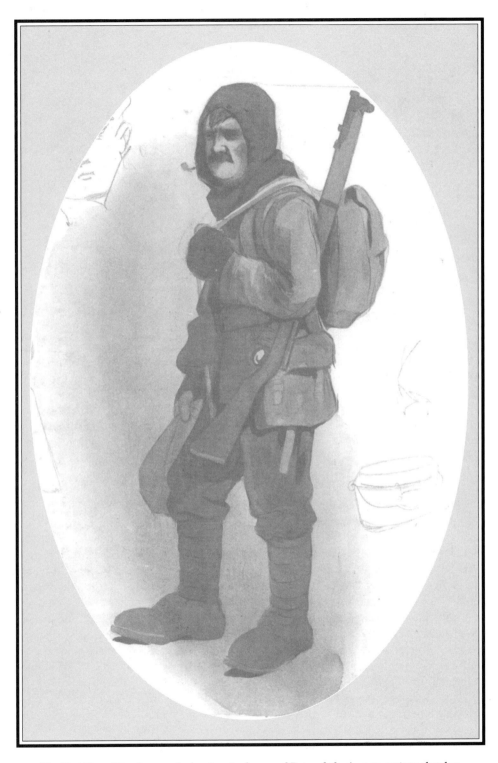

The 'Out Since Mons' man, who has inspired some of Bairnsfather's more serious sketches.

Trekking at La Bassee.

and everything to him depends on whether the Sergeant gives him a definite or an indefinite reply. To him, the disposal of that tripod is of more importance than the whole future of Serbia or Belgium. It is the problem of war. That's all I can say about it. I don't know that it's particularly funny. But there it is."

I didn't know myself that it was particularly funny. But when I looked at it again, in view of Bairnsfather's explanation, a laugh surged up from deep in my interior, and lasted quite a long time. I sought further explanations and we turned over *'Fragments'* at leisure.

I came to the picture entitled *"I'm sure they'll hear this damned thing squeaking."*

"What," I asked, "is the actual humour of that situation?"

Again, my artist seemed diffident.

"It's much the same as the man with the tripod," he said. "That fellow's job at the moment is the drawing of water out of that pump. He knows water has to be drawn, and that he is responsible for drawing it. But he does think it a cruel world which makes the filling of a mere jar of water - water mind you, not rum, or anything really worth dying for - such a dangerous proceeding. He is fully prepared to be shot, or gassed, or bombed, or bayoneted in battle. That's what he went out expecting. But he doesn't like the prospect of meeting his end because a 'damned pump' squeaks. All pumps in Flanders squeak, and if this *'Fragment'* had a lot of success, it's because every man in northern France was perfectly sure it was the particular pump he had had experience of himself. I had heaps of letters claiming the pump, and I'm still receiving them."

"Now," I continued, "people say that your Tommy is represented as 'fed up.' I've heard it said that to depict the British Tommy as fed up is to give a false impression of the spirit of our troops. What about that? For instance . . ." We turned to the famous picture entitled *'So Obvious'* - *"Who made that 'ole?"* - *"Mice."*

"Now," I said, "the man sitting down is undoubtedly fed up, isn't he?"

"Yes. He's so fed up that when his attention is directed to the hole, which he knows is

there, he doesn't even look round. He's been conscious of that hole for days and days. He doesn't want his attention directed to it at all, and when it is, he gives an answer which he knows to be inadequate and unconvincing. That's that," concluded Bairnsfather.

We turned next to the *'Fragment'* called *'The Thirst for Reprisals'* - "*'And me a rifle, someone. I'll give these buggers 'ell for this.'*"

"There," said Bairnsfather, "you just see hate concentrated. The figure under the debris feels, for the first time, that full spirit of hate for the enemy, and the full desire to bring about his annihilation, and it isn't because of the sinking of the *Lusitania*, or even the murder of Miss Cavell, or the general outrages of the Prussian military caste. It's just because, at this particular moment, he has been placed in an intolerable situation, and he desires to fix the responsibility on the guilty ones that he can get at, even if it's only with one hand. The war has just been brought home to him for the first time. If the British public had the war brought home to them in the same way, they'd feel the same thing, and the trouble is that they haven't, except where the Zepps fly, and in consequence, they don't feel the war. They might either end it tomorrow or let it go on for years and years. But whichever they did, it wouldn't be as a result of actual experience. The Tommies I depict as fed up are fed up with war not because it is war, but because of the ways in which it expresses itself in regard to the individual. War is a business in which you have too much of everything. When you walk, you have to walk *too* far: when you rest, you have to rest *too* long: when you have leave, it's *too* short, and when nasty things happen, they always happen at the wrong moment, as for instance when you're washing, or changing your socks, or boiling a kettle. It's that sort of thing that causes my Tommy to be fed up, not the state of war itself, which Tommy accepts without repining. He quarrels not with the show itself, only with the way the show is conducted. The spirit of the thing is expressed by the Tommy on the transport who is saying "*I wish they'd 'old this war in England, don't you?*" It's the idea that this war is something that's being 'held,' and what's wrong with it in the case of the victim of seasickness, is that it's being 'held' in the wrong place."

These few 'explanations' don't perhaps make the jokes any the funnier. What they do explain is Bairnsfather's own mental attitude - his philosophy, if you may call it so. He regards the war as it affects the individual, and in none of his cartoons does he offer one word of criticism of the war in itself - no, not even where the Hun himself is concerned.

Bairnsfather is as good a Hun hater as anybody when at the Front, and I find his views on the ethics of the war, when he expresses them, to be as orthodox as those of any man living. But he doesn't hate with his pencil as Raemaekers hates. He has no propaganda. The sketches where Huns figure show the Hun just to be a human being - as nearly as possible. One of the pictures that made me laugh as much as any other is that which shows Fritz exclaiming "*Gott strafe this barbed-wire.*" Here we see the family resemblance to Tommy. Fritz doesn't strafe England, merely the barbed-wire which happens, for the moment, to be causing him annoyance. For, as 'Germanski officer' writes, from somewhere in Siberia:

Situations of the kind so truthfully depicted by Captain Bairnsfather are not exclusive prerogatives of the British. No more is the standard remedy against the spiritual unpleasantnesses of such situations - humour - an 'Allies' monopoly.

Another Hun picture is *'The Tactless Teuton'* - a member of the Gravediggers' Corps joking with a Private in the Orphans' Battalion prior to a frontal attack.

It is happy not only in its portrayal, but also in the subtle way in which, when

Bairnsfather has a joke that is slightly brutal, he fathers it upon the enemy. It is the same when the joke depicts intoxication. Bairnsfather cautiously, and with an eye on the censor, illustrates the *'Maxim Maxim'* that *'machine guns form a valuable support for infantry'* by showing the intoxicated person to be an enemy. So safe!

Otherwise, on the whole, he leaves the enemy alone - in his pictures. He professes rather to despise mere pen-and-ink abuse of a person who is being dealt with by more drastic means, and who, in any case, isn't handy to retaliate in kind.

Among Bairnsfather's sketches are, of course, those which are mere plain pictorial jokes, which don't bear any special analysis, or depict any particular state of mind. We get chaff pure and simple, of the kind which prompts the query, *"Well, Alfred, 'ow are the cakes?"* in which Bairnsfather shows himself to have a pretty way of combining a funny picture with a funny 'tag'.

We have the delightful drawing *"What time do they feed the sea-lions, Alf?"* the origin of which is doubtless fact, for he takes it on himself on some occasions to depict the contrast between the real and the romantic. Possibly his home surroundings have had something to do with this habit of thought, for wandering around Warwick and Kenilworth, in and out of Stratford, with the spirit of the Bard ever present, the mind acquires the habit of transporting itself back over the years, and one finds oneself often contrasting the most mundane things as they are with things as they probably were.

Bairnsfather contrasts the romance with the reality of war in two pictures, *'Other Times, Other Manners,'* in which we see Sir Plantagenet Smythe at the battle of *Vin Ordinaire*, exclaiming, *"On, on, ye noble English"* on the one side, and his descendant Lieutenant P. de Smythe at the taking of *Dead Pig Farm* exclaiming, as he crouches, revolver in hand, *"Come on, you chaps. We'll show these blighters what side their bloody bread's buttered on."*

The other shows *'That Sword'* as the young officer thought he was going to use it, and how he does use it - as a toasting fork. I rather fancy that picture, which was one of the early ones, 'did its bit' by revealing to those at home how little of romance and gallantry there is to compensate the boys of the best families for the dangers they run, the effect of which must be to make our admiration for them all the greater.

Little glimpses into the future form a feature of the scheme, as for instance the two venerable greybeards in the trenches remarking, *"I see the War Babies' battalion is coming out,"* and the picture showing General Sir Ian Jelloid at home, who has found the interior of a howitzer an excellent substitute for his country seat, Shrapnel Park, being infinitely cheaper and not a bit draughty if you keep the breech closed.

A kindred country-house touch is given in the sketch where Colonel Chutney VC, home on short leave, decides to keep in touch with dugout life by taking his night's rest in a cucumber frame.

Trifles, these, perhaps, but the world of black-and-white art humour has reason to welcome the country-house touch as a relief from the eternal towniness of the past.

Whatever may be Bairnsfather's love of the crowd, he is equally a lover of solitude and stagnancy. Open meadows, still streams, tall upright trees and silence have an immense fascination for him. His early efforts at sketching - some examples are on the walls at Bishopton - were of lanes and fields around his home: he also has a love of ruins. It was an irony that his penchant should be gratified in such terrible scenes as Flanders.

Yet in the double-page drawing *'We are at present staying at a farm,'* one sees the invincible humour at work on a scene after Bairnsfather's own heart. Only one with a

"I've had many close shaves!"
(Taken from a letter to a friend.)

keen eye for country life could have noticed those pathetic evidences of rustic peace. I suggest that no town-bred humorist would have thought of that deceased donkey.

Another grim satire on country life in wartime is in that grimly humorous picture which shows 'Directing the way at the Front.' "Yer knows the dead 'orse across the road. Well, keep straight on till yer comes to a perambulator alongside a Johnson 'ole."

Of compliments Bruce Bairnsfather is fond, as is every true artist of comedy whose function it is to deserve compliments. It rejoices his heart to see his shafts go home. He confessed to me, however, that there are tributes he values more than others, and among these is one which came straight from the heart of the trenches to the *Edinburgh Evening News:*

> To us out here, 'Fragments' are the quintessence of life. We sit moping over a smoky charcoal fire in a dugout, cursing the luck that has brought us here. Suddenly someone more wide-awake than the others remembers the 'Fragments'. Out it comes, and we laugh uproariously over each picture, for are not these the very things we are witnessing every day - incidents full of tragic humour?

Another valued tribute was that of the well-known writer who signs himself 'Ensign,' and writes in the *Outlook:*

> You may have possibly seen Captain Bruce Bairnsfather's two inimitable pictures depicting the hour before going into the trenches and the hour after coming out. Well, they are absolutely **it**. Lord, how we laughed over them in the front line: and mind you I am not puffing Bairnsfather up: he does not need it . . . but take it from me he is one of the people who, by supplying roars of laughter and joy to the troops, are helping to win the war.

Lastly, one must not omit that remarkable tribute from 'the enemy' himself, to which allusion was made earlier. It reached the *Bystander* office in June, and read as follows:

'Somewhere in Siberia'
May, 1916.
To the Editor of *The Bystander*
Dear Sir,
You will no doubt be gratified to hear that a copy of your publication, 'Fragments from France', by Captain Bairnsfather has penetrated to the very heart of the Asiatic Continent and, chancing upon a colony of officers in somewhat doleful circumstances, occasioned a most welcome spell of hilarity there.

It is to be feared, however, that your gratification will undergo a violent shock on the disclosure that the officers in question are German prisoners - members of that ill-favoured people who, according to the established notion among Englishmen, are totally void of humour and, to use the term of your 'Foreword,' went into the war scowling.

Reluctant as I am to return good with evil, I cannot spare you the disappointing intelligence that certain fears expressed in the 'Foreword' already mentioned have proved groundless. Far from being 'infuriated' on turning the pages of 'Fragments from France', the enemy so far forgot his true nature as to enjoy a very hearty laugh.

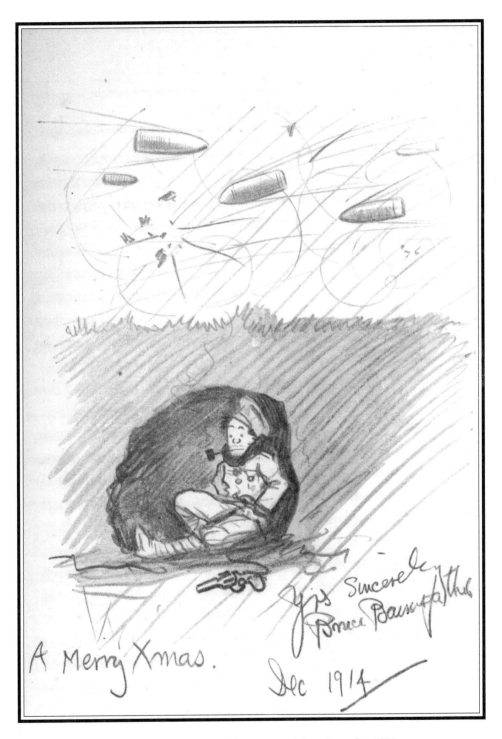

An original Bairnsfather Christmas card from December 1914,
probably drawn and sent before the unique 'cessation' of hostilities occurred
and Christmas Day was celebrated by both sides in peace.

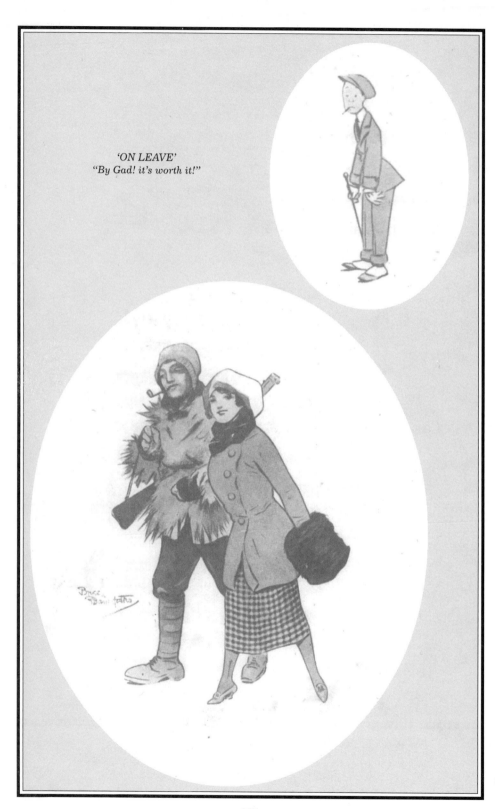

'ON LEAVE'
"By Gad! it's worth it!"

158

Situations of the kind so truthfully pictured by Captain Bairnsfather are not the exclusive prerogatives of the British. No more is the standard remedy against the spiritual unpleasantnesses of such situations - humour - an 'Allies' monopoly.

Publications of the *'Fragments'* type are as popular with us as with you, and go like hot cakes when they are to be had. But it's hard to beat Captain Bairnsfather's rendering of the subject.

The experience of the Baron of Grogzwig, who, by a timely laugh banished the genius of despair and suicide, may be likened unto the more recent example (illustrated on page sixteen of *'Fragments'*), in which Private Jones (late Zogitoff, comedy wire artist) demonstrates humour as a reducer of hate. I am of the opinion that the whole booklet tends towards an effect similar to that produced by the admirable Mr Jones's stunts.

This avowal on the part of 'an arch-enemy' is, I fear, calculated to compromise you horribly if ever known to the persecutors of your cartoon, 'Reported Missing' - who, by the way, are very likely disguised Teutons; or how would you account for their suspicious lack of humour?

Let me, therefore, out of gratitude for the enjoyment bestowed upon us (even though that bestowal was unintentional), entreat you to abstain from carelessly committing this dangerous document to the paper-basket. I should recommend either to destroy it secretly at the dead of night, or - after sprinkling well with holy water - to secrete it in the confines of your most innocent-looking, therefore safest, strongbox.

I very much regret the present impossibility of enclosing the conventional card, and remain,

Yours truly,

Germankski Officer (temporarily sidetracked).

PS 1: With regard to the subject of 'hate,' will you permit me to point out that this invigorating quality is less appertaining to the fighting soldier than to the inspired civilian (uniformed or otherwise), who is freshly charged with it every morning at breakfast from the columns of his daily paper. We read English papers here occasionally, and tremble in our shoes!

PS 2: Compliments to Captain Bairnsfather, and we should like him to know that we are *so* pleased to provide a source of innocent amusement in the shrinking tendency of our forage caps and the generous dimensions of our waist measurements. Alas, that there should exist degenerate exceptions! My own personal 'outer man' lacks both these endearing characteristics. I feel quite an impostor!

Captain Bairnsfather has an observing eye for the *coiffures en vogue* among the belligerents. It remains a matter of taste whether to back the scalp of bristles or the head of hair like a wheatfield after the tornado - as patronised by your Tommies!

Let us meet half ways and call it a choice of evils!

Bruce Bairnsfather, in conclusion, is no exponent of the gospel of hate - no true soldier is. His hatred is for the enemy in the field, but not for his fellow man. This being the

case, he values this testimony from the enemy that his humour is a 'reducer of hate.'

In the distant days to come, when the world is at peace, perhaps *'Fragments'* may penetrate the heart of the enemy country and do just a little to sow on the stony soil of Teutonism the seed of that humour which, had they but possessed it before, would have restrained the Germans from so terribly unhumorous an act as to plunge the whole world into war with themselves on the wrong side.

THE 2ND BAIRNSFATHER OMNIBUS

Somme Battle Stories

illustrated by

Bruce Bairnsfather

1916

(with text by Captain A. J. Dawson)

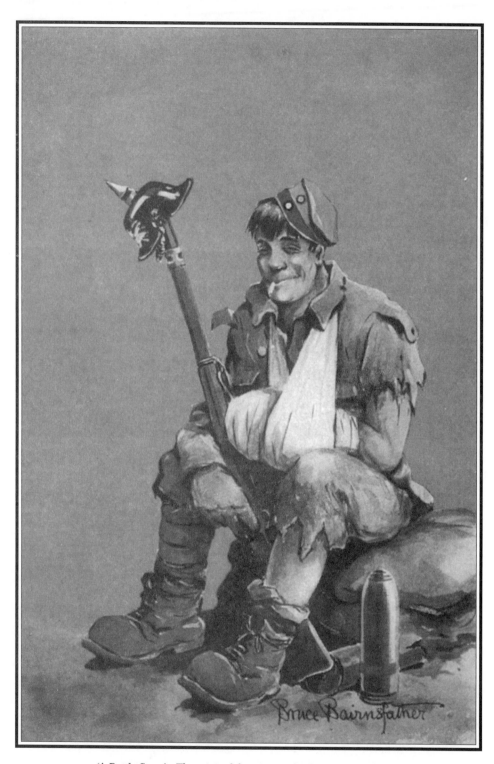

'A Battle Story' - The original frontispiece by Bruce Bairnsfather.

Chapter 1

"WHAT IT'S LIKE IN THE PUSH"

There is nothing of the professional publicist about the average wounded soldier, officer or man, now landing day by day at Southampton. They are all more concerned - thank goodness - with action than speech; with doing things and getting them done, rather than with describing them.

It is not, of course, that these heroes of ours are either unwilling or unable to talk. They are almost invariably, and no matter what the nature of their wounds, in the highest of good spirits; delighted to pay a visit to Blighty; happy to have had the chance of playing the fine part they have played in the great Allied offensive; absolutely assured as to the victorious outcome of the Push. But they have no very accurate notions as to the relative values of the different, disjointed, staccato, frequently vivid bits of information they have to dispense. With matches, or scraps of paper, or a nicotine-stained forefinger made to serve as a pencil in the nearest conveniently dusty surface, they will give you elaborate expositions of the tactics they have helped to work out. Their little lectures on the strategy of the Push are frequently couched in language more graphic, racy, and convincing than the most free and easy of Generals ever permits himself to use. And their loveable faces sometimes show a glimmer of disappointment, for that one does not take copious notes regarding these demonstrations. But, on the other hand, they deprecate with almost pitying wonder the notes I jot down from time to time in talking with them, when (by accident) they enrich me with some vivid, stabbing little thrust of triumphant scene-painting likely to provide an answer to the constantly reiterated question as to 'what it's like' in the Push.

"Oh, I say, you know, don't bother about that guff. Everyone knows about that, of course. But, if you really want to know what the plan was in the [censored] show, I can tell you in a minute, so far as our Brigade went. You see, zero was at [censored], and we were on the right flank of the [censored]," etc., etc.

At the moment I have specially in mind a young Company Commander, a Captain, almost the last wounded officer to be landed from the hospital ship on a certain recent night. He had a good deal of the descriptive gift, and was perfectly unconscious of his occasional use of it. I confess I strained his indulgence a good deal, and took many notes while talking with him. What I set down here are just the bits he regarded as "guff"; convinced that "everyone knows about that, of course." I promise his fluent strategy and tactics shall be preserved in the archives of his grateful country.

THE COMPANY COMMANDER'S STORY
Eh? Oh, just an ordinary front-line trench, you know; rather chipped about, of course, by the Boche heavies, you know; but . . . Oh, hang it! You know what the ordinary fire-trench looks like; along the north side of the Mametz Wood we were. What? Oh, yes, we were packed pretty close, of course, while we were waiting; only got there a little before midnight. My chaps were all in splendid heart, and keen as mustard to get the word 'Go!' I was lucky; met a

friend almost directly we got in. He'd had months in that bit of the line, and knew every twist of it, so was able to give me some tips. He took me along to his dugout, after I'd got all my chaps in position, and gave me some jolly good hot *café-au-lait*.

Tell you a funny thing about that dugout after. Good dugout, with a darned sight better overhead cover than most, or it wouldn't have been there, after the pounding the line had had in the week before. He had a magnificent arrangement for cooking. I forget the name of the stove; but you pump it up like a bicycle tyre, and then it burns like the deuce; gives you a hot drink before you can turn round. I'm going to have one before I go back. We had two good-sized kettles, and after we'd finished our drinks we ran a regular canteen for about half an hour; boiling up *café-au-lait* as fast as the machine would turn it out, and dishing it out all along the line to my fellows in their mess-tins.

The weather was jolly just then; but there'd been a lot of rain and the trench was in a beastly state. You know what it's like, after a lot of strafing, when you get heavy rain on the churned-up ground. It was like porridge with syrup over it, and we were all absolutely plastered, hair and moustaches and everything, before we'd been half an hour in the place.

The Boche was crumping us pretty heavy all the time, but it didn't really matter, because for some reason he didn't seem to have got our range just right, and nearly all his big stuff was landing in front, or behind, and giving us very little but the mud of it.

What did worry me a bit were his machine guns. His snipers, too, seemed fairly on the spot, though how the devil they could be, with our artillery as busy as it was, I can't think. But I know several of my sentries were laid out by rifle bullets.

I particularly wanted to let the others get a smoke when they could, seeing we'd be there three or four hours; helps to keep 'em steady in the waiting, you know; but we had to be mighty careful about matches, the Boche being no more than a hundred yards off.

I hate the feeling of that stinking porridgey clay caking on your hands and face, don't you? But one didn't notice it after a bit, because it was the same all over. But one had to watch out for rifles and ammunition, and that, you know. Pretty easy to get all the rifle barrels bunged up, in the dark. Our Adjutant came along about three, checking watches and giving us 'Divisional time'. Mine was all right; never stopped once from the day I bought it till that left wrist of mine was hit. See! It registers my first hit - at 3.26. I'll keep that as a souvenir, but I'm afraid it's done as a timekeeper.

Just before three I got my position, right in the middle of my company. We were going over at 3.25. The trench was deep there, with a hell of a lot of mud and water; but there was no set parapet left; just a gradual slope of muck, as though cartloads of it had been dropped from the sky by giants - it was like spilt porridge. I wanted to be first out, if I could - have a good effect on the men, you know - but I couldn't trust myself in all that muck; so I'd collared a rum-case from someone's dugout, and was nursing the blooming thing, so that when the time came I could plant it in the mud and get a bit of a spring from that. I'm glad I did, too.

I passed the word along at a quarter past three to be ready for my whistle;

but it was all you could do to make a fellow hear by shouting in his ear. Our heavies were giving it lip then, I can tell you. I was in a devil of a stew lest some of my chaps should get over too soon. They kept wriggling up and forward in the mud. They were frightfully keen to get moving. I gathered from my Sergeant that their one fear was that if we couldn't get going soon our artillery would have left no strafing for us to do.

How little they knew their Boche, if they thought that!

I thought I could just make out our artillery lift, about a minute and a half before three twenty-five, but I wouldn't swear to it. On the stroke of three twenty-five I got a good jump from my rum-box, and fell head first into a little pool; a whizz-bang hole, I suppose; something small. It loosened two of my front teeth pretty much - I'd my whistle between my teeth, you see. But I blew like blazes directly I got my head up. Never made a sound because the damned whistle was full of mud. But it didn't matter a bit. They all saw me take my dive, and a lot were in front of me when I got going. But I overhauled 'em and got in front.

I believe we must have got nearly fifty yards without a casualty. But it's hard to say. It wasn't light, you know; just a glimmering kind of a greyness. It wasn't easy to spot casualties. The row, of course, was deafening; and we were running like lamplighters. You remember our practice stunts at home? Short rushes, and taking cover in folds of ground. *"Remember your file of direction, sir; dressin' by the right,"* and all that. Oh, the boys remembered it right enough. But, good Lord! It wasn't much like Salisbury Plain.

We were going hell for leather, you know. You think you're going strong, and then *whoosh!* you've put your face deep in porridge. Fallen in a shell-hole. You trip over some damn thing and you turn a complete somersault, and you're on again, not quite sure which end of you is up; spitting out mud, wondering where your second wind is. Lord, you haven't a notion whether you're hit or not. I felt that smack on my left wrist, along with a dozen other smacks of one sort and another, but I didn't know it was a wound for an hour or more. All you thought about was trying to keep your rifle muzzle up; and I guess the fellows behind must've thought a bit about not stickin' us with their bayonets more than they could help. I was shouting the name of the regiment, you know. The boys like it. But my Sergeant, who was close to me, was just yelling, *"Down 'em, boys!"* and, *"Stick 'em! Stick 'em!"* for all he was worth.

My lot were bound for the second line, you see. My No. 12 Platoon, with thirteen of 'D Company' were to look after cleaning up the Boche first line. There was no real parapet left in that Boche front line. Their trench was just a sort of gash, a ragged crack in the porridge. Where I was there was quite a bit of their wire left; but, do you know, one didn't feel it a bit. You can judge a bit from my rags what it was like. We went at it like fellows in a race charging the tape; and it didn't hurt us any more. Only thing that worried us was the porridge and the holes. Your feet sinking down make you feel you're crawling; making no headway. I wish I could have seen a bit better. It was all a muddy blur to me. But I made out a line of faces in the Boche ditch; and I know I gave a devil of a yell as we jumped for those faces.

Lost my rifle there. I'm afraid I didn't stick my man because my bayonet struck solid earth. I just smashed my fellow. We went down into the muck

together, and another chap trod on my neck for a moment. Makes you think quick, I can tell you. I pulled that chap down on top of my other Boche, took one good look to make sure he was a Boche and then I gave him two rounds from my revolver, with the barrel in his face. I think I killed the under one too, but can't be sure.

Next thing I knew we were scrambling on to the second line and that's when I got my knock-out; this shoulder, and some splinters in my head. Yes, it was a bomb. I was out of business then; but as the light grew I could see my chaps having the time of their lives inside that second line. One of 'em hauled me in after a bit, and I got a drink of beer in a big Boche dugout, down two separate flights of steps. My hat! That beer was good, though it was German.

But look here, I'm in No.5 train, that that chap's calling. I must get ashore. I just want to tell you about that dugout of my friend's in our own line, you know. It was four o'clock in the afternoon, and we'd got to Bazentin Wood all right; my orderly, who never got a scratch, was helping me back, making for our dressing station. We crawled into what had been a trench, and while I was taking a breather I sort of looked around and made out a bit here and a bend there. Begad! It was the trench we'd started from!

Seems like nothing now, but you've no idea how odd it was to me at the time; like dropping into a bit of England after about a century and a half in some special kind of hell, you know. Seemed so devilish odd that any mortal thing should be the same anywhere, after that day. Not that it was the same really. My rum-case was in splinters, sticking up out of the porridge, and I found my map-case there; torn off my belt as we went over at 3.25.

'Won't be much left of that dugout,' I thought; and I got my orderly to help me along to see. Couldn't find the blessed thing, anyhow. Went backwards and forwards three or four times. Then I spotted the head of the long trench stick that my friend had carried pokin' out through soft earth at the back of the trench. The orderly worked that stick about a little, and the earth fell away. It was just loose, dry stuff blown off the roof of the dugout, and blocking the little entrance. It came away at a touch, almost, and there was the little hole you got in by. I worried through, somehow. I was really curious to see. If you'll believe me, the inside of that dugout - it looked like a drawing-room to me after the outside, you know - it was exactly the same as when we'd left it the night before. There was the fine stove we'd made the *café-au-lait* on, with a half-empty box of matches balanced on the side of it, and the last empty tin of the coffee stuff we'd used, with the broken-handled spoon standing up in it, just as I'd left it; and my friend's notebook lying open and face down on an air pillow, in his bunk. It really was most extraordinarily homely.

There was I, looking at his notebook and his hold-all, and he, poor fellow was dead. Yes, I'd seen his body. And the rats, too; the rats were cavorting around on the felt of the roof, happy as sandboys. They didn't know anything about the Push, I suppose. By the way, we found only dead rats in the Boche trenches. They say it was our gas. I don't know; but there were thousands of dead rats there; and millions of live fleas; very live they were.

I must get off now. Cheerio!

Chapter 2

THE SPIRIT OF THE BRITISH SOLDIER

There is no vestige of any falling off in the general level of high spirits and confidence among our wounded officers and men from the battlefields of the Somme. I write of battlefields in the plural, because in this Push there have already been a score and more engagements which, as we used to judge war, would take rank as very notable and sanguinary battles; just as there have been, literally, many thousands of individual acts which, in war as we have known it in the past, would have won for those responsible the very highest distinctions we have to offer.

"I don't know what the dispatch writers, let alone the military historians, are going to do about this Somme fighting," an elderly Major, wounded in hand and shoulder on the Bapaume-Albert road below Pozières, told me. "I saw rather a wider sector than some other officers, simply because it happened I had to get to and fro several times between our Brigade Headquarters and three of our battalions. I assure you I could easily compile a volume of bald records of individual acts of heroism and the heroism of isolated sections, taking only what I saw with my own eyes. But I should hesitate to do it, because of the implied injustice to the troops on other sectors. I've talked with lots of officers between the trenches and here, including one Divisional Staff officer and two Brigade Staff officers from different parts of our Front, and I gather the same impression from all. The things I saw would have been exceptional, very exceptional, and the sort of things that pages and pages were written about - before this war. But they weren't in the least exceptional, as incidents of this present Push go. Such things have been happening, literally, all along our line, and during every hour of every day and night since July 1st."

"Does that tally with your experiences?" I asked a Company Commander, a Captain, who was leaning beside us on the ship's rail waiting for his time to go ashore for the train. His left arm was in a sling and bandages were swathed about his head.

THE CAPTAIN'S STORY

Funny! I was just asking myself that very question. I was just thinking, he replied, I was wondering how I'd manage if somebody asked me for a dozen names from my own company, for men to receive distinctions. I tell you it would be a devil of a job, and one I'd much rather not have. Suppose I try to think, on the other hand, of any one man in my company, or in what I saw of the rest of the Battalion, since July 1st, whom I'd just as soon have been without, a man who didn't play the game as well as he might have done. Gad, do you know, there's not a blessed one, not a single one. And, what's more, I haven't heard of one in any other unit, not a single one, and one hears a devil of a lot, one way and another, bucking with this man and the other all the way between there and here, you know.

Afraid I'm not much of a praying man; but I'll tell you what, if I'd set to work praying on the night before we went into this show - and, mind you, I daresay lots of chaps not previously given that way did pray that night. It's a big thing,

167

you know, taking your men into a real large-scale battle for the first time, when they were all civilians a little time back, and perhaps you were the same yourself - if I had, on that last night of June, I reckon what I should have prayed would have been that my company should accomplish just about half what it did. Upon my soul, I shouldn't have dared to ask that they should do all that they actually did when the time came. I should have thought that was asking a jolly sight more than was reasonable. No, I'd have asked for about half what I got, and thought myself thundering lucky if I got it. As it was, I'm perfectly certain that a company of Guardsmen, with ten years' soldiering behind each man of 'em, couldn't have done more than my chaps did. They mightn't even have done quite so much. You see, our chaps felt the honour of the New Army was at stake, and its reputation all to make. We'd told 'em how Kitchener's men didn't count seriously, and all that; and, by gad, they went into the scrap like knights of the olden time with their ladies lookin' on, you know; as though the New Army would stand or fall in history according to how each single one of 'em carried himself in this show. You couldn't check 'em; nothing was too bad for 'em; and, I give you my word, nothing you can possibly say will be too good for 'em.

"Well, Sergeant, what's yours?" My next inquiry was addressed to a fine, upstanding Sergeant of the Middlesex Regiment, who elected to walk ashore instead of being carried, though he was glad of a comrade's shoulder to lean on. A year or two ago the question might have suggested an American bar, but not on the landing stage at Southampton in these days.

THE SERGEANT'S STORY

Oh, I got it just below me thigh, here, sir; nothing to write home about, anyway. I ought to be back this way again in a week or two. I hope I will. You see, sir, the second Sergeant in my platoon got it fairly in the neck - proper bad, I'm afraid he is. They do say he may have to lose his right foot. Anyhow, he won't be back for some time, if at all; and it's bad for the platoon for the two of us to be away. Now they've made such a fine start I want to be with 'em an' keep 'em up to it. Though you wouldn't have said they wanted much keeping up to it, sir; not if you'd seen 'em at it. I reckon they saved the Battalion's flank there between Authille an' Ovillers; an' there's no sort of doubt they smashed the flank of the Boche battalion. He'd got a regular nest o' typewriters there; machine guns, I should say, sir. We stood it for a bit, an' then my officer he began to get pretty mad with 'em. Always was a bit on the hot-tempered side, you know, sir; but as good an officer as ever I served with.

"Here, damn their German eye," he says, just like that, when he sees our chaps a-droppin'. "We'll get these devils in the flank," he says. "They're not goin' to tell off my platoon that way. Come on, Sergeant," he says, "at the double now. Get those bombers of ours close up here behind me."

We fairly raced then for their right flank, an' all there was of us tumbled down into their ditch all of a lump. "Bombers here!" yells my officer. He'd got two machine-gun bullets in him then. Much he cared for that. We got our bombers up, and - well, as my officer said, sir, we did fairly give 'em hell after that. The platoon went through that trench like a dose o' salts, as you might

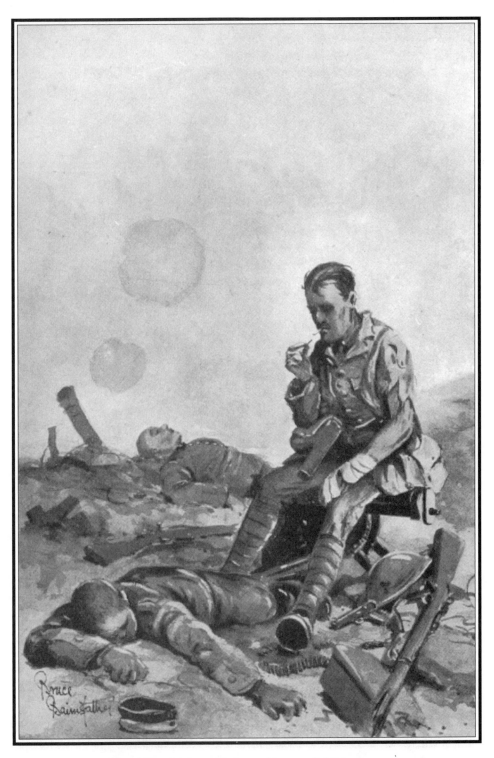

I found him sittin' on a Boche machine gun, lightin' a fag . . .

say, sir. Worried along it, like terriers in a rat earth. Never so glad in my life to have plenty of bombs. We bombed the trench fair empty; an' any Boche that missed the bombs, well, he got the steel, an' got it good an' hard; in an' out, an' in again every time, to make sure.

An' that's how our Battalion was able to make such a good advance, sir. The rest of our company was layin' doggo while we promenaded down that bloomin' trench; an' when my officer gave the word - he'd got a third bullet in him by then, sir, not to mention bomb splinters an' the like o' that - they came on like a cup-tie football crowd, an' the rest of the Battalion after them. They went over that first line with hardly a casualty, barrin' just a few from shrapnal; an' if they didn't give the Boche what for, in his second an' third lines, I'd like to know.

My officer was fair runnin' blood by then. He got so many splinters, you see, sir, about the head an' face, besides the three bullets he'd got in him. I found him sittin' on a Boche machine gun lightin' a fag; a cigarette, I should say, sir. The Boche machine gunner was there too; only he'd never smoke no more cigarettes, nor fire no more machine guns. He was done up pretty nasty, sir, was that gunner. But his gun was all right, because I saw two of our machine-gun section firing it off not many minutes later.

I tried to make my officer let me help him back for dressin', but he wouldn't have it - not then. He smoked his cigarette, while I put the platoon on cleaning out dugouts in that trench. I don't mean the mud, you know, sir. We knew we weren't goin' to hold the trench, because we was pushin' farther on. No, but a good many Boches had taken cover in them dugouts; an' what wouldn't come out when we gave 'em their own bat, you know, sir - "Kommen Sie hier," an' all that - well, they had their choice between the bomb an' the bayonet, as you might say.

There was a few of 'em played the game pretty well, I will say. They'd a young officer with 'em, an' they fired at us as fast as we could get near the mouth o' their dugout. We didn't want to hurt the beggars, but we'd got our job, same's they had theirs; an' in the end theirs was bombs - in the neck. But most of the others jumped to the word, an' come out quick an' lively on the order. We got forty-seven of 'em, very little damaged. We disarmed the lot, an' when we joined up with the rest of the company my officer took that bunch of prisoners back to our lines by himself. Got two of the biggest to carry him at the rear of the squad on two rifles. He had his revolver in one hand and a Mills bomb in the other.

"Cheerio, Sergeant!" he says to me. "Keep the boys a-movin' till I get back." But bless you, sir, they don't want any telling. No more'n terriers want tellin' to get after rats. I was wounded half an hour after that; an' next time I saw my officer was down at the dressin' station.

I only saw the one German officer - that boy in the dugout. I think that's one reason why the Boche is losin' heart a bit, an' shows himself pretty ready to be taken prisoner. His officers do keep most uncommon well out of the way; very different from ours. An' I suppose it makes their men feel the game is up. But they fight real well till you're right on top of 'em. I'll say that. Only, man for man, when it comes to it, they can't live alongside our chaps, you know, sir - not they.

Chapter 3

THE MORALE OF THE BOCHE

These are the words of a Lieutenant-Colonel, spoken just before he landed from one of the hospital ships; "Yes, I think you may take it Master Boche will never again set foot on the ground we have won from him this month, and I think he knows it. But, although it's mighty hard to get, the ground we've got from him is the least of the things we've taken from the German Army, as I see it. The main gain is in the changes wrought in the two armies - the Hun's and ours - since July 1st. And that you can't reckon in figures. Begad! There aren't any figures big enough for the reckoning."

His wound, one is glad to say, is a slight one, affecting one hand only, and this gallant officer himself regarded with some irritability the action of the medical authorities in separating him from his unit at all at the present time. "I asked for a dressing, and they insisted on giving me a trip to Blighty. However, thank goodness, I can trust my Second-in-Command, and I shall be back with my Battalion before very many days are over."

A wounded Captain from another battalion was sitting beside us in the companionway, and nodded thoughtfully over the Colonel's reference to those of our recent gains which cannot be measured in villages or in thousands of yards.

"Yes," said the Captain, "it's the blow to the Boche morale that counts more than the ground."

"Morale. It's one of those words that people are constantly using," said the Colonel. "I wonder if the general public have any very clear idea what it covers. They use so many words now which don't really give 'em pictures, and words that don't convey pictures to the average mind aren't very informing, you know, really. When I've been home on leave I've found all sorts of people talking glibly of dugouts, fire-trenches, barrages, consolidation, and so on, with never a hint of a picture in their minds of what the words really stand for.

"Fighting's a pretty queer business, you know, when you come to think it out, especially this sort of tornado of fighting we get now, and for twentieth-century men, lots of whom never had so much as a shot-gun in their hands till a year ago. It's more of a miracle than people at home will ever understand, is the New Army. And one of the most miraculous things about it is that at the present moment it is carrying on fighting of a kind vastly more terrible than any that the world has ever seen before, and, mark you, carrying it on with as fine a steadiness, with as much stubbornness, and as much dash, too, as any veteran army known to history has ever shown. And if that isn't something of a miracle - well, you ask any Commanding Officer with more than ten years' service behind him.

"This business of fighting - fighting continuously and cheerily in the presence of devastating casualties has a good deal in common with swimming and bicycling and things of that sort in which instinct plays a big part; horse-riding too; anything that demands perfectly smooth co-ordination of thoughts, nerves, muscles, and . . . well, and spirit.

"The material supplies are essential, and in the fighting we've got before us now any failure in the material supplies must mean complete and most bloody failure all along the line. But there are other essentials, too. Every experienced leader of soldiers knows it; aye, and prays over it, if he happens to be that sort. But I suppose nobody can describe it; define it, I should say."

The Colonel and the Captain were clearly thinking hard, in this odd interlude in their journey from shell-swept trenches to quiet English hospitals. They nodded occasionally one to another, as two men who perfectly understood the matter in hand, and entirely agreed that it could not be explained.

"Your Staff arrangements may be perfect, and your material all there, you know, but if the other thing is missing, or weak, wrong in any way - well, the fighting doesn't come off; that's all there is about it," continued the Colonel. "You can't measure it or weigh it up, any more than you can measure a cool breeze on a sultry day, but you can feel it rippling through the ranks, just as clearly as you can feel the little breeze. And God help you if you feel the absence or the failure of it, because in fighting there can be no success without it. But we've never been without it for a moment in this Push."

The Captain nodded, slowly and emphatically, beating time, and underlining his assent with his cigarette.

"I tell you this New Army's got it, for keeps," continued the Colonel. "If you start thinking about the balance and steering of a bicycle you're going to run into a kerb or something - if you start thinking. But if you *know*, hand and mind and nerves all one - why, she goes, like a charm. Fighting's rather like that; plus heat and anger, and din and fury, and - fight, you know.

"I've been in this show since it began, since the morning of the 1st, you know. Our chaps have remained much the same all through, except for one thing. At the outset they had duty in their minds, doing their bit, you know - their job. Now they've got victory in their blood. They've got to real grips with the Boche. They've found he can fight all right. They've seen he's got to. And they've found he's splendidly equipped. But they've found something else. They've found they can beat him. They've found they're just as well supplied and backed up, and a bit better.

"And, above all, they've found that when it comes to actual grips, knee to knee work, they can beat the Boche every time. They've found they are better men and in better heart; which they certainly are. That's the only change so far as they're concerned. That's the advance they've made. And I can tell you it's a mighty big one; bigger than anything you'll measure in kilometres.

"But it's not so big as the other part of the advance they've made. They've accounted for hundreds of thousands of Boches, killed, wounded and prisoners. But they've done more, far more. They've hit every single Boche soldier the German High Commands have put up against 'em, and hit him very hard, and very much where he lives. And, for aught I know, they've hit every other German, every Hun that lives, whether he's in uniform or not."

"By God, they have!" interposed the laconic Captain, with several emphatic nods.

"Double-edged business, you see," continued the Colonel. "For every ounce of morale you gain you take at least one from the enemy."

"One pound, sir; at Mametz, anyway," said the Captain.

"Well, maybe a pound. My point's this: the Hun - poor devil! - has been very carefully taught. The Boches are regular artists at propaganda. He's been taught, ever since he scratched into the lines we've taken between Thiépval and Combles, that the very most

the contemptible English could ever do would be to hold their line, to sit still, until such time as the All Highest was ready to give the word to sweep them into the sea.

"Offensive movement was quite impossible for these make-believe soldiers of ours. We were all shopkeepers who did not know one end of a rifle from another, and too soft, anyhow, to stand up for a moment against real, live Huns, once the Hun had made up his mind to move. We were cruel, cowardly devils, who would torture and kill any worthy German who was misguided enough to fall into our hands; but we were not soldiers: our soldiers had all been killed by the valiant German Army in the very beginning of the war, and a real offensive was utterly impossible for us. I've talked to lots of prisoners, and I assure you that's the sort of thing they've been taught, and that's what they believed.

"I tell you, it would have been better for Germany today if her leaders had told fewer damned lies in the past; better in a thousand ways. It would have been a deal better for the Hun today if they'd taught their soldiers that the British Army was their most deadly and formidable enemy. They're beginning to see it now - too late.

"Their organisation is so complete, their subjection of their people so brutally thorough, and, mark you, their teaching of their soldiers is so good, that they'll go on fighting automatically whatever happens. And they are perfectly equipped. The material is all there, the most formidable fighting machinery in the world is there; but the indefinable something, the thing that enables you to balance and steer your bicycle so easily and naturally without thought, the spirit you want to feel rippling through your ranks like a cool breeze - if you are to win; they've lost that, and we've got it, got it for keeps.

"People who try to measure the importance of the Push by the ground gained, or even by the casualties inflicted, will fall a long way short in their estimate of what it all means. The object in war is the destruction of the enemy, and the most important asset any enemy has is his spirit - the morale of his troops. Since July 1st our New Army has inflicted a crushing blow upon the enemy's morale. With the same troops the Boche can never again achieve the same ends.

"With the same troops on our side we can achieve greater ends. It's partly the successful bravery and dash, and the stubborn endurance of our troops, and the tremendous weight of our munitions, that have so reduced the Boche morale on the Somme, and it's partly what the Boche himself has done, in the matter of long and careful teaching based on lies.

"Our chaps have let in the light of a little truth into the Hun's lines. It would have done 'em no harm if they'd been fed the truth. But they've been fed on lies, and the new diet's upset their digestion.

"In my opinion, what's been accomplished this month would have been a big gain to the Allies if our casualties had been five times what they have been. Napoleon may have been right when he said an army marched on its stomach; but, believe me, a modern, educated twentieth-century army fights on its nerves and spirit. And that's where we are immeasurably ahead of the Boche, and a long way ahead of our position of even last June."

Chapter 4

AN IRISH OFFICER DESCRIBES THE INDESCRIBABLE

The mellow Irish voice of a Lieutenant was the first to welcome me on board one of the hospital ships on a recent fine morning. I was glad to find this very popular Platoon Commander a 'walking case'. From others I had already heard much of the fine and dashing work done in the present Push by the Irish Regiment to which this chap belongs. But there were certain other officers whom it was necessary to see at once on this particular steamer, and, knowing of the Lieutenant's nimbleness with his pen, I bade him sit down in the ship's companionway forthwith, and write out a full, true, and particular account of the Great Push.

Give us the realities, real pictures, something much more informing than any of your letters I have seen, he was told. Perhaps I made some other remarks not conspicuously more reasonable. Here, at all events, is what he wrote, in indelible pencil, on the thin pages of an Army Book 155, the cover of which bore the stains of French trench dust and English blood. There may be little here to indicate the dashing gallantry, the dogged, always cheery bravery of his Irish fighters; but it is worth reading, all the same, and as for bravery - well, there is not a battalion on the British Front, between Thiépval and Guillemont, which has not earned imperishable honours and distinction since the 1st of July.

THE IRISH LIEUTENANT'S STORY

What you say about my letters home may be entirely deserved, my dear Skipper; but it is also, I think, quite unavoidable, even apart from the necessary censor restrictions. Let me tell you, sir, as one not wholly devoid of practical literary experience, that what you are looking for is simply not to be had. The business of this Push - of any other important phase of the war, for that matter - is too big for letters. Begad, it is too big for literature itself. You won't get it on paper.

You can get little bits; yes, and much good they will do you. Almost any written bit is calculated to mislead the innocent. Why? Because, taken by itself, it is essentially untrue. It's only true when seen as it is seen in reality - one chip in a mosaic. Looked at all on its lonesome, it is essentially false.

Why, if you'll believe me, the Colonel of the battalion next to ours borrowed a handkerchief from me to blow his blessed nose with in the middle of one of the bloodiest little shows that ever was.

"Got a handkerchief to spare?" he said, in a casual sort of way. "I used mine, tying up a fellow's arm, back there."

I gave him my handkerchief, he blew his nose comfortably, and shoved the rag in his breeches pocket.

"That's better," says he, and hurried on with the advance. He was with the rear company of his battalion, and the way he managed to get in and out among his men, cheering them on, was wonderful. He was rather badly wounded

later on, in hand-to-hand fighting with four Boches who had cornered two of his men, in their second line. But he's all right, I think.

Men were dropping all round us in that advance. It was an extraordinarily bloody business, and had been for thirty hours and more before that. But one remains human, you understand. One tries to get a mouthful of grub at certain intervals, and a smoke if possible. And a man wants to blow his nose on occasion, even though all hell's let loose, and - well, some of us prefer to use handkerchiefs for that purpose, if we can. You follow me. But how easy to convey an entirely false impression, with a picture of a Commanding Officer borrowing a handkerchief and blowing his nose in the midst of a hot advance.

Suppose I set out to depict something of the shapeless, grisly horrors of it all. God knows there's enough of 'em. What's the best effect I'll produce, especially on anyone who's never been out there? An effect of shapeless, confused, purposeless horror. Well, is the Push no more than that? You bet it is.

Why, looked at from one point of view, it is positively beautiful. From the platoon standpoint it may be a colossal lark or a tangled horror, whilst, from the High Staff standpoint, the main impression may well be one of mathematical nicety, perfectly dovetailed detail, and smooth-working precision.

To give you an instance: the other afternoon I came mighty near to puking in a warren of Boche trenches we took outside Longueval. Nothing much. We've all seen worse things. A little heap of four dead Boches. They were decently buried an hour later. It just happened I was about the first of our people to see this particular shambles.

You know how careful our chaps are, with their kindly sense of decency. Their first thought is to cover a dead Boche's face, give him some decent dignity, even if they're not able at the moment to give him decent burial. English, Irish, Scots, Canadian, Australian, South African - all the British troops are like that. Well, they hadn't had time to clean up here, and these particular Boches had been done up pretty nasty, as they say, very nasty, indeed. Some of our heavy stuff must have landed right among 'em. They were in the mouth of a dugout.

Right. Two minutes later I came upon as homely a little picture as you'd find in the neighbourhood of any peaceful Irish or English village: three of our lads crouching over an old brazier, on which they were making afternoon tea, if you please, frying a scrap of bacon and boiling the water for tea at the same time, I took it in, and passed on, pondering the queerness of the whole business. I wasn't more than sixty or seventy paces away, when three Boche shells arrived, like a postman's knock, somewhere close behind. Just three and no more; one of the flukes of the day.

Something made me turn back and go to take another look at the tea-party. One of its members had been instantaneously killed, his head smashed to a pulp. Another had been terribly mauled about the loins, and was already being attended to by a couple of stretcher-bearers who had been resting in a dugout within sight of the party, and themselves had been covered with earth and dust from the shells. I lent a hand, and they very soon had the poor chap on his way down to the dressing stations. But I feel sure I won't ever see him again. You know that hopeless yellow pallor.

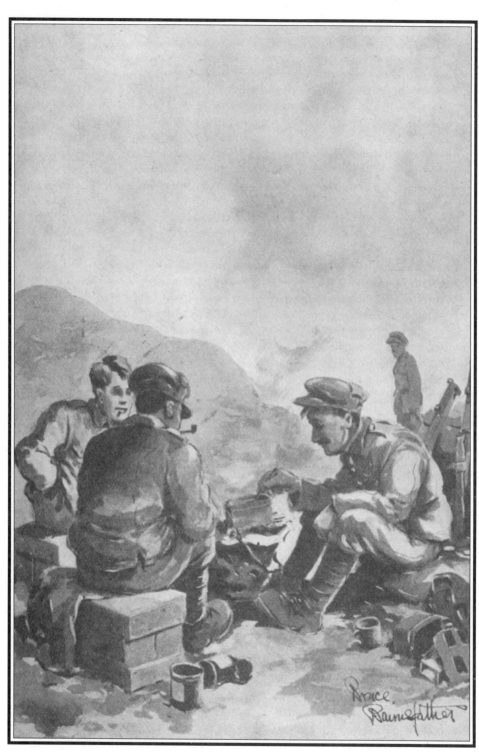

Two minutes later I came upon as homely a little picture as you'd find in the neighbourhood of any peaceful village . . .

I was back that way within a quarter of an hour, and there was another man, rolling a cigarette in a bit of newspaper, having just finished the bacon. His half-filled canteen of tea was alongside the brazier, which lay now on its side; upset, no doubt, when the shells came: indeed, it was half buried. But he told me the bacon had been saved, and, in some queer way, the tea. So he had had the other chaps' whack as well as his own, and as he rolled his cigarette in the scrap of a Sunday newspaper he was humming 'Keep the home fires burning'.

My dear Skipper, you can no more hope to get the Push described for folk who haven't been out, than you can hope to get the world described, or human life explained, on a postcard. The pen may be ever so mighty, but, believe me, it has its limitations.

What's the Push like? It's like everything that ever was on land or sea, and nothing that ever was as well. It's all the struggles of life crowded into an hour; it's an assertion of the bed-rock decency and goodness of our people, and I wouldn't have missed it, not for all the gold in London town. I don't want to be killed, not a little bit.

But, bless you, I simply can't be bothered giving it a thought. The killing of odd individuals such as me is so tiny a matter. My God, Skipper, it's the future of humanity, countless millions, all the laughing little kiddies, and the slim, straight young girls, and the sweet women, and the men that are to come; it's all humanity we're fighting for; whether life's to be clean and decent, free and worth having - or a Boche nightmare.

You can't describe it, but I wouldn't like to be out of it for long. It's hell and heaven, and the devil and the world; and, thank goodness, we're on the side of the angels - decency, not material gain - and we're going to win.

Chapter 5

CLOSE QUARTERS

Among those who were permitted to board a certain hospital ship when she berthed at Southampton was a Lieutenant, an officer from a Territorial regiment, whose Battalion accomplished some fine work at Pozières. This officer was sent home during the early part of the Somme offensive, slightly wounded, and will by now have returned to duty. He had not taken half a dozen steps on the vessel's deck before he was saluted by a private of his own Battalion, whose jacket was thickly coated with the grime of later fighting at Pozières, and splattered over with blood up to its left shoulder. In the powwow that followed one tried to get this man's own words. What follows is about the way of it.

THE TERRITORIAL LIEUTENANT'S STORY

I found your glasses and stick, sir, close to where the stretcher-bearers were hung up that time; you remember, sir, that little dead-end where there had been an old French dugout. There was a big gas-gong hanging there, you may remember, sir, on the haft of a broken pick in the side of the trench. I gave 'em

to the Sergeant so they wouldn't be lost.

The platoon's in clover now, sir. They were coming out for a rest when I was taken away. It was after the Pozières scrappin' was over I got my second wound - getting back down the new sap we made. My first was nothing - a machine-gun bullet.

The platoon's to have two or three days rest, I believe, sir. Seems queer, resting back there in what used to be the Boche lines, you know, sir. They're ours now, all right, and some of the deep dugouts are first-rate; came through the crumping all right, they did. That place the [censored]s raided, you know, sir, in June it was, when the prisoners started scrappin' on the way back across no-man's-land. You could see our chaps lying about there smokin' and usin' the Boche's cookers now.

But we had a hot time all right after you left, sir. The way it was when you left, it went on just the same - not a minute's break - for the rest of the night. All day long, and the next night, before any ease-up came. But the Captain said the platoon had done real well, sir, what there was left of us. You could see he was pleased, and the Commanding Officer, sir, he said we was a credit to the Regiment; so I think you can feel all right about the platoon, sir. We were moved up to the right - our Company - after you left, and were next to the Australians, and I must say they did fight like men, sir; but not any more than our boys. There was a bit of racin', like, between us there, you know, sir, and one of the Anzac Corporals told me we made it easy for them; but that must've been his blarney, sir, because there wasn't nothing easy for anybody in such a hell as that Pozières was.

I thought at first being dark would make it better for us, but now I think the daylight best. We got to that road at last, you know, sir. It seemed we never could, because of their machine guns; but we did, and the Boche he had it fair honeycombed with deep dugouts and trenches; but we put the wind up him properly when we got there, sir, my word we did, and those what was left was pretty glad to put their hands up. After the cruel time they'd given us on the slope, our boys did want a mix-up at the end; but the CO and the Captain, they wouldn't have it, sir. They were runnin' up an' down our line tellin' us about it, an' the Captain, he was near choking for want of breath; but he shouted all he could, and kept on putting himself between the Boches with their hands up and us, an' every one o' they Boches was taken prisoner, and not a one hurt. It's right, too, of course, when they surrender.

When the order came for our platoon to hold on to that little ridge above where you was hit, sir, I must say I thought it couldn't be done. We was all alone, you know, sir, an' when they tried to bring up another platoon they had to be recalled, for the Boche had that ground so swept with his typewriters a swallow couldn't have flown there. Five separate times the Hun came down on us; an' when he wasn't charging he was crumpin' an' machine gunning something chronic. If you lifted your head to look just for a second, you got it in the neck every time. When we got the reinforcement up that night from No.8 and No.7 there was only one of us hadn't been hit; that was little Joey Green, in my section, you know, sir. But we were able to keep the Lewis gun going when they were charging. I think that's what saved us, really, sir. Couldn't use it, only when they was charging, or it would ha' bin blown out of action in

a second. But we peppered 'em all right when their fire lifted to let 'em charge.

A good little gun, sir, though it did get red-hot. I tell you, sir, I felt like blessin' the chaps who made it so's it could stick the job, an' the chaps that fired it, too, when they'd been pretty badly wounded.

You see, sir, we was all right with the bayonet, so long as it was only maybe two Boches for each of us when they charged. We could manage that pretty comfortable. But if it hadn't been for the Lewis I think we'd have had half a dozen Boches to each one of us every time he charged; and I don't think we could've stood it.

I had a little parapet of three of 'em, head to tail, in front of me, and I reckon that sheltered me quite a lot. I've got their three caps and bayonet sheaths here, that I tied on the back of me belt.

The fifth time the Boche charged I stopped one with a bullet just before he could reach my bayonet, and the one behind him threw down his rifle an' shouted "Mercy!" with his hands over his head. I wouldn't have hurt him; didn't want to hurt the beggar, you know, sir; though you'd be pretty sick to see one of our boys do the like o' that. But it seemed he couldn't help himself, an' he ran right onto my bayonet; spitted himself, he did. I did my very best to patch up the last one; but it was no go, he snuffed it, sir, while I was fixing my field dressing on him. I felt sorry for that Boche, in a way, seein' I hadn't wanted to hurt him at all. I suppose they can't help bein' different from our chaps, "Mercy, Kamerad!" an' all that.

And here is another little story of a Private soldier who did his bit on the left of Pozières. A company Quartermaster-Sergeant, who was wounded by a stray bullet at a ration dump well behind the lines, gave me a note for an officer now in hospital in London. I found out what hospital he was in from the Royal Army Medical Corps (RAMC) staff, and wired asking permission for the publication of the note I was sending him. His reply was, "Anything you like that will do justice to as fine a lot of men as any officer ever had." Well, I don't think this note does them any injustice, anyhow.

THE BATMAN'S NOTE

I am bringing you the wristlet watch that was on [censored]'s wrist, because the other batmen told me it was yours, and only lent to him. As I am told you are somewhere in London, sir, I daresay you may be seeing his family. He was with the front line on the left of Pozières, with the rest of his platoon. His mates tell me his rifle had been knocked out of his had. The shell-holes there must have been hard to cross at the double, in the dark, with such a heavy fire on, too. But he somehow managed to down his man all right. When they found him he had a Boche's bayonet and rifle in his right hand and his left hand was at the throat of the Boche he'd killed. He was lying right across the man, and he had a bullet through his head. We think a machine-gun bullet got him while he struggled with the Boche on the ground, after sticking him with his own bayonet. So you see, sir, your batman died pretty game, like the rest of our boys who went West. But I am glad to say our casualties have been pretty light on the whole, when you think of the masses of Boche dead, not to mention the prisoners.

I hear the Brigadier is very pleased indeed with the Battalion's work, and

that many in our company will be mentioned in dispatches.

The Sergeant-Major sends his best respects, and hopes your wound is healing well.

We have been doing fine lately in the matter of boots and socks, and the rations and bath arrangements have been going like clockwork since you had it out, sir.

Chapter 6

THE DEVIL'S WOOD

They were all three walking-wounded cases, seated at that moment in the companionway of the Red Cross ship just berthed. Their bandages were clean, and I have no doubt their wounds were also clean; but for the rest, all that was visible of those three Subalterns was . . . well, it had too much of Delville Wood about it to be clean. One feels that some of these tattered, blood-and-soil-stained uniforms should be preserved precisely as they are when their wearers step ashore at Southampton. No doubt some will be. Proud mothers and sisters should see to it.

Delville Wood, for example - one example among many - will remain a tremendous memory for a good many of our heroes of all ranks; and, too, a marked point in history.

"No, we don't know anything about Pozières. We're from Delville Wood, all three of us. Oh, I don't know. There may have been worse places, you know; but it was a pretty hot shop when we were there; not exactly a health resort, you know, anyhow. If Pozières was worse it must have been quite nasty."

"I did get one cigarette, or half of it, as a matter of fact, in Devil's Wood," said the fair-haired Subaltern whose bloody tunic had been holed over the right shoulder-blade, as well as slashed to ribbons in front. "But that was a fluke. I was in quite a deep hole then. You remember that place just below the left drive. Mostly, the only way to get a moment's comfort in Devil's Wood was to get out of it, dead or alive; and there were times when you felt it didn't much matter which."

"Oh, I say, come off it!" protested the dark boy, who, after a course of Turkish baths, might have posed for an artist specialising in cherubic choristers. "It was never so bad as all that, sir. It's rather good to have something to chew in a place like that. Seems to mitigate the stinks, too. I had milk tablets; jolly good things."

"It did niff a bit, didn't it?" said number three. "Always used to think dead Boches were the most satisfactory kind of Huns; never thought one could see too many. But there were rather too many in Delville Wood. Must say I didn't like 'em; especially at night, when a fellow was crawling about. Flies too; there were more flies than one really wanted in Delville."

"Oh, damn! I hate those flies. One was always thinking what they'd been on last."

"Really? Did it strike you that way? I can't say I had much time for thinking about the beggars. But I noticed they were a bit thick. Flies like blood, you know."

"Do they? Well, Delville Wood's the place for 'em, then. There's plenty of blood there - my aunt! I saw Boches there bled white; the ground all round 'em soaked."

"Hmph! Our own, too. By God! That northern strip was a hot shop. How many machine

There's a good deal of solid comfort in a Lewis, if you can find a decent shell-hole handy . . .

guns do you reckon the Boche had there? Like a typewriting shop, wasn't it?"

"But it was rather jolly when Fatty got our little Lewis up in front there, wasn't it? Made the rifles seem a bit slow. There's a good deal of solid comfort in a Lewis, you know, if you can find a decent shell-hole handy. I liked the red spit of it in the night. Pretty comforting that when you heard the Boches creeping about."

"That was one of the things about the Wood; you never could move in it without making some row."

"Row! But did you ever hear anything like the row our heavies made in that last hurricane burst? I was trying to explain to my Sergeant just what we were going to do, when the curtain lifted, and, upon my word, though I yelled in his ear, he couldn't hear me."

"Fine, that, wasn't it? The scramble when it lifted. God! It was a great fight, that last bit. Our chaps had their teeth set then, all right. One of my section commanders was wounded in three places before we started; but he went like an absolute madman in that scramble until that little ridge. Never saw anything like it in my life. His face was covered with blood, he'd got no coat, and his shirt had been all torn away in putting field dressings on him. I tried hard, but he got ahead of me, and he downed two big Boches in that shallow trench as though they'd been thistles, just smothered them he did, and then he got it fairly in the neck. A bomb burst right at his feet; laid out three other chaps at the same time. He was a man, that chap. I got a bit of his own back for him. It was a Boche Sergeant shied that bomb at him; but he'll never throw another. I beg pardon? No, no; I hadn't got a rifle then. But I had my little truncheon though, and it was good enough. Oh, I don't think he was the surrendering kind. Anyway, he didn't get the chance. He was one of my own section commanders, you see, and one of the best. Yes, I made quite sure about that particular Boche. He wasn't a bad sort; put up a good enough fight."

"Aye, aye, a queer business. You know there were some real brave things done at the end of that show. They can't give DCMs to everyone, you know; but, honestly, all those men earned it, just as well as any of the chaps who get it."

"Of course they did. So do thousands every day in this Push. Thousands of 'em every day are doing bigger, finer things than lots of things men got the VC for in the old days."

The "old days" are, of course, the days before 1914, to these young veterans. God bless them!

"Yes, but look here; what I was thinking of was the lot of things that nobody at all ever knows about; not even a man's own mates. Now, look here. You know we had to fall back a bit, once, from that shallow trench at the top. No, I mean after we'd been in it, and thought we'd got it. Yes. Well, we fell back for - oh, it must've been ten minutes, the time I mean, and a lot more Boches came up along those communicating saps, and it almost looked once as though we wouldn't get it back again."

"Never looked any other way, I thought. Can't for the life of me see how the devil we ever did get it. Damn it! It was obviously impossible to get it, because of those machine guns."

"I know. Well, I got my dose in the trench, you know. When I saw you all falling back I tried like the devil to get out. I was in quite a deep bit, alongside that traverse with the big tree on it, where what's-his-name was killed. I nearly broke blood vessels trying to get out; but it was no go. My shoulder was giving me hell, and the right arm wouldn't work at all. Well, you know, I'd rather have been sent West altogether. I always did feel I'd rather anything than be taken by the Boches. I had my revolver, of course; but I'm

not much good with my left hand. Ten to one they'd have got me alive. I could just see over the edge, and I was cursing my luck, when I saw a chap deliberately stop, turn round and look at me, and sort of weigh up his chances. He was falling back with the rest of our lot, you know. Just then a Boche machine gun opened, as it seemed, right alongside me. It was really just round the big traverse. 'That settles it,' I thought. 'I'm done for now.' And it did settle it, too. That chap I'd seen, who'd evidently decided once that it wasn't good enough, altered his mind when the typewriter began. Down on his hands and knees he went, and scuttled all the way back to where I was, like a lizard. He fairly gasped at me; no breath, you know. 'On me back, sir,' says he. And, somehow, he hauled me out and slung me over his back. I fell off three times while he was scrambling down the slope with me, and three times he stopped, in all that fire, and fixed me up again. And then I felt him crumple up under me, and at the same time I got this; through the left arm. I rolled clear and looked at his face. I'll never forget his face, but he had no coat or cap, and I didn't know his battalion. His forehead was laid open and bleeding fast. I dragged him behind a stump and laid him with his head on my haversack. Then I scrambled out to find a stretcher-bearer for him. But I got caught up in our advance then. You know what it is. And I went on, thinking I'd find my man after. Glad I went in a way, because I had three bombs a wounded Corporal gave me, and it was easy lobbing them with my left at close quarters. By gad, I lobbed 'em all right, before we cleared the trench. It was hours after, before I could get a man to help me look for that good chap who'd dragged me out, and we never found him - never a sign of him. But to do what he did, thinking it out, too, in all that hell - why, many a chap's got the VC for no more that that, I think."

"Yes, and there were dozens of things like that in Delville alone."

"Same all along the Front."

"Right through the Push."

"I believe it was, upon me word."

"I'm dead sure of it."

"Oh, I tell you, as the men say, 'The Army of today's all right!'"

"London train? Yes, that's me, orderly. Come on, boys. I beg your pardon! Good-bye, sir!'"

Chapter 7

THE COCKNEY FIGHTER

A mong the wounded who arrived recently at Southampton I found both officers and men whose experiences since July 1st may be described as unique in all the world's history of war. These are men who 'went over the sticks' at 7.30am on July 1st, and have been fighting at one point or another in the present great offensive north of the Somme ever since.

There are, of course, magnificent soldiers in the French Army who have been through an even longer period of fighting at Verdun; and the fighting before Verdun was probably the most intense recorded in history up to that time. But, as a French officer stated only the other day, after returning wounded from the south of Péronne, "The British part in

the Somme offensive has been Verdun magnified, Verdun on a bigger scale."

Another French officer has stated that the artillery fire in some portions of this line has been "more terrible, more intense, more devastating than the worst seen at Verdun."

When one carefully thinks out what the day-to-day and night-to-night fighting has been between Authille and Guillemont since July 1st, and then comes to talk to a soldier who has actually been through the whole of it, one marvels that any ordinary twentieth century human being could possibly survive such a month so spent.

I talked with many, on the landing stage, who not only have survived it, but can jest about it, and talk with indomitable cheeriness about getting back to it "before the show's over."

One particular Private will always retain a prominent place in my gallery of such wounded heroes, who have not the faintest notion that there is anything heroic about them. He is a Cockney. I have met his like in the ranks of the old Army, the Territorials, and the New Armies; but never, certainly, one who has known such months as he has just lived through; never before this year.

"Fed up? Wot, our boys fed up, sir? Not likely! Why, we're just beginnin' to like it. But I bet Mister Boche is gettin' a bit fed up. Least, some o' them as I saw, they was; right up to the bloomin' neck, as you might say, sir."

But I feel there is something terribly inadequate about my attempt to reproduce his racy vernacular; also I cannot hope to convey on paper any conception of the incorrigibly humorous devilry in the man's mobile face. Brave! I would say he was braver than a stoat; and that may mean something to anyone who has known a stoat defy him and his stick on a footpath; who has been deliberately challenged, as I have been, to mortal combat with a stoat over the body of a crippled fieldmouse.

The Private got his quietus in Delville Wood. Three separate times before, after July 1st, he was slightly wounded, and received all the attention he would accept at advanced field dressing stations. In Delville Wood he went on fighting for a long time with considerable wounds in the left shoulder and arm, and only gave out when rendered perfectly helpless by a smashed ankle and two slight head wounds.

THE COCKNEY PRIVATE'S STORY

To 'ear the way they talks abaht that Devil's Wood you'd think there was something *wrong* abaht the bloomin' place. For me, I like the in an' out close work, I do; better'n this bloomin' extended order work in the open, with the bloomin' typewriters clack-clackin' till you can't 'ear yourself speak. An' they can't 'ardly 'elp hittin' you, neither. Same's it was at Monterbang an' comin' up to Longyval. No, give me the in an' out work, I say, every time. You do get a bit o' fun for your money in a place like Devil's Wood. I've done a bit o' scrappin' down at Wonderland, I 'ave, an' when my orficer give me a little trench dagger, wot fitted on me left 'and like a knuckle-duster - 'e 'ad two or three of 'em, 'e 'ad - why, I tell you, it was a little bit o' alright for me.

There's somethin' to keep a man amused abaht that sorter fighting. Not like this open order work, where you never knows who 'its you. I didn't arf walk into them Boches when we rushed 'em in the Wood; nor arf, I didn't. 'Time gentlemen!' I useter say. Much I cared abaht their toastin' forks once I could get close in. You let me close in, sir, same's we did in Devil's Wood, time an' time again, an' I'll back meself to serve you up Boches fast as you can open oysters.

No, I've got no fault to find with Devil's Wood. If only a Royal Engineer's fatigue party could o' got in there first an' done a bit o' a clean up, as you might say; got some o' the wood an' wire an' rubbish an' that outer the way, an' just levelled it up a bit - why, you couldn't've asked for a nicer place for a scrap.

Wot do I think o' Mister Boche? Oh, 'e's alright once you get to know 'is little tricks - the blighter. 'E's got some tolerably dirty little tricks; but 'e's a sticker, you know, sir. Yes, 'e's a sticker, alright, especially with a machine gun. 'E' don't count once you can land 'im one on the point o' the jaw. The sight o' steel makes 'im proper sick. You gotter be quick as a flash once you get to 'im, or 'e'll up with 'is 'ands, an' then you mustn't touch the beggar, although you know bloomin' well that if you 'appen to stumble, or give 'im arf a chance, 'e'll stick you when you're not looking - almost the only time 'e will, that is. But 'e's a pretty good soldier at shootin' ranges.

The Push? Oh, the Push is alright, sir. Take a bit o' time, you know, to flatten 'im out proper; but 'e's goin' to be flattened alright; not arf 'e ain't. Did I get any sleep last month? Lord bless you, yes, sir. I can't get on without me sleep. We used to doss in shell-holes; any old place. Soon get used to that. 'Ad me tea, too, most afternoons, I did. Bit uv a relish with it, too, when we'd got in a Boche trench. I'll say that for the Boches, their dugouts is prime. Generally always find a bit o' somethin' tasty in a Boche dugout, an' if you strike an officer's dugout it's a Lord Mayor's banquet for certain.

It is impossible for me to begin to do justice to this Private on paper. I wish he could meet some of our literary masters of Cockney humour for, though what I am able to quote may but faintly indicate it, men like this are perfectly wonderful in their attitude towards the great things they have seen and done. This man - who is only one among thousands - has moved and lived and had his hourly being night and day for many weeks past in a nearer approach to the old writers' dreams of hell than anything ever previously seen on earth. Not for an hour in all that time has he been out of reach of gun-fire, or away from the maniacal din, the murderous fury of it all; he is now pretty badly cut about, and has lost a lot of blood. But he hardly ever opens his mouth without emitting a jest of some kind; he talks cheerily of getting back into the inferno, and very probably will be back there before very many weeks have passed. As for Delville, which several officers have told me was the most awful and bloody shambles of the whole terrific series, he says that bar its untidiness, so to say, "You couldn't 'ave asked for a nicer place for a scrap!"

If the Kaiser could produce many such soldiers as this one - well, the war would last a very long time. Myself, I greatly doubt if the All Highest could produce one such among all his legions. And I have talked with many scores of just this type, and hundreds of other types as fine in their different ways, during the past few weeks alone.

It is to be remembered always that this is the spirit they show when wounded, and straight from the most exhausting kind of fighting ever seen, and a long tiring journey. Heaven help the Hun who meets them when, with all the knowledge they have gleaned of his little ways, they re-enter the fight at the end of comfortable weeks of good living and recuperation!

He went on fighting for a long time with considerable wounds in his left shoulder . . .

Chapter 8

WE DON'T COUNT WOUNDS IN MY REGIMENT

Standing close beside the gangway of the first hospital ship to be berthed at Southampton during one recent day was a tall, fair-haired Sergeant, who came to attention and saluted, like a guardsman on parade, though his left arm was in a sling and his tunic in tatters. The dust which covered his ragged jacket was caked on it by darker, thicker stuff than water: the familiar, unmistakable stain which covers so much khaki on hospital ships; the stain that tells you a man has given freely of the life within him in the service of King and country.

There was nothing in these details to hold my attention to the Sergeant; for these are external characteristics shared by most of our new arrivals at Southampton. But in some indescribable way the Sergeant was trim and smart, though bandaged and clothed in rags that were muddy and bloody. His smartness, then, must have gone a good way beneath the surface. It certainly was marked. I waited for a few minutes to chat with this NCO.

"Well, Sergeant, how do you think the New Army is shaping?" I put to him.

There was something at once humorous, modest, and very pleasing about his flickering half-smile. "The New Army, sir? Oh, I think the New Army's all right, sir. Doing fine, I should say. Master Boche finds 'em a pretty tough nut to crack, I think. I don't think there's much the matter with the New Army, sir, from the little I've seen of it."

"Why, haven't you been out long, then, Sergeant?"

Again the flickering, modest, humorous smile.

"I was in the retreat from Mons, sir; wounded there, and hit again at Loos, sir. This is my third trip home in a hospital ship. But, of course, it's all different now."

"Then you are of the Old Army?"

"Fourteen years' service, sir, come next month."

"H'm! When you come out of hospital this time you'll wear three gold stripes, Sergeant."

The smile was perfectly radiant this time.

"We don't count wounds in my Regiment, sir."

It would be most difficult to explain how much this Sergeant impressed me, or what was conveyed by his smile and his tone. There was, for example, a kind of caress in his voice when he used those two simple words "my Regiment," which I am quite sure cannot be described.

Some hours later, on another ship, I had some little talk about it with an officer of the Regular Army, a Captain whose Majority cannot be far from him, I apprehend. He had seen service in Gallipoli, as well as France, and been wounded in both theatres of war.

"Odd you should mention that," he said. "I've been thinking of that very point: the New Army and the Old. I put in two days and a night at Havre, you know, on the way from the Front, and some kind soul has supplied the place I was in with stacks of newspapers. I read papers of every day for a month; all about the present offensive. I was awfully glad to see the public have been getting lots of information about the way

the Service Battalions have distinguished themselves. I think they deserve every word of praise they've got, and more. They really are wonderful. It's a great achievement for men to be so steady in attack, after so short a training. Their officers have done splendidly, too, and it's good that the public at home should learn something about it. I very much doubt if any other country in the world could have accomplished anything approaching to it, in the time. Tradition counts for an enormous deal, you see, in any army; in the training and the fighting men make soldiers of one another, you know, given the tradition and the atmosphere. And in the absence of these things to have accomplished what this country has accomplished in the New Army - well, it's a wonderful tribute to the qualities of the race. Nobody knows so well as a regular soldier what a wonderful miracle it is."

I forget just how my next question was worded, but I know it provoked frank and hearty laughter from the Captain.

"Oh, Lord, no!" he said. "No need to tell the public about the Regulars. They don't need any telling about regiments that have been fighting in different parts of the world for centuries. The world hardly wants telling at this time of day that Tommy is an invincibly fine soldier - the very best. He proved it such a long time ago, and he's been proving it ever since. But it's only right that our people should be given all the facts about the New Army. It had to prove itself; and, begad, it's done it magnificently! I don't think there can be a shadow of doubt about that. But I do think it's only right and fair that the facts which prove it should be made public. Everybody who's been in the show knows it; but the world ought to know it, too. As for us - well, they know all about us, don't they?

"Of course, it's a mistake to suppose that we have two separate fighting forces - Old Army and New Army, It isn't that at all. The Service Battalions, as you know, are mostly battalions of regiments whose records were fine records before the German Empire was ever thought of. Some of them have been lucky enough to get a certain number of Regular NCOs and some a few Regular officers. Some have been luckier than others in the matter of the number of ex-Regulars they got in their ranks. Those things are a great help, of course, in the training, as well as in the campaign. The old Regular senior NCO or warrant officer is a finely finished production, as you know; a pretty valuable centre of influence. There are battalions and companies in the New Army that owe an enormous deal to a single Regular Sergeant-Major, and there are Service battalions with retired Regular officers commanding, whose training has made them equal to any line battalion in the world.

"Then, of course, there are plenty of Regular battalions with hardly a score of the old hands left in the ranks. They have done their bit from the first to last, and done it so well that they have had to be remade many times over from drafts. But the Regiment never dies, you know. The root of the matter is there all the time, and the surviving officers and NCOs work pretty hard to prevent any falling off in its quality. I think, perhaps, that's really the whole thing, isn't it? A strictly non-military nation has, in an extraordinarily short space of time, built up a huge Army from the very closely pollarded stem of a little one which - well, perhaps the arch-Hun did make a bit of a mistake when he described it as 'contemptible' as well as little. Its record wasn't exactly contemptible, was it? The root is the old root, and the present big tree seems to me to have the old fibre running all through it. Can't very well give it higher praise, can you? And, mind you, it deserves the highest praise that can be given, as I think the Boche is beginning to realise."

The old regular senior NCO is a finely finished production . . .

Chapter 9

A REVEREND CORPORAL

The last wounded man I talked with on the landing-stage at Southampton on a certain night was in hospital away up north the next morning. His two wounds were both clean and slight, and within a week or so he would, no doubt, be enjoying sick leave in his own border-country home. Wherever he is, he will, I think, be an influence for good; and - yes, I am sure of it - a greater influence for good than he could have been if he had played no part in this war.

He is a Corporal now, and his name was in his battalion orderly room for a Lance-Sergeant's stripes when he stopped the bullets that gave him his break for rest and recuperation in Blighty. Up till some time early in 1915 he was a minister of the Gospel, newly ordained. When the end of the war comes he will resume his sacred calling, and I would like to hear him preach. I am very sure he will not have lost anything as preacher, teacher, or minister by his service in another capacity. A man does not lose by the teaching of discipline and the experience of shoulder-to-shoulder comradeship in the trenches with men who voluntarily offer their lives in the defence of all that every good man holds sacred.

This Corporal's face and neck and hands are of a rich old saddle brown, and his eyes, despite the weariness in them, have a light which it is good to see in the eyes of a man. He knows a very great deal more about many things, including life and British human nature, than he knew eighteen months ago, and he has found it all well worth fighting for; dying for, if need be, as he has seen many of his comrades die.

THE 'REVEREND' CORPORAL'S STORY

I was just north of Ovillers, where the new line joins the old, you know. We are practically at right angles to our old lines there, you know; looking north now instead of east, and in our rear you can walk about and take your ease in the warren that stood for death to us before July 1st. And what a warren! Round about Ovillers and La Boiselle, I mean. It's marvellous to think those lines could ever have been taken. I am not a bit surprised the Hun thought them impregnable. Anyone would, when you come to look over them. Even now, when they have been pounded out of all recognition by our heavies, you'd think such a network could be held against any possible advance. The Boche thinks the same about Thiépval, you know; that no power on earth will ever take it from him, because he's made a fortified arsenal of it. But there's a force behind our chaps that he can never have in this war, and I doubt if his Generals make any allowance for that.

And yet, you know, that force, whatever you like to call it, will presently smash Thiépval just as surely as it smashed Ovillers and La Boiselle and the other impregnable strong points. I'm no expert, of course; but it seems queer to me that these highly trained people who run the Boche machine should show the ignorance they do of everything they can't weigh and measure and

touch with their fingers. It's been the same all through the war, from the very first outrage in Belgium. So far, the Boche would seem to be incapable of grasping the existence of anything that cannot be turned out of a foundry.

Of course I know the foundry has played a tremendous part in the war, and I know the bravest heart can't go on beating after you've smashed it with a Boche shell. But that doesn't alter my point, really. Shells alone would, I think, have left places like La Boiselle and Ovillers what the Boche thought them: impregnable. But behind and over and above our shells - without which we can, I know, do nothing - our fellows have something which the Boches have not got in this war, or in their nation as at present constituted, and, believe me, it's that something that's winning the war for us and our Allies.

Oh, I'm no authority, of course. But, just as it's their job to know all about tactics and munitions, so it was mine, and is, to know a little about men's souls or spirits; to try hard and learn about them, anyhow; to study them all I can. I've been studying more closely since I 'joined up' than I ever did before, and the study has brought me two certainties, that the German Army and the German nation have set themselves a perfectly hopeless task, and that they cannot possibly prevail against us, and that the Allies will presently beat the Germans absolutely to a standstill, more than anything else because of elements at work on our side which Germany does not recognise or understand, and of which her magnificent organisation has taken no account at all.

Am I preaching? Forgive me. It boils down to this: their machinery for destroying our flesh and bones is pretty good, though I think we have mastered that this year, thanks to our unarmed armies in the home workshops. But they have devised nothing adequate to put up against the spirit of our armies in the field; nothing adequate at all. And yet, mark my words, that it is that is going to carry us through their lines. It's that that is going to enable me to smoke my pipe in the midst of their fortified arsenal at Thiépval when I get back. I'm just as certain of it as I am that I smoked a pipe the night before I was hit, in the middle of what, in June, was such an utterly deadly place for us as the chalky trench walls beyond Mash Valley, between Ovillers and La Boiselle.

Whether or not there was logic in his words, there was a conviction behind them which I found most compelling. That is one reason why I want to hear this Corporal preach after the war. I asked for further details as to this asset of ours against which the Hun has made no provision.

Ah! I'm afraid I can't do that, I'm not so sure that anyone could. You can't measure it, remember; and it's not made in factories. It would be so easy to use words that would mislead you, words that might mean one thing for me and another for you, And I don't really think that any words could do justice to it, anyhow. It is there, all right, I can assure you. Men cannot march smilingly into certain death with a cheer on their lips without it. Specially primed men may be driven anywhere, as we have seen Boches driven; but our chaps are not primed, and never driven. Yet the Boche cannot make them waver.

No, it is beyond me to describe it. I think, perhaps, one must live among our fellows in the trenches to understand it rightly. Our officers know all about it. The Boche fights because he's got to fight. Our chaps fight because - well, the

fact that as soldiers they have got to fight is the least of the things that make them fight. For one thing, they know as well as I do that we are going to win. They came forward voluntarily to fight, because they know we ought to win; and that for our sort of people, for people holding the sort of beliefs the British people hold, life wouldn't be worth living, ever, if we didn't win.

But I feel that the words I am using are quite futile - such little shadows beside the thing itself. I fancy the public will get as near understanding it as anybody can without living in the trenches and seeing the spirit at work among the men, if they just think carefully over what our men have been going through on that Front, what they have been doing since July and how they have done it - cheering, singing, shouting - how gladly they have done it. Then let the public ask themselves how and why. The most of the men of the New Armies have no military tradition behind them; had never handled a gun till they 'joined up'. Yet they have faced bigger things than any veterans ever faced before, and faced them steadily; ah, so steadily; seeing it all very clearly, and fearing it not one scrap, though they have forced mad fear into the highly trained troops facing them again and again. That is because they have something that you cannot make in foundries; that you cannot even give by training. Words won't explain it, but quiet thought may. I could give it a name the Church would recognise. But let's just say they know their cause is good, as they very surely do. The Germans may write on their badges that God is with them, but our lads - they *know*.

Chapter 10

BROTHERS OF THE PARSONAGE

There have been busy phases of the day's work at Southampton, when two of the green and white hospital ships have been lying alongside the stage together, both with full passenger lists of wounded from the Somme. On one such occasion the living freight of the smaller boat was still being discharged when I went on board the big one. There I was talking with one of the cot cases, whose foot had been rather badly knocked about by a German bomb. In his pleasure in the fact that it was his foot, and not his head, which caught the more malevolent portions of that particular bomb, this Lieutenant seemed to think it was rather an advantage than otherwise to lose a toe or two.

"Nothing to write home about, anyhow," was his way of putting it.

I had occasion to ask his name, this high-spirited fellow who thought himself so extraordinarily lucky to have nothing more than a temporarily smashed foot. And then I turned back to another page of my notebook. "Why, there's another man of your name," I said, "on board the hospital ship lying just astern here."

"You don't mean to say it's Teddy?"

"Don't know, I'm sure. Here's the name, look."

"Well, I'll be jiggered if it isn't Teddy. I say, you must excuse me, you know; but that's my elder brother. He must have been in this show, too. They only came out about

There's a force behind our chaps that the Boche will never have in this war . . .

Christmas-time, you know, and I never knew where his brigade was. How was he hit? How is he? Is he a cot case or a walker? How'd he seem? Does he look all right? What an extraordinary lark! Fancy Teddy being here too, what!"

Five minutes later I had secured permission from the kindly RAMC Staff Officer for 'Teddy' - the senior in years was the junior in rank, I noticed - to leave his ship and come on board the other vessel till his train was ready. It was rather pleasant to watch the meeting of the two brothers who had been in France for eight months without either knowing precisely where the other was. Teddy was a walking case as it happened, so that there was no difficulty about his getting to his brother. He had been hit when fighting beside the Bapaume Road, close to Pozières; his brother was hit on the terrible northern slopes of Delville Wood, above Longueval.

I rather wished I'd had a phonograph on which to record some of the talk that passed between these two sons of an English country parson who had last met during their training period in 1915, in a sequestered south-country rectory, and had since lived through many months of strenuous trench warfare, and some weeks of such strife as the world has never seen before, all between the Ancre and the Somme.

Both have known winter in waterlogged trenches and abysmal mud; both have gasped and spat from the choking thirst that comes to a fighting man during July and August heats on a chalky soil, when he struggles in blinding dust and dense choking smoke over ground which has been pulverised in almost every yard of it by bursting high explosive and rending steel. They had a good deal to say, and some of it was not very coherent or easy for the outsider to follow; both were in the same tearingly high spirits. Men wounded and broken in the war! It was hard to believe it, as I watched their sparkling eyes and the constant flash of white teeth against dark, sunburnt skin, while they laughed in sheer gaiety of heart. Wounded, perhaps, but I felt that would not affect them for long for these English lads are not so easily broken. There is a good deal of the born fighter in them, despite our non-military traditions; and, for one who knows the trenches in northern France, it is striking evidence of enduring virility and invincible good-heartedness to find men so amazingly debonair, and in the towering spirits of holiday schoolboys, after eight or nine months spent in the fighting line between Fricourt and Arras.

What follows is a specimen of the sort of verbal battledore and shuttlecock which went on between the junior superior officer in the cot and the senior of lower rank who was a walking case.

THE BROTHERS' STORY

"Fancy you, you secretive old beggar, being here, and I never even knew you were in the show."

"Well, what about you, if you come to that. You got it in the foot, eh? What is it - shrapnel?"

"No, a bomb. Yours in the arm, you old blighter?"

"Shoulder; in up here, near the collar-bone, and out through the shoulder-blade. Machine-gun bullet; clean as can be. I'll be clear in a week or two. What the deuce d'you want to get a bomb in the foot for? What were you doing?"

"I was jolly lucky, I can tell you. We were rushing their last trench in Delville Wood; weren't more than a dozen paces in front of it. I fell, regular somersault, in a shell-hole, at the very moment one of their bombs went off right alongside me. Head down in the hole, safe, you see; heels up, and one of 'em got caught.

But my orderly got the Boche who threw it; got him for keeps, I can tell you. First Boche he'd killed, I think, and, begad, he made no end of a mess of the chap. Insisted on giving me the fellow's helmet. Here it is, look; though, as I told him, it was more up to me to be giving him something. He seemed to think it was a gross kind of insubordination for the Boche to have thrown a bomb at his officer. Nice boy. His mother keeps a little shop of sorts. We must look her up. So you were up there by Pozières?"

"A bit south-west of it."

"Hot stuff, wasn't it, Pozières?"

"So so; not a rest cure, you know. I've got a helmet, too; but I can beat you, me boy. Mine's an officer's - a real live Boche officer; least, he was live enough then, with a sword-stick of all things, and I've got his sword-stick, too."

"No, Teddy! What a lark! Did you really get the beggar?"

"Well, he got me first; punctured my left hand here, you see. I'd lost my revolver long before; but I'd got a Boche rifle and bayonet - pretty good one, too. You'd have laughed to see the duel; like a Naval and Military Tournament show, you know - sword *versus* bayonet. I daresay he was a swordsman. Lots of these Huns are, you know. If so, I 'spect my ignorance of the game put him off. I simply rushed him, you know, got him clean through the chest. Queer thing! He was the only Boche officer I've seen, and we've been in front ever since the 1st."

"I know. They've been lying remarkably doggo. Getting a bit short, I suppose - else they've lost their appetite. How'd your men do?"

"Finest platoon in the New Army bar none!"

"Oh, come; I swear they're not that; can't be. I've got the best; everyone in our lot knows that. But yours were good, were they?"

"Good! My dear chap, there isn't a man in the platoon that oughtn't to have the VC; not a blessed one."

"H'm! So yours were the same, eh? Mine were absolutely perfect. I knew they were fine, but honestly I'd no idea how fine till we got into Delville. Honest Injun, a man can't help loving 'em."

"I know. It's queer, isn't it? The way you feel that. You really can't help loving 'em - damn 'em! Seen the papers?"

"Saw some last night. All this business about the third year, and Big Willie trying to keep their spirits up. Notice the way the Boches try to make little of the Push. We've gained such a few miles, they say. Pretty useful miles, though, to the top of the ridge."

"Oh, besides; it's not only the ground, you know. See what it really means. They've taught their people the English couldn't really stand against 'em, let alone advance. How could we advance even one mile on selected ground they want so badly, and get thousands of 'em prisoners and regular piles of 'em dead if we were really so contemptible? They'll find it hard to go on pumping in the same kind of tosh to any of their troops that have been in this show. Never get them to believe it any more."

"No, by Jove! They'll go on fighting, of course. They jolly well can't help that. And their artillery and machine guns will go on playing merry hell, no doubt; but I think the wind's up 'em; I do really, Teddy. I know it was at Delville; fairly up 'em."

I slipped away at about that stage and had a little talk with some of the kindly RAMC people, with the result that the brothers did not go away by different trains, but were booked for the same hospital, which I hope they will very soon leave together, for a few weeks of holiday recuperation in the south-country rectory. Our Army is full of lads like these, and their quality is super excellent.

Chapter 11

THE AUSTRALIAN AS A FIGHTER

Although the upper part of his face and head were all hidden in white bandages, and he had had a machine-gun bullet through the upper part of his left leg, this Company Sergeant-Major was - "Doing very nicely now, thank you," and was in first-rate spirits, both over the prospect of a few weeks' holiday at home - that is how he regards it - and with regard to the outlook at the Front. "I think this must be my month for doing it, sir - August," he confided while enjoying a cigarette in his cot on board one of the hospital ships at Southampton.

THE COMPANY SERGEANT-MAJOR'S STORY
When the war's over I shall have my hands full every August with celebrations. I joined up on August 15th, 1914, went to France on August 2nd, 1915, was knocked out near Bazentin on August 2nd, 1916, and born on August 3rd, 1884. Certainly must be my month for doing it, sir, mustn't it?

I think the Boche will be a long time before he forgets August, 1916, sir, or July, either. Don't think he likes our boys when they've got their tails fairly up, the way they have now. He's all right at a comfortable distance, when he's got things his own way, is Master Boche; but he don't like it a little bit when our chaps get right in among his lot, the way they're doing now. He don't like that, sir; not a little bit. With rifles, machine guns, heavies, trench mortars, rifle grenades, *minenwerfers*, and all the like o' that, he's just as happy as the day is long. He can go on at that game till the cows come home, and I'm not saying but what he's mighty good at it. He is, you know, sir. And what with his fine dugouts, an' one thing with another, he can stand a whole lot of it from us, too, an' not be very much the worse for it. But he do not like close quarters, sir, and he won't stick it, that's the next thing.

I reckon, if they could arrange for this war to be decided by one good fight between a Boche battalion and a British, in one open field with never a hole or a trench in it, the war would be over in twenty minutes, and there wouldn't be any more of that Boche battalion left; no, not if it was the best they've got in their Prussian Guards. The best of 'em can't stand up to our lads once they get down to real business alongside each other. The trouble is to get near enough, of course. But we'll be there all right before long, now, sir, if we can keep up the munitions supply.

You see that chap down there in the cot next the ladder, sir, the one speaking to the Sister now, that's him. He's an Australian, he is; comes from a place in

New South Wales. His battalion was in the thick of the Pozières show, and they say he's goin' to be given a Commission. I don't know. But I was talking last night to a chap in his platoon who was alongside him in the last fighting there, and he told me there was one traverse that chap got into where the Boches was too thick on the ground, as you might say, for him to work his bayonet. They reckoned they'd got him, of course; goin' to eat him, they was. They'd got his rifle out of his hands; such a jam he couldn't draw back for a thrust, you see. And they'd somehow got him down, when his mate came round the corner of the traverse. He says there were seven of the Boches.

Well, what his mate saw was just the seven Boches, like in a football scrum, swayin' to an' fro. He couldn't see this chap at all. He was underneath, you see. So this other chap, he just gives one yell an' starts in with his bayonet. That made a bit of a break-away, as you might say, an' after that the fun began. The chap who told me was a little bit of a fellow, couldn't have been more'n five feet five, another Australian, a lightweight, he was. He hung on to his bayonet, an' put in plenty footwork, keepin' clear, you see. An' he says the way his mate - the big chap in the cot there - laid them Boches out was the sight of a life-time. He just downed 'em with his hands, an' the chap told me that when he got a Boche down, that Boche was done; he wasn't takin' any more. Anyway, they took two of 'em prisoners, an' they couldn't take the other five because they was dead - dead as mutton. And the fellow told me that big chap did it all with his two hands. He's cut about a bit, you know, and they laid his head open for him, but - one man against seven, you know, an' them all armed! It takes some doin'. The Sister told me he'd be all right in a week. They're hot stuff, you know, sir, these Australians, once they get goin'. Our boys are the same. They're happy when they get to close quarters, an' that's just what Mister Boche can't stand at no price.

One of the things one notices about ninety per cent of our wounded is that to get the story of their own personal part in the fighting one has to go to someone else who was with them. They are talkative enough about their mates, but they are given to a modest and wholly loveable reticence regarding their own exploits. This Company Sergeant-Major, for instance, who told me about the Australian, told me no word of the incident of which an officer of his Company afterwards told me on the landing-stage. Despite his head wounds and a bullet through his upper leg he had carried his wounded Company Commander from a Boche sap into our own line, under a fire which would have made most wounded men think only of lying very low, in any sort of cover they could get.

THE LIEUTENANT'S STORY
There was a Private in our Company, the Lieutenant who told me of the Sergeant-Major's brave act began, who earned a mention in dispatches which I'm sure he'll presently get if ever a man does. One of these jolly, larky little chaps he is, always turning up at the orderly room in the morning when we were training at home - incorrigible chap for the very small misdemeanours, you know - but what a little brick when he was really up against it!

The NCOs of his platoon were knocked out to a man, just north of Bazentin-le-Petit there. Fritz had a machine gun behind a knoll that simply kept us grilling. This little chap got the balance of the platoon together - fifteen or

197

twenty of them, you know - and made a dash for the flank of that knoll. There were only five of them got there, I'm sorry to say, and by that time this chap had three bullet wounds. But when they got there they just wiped the earth with the Boches at that gun, smothered them; and this chap turned the gun on the Boche line and kept it clacking two or three hundred to the minute till I was able to get along there with No.9 platoon and take over; and he wouldn't have slacked off then, in spite of his wounds, if I hadn't made an order of it - a great little fighter and a born leader, mind you, too. There's lots of his sort on our side, thank goodness!

Chapter 12

NEWS FOR THE OC COMPANY AT HOME

It would not be easy to find among the wounded as they arrive men who have recently had any experience of either leisure or comfort. Freedom to rest, to chat, to eat comfortable meals and smoke a pipe at ease, to read a newspaper or to write a letter - all these things have the charm of novelty and are enjoyed with the zest that belongs only to unaccustomed luxuries by our newly arrived wounded officers and men.

"Haven't been able to write a word except my signature on two or three field service postcards since the big Push began."

One has heard that remark from a good many of the newcomers. One morning a wounded officer had a rather longer wait between the time of his ship being berthed and his train pulling out than the average.

"It's rather different from waiting in a trench," he said; "I could stand a good deal of this." As a matter of fact he put in most of the time in writing to his Company Commander, who, having been wounded at an early stage in the present offensive, has since lain in a London hospital. From that letter I am permitted to reproduce the following account.

THE WOUNDED OFFICER'S STORY

It's no good my attempting to give you any war news, because there in London I've no doubt you get far more than we do and know more about it; but, as you've been away nearly a month now, I thought you'd like a line or two about the Company. I don't suppose we've appeared in the leading articles yet, have we? Not but what the men of your Company deserve as much space there as any in the Army; I'm jolly sure of that. We've lost nearly half our strength - not killed, I'm glad to say, but wounded - but the spirit of those that are left would do your heart good. I want to tell you one thing particularly.

You heard about the way the Battalion took and held that damned trench last week, north of [censored]. Our Company led, as you probably know, and though I say it as shouldn't, since I had the honour of being in command, the work they did was absolutely top-hole - they excelled themselves, and I want to tell you why.

We got our orders the afternoon before, at about five, and at half-past six

the CO paid us a visit and gave the Company a little talk. We were back in [censored], you know, luxuriating in the old Boche trenches and dugouts, which, with a little repairing and scooping out, have made a first-rate rest place. Well, I wish I'd got a shorthand report of what the good old skipper said. By gad! You know, it's marvellous the way he's stood the strain of the last month, at his age. Positively seems to thrive on it. Brave! There isn't a boy in the Battalion more absolutely indifferent to crumping than he is. Where was I? Anyhow, it was all about you, and between ourselves I don't mind confessing to you there was a certain amount of sniffling before he was through with it. You remember those Saturday morning talks of yours to the Company in 'A' and 'B's dining-room at home. We knew the CO looked in once or twice, but I don't think anyone knew just how much notice he used to take. I tell you there wasn't much went on in the camp that he missed,

Well, he reminded the men of some of the things you used to tell them, and talked about how we'd lived up to it so far in France, and the responsibility that rested on us as the first Company in a Regular Battalion of a great Regiment and all that, you know. Paid what I think they call a graceful tribute to the Service Battalions, too, he did. And then he wound up with a little about the job we were in for in the morning; what an honour it was for the Battalion to have been selected by the Brigadier, and what a double honour for 'A' Company to lead it, and so on. We were all rather worked up, you know. And then it was he rung it in about you to top off with; said how grieved you were to be out of it; how he'd written to tell you what 'A' was to do; how you'd be thinking about us in your bed there in London; how we wished you could be there to lead us, and how, by God, every man of us would go into that show to do you proud, you know, and more careful than if you really were watching us, and all that.

I wish I could give you his words, by Jove I do. But it was fine; I can tell you that. The CO himself was blowing his trumpet with the dirtiest old handkerchief you ever clapped eyes on; the CSM nearly choked himself trying to stand fast at attention with a good chest on him; and as for little Sammy - there isn't a better platoon commander in the Battalion than little Sammy is today - he was fairly crumpled up. Had to edge round behind the CO to hide his blooming emotions, as they say. Oh, it was what the men call a great 'do' all right, and seriously I'm awfully glad the old man did it.

You've heard how we got on, of course. 'C' and 'D' suffered pretty heavily, I'm sorry to say - worse than we did. It was a complicated job. We had to rush the trench first, followed by 'B'; then we had to rush the support trench and keep Boche as busy as we could there, while 'C' and 'D' cleaned up and consolidated the front line, which was to be permanently held. As it turned out, the Boches had considerable difficulty with their men. The beggars simply wouldn't turn out of the dugouts to face us. We found barely five and twenty men in the front line, and those, of course, we absolutely smothered; took them in our stride, you know. I got one myself with my trench dagger, and the CSM who was next to me killed three to my certain knowledge. I saw it.

Well, in next to no time we were in their support line with very few casualties. Sorry to say Sergeant [censored] was killed between the two trenches. And there we had some show, I can tell you. Curious there should be so much

difference between the spirit of the Boches in the two trenches next to one another. In that second trench, I won't say they fought like soldiers and men, because honestly they didn't; but they fought like mad beasts. At least they fought hard, I'll say that for them. In the front line they funked it at first. But their NCOs got them up to some purpose, while 'C' and 'D' were cleaning up there and making good.

But in our line they fought hard from the word go, and they fought like beasts. I lost my own temper pretty badly, and as you know I'm pretty easy going. Two of the swines found little Jimmy (you remember Jimmy in No.3) lying wounded beside a traverse. They both leaped at him, seeing that he couldn't possibly defend himself, and started slashing him through and through with their bayonets - poor little chap. That let me out, and I tackled those two for you and myself together. I was much too late to save Jimmy; but those two Boches will never stir again.

There was a lot of that sort of thing. As I say, they fought like mad beasts, not like soldiers. I can't help thinking they must have had some drugs or something given them before we attacked - I never saw such brutes. And I never saw our chaps in finer form. Gad! It would have done your heart good to see them. Your name was shouted half a dozen times. We cleaned out every living thing before we finished, and I really think we could have held that second line till morning; but I had my orders, and, anyhow, an orderly came along from the CO with a message that I was to retire to the front line and help 'C' and 'D', who were rather glad of our help in the clearing up.

The Boche countered five separate times, and each time we let him get pretty close and fairly mowed him down with Lewis bombs. No exaggeration - they were thick on the ground, like mown corn. We were specially glad of the way the show went, partly because the Boches had been such unutterable beasts there, and partly, too, because I'm certain every man of ours strained an extra pound or two on the strength of what the CO had said about you overnight.

Chapter 13

'STICKFAST' AND HIS OFFICER

An RAMC Officer on board one of the hospital ships at Southampton put me in touch with a couple of its passengers whom I would have been sorry to have missed. They lay in different parts of the ship, weakened by loss of blood and considerably knocked about; both were smoking cigarettes when I saw them, and neither could have been in higher spirits if they'd been twelve-year-old schoolboys arriving home for the summer holidays.

The senior is one of the oldest Privates in our New Armies; the junior is one of our youngest officers, for he celebrated his nineteenth birthday in a front-line trench in France last June. His friends may fairly be proud of him, for though only in his twentieth year he has already proved himself a brave officer and a gallant gentleman. When the war began this officer had just left school - within the week of the declaration - and a

few weeks later he was to have entered a merchant's counting house in a busy northern city. As things are, his experiences have been quite other than clerical. For nine months he has been a platoon commander in the fighting line in France. He was wounded once before, early this year, but so slightly that a week out of the line in a field ambulance put him right again. Now he will enjoy a somewhat longer rest, but he reckons on being back in the line in a month. "Don't want to miss *all* the fun, you know," and a surgeon told me he will probably have his wish.

He told some stirring things about the conduct of his men in the fighting round Longueval. But what I want to tell here is something about his own conduct, as I learned of it from the man most intimately concerned, and an eye-witness who was that man's section commander.

It was guesswork to call this Private one of the oldest men in the New Armies, for I did not ask his age; but his hair, or what little I could see of it under his bandages, is white, and his week-old beard and grizzled moustache and appearance generally are those of a man well past middle age. I'll wager he committed a gallant perjury when he enlisted, and that he will get a decoration for it in heaven!

THE OLD PRIVATE'S STORY

Well, it wasn't what you'd call a regular attack, sir, it was more of a raid, like, that our Company was in that night - up to the left o' Longyvally it were. We was on the right, bein' in No.3 platoon, sir. We wasn't to take their line, you understand, sir, but just to stir the Boches up a bit, as you might say, an' find out what they was doin' an' put a stop to it; which I think we did put a stopper on it all right, sir, so far's them particular Boches is concerned.

Our artillery gave 'em taffy before we started, sir, toppin' off wi' five minutes' hurricane fire, when you couldn't hardly hear yourself shout. An' then over we went, sir, my Mr [censored] leadin', an' a proper young gentleman he is, too, sir; as fine an officer as we've got, I reckon, for he never fails his men, he don't, he never forgets 'em, an' the best of everything that's going he gets for 'em; an' I don't see how a officer can do more'n that, whoever he be.

I got a bullet through me left arm while we was crossin', an' that made me a bit awkward like wi' me bayonet. But I got me Boche all right, sir, when we got to the trench - I did that, an' I stuck him twice I did, for I wanted to be sure of him. An' just when I was drawin' me bayonet back the second time an' wonderin' if I'd have any more luck, a big Boche Sergeant come at me - I saw the stripes of him, sir, an' before I could get me bayonet back for a thrust he caught me over the head with the spiked club he carried. I saw the club, aye, an' saw it comin' for me head. Somehow I knew I couldn't stop it - couldn't get the bayonet that high up quick enough you see. So I thought, let it be then, we'll go together. An' so I let drive wi' me bayonet for his stomach. An' that's all I knew about it.

At this point I had to turn to the next cot but two, where the grizzled warrior's section commander lay with a broken ankle - a fair, red-haired, blue-eyed giant, of about three or four and twenty. Before he would tell me anything else, the section commander had to put one hand to his mouth whilst I bent down low towards him, by order, to receive in my ear in a hoarse whisper the following piece of information, "You might think him queer, but a gamer old blighter never wore out shoe-leather - if you can follow me, sir."

201

The jerks of the section commander's head, his ponderous winks, violently twisted mouth, and gesticulating right thumb were upon the whole sufficient - to the entire ward, one would have thought - to indicate that he referred to my grizzled friend. A transparent person, the section commander - Heaven send him sound ankles and good luck wherever he may go! The elaborately set forth unconsciousness of his look across at the grizzled one, after his hoarse whisper to me, was a thing beautiful to see.

THE COMPANY COMMANDER'S STORY
We made what you might call a nice clean job o' that bit o' trench, an' the dugouts - remarkable clean job of the dugouts, sir - with Mills hand grenades an' plenty of 'em. An' after the hand grenades, three men with the bayonet in each, sir, so's to leave all tidy. Great one for tidyin' up, sir, is our officer. An' then he blew his whistle three times, sir. That was the signal to retire, an' we all climbed out beside him, just as he'd told us: hand an' knees outside. Mr [censored] came out last, an' when we'd gone, it might be ten paces, sir, "Hullo!" he says, "where's old Stickfast?" By which he meant to refer, sir, to his Nibs here, not meanin' any harm to the old boy, sir, not at all, but we call him 'Stickfast' because he never was known to fall out, or go sick, or give up. Next thing I knew, Mr [censored] was runnin', as you might say hell for leather - if you can follow me, sir, - for that Boche trench, yellin' "Stickfast!" loud enough to startle the Kaiser. But just before he started he'd said, "You get on back to our lines, lads. Take them back, Sergeant."

"Orders," says the Sergeant, sorter grumpy like. You could see he didn't like it, but off he goes with the platoon. Well, I stooped down to do up me bootlace, you see, sir, an' I grabbed two men o' my section, an' told 'em to do up theirs, you see, sir. An' when we got back into the trench we was only a yard or two behind Mr [censored]. "Hello, Corporal," says he, all friendly-like, like that, sir, "what the hell are *you* doin' here?" he says; just like that. So, of course, I told him the Sergeant sent us back to lend him a hand, and just then old Stickfast there did a bit of a groan, and a bunch o' Boches come round the edge of the traverse, feelin' their way with bayonets well out, thinkin' we'd all gone.

Then Mr [censored] lets out a yell you could hear a mile off. "Let 'em have it, boys! Bomb 'em out! Give 'em hell! All the lot of you!" says he, just as if he'd got a company behind him. I had one bomb left, by chance, an' gave it 'em over the traverse politely as I could, an' Mister Boches bolted like rabbits - couldn't see their tails for smoke. Old Stickfast wouldn't let go of his rifle, so we had to yank it out of the big Boche he had skewered in the belly, an' then we lugged him out of the trench. Mr [censored] has got the Boche's knobkerry - a beauty with spikes an inch long on it. Goin' back with Stickfast I got a bullet through me ankle, and Mr [censored] he got another in the shoulder, an' Stickfast, 'e got one in his left hand. But otherwise we was all serene, an' I got in on me hands an' knees, with two Boche helmets. So we didn't do so bad. But we reckon Mr [censored] would have gone back after Stickfast by himself if he'd had to walk to Berlin for the old man.

The temporary officer is apt to be quite permanently a man, and the men he leads will follow his like while breath is in them.

Chapter 14

A COOL CANADIAN

Their rollicking high spirits are certainly what impresses one first and most about our wounded officers and men as they arrive. But there are other impressions. One notes a striking prevalence of true modesty. And upon investigation one often finds a deal of shrewd, direct thoughtfulness.

The second-in-command of a battalion which has been doing some hard and bloody fighting on the immediate flank of our Allies, down Guillemont way, was among the cot cases I talked with.

He had been rather badly knocked about by a German bomb at close quarters, but he allowed me to light a cigarette for him, and obviously enjoyed smoking it while we chatted.

THE BATTALION SECOND-IN-COMMAND'S STORY

Efficiency, organisation, thoroughness - jolly good things in their place, you know. The Germans have them splendidly developed, and in the past perhaps we've been a bit lacking in this direction. But my own impression is that the folk who talk about the Huns having gone mad - being the mad dogs of Europe - they're not really exaggerating so much as you might suppose. I believe a tremendous number of Boches are, to all intents and purposes, mad. I'll tell you why.

Their worship of efficiency and thoroughness - machine organisation - has carried 'em so far that they have entirely lost all sense of humour. Now, when a man really loses all vestige of the sense of humour, I tell you he's too nearly mad to be good company. It really is so. Complete absence of the sense of humour is in effect madness, or leads to it, anyhow. And that's what's the matter with the Boche today.

When the Hun was practically having things his own way a year ago, you know, the news he gave the world was quite intelligible, and a good deal of it was to be relied on. He lies like the devil now in all his news. Well, that's all right; one can easily see why. But if you read his lies carefully - I've been reading them all the way between Amiens and here - you'll find they're the lies of a madman; they are quite mad lies.

He says our offensive has been smashed; that we have given it up, having accomplished nothing at all; that we have failed to injure him in the least, have gained nothing, and are so appalled by the terrible casualties he has inflicted on us that we have finally given up in despair. Well, really, you know! Well, I ask you, do we look like it? Perhaps you'll say you can't judge. Well, you ask any man you like who comes from the Front. I don't care how hard he's hit: he can't help knowing the preposterous absurdity of that sort of guff. Everybody on our side knows we hold the initiative and dictate every move. On the West Front every move must be costly because it's all over ground

fortified and prepared for a couple of years - an unending chain of fortress really. But we keep going forward; we never go back, and every hour, day and night, we are inflicting more casualties than we suffer.

Thank goodness, at our worst, we never showed much sign of losing our sense of humour. I've been studying the Boche in the field for over a year, and I'm convinced he's lost his entirely, and that this is a worse loss than anything in ground or munitions. Indeed, I think it's fatal. His monstrous war machine is still immensely strong, and will go on working and destroying for a long time yet. But his individual fighters - they are either drug-and-machine driven maniacs, foaming and fighting as mad dogs fight, or in other places they are broken and despairing wretches who, in the absence of blows and pricks from their herdsmen, beg for mercy and capture. They've no sane medium left. Our chaps are all sane medium, cheery, game fighters with an active sense of humour which would redeem the worst sort of shambles. To the last gasp our chaps remain human, so do the French. The Allies will win if only because of that. They remain human - men and good fellows - no matter how much horror the mad dogs put up. 'Mad dogs' is not too strong, believe me. I've seem them spitting and biting. I know - by God I do!

A Canadian Captain with his left arm slung and a German officer's helmet in his haversack was next.

THE CANADIAN CAPTAIN'S STORY

Oh, I'm a fraud - oughtn't to be here at all. There's nothing the matter with me but a bullet through my arm. And, anyhow, logically, I suppose I ought to be dead or a prisoner with the Huns. We took a trench north-west of [censored], you know, and our chaps hurried on to the second line without orders. No doubt they thought they'd cleared the front line. I tried hard to get out after them, but it was an awkward place with a high, sloping bit of parados, and you'd hardly believe how important your left arm is till you try a job like that without it - my elbow was broken, you see.

My orderly was with me. He'd got pipped through the shoulder outside the trench. While I squatted there I heard a scuffling underground just round the other side of the traverse I was leaning on. Took a look round the other side and found a Boche officer - the first I'd seen - just appearing at the mouth of a dugout, feeling his way out. I could see the spikes of helmets behind him. So there it was. My revolver was empty. My orderly had lost his rifle away outside the trench. Awkward, wasn't it?

Well, of course, I pointed my revolver at the Boche officer. One does that instinctively, I suppose. And to my surprise he said in English, "Don't shoot!"

I said I'd shoot the lot of them if one of them moved. "You sit perfectly still. Sit right down where you are, Mister Boche, and I'll take you to England, but if you move you'll get six service bullets, and my men will come along and bury you in your dugout."

They sat down like lambs. I managed to whisper to my orderly, round the edge of the traverse, to get forward somehow and bring some men, and first of all to find me a rifle and bayonet, or a bomb, or a toothpick, or some blessed thing better than an empty revolver.

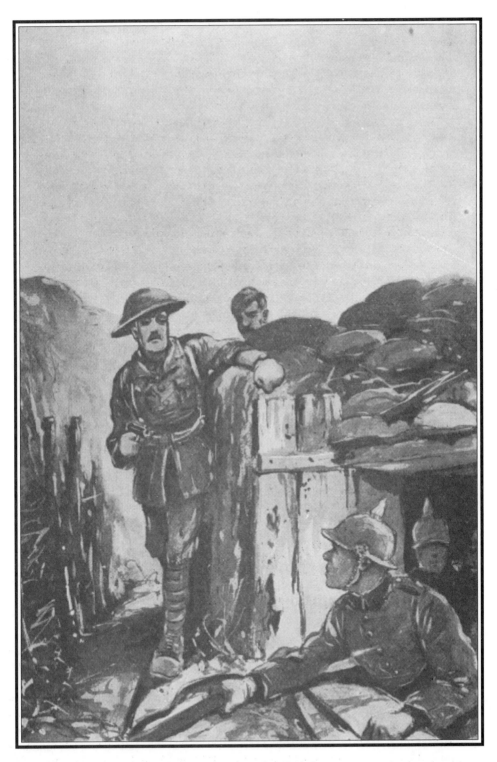

"Don't shoot," he said in English . . .

"Now do be careful, Mister Boche," I said to the officer. "I'm a conscientious objector when I'm at home, and I hate killing like the devil." I don't know for the life of me what made me tell him that. "But I shall be bound to give you six bullets if you budge one inch, and they're clumsy brutes, these service bullets, they make a devil of a hole at close quarters, worse than two or three rifle bullets."

"We're not moving," said the Boche. He seemed a bit sulky, I thought. So we sat and waited. My orderly had gone and nothing seemed to happen. I felt for my pipe with my left hand, but it was no go. That arm was out of business.

"Got anything to smoke?" I said to the Boche, and as he moved I saw the risk, and told him pretty sharply to put down the rifle he carried. "Over this way, please; gently now, along the ground - careful!" I told him. And so I got a first-rate weapon. Seems incredible I shouldn't have thought of that before, doesn't it? That's why I say I ought logically to be dead.

Well, after that we got on famously. He found a cigar, and gave it to me; but I had to pretend I didn't like cigars, because with only one hand in working order I didn't dare to risk lighting it. But the Boche officer remained curiously sulky, I thought. I tried him on half a dozen subjects, and I know he could speak English as well as I could; but I couldn't get much out of him, except that he didn't like our artillery at all, and that he supposed we must be near the end of our ammunition. Oh, and he said that now the Zepps had complete command of the air all over England, life must be pretty beastly for us there. I told him I thought they had managed to kill a few dogs and cats, a horse or two and so on; but that the only thing that worried our folk was that so few people had been able to see a Zepp, and they were all very curious to have a look at one. He didn't seem to like that.

After a long time my orderly got back with three men and a corporal, and then I ordered the Boches to march out without their weapons. There were twenty-two of them altogether. I thought my empty revolver was rather a good joke, so I told the Boche officer about it then; but he only scowled and growled, and after that he was sulkier than ever, so we had no more talk.

Chapter 15

THE HOSPITAL MAIL-BAGS

A medical officer, whose duties take him to many of our military hospitals, has been good enough to obtain, and lend, extracts from a number of letters received by wounded officers and men from comrades in other hospitals.

All over the world the men and women of our race and our brave Allies are thinking, talking, and writing of the great offensive north of the Somme which began on July 1st. Histories are already in the making, no doubt. But I doubt if any of them will contain more direct human interest than could be found just now in the mail-bags of our military hospitals dotted over the face of Britain from Edinburgh to Torquay. Our wounded soldiers are enjoying an amount of leisure and rest which is, of course, entirely out of

the reach of anyone serving at the Front, and here, in our own country, a certain freedom in writing which can never exist in the neighbourhood of the enemy is permissible.

One finds in our hospitals and convalescent homes officers and men who were in close contact with the enemy three days ago, and others, again, who have not seen the trenches for three weeks, or three months, and even here and there those who left the Front as long ago as the beginning of the present year. And among these patients, with all their differing stages of freshness from the fighting line, there are, of course, family ties in the military sense as well as the civilian sense. The military family is the division; its branches are the brigades; its households are the battalions. One man, who counts the time he has been in Blighty by weeks or months, gives homes news (in the civilian sense) to another who as yet can only count his time in England by days, and the second man, fresh from his unit in France, gives home news in the military sense to the first.

Thus a Lieutenant in a Scottish hospital who arrived home wounded a few days after the present great offensive began, writing to a senior officer of his unit in a London hospital, newly arrived there from the neighbourhood of High Wood, after thanking his senior for news of the Battalion, had this to say:

THE SCOTTISH LIEUTENANT'S STORY
Some of the things at home will puzzle you at first. Having time to read the newspapers right through makes a difference. I was awfully puzzled at first to find they still have tribunals and exemptions and things, and people grousing about the docking of holidays and week-ends and the terrible hardships of being taken away from their business for military service, and so on. But these things are only surface incidents, really, and don't mean much, though they make a good deal of noise. The country's perfectly sound at heart, I think, and I am told the munitions workers really are playing up like sports.

One's got to remember, you know, that in spite of all that's happened our folk at home here have not *seen* war the way the people have in France. It makes all the difference. Also the whole idea of citizen military service is strange and new to them as touching themselves. They hear of married men of forty being called up for training, and they seem to think it's an unheard-of-kind of heroism or martyrdom, or something. Dear souls! They're so extraordinarily sentimental.

As you know, in our Battalion over sixty per cent of the men were married and all enlisted before November, 1914. The proportion of over forty was very considerable, although the age limit then was - what was it? - something in the thirties, I know. They gave up their jobs and left their wives and families to lie about their age - bless them! - and to train with us without being told to by anyone, and nobody thought to call them heroes or martyrs, and I'm sure it never struck them that way, though they've been living in the trenches just on a year, and the new lot that get so much sympathy have been raking in the shekels at higher rates of pay than they ever had in their lives, during twenty months of war, and enjoying all home comforts.

Queer, isn't it? And then to think of men a month or two over the age being keen to take advantage of the calendar *now*! And other chaps prating to the tribunals about their consciences and their businesses and things (mostly businesses, I think) *now*, after two years, and at the height of the Somme Push! But the country as a whole is sound, and quite unalterably determined, and I

think we can rely on it there'll be no slackening in the munitions output; and if I'm right there the Boche's number is up and nothing in the wide world can save him.

A Sergeant on the south coast, wrote to his platoon commander in Manchester:

It is three days now since I landed, sir, and I was very glad to have your letter this morning. You really must not worry about the platoon, sir. They would be very much upset if they knew you were worrying about them, because they would think you could not trust them, and, you know, sir, they are worth trusting. I left the Lance-Sergeant in charge. He's come on wonderfully, and I asked the Captain if he would recommend him for full Sergeant. He's worth it. The doctor here promises me that I can be out of hospital in a week or two, so I may get back before you. And, in any case, the platoon will do nothing to disgrace you, sir, you can rely on that. In the push up north of Pozières we had the right flank of the Company, and the Captain said we did splendidly. We had nine casualties, and I'm quite sure we got three times that number of Boches, besides eleven prisoners we took. After we'd got their front trench, one of the Corporals and three men of his section went out on their own - the moon was clouded then - and got a Boche machine gun from their second line and brought it back with three helmets. The Corporal was slightly wounded, and the others not touched. The CO was told about it. They all want you back, sir, but the platoon's doing fine, and you must not worry about them. I think we've got the Boche fairly moving this time. He won't hold Thiépval much longer.

The following is from a Private in Colchester to a fellow Private in London:

I saw [censored] today, and he told me you were in London. How goes it, old sport? I got a bit of shrapnel in my shoulder, but nothing to worry about. We had a great do outside Longyvally after you left. You remember that ridge on the right past where the reaper lay? We had Master Boche on toast there. He came on at us in great blobs, like those stunts we did at Codford. We held our fire, and then let him have it at close range, four Lewis guns and our own rapid, hard as we could lick. My rifle burned my hand. You never saw anything like it, the way those Huns went down. Seemed a shame to take the money. And then, all of a sudden, "Cease fire!" And the Captain yells out, "At 'em, boys! Finish the blighters!" And over we went.

It was a proper circus. We thought it was to be just a defence, and instead we took their blooming trench and fairly put the wind up the lot of them. You never saw the like. Half of 'em was bayoneted climbing over their own parados, fairly spiked to it, and the rest of 'em was prisoners; fair screaming for mercy they was. We held that trench for over an hour, and bombed right along their communications and blew in their dugouts and two machine-gun emplacements. And while we were doing it 'B' Company was cutting a sap out from our own front line, so's we had cover most of the way back.

A great do.

The next extract is from a Subaltern in Glasgow to a Subaltern in London:

I've just heard I've got my second star; so you'll have to be a bit more respectful in future, my son. Three weeks in command of the Company, you know, with only one star - what a hero! Mind you, they did play up well. I'll never forget it. There wasn't a man in the Company but was trying to help me all the time, and as for the old CSM - bless his Geordie heart! - I'd like to put up a statue to him. For three days before he was killed I don't believe he was ever off his feet. And, mind you, we were hard strafing most of the time. He did a bit of everything, the CSM, from bombing and machine-gunning to burying Huns to get 'em out of our road. I got a couple of helmets, but I gave one away because it was given me. The one I've kept I took on my own from the beggar who got his bayonet through my arm. I'll never go without a rifle and bayonet again. Had to tackle the beggar with my hands; but I finished him with my revolver, and after that I carried his rifle, you bet, and hung his pickle-tub, or whatever you call 'em, on my belt. There's lots of fight left in 'em, of course; but we've got 'em cold this time, I'm certain of it. The prisoners we take are jolly glad to get out of it. People say human nature's the same everywhere. Well, it isn't. You take it from me, these blooming Huns are not the same stuff as our men. Our chaps mostly want to go straight; they're all decent at heart. Boche wants to go crooked, and begad he does.

Chapter 16

THE DIFFERENCE

As a listener only, I participated in a rather interesting meeting on the deck of a hospital ship just berthed at Southampton where a Captain, who was invalided home from the Western Front in the spring of this year, was outward bound for the same sector of our Front, and was given permission to board the hospital ship to meet a Lieutenant, a relative serving in the same unit, and homeward bound now, as the result of a wound received forty-eight hours earlier in the fighting north-west of Pozières. With the salutations and first inquiries ended, this is how it went:

THE CAPTAIN AND THE LIEUTNENANT'S STORY
"Well, it seems I've missed the best of the fun. I strafed like blazes to get out in the beginning of July, but couldn't bring it off. And now, according to the newspapers, we're getting back to sort of pre-Push conditions."

"Who says so?"

"Oh, some correspondent or another."

"Well, I'll bet he hasn't been in the trenches much if he says that. There's nothing the same as it was, even in June, let alone when you were there."

"But what's the difference?"

"Oh, every mortal thing is different. It all *feels* different."

"But how?"

"Every way. For instance, there was nothing but bare mud all round our trenches when you left, and long before the Push there was green stuff growing round everywhere; creepers and things straggling over the sides of the trenches; weeds sprouting everywhere. And that's been altered again since the Push; everything being ploughed in, as you might say, by the artillery."

"Yes, I suppose the heavy stuff has chewed it up a bit; but we saw plenty of that before I left. You remember how the Boche mortars and oil-cans smothered us the week before I left, below La Boiselle?"

"Oh, that! My dear chap, that was a rest cure. We used to notice a shell-hole then. What you notice now is a place where there's no shell-hole, and you don't often find it. And anyhow, of course, all the trenches you knew are away behind us now. One goes overland all round there. Even north of that's the same. Lancaster Avenue, Rivington, John o' Gaunt, Coniston, right along to Chorley, Chequer Bent, Lime Street, Liverpool Avenue, all those streets we worked in before you left - God, the water and the mud there was there - well, they'll never be used as trenches again, you know. All overland there now - stray bullets, of course; but just as safe as the villages we used to billet in."

"Yes, of course, you're further forward, but when one gets there I suppose it's much the same as the old places used to be?"

"Not the least bit. It's all totally different. You see, we don't go into trenches now to hold a bit of line, as it used to be. We're on the move now, you see. Oh, no, we've done with that rotten old grind of everlastingly going back to the same old quagmires. Then, you know, we're on the high ground now. That makes an enormous difference. You can see the Promised Land, as Tommy says, see it all the time, and we're nibbling chunks out of it all the time. Oh, the chap who says it's as it was doesn't know what he's talking about. Nobody feels a bit the same, I can tell you. Why, our artillery's working now in places where the Boche artillery used to be, away ahead of their old Front, you know - what used to be behind it.

"The main thing about the ground one used to look out over was its emptiness. Remember how desolate it used to look? Dead and empty like those Wells stories - before the earth had any people on it. Begad! It isn't empty now. We clear it up behind us, of course; the salvage chaps see to that; hundreds of tons of Boche rifles, equipment, and so on. And out in front you get the same mess, but different when the breeze is from that way, because of the number of dead Boches, you know. Lots of ground we take is full of dead Boches before ever we get near it - dugouts full, trenches full, shell-holes full - dead Boches everywhere; dead rats, too, by the thousand. And yet the Boches do their best to get in their own dead. They're pretty good at it. Like everything else they do - matter of policy, you know. The sight of so many dead is as discouraging to their troops as the stink of 'em is sickening to us.

"Oh, I can't tell you what the difference is, but you can take it from me there's nothing the same as it was, nothing at all. You've only got to look at our men to know the difference. They - well, they've became veterans, you know, real old warriors. Before, we went plodding along, pegging away, you know, because one had to do one's job; but now - now, we're winning the war, we're getting ahead - everybody knows it. I can't explain the thing, but you'll see what I mean directly you get out. We get held up here and there; we shall go

on getting held up, of course. But there's no deadlock; you know we're getting on with it all the time, and the Boche is getting smashed up. Oh, it's different, all right."

Looked at on paper there is something curiously dumb and inarticulate about it all, but I could see the Captain felt, as I did, that it certainly was 'different'. If the Lieutenant could not explain very well, he was able to transmit his own conviction.

Another letter reached me from a wounded officer who landed here recently, and was sent to a London hospital. He had been asked to let me know what impressed him most about the revolutionary change he passed through from the fighting line, north-east of Bazentin-le-Petit, to his present resting-place in one of the surgical wards of a military hospital in London.

THE WOUNDED OFFICER'S STORY

But the first thing is the bed, you know clean sheets and absolutely unlimited sleep. At first I had a dozen or more sleeps in the days as well as the solid night slabs of it. Even now I'm hogging it a bit in that respect. It is an absolutely glorious thing to feel the clean sheets all round you, and know you can sleep as much as ever you like. Then the baths. To wash as much as ever you like! I tell you you've got to go seven days and nights without ever taking your boots off or seeing soap or a towel, to know what this luxury means - it's priceless. And then the grub. It seems I'm a pretty fleshly sort of a chap, eh? Well, it's true, anyhow; I still find it a great joy to see a tray with a snowy cloth and shining things put down on my bed-table. It sounds piggish, but the eating of the nice clean food is a tremendous joy, just sitting there eating, with a book beside the tray too, and to feel you haven't got to hurry, or watch out, or listen, or arrange for any blessed thing at all. Sometimes I just sniff the sweet, clean air and enjoy that. I just lie, and let my eyes drift up and down the ward, hearing nothing, looking at nothing, enjoying everything - it's peace. I never knew what the word meant before. Nobody can who hasn't lived in the firing line. I've made up my mind what it is that sort of heals and recharges one more than anything else - it's being not responsible for anything or anybody.

Chapter 17

WHAT EVERY MEDICAL OFFICER KNOWS

The public probably realise now a good deal more than they did before the present Allied offensive north of the Somme, as to the terribly far-reaching character of the destruction wrought by the kind of fighting that is waged on the Western Front. The wars of the past have been child's play by comparison with this kind of fighting.

One has grown accustomed to finding among the wounded a few men who have been struck down without ever being near the firing line. Transport men, Quartermaster-Sergeants, orderlies in villages behind the lines, and all sorts of people whose work

keeps them well in rear of the fighting lines, have seen their share of death and destruction in this war. Even before the present offensive, and in parts of the line which were called 'quiet', death came flying through the air from time to time, to scatter devastation in all kinds of unexpected places.

During the last few months our artillery has been making life extraordinarily difficult for the enemy, even in places situated two or three hours' march behind his fighting lines. In this work, one gathers from all new arrivals from the Front, our gunners have established a very marked superiority over the Boche. Wounded airmen have told one that for every shell which has exploded during the past month in villages and rest places behind our Front, fifty of our shells have landed, with deadly effect, among the Hun's lines of communication.

The fact remains, however, that, even on our side, the risks of shot and shell are by no means confined, in this war, to the combatants. Many of our stretcher-bearers take almost as much risk as the average Private of the line, and our medical officers often carry on their labours in circumstances of the most deadly exposure.

I was talking with a newly landed RAMC officer, who carried on his work of tending and dressing wounded men for several hours, after being badly mauled himself by shrapnel splinters. His point of view was different, of course, from that of the fighting man, but not less interesting and valuable, I thought.

THE RAMC OFFICER'S STORY

In a war like this, you know, one comes across all sorts of bravery quite outside killing and being killed. Perhaps the public hardly realises yet what a lot there is in soldiers' lives, outside fighting. I sometimes think the actual fighting is among the least severe of the strains placed upon the soldier.

The recent fighting has been on such an epic scale, such a huge and devastating business - what's the word I saw in the papers this morning? 'Grandiose.' Yes, that's it - that I suppose it's natural the stay-at-home public should be apt to forget the merely human aspect. But it's there just the same. Our chaps remain just as human as ever, in their rough kindliness one to another, and - don't forget - in the different ills and disabilities to which humans are subject.

Fighting makes plenty of demands for two-o'clock-in-the-morning courage, of course; but so do other things in this life at the Front, I assure you. And, whereas the public hears something about the fighting heroism, it knows very little about the other kinds. Oh, well, they are all fighting courage, of a kind, of course.

What I mean is this: toothache, neuralgia, dyspepsia, colic, stomach cramps, sick headaches, sore throats, whitlows, and homely little things of that sort, are not washed out by terrific bombardments and epoch-making advances. Not a bit of it. The world's greatest philosophers have often admitted that neither their philosophy nor anyone else's was proof against a stomach-ache or the torments of an exposed nerve in a hollow tooth. Regimental officers will tell you that it takes a pretty full man's share of pluck and endurance, even when one is very fit, to 'stick it,' cheerfully in some of the phases of an offensive like this.

Well, I'd like the public to bear in mind what is known to every medical officer in the Army, that in every single unit on the Front there are officers

and men who are 'sticking it,' hour after hour, and day after day, with never an interval of rest or comfort, or anything to ease them, when, if they were at home, no matter how urgent or important their business, they would be in bed, or at least receiving such ease and comfort, such relief from pain, as medical attention can provide in civil life.

I'd like everyone who is doing his bit at home, every man and every woman, to remember this. These brave fellows of ours they won't 'go sick', you know, during an offensive. It's as much as one can do to get some of them out of the fighting line even when they are quite badly wounded, and as for the wounds of sickness - sometimes infinitely more exhausting and trying to bear - well, they just set their teeth and say nothing about these.

In the last week, I assure you, I have been quite glad to see coming my way with wounds (so that I could get them the rest and medical attention they needed), soldiers, from Colonels to Privates, who, to my certain knowledge, must have been suffering horribly for days, and in some cases for weeks, without the slightest kind of alleviation of any sort, whilst keeping a stiff upper lip, and carrying on with never a spoken word that wasn't cheery, in all the din and fury of the front line; men with acute internal troubles, racking neuralgia, or violently painful things like whitlows, living on biscuits and bully beef in shell-pounded, sun-baked chalk ditches, for a week or so on end, half-blind for lack of sleep.

The very last man I dressed had a slight wound in the left hand. "You might fix this up as soon as you can, will you, Doc.," he said cheerily, to explain why he did not want to wait his turn. "I must get back to my platoon as quick as I can. We've got a little raid on this evening." A moment later he was vomiting. Well, I won't bother you with detail, but his case was perfectly clear. In ordinary life he'd have been in bed, and probably operated on, weeks before. I knew beyond possibility of doubt the sort of torment he must have been suffering for weeks and the exact reasons why he looked such a scarecrow. I fixed him. I was his senior in rank, and when he tried to get away I placed him under arrest; begad, I did. At the clearing station, later on, I found out from his Company Commander, who was wounded, that, though everyone could see he was pretty ill, this Lieutenant had never said one word about his condition or allowed anyone else to talk about it. He had just gone on with his job, day and night. "About the best officer I've got, too," said his Company Commander. "Couldn't eat, himself; but he never missed seeing the last handful of his platoon's rations properly dished out. Oh, he mothered them well."

To a medical man some of these cases are wonderful. We know precisely what they mean. It's the kind of heroism that doesn't win decorations; but it's the real article all right, I can assure you, and this New Army of ours is full of it. I'd like the people at home to understand something about it. It should make it easier for them to stick their bit without bothering too much about missed holidays and things.

This medical officer had nothing to say about the quiet heroism of many of his comrades of the RAMC. One has to look elsewhere for appreciation of that very real bravery.

Chapter 18

THE SOUTH AFRICAN

Among all the laughing, smoking, chatting, cheery thousands of wounded men I have seen land in England from the Front I have met only one who was sad. This was a South African Company Commander who landed with shrapnel wounds in hip and ankle. It required some perseverance on my part to obtain any information at all from this particular Captain; but the striking difference between his mood and that of all those round him impressed me, and I am glad I did eventually fathom the reasons of it. Apart from their general human interest, they throw a notable light on the relations existing between the officers and other ranks in the South African units.

The sector of new line that this Captain's company held north-east of [censored] was most furiously counter-attacked by the Huns after an intense bombardment. The third and fourth and fifth waves of the attack were broken by the company's trench fire, which included Lewis guns handled to the best possible advantage.

But still the Boche came streaming on, and accordingly the company rose out of their shallow trench and rushed forward a bit to welcome the invader, having learned on more than one occasion during the preceding week just how little the Hun likes the steel.

In that advance the Captain was struck down. As he lay helpless on the ground he saw plainly that the enemy's charge was broken, and he ordered his company back, and he sent a young Lance-Corporal - who had only earned his stripe during that same week - to ram the order home. So the defenders began to stream back unevenly as the word reached them.

Just then the Captain saw two things. He saw four straggling Boches approaching where he lay, and he saw the young Lance-Corporal (whose rifle had been smashed earlier on) deliberately returning to him from the direction of the trench. The Boches had doubtless recognised his uniform, and were anxious to kill or capture a Captain. The young Lance-Corporal was coming on slowly and steadily, like a man drawn irresistibly by some kind of fascination.

"Get back to the trench, man! Get back!" shouted the Captain. One of the Boches dropped on his knee to fire. The Lance-Corporal came steadily on. "Go back," shouted the Captain as sternly as he could. "D'you hear me, Corporal? That's an order. Go back, or I'll put you under arrest. Damn you, go back!"

The kneeling Boche fired twice, and missed. The Lance-Corporal - no more than a boy in years - looked back and forward. He had his orders, and was a well-disciplined, good lad. It was as though the sharp order had placed weights about his feet. So he swayed. Then he gave one look at his Captain - you know the way your favourite dog looks at you if you order him back home when, perhaps, you've a gun under your arm? - and, in defiance of the discipline which made an order tug at his feet, the boy strode on again towards his Captain, glancing from the Boche to his officer, as though measuring his chances.

The Captain managed to level his revolver. It was worth a bluff to try and get the fellow back he admitted.

"By God, Corporal, I'll put a bullet through you if you don't go back!"

And at that the Lance-Corporal broke into a run - but towards the fallen officer, not the trench. He fell, with a bullet through his heart, within three paces of his Captain. Two Boches were on their knees firing at him then. The other two were advancing, at the crouch, on the Captain. The Captain had not yet used a round from his revolver, so he turned that now on the advancing Boche. But at that moment a Lewis gun in our own trench, firing pretty high, opened on that bit of no-man's-land. The incident had been seen, evidently. The fire was too high to hurt anyone, really, for the gunners feared to hit their own officer. But the Boche did not understand that. Their own gunners are a good deal less particular. So they turned tail and ran hard for their own trenches; while the Captain, having emptied his revolver at them, lost consciousness, and knew nothing more of the business till he found himself in our own trench dressing station.

And now this Captain finds it sadly hard to forget the solemn, puzzled face of the young Lance-Corporal who so deliberately elected to give up his life for his officer.

But I told the Captain he must be very proud of that young Lance-Corporal, not sad about him. There have been many such noble deaths among the men of the New Army, and the bulk of them are in no way recorded - by mortal scribes. In other days, where our fighting has been always on a much smaller, less intense scale, it was possible to record a larger proportion of the heroic deeds done. But as an RAMC officer with whom I talked of this particular incident, after the wounded Captain's train had started on its northern journey, said, "I think it's up to us as a nation to take good care that none of these sacrifices is wasted. Three parts of them will have no other record; but, if the people choose, they can make the nation's future the best possible sort of record, and the best sort of tribute and acknowledgement, too. All the nation has to do is to carry on, right through, in the same spirit that these chaps gave up their lives."

Chapter 19

IT'S A GREAT DO

High spirits would seem to be the rule among all who land in Blighty from our hospital ships. At least, I have come upon only the one exception to this rule (mentioned in the preceeding chapter). But, in my recollection, high-water mark was reached by a certain laughing crew of bandaged merry-makers, who arrived on a sunny Monday morning at the end of the summer.

The word 'merry-makers' seems extraordinarily out of place in this connection. But what would you call them? They were all laughing and talking nineteen to the dozen. True, all were bandaged; the clothes of most were torn and bloody; many were unable to move from their cots. But all were laughing and talking with a boisterous jocularity, and smoking cigarettes, and generally comporting themselves like exceptionally cheery and high-spirited holiday-makers on a pleasure excursion.

Here in England we discuss and speculate upon the fluctuations of the world's greatest war upon all its various Fronts. The British soldier, even when at his weakest, from loss

215

of blood and a long journey in hot weather, exults in the sure and certain confidence of victory, of success. He has only seen his own little bit, of course; but he is magnificently happy about what he has seen.

"There's nothing on earth can stop us now, so long as the munitions keep going at full pressure," said a young Captain, who knows that he has to lose his right foot, and is less cast down about it than the average civilian is over the prospect of losing a worn-out tooth. I have heard almost the same words, continuously the same emphatic conviction, from many scores of wounded men.

There was one particular party of Private soldiers, with a Lance-Corporal and a couple of Corporals among them, which, as a specimen group of our magnificent New Army men and as an illustration of the inimitable spirit that animates them, will remain always in my memory, They were gathered together in the shade of a projecting portion of a boat-deck; all walking cases, mostly bandaged for more than one wound; all ragged and blood-stained as to their uniforms; bronzed and weather-worn as to their hands and faces, with the indescribable fighting-line look in their eyes; full of laughter and good cheer, and carrying among them a wheelbarrow-load of souvenirs in the shape of Boche helmets, clubs, daggers, and the like. One half of the party, I should say, were from the neighbourhood of Pozières, and the rest from the extreme right of our line, where we join hands with our gallant Allies, round and about Guillemont. Some of these last were more than twenty-four hours from the actual firing line. All were glad to talk.

"It's a great do, sure enough; an' if Fritz has to put in another winter in the trenches he'll be a mighty sick man before it's over. I don't see how he's goin' to stick it."

"Come to that, how does he stick it now? 'Tain't because he likes it. What else can he do? You saw the machine-gun chains. He's driven to his job like a beast, is the Boche."

"That's so. I'd be sorry for the beggar if he didn't play so many dirty tricks."

"Not me, mate. I'll never be sorry for the Boche. Seen too much of the blighter. If you'd seen the way he killed my officer, you wouldn't waste no bloomin' sorrow on him. Them as I've seen is as full o' dirty tricks as a cartload o' monkeys, or mad dogs. A Boche is no good till he's dead, I say. We've bin too soft with 'em."

"What was it about your officer, then, Micky?"

"He was as fine a lad as ever you saw on parade, an' he knew how to take care of his platoon, too, I can tell you. We was in their front line then, clearin' the trench. We'd took a whole lot o' the beggars prisoners, an' he'd never let you lay a finger on a Boche if the fellow made a sign o' puttin' up his hands, although he'd seen something o' their dirty tricks, too. 'No, by God!' he said, 'not in my platoon, Micky. It's a point of honour, Micky,' he says. Much they care for honour, the cruel beasts they are. We came to a dugout that had the entrance to it half blown in, an' I was all for bombin' it first, and askin' questions after. But my officer, he wouldn't have it. He kept in front, with me an' the rest o' No.1 section behind him. 'Wo ist da?' he sings out down the dugout, in their own lingo, you see. And one of the sausage-eaters he calls out, all so meek an' polite, in English, you know: 'Only me, sir,' he says. 'Well come on out, and nobody'll hurt you,' says the officer. 'Cannot move, sir; very bad wound, sir,' says the Boche - damn him!

"Well, I wanted to go and see to the blighter, but he saw the bomb in me hand, and didn't altogether trust me, maybe. 'Wait a minute, Micky,' says he; an' down he goes. Next minute I heard a groan, an', 'They've stuck me, Micky,' very faint like.

"Here, my God, boys!' I says to the section. 'the rotten swine has killed him.' Well, we just made one rush for that dugout. One of 'em stuck me with his bayonet, here, you see, at the end of the passage. He'll do no more stickin.' I smashed his head with me

butt. An' I could hear others runnin' like rabbits in the passages. I got one of ours to look after our officer, though I could see he was done for, and I sent the others back to the trench quick to see if they could catch any of the Boche getting out another way. Then one other chap an' me, we followed on where we heard 'em runnin', an' I don't mind tellin' you, what with seein' that poor young officer an' the sting o' that Boche bayonet in me side, I was seein' pretty red.

"There was two of the devils I'd got in the dugout, an' there were five more altogether, one a Sergeant. There was two o' my chaps waitin' for 'em when they got to the other entrance in the trench, an' my mate an' me we come along pretty close behind 'em. They squealed all right when they saw the point of Tim's bayonet in the sun just at the mouth of the dugout, where they thought they was goin' to get clear. They turned an' come our way then, with Tim an' his mate behind 'em. An then they met me an' my mate, an' - well, they won't meet nobody else this side o' hell. We fought like rats in that hole, an' poor Tim he was killed. I got chipped about a bit meself; but I was that wild about my officer, they hadn't got much of a chance, the dirty hounds!"

"Aye, 't'were a pity they got Tim an' the officer; a pity that."

The speaker was a very big man with a rough-hewn granite-like face - a farm worker, I would say - by no means sad or gloomy; but of a reflective turn. His hands were enormous, and another man told me he had done great execution with them at close quarters. I could well believe it. He ruminated now, apparently with great satisfaction.

"There's nothing very civilised about 'em, even when they've lived in England. If England's got any sense there won't be any more of 'em live here yet awhile."

"Tom's goin' to stand for Parliament when the war's over!"

"I could teach 'em a bit about the Boche if I did."

"Well, see you raise the bacon ration for us, Tom."

"An' you'll mention that little matter of the strawberry jam, won't you?"

Chapter 20

ON THE WAY TO LONDON

For the time being I was leaving behind me the long, trimly kept landing-stage at Southampton, with its acres of clean garnished sheds in which the wounded lie in serried ranks quietly awaiting the different trains. I was travelling with some of them in one of the smoothly running hospital trains bound for London.

From engine to guard's van the interior of the long train was immaculate, spotless, a triumph of scientific organisation, of carefully thought out, most admirably and consistently administered system. The accommodation was simply the very best, neither more nor less, that modern ingenuity can provide for the easy transport of the sick and wounded. For the general officer and for the Private it was all precisely alike; not by reason of haste or emergency or accident, but because nothing better can be designed, and the authorities hold that the best cannot be too good for the soldier of whatever rank who is struck down in the performance of his duty; in the war which for us means the defence of civilisation against the onslaught of the modern Hun - the mad dog of Europe.

The train slowed down to a momentary stop, half in and half out of the station, at historic Winchester. A fast train from town had just previously passed through, bringing with it early editions of evening papers. Our pause was hardly appreciable; perhaps we did not quite come to a standstill. But one enterprising orderly managed to obtain a single copy of an evening paper through a window near the guard's van. At that time I was at the far end of the train, near its engine, talking to some wounded men of a north country regiment.

In a matter of perhaps two minutes - before the train had regained its full speed - the news in that evening paper reached us there in the fore part of the train. I am not quite sure how it came. I started then on a walk through the train to its rear end. It is a pleasant privilege to carry cheery news to these devoted lovers of good cheer - the wounded. But it was I who was given the news; from every cot and with tumultuous enthusiasm among the sitting cases. No more than two minutes had elapsed since we glided through Winchester.

"Romania's come in."

"Oh, yes; it's official."

"What about the Balkan-Zug and the highway to Baghdad now?"

"Pretty good day for Serbia, this!"

"Didn't some fellow say it would shorten the war by six months?"

"The blackboard writers in the trenches will be busy tonight."

"News for Fritz, all right, today."

"This ought to show 'em the Allies don't mean to stop at any half measures. The Boche fighting machine has got to be smashed right up. They ought to see it coming, now."

"Well, I'm glad," said an elderly Colonel, with his right arm slung. And the cool, quiet satisfaction of his tone, so suggestive of a man's inalterable determination, was curiously impressive. "People have thought them slow, but I suspect they had excellent reasons for biding their time. You may be pretty sure they knew the best time. It's a sort of underlining of the letters of fire on the wall. Yes, I'm glad. I fancy the Boche will be able to read this."

I was unable to find a single man who had not had the news. One heard quietly cheery murmurs of "Good!" "First-rate!" and the like, even from the sort of 'cases' one does not speak to, because they lie so still, or because, perhaps, a glance at labels or bandages has previously told one that their condition is serious.

"It's true, is it, about Romania, sir?" said one muffled voice. And I recognised a Corporal for whom, with some difficulty, I had arranged the smoking of a cigarette on the landing stage. His bandages were a very complete disguise, and I had learned, what I think he had known for a day or two, that he would never see again. I was told this Corporal had thrown a number of bombs, after the explosion which had robbed him for ever of his sight, and wounded him in half a dozen places. Inscrutable, incomparable courage, of the spirit that no devilishly inspired Boche device can ever quell! The very voice of this man was eloquent of modest but quite unquenchable good cheer. Being English, we cannot embrace such men; but to the end of our days we can pay them the homage of real respect. We can see to it, in strictly practical ways, that we never become wholly unworthy of their splendid sacrifices.

"Yes, Corporal; it's true." And then some sudden stir in me made me add, "And coming on top of what you did, there below Thiépval, Corporal, it's pretty good, isn't it?"

What they did there below Thiépval! He was only one of that heroic band; all humble,

all modest, all invincible; merely invincible. I have talked with a number of them.

The truly great, the epic episodes of the vast war, are so numerous, so almost continuous, that the world cannot hope to know very much about nine-tenths of them. But, known or unknown, nothing truly great can ever really be wasted. It can never be as if it had not been. Never. The measure of these episodes cannot be taken. The limit of their results cannot possibly be set. Each is one impulse in the rhythmic symphony of pressure which is presently to rid the modern world of the most deadly peril civilisation has faced in our time or any other time.

If there are left in Berlin sanely understanding students of the cataclysm, a knell must be rung in their hearts by all such episodes as that in which this simple English Corporal (with no thought or desire in life but just, very simply, to do his duty), smitten to his knees and blinded by the explosion of a German shell, continued fighting, with the weapon he had been taught to use, till carried away, because he happened to be one of those who had been 'detailed,' as the phrase goes, to present a forthright English "No!" to the ferociously desperate assertion of the might of the vaunted Prussian Guard.

"No, we didn't let 'em through, sir; they couldn't get through us."

That was as much as the Corporal had to say about it, and it is not easy to induce any of his heroic comrades to say much more. That is their English way - God bless them! Yet from one here and there, from a gunner officer, from an intelligence officer of a unit not in the 'show,' and, for that matter, from the terse and pregnant lines of Sir Douglas Haig's own *communiqués*, we know that even this unparalleled war has yielded no more splendid instance of sheer endurance, of stark, unshakable bravery, than that wild week gave us below Thiépval, where German desperation saw its most concentrated efforts and the flower of its Army broken, wave after wave, against the cool, unalterable determination of the citizen soldiers of Britain's "contemptible little Army".

"The men were splendid!"

Captain A. J. Dawson
from the Daily Graphic
(part of the same group as The Bystander)
1916/17

Glossary

ADC

Aide-de-camp - an officer who attends a general, governor, etc. and acts as a personal assistant

AIF

Australian Imperial Force

ASC

Army Service Corps

Adjutant

an officer specially appointed to assist a commanding officer

Billets

allocated sleeping- or resting-places (for soldiers)

Blighty

(military slang) home, the home country (from the Hindi 'bilayati', meaning 'foreign')

Blighty wound/Blighty one

a wound (often not unwelcome) necessitating a return home

Boches

derogatory WWI slang (originally French) - German soldiers

Bois de Ploegstert

known as Plugstreet Wood by the British

Boulogne

town and port in northern France

Bristol board

a smooth cardboard

Bully beef

canned corned beef, the main protein ration of the British army

Bystander

popular magazine/periodical

Château

a castle or large country house (especially in France)

Crump

(military slang), the sound of an exploding bomb

Dressing-station

a place where wounded were collected and tended by members of a field-ambulance

Dugout

a rough dwelling or shelter dug out of a slope or bank, or in a trench

Estaminet

a small bar or café

Fire-bucket

a metal container (often a biscuit tin) in which a fire was lit

Fire-step

a ledge on which soldiers stand to fire over a parapet

First Hundred Thousand

reinforcements raised by Lord Kitchener, Secretary of State for War, following an appeal on 11 August 1914. This first batch of volunteers, known as the 'New Army' was raised in a fortnight

Flanders

a region of northern Belgium

Front

the foremost line (of soldiers or battle); the scene of hostilities

Funkhole

(military slang) a place of refuge, a dugout

Gibson Girl

a representation of female beauty, characteristic of its period, depicted by Charles Dana Gibson (1867-1944). His pictures, which enjoyed an enormous vogue, were based on his wife Irene and her sisters (one of whom was Nancy Astor), and portrayed the American girl in various poses and occupations, her individuality accentuated by the sweeping skirts and large hats of the time

Gillray, James

English caricaturist (1756-1815), best known for his political cartoons, especially about George III, he also satirised the Napoleonic Wars, depicting Bonaparte as a manic midget

Guinea

an obsolete English gold coin, first made of gold brought from Guinea, in Africa (its value now £1.05)

Gutter perka/Gutta-percha

a highly resistive, waterproof substance, like rubber but harder from which identification discs (name-tags bearing service-number, unit and religion) were made. From 1917 British servicemen wore two, No. 1 (green) to remain on the body of a slain man to ensure identification for reburial, No. 2 (red) to be removed as proof of death

Hate

(usually 'morning hate' or 'evening hate') - the opening of artillery fire by both sides at dawn and dusk

Hide

(old English law) a variable unit of area of land, enough for a household

Jack Johnson

nickname given to the German 150mm heavy howitzer shells, renowned for their loud noise and black smoke explosions (after the first black American heavyweight boxing champion of 1909 to 1915)

Johnson 'ole

a crater made by one of the above shells

Lewis gun

light machine gun

Lonsdale Belt

an award in the form of a belt for winning the same boxing title three times in succession

Mailed fist

physical or military force

Mal-de-mer

seasickness

Mess-tin

a soldier's utensil serving as plate, cup and cooking vessel

Neuve Eglise

village in Belgium

New Army

volunteer troops raised by Lord Kitchener under regular terms of service

No-man's-land
neutral or disputed land, especially between entrenched hostile forces

Oil-can
German mortar bomb (from the shape)

Old Contemptibles
nickname adopted by veterans of the British Expeditionary Force who first went out to France in 1914. Corrupted from Kaiser Wilhelm's (alleged) reference to the BEF as a 'contemptibly little army (referring to its size, rather than its quality)

Orderly Room
a room for regimental or company business

Parados
earthworks protecting against a rear attack; side of trench furthest from the enemy

Parapet
a bank or wall to protect soldiers from the fire of an enemy in front; side of trench nearest the enemy

Platoon
a subdivision of a company

Ploughed
(university slang) rejected in an examination, failed in a subject

Plugstreet Wood
Tommies' 'anglicised' version of Bois de Ploegstert

Plum and apple
the most common jam issued to British troops; 'plum 'n' apple became almost synonymous with jam, no matter what flavour

Prussia
a former kingdom and state in Germany

Pussyfoot Johnson
W. E. Johnson (1862-1945), the temperance advocate, gained his nickname from his 'cat-like' policies in pursuing law breakers in gambling saloons and elsewhere in Indian territory when serving as Chief Special Officer of the US Indian Service (1908-1911). Later, he devoted his energies to prohibition and gave over 4000 lectures on temperance

Raemaekers Louis
vehemently anti-German Dutch artist who produced bitter, satirical cartoons during WWI

RAMC
Royal Army Medical Corps

Red tab
staff officer (from the red patch worn on the collar)

Salient
an outward-pointing angle, especially of a fortification or line of defences

Sandbag
a bag of sand or earth, used especially to protect against bomb blasts

Sap, sapping
a trench (usually covered or zigzag) by which approach is made towards a hostile position

Shilling
a pre-decimal currency coin worth 12 old pence (now worth 5 new pence)

Sinn Fein
political movement and party in Ireland championing a republic

Sovereign
a gold coin (no longer used) with a value of £1.00

Star shell
a shell that explodes high in the air, lighting up the scene

Strafe
to fire upon with rifle or artillery (from the German battle cry "Gott strafe England" - "God punish England"

Subaltern
a military officer under the rank of Captain

Tommy Atkins
generic name for a private in the British Army (originally, a name used in specimens of completed official forms)

Transport Farm
a place from where the conveyance of troops and equipment was organised

Traverse
a crossing or passage across; a parapet

Tumbril
a two-wheeled cart; the name given to the carts that conveyed victims to the guillotine during the French Revolution

Ty Cobb
American professional baseball player (1886-1961)

Typewriters
(military slang), machine guns (from the noise made)

Uhlan
a light cavalryman; a Prussian lancer

Verey light
a signalling or illuminating coloured flare fired from a pistol

Via Dolorosa
the way to Calvary (literally, mournful way), an upsetting or daunting course of action

Virgate
an old measure of land, usually 30 acres

West (to go/or be sent)
to die, or be killed

'Wind up'
nervousness, agitation, apprehension

Wireman
a telegraph fitter or electrician who installs or maintains wires

Ypres
town in Belgium, famous for its weavers and cloth, hence the most famous landmark of its Cloth Hall, Tower and Cathedral which were devastated during WWI. Known to the Tommies as 'Wipers'. The town is now the home of the Menin Gate memorial

References:

*Brewer's Dictionary of Phrase & Fable (15th Edition)
 Cassell - 1996*

*Chambers Dictionary
 Chambers Harrap - 1993*

*The World War One Source Book
 Philip J. Haythornthwaite - Arms and Armour - 1994*

*Phrases & Sayings
 Nigel Rees - Bloomsbury - 1995*

*Microsoft Encarta '98 Encyclopedia Deluxe Edition
 Microsoft Corporation - 1993-1997*

The BB Files:

Notes on the original editions of the books featured in this omnibus.

THE BAIRNSFATHER CASE - In July 1919 Bruce Bairnsfather's career entered a new phase when he became Editor of his own weekly magazine, *'Fragments'*. Published by the owners of *The Bystander*, the new magazine was an immediate and totally predictable success. Orders for the very first issue exceeded 1,000,000 copies, and at its peak *'Fragments'* reached a circulation of over 750,000. In addition to a variety of regular features and competitions (including one to find Old Bill's real life double) there was an 'In Reply to Yours - BB's GPO' letters page. The response to this was, again, fairly predictable. Thousands wrote to ask Bruce all sorts of questions; the vast majority about his work. Recognising the impossibility of his now world-famous celebrity Editor being able to answer each and every letter individually, William Mutch, a member of the *'Fragments'* editorial staff, suggested the solution might lie in producing a book about the cartoonist, which, if produced in answer to the questioning letters, should more than satisfy the public's insatiable demand for information on the cartoonist.

The Bairnsfather Case - As Tried Before Mr Justice Busby (Old Bill to you and me) took the unusual form of a court case, with the 'defence' provided by Bruce Bairnsfather and the 'prosecution' by William Mutch. The book was published in London and New York by G. P. Putnam's Sons, on 15th September 1920. The 'case' theme began appropriately enough on the dust jacket, which featured a drawing of 'a bewigged Old Bill delivering sentence on the diminutive delinquent (Bruce), "Five years hard laughing at your own jokes!"

No record of the number of books printed or sold survives, although the figures were probably considerable. Putnam's had, by all accounts, already done very well from sales of all Bairnsfather's previous titles, to which they held the American territorial rights. And by 1920, the year *The Bairnsfather Case* was published, the cartoonist was immensely popular in the United States, having only recently completed a major lecture tour there, with another scheduled to follow shortly after the book appeared. This, together with the popularity he was experiencing in the UK through *'Fragments'* and his continuing work for *The Bystander*, would have been likely to result in a substantial demand for *The Bairnsfather Case* on both sides of the Atlantic.

BAIRNSFATHER: A FEW FRAGMENTS FROM HIS LIFE - Early in 1916, the owners of *The Bystander* magazine became disgruntled with the agreement, made between Bairnsfather and London-based publisher Grant Richards without their knowledge or consent, to write a book about his 'adventures' during the war. From mid 1916 *The Bystander* was exercising control over Bruce's output and the Grant Richards' book was seen as a venture from which they stood to make no financial gain from the labours of 'their' cartoonist. By this time they were well aware that any volume bearing Bairnsfather's name would be an instant best-seller, and considering themselves to have been 'beaten' to getting their 'star' to write a book about himself, were keen to ensure they did not lose out further. In the Summer of 1916, *The Bystander's* then Editor, Vivian Carter (soon to don the khaki himself) set about compiling a book on the officer cartoonist, the owners of the magazine no doubt hoping the assured success of Bruce's first book (published as stated earlier by Grant Richards) titled *'Bullets & Billets'* would rub off on their product and make it a smash hit too.

Carter's book (and very patently an attempt to jump on the 'Bairnsfather' bandwagon) was an illustrated biography of the now famous 29-year-old cartoonist, and Bruce provided a large number of drawings (whether willingly or because of contractual obligations is unclear) for inclusion.

'*Bairnsfather: A Few Fragments from His Life*' was published for *The Bystander* by Hodder and Stoughton in December 1916, and, surprise, surprise, its launch coincided with the appearance of '*Bullets & Billets*'. The print run was 25,000 copies, with 17,419 being immediately bound up for sale. The costs of paper, printing, binding and other production expenses came to £1,139 2s 10d, with a further £76 12s 5d spent on advertising. Sales to the end of March 1917 totalled over 16,500 copies (including 1,000 to Canada, and 6,454 to the Colonies). Hodder and Stoughton's profit of £132 3s 3d for the first four months took into account royalty payments of £339 19s 4d.

On 1st April 1918 the publisher's stock consisted of 342 bound and 7,581 unbound copies of '*Bairnsfather: A Few Fragments from His Life*'. As with many of the books by and about Bairnsfather, the huge demand for copies soon receded. Although Hodder and Stoughton bound up their entire remaining stock of the book in 1917, the majority of sales that year were made by *The Bystander* magazine, who purchased a stock of 7,400 copies which they then sold direct to their readers. This was obviously a more lucrative market place - only 213 additional copies were sold through Hodder and Stoughton that year, with net profits down to £30 4s 7d. This is the last year for which any sales figures exist, although the records show that at 31st March 1919, Hodder and Stoughton had a stock of just fifteen bound-up copies of '*Bairnsfather: A Few Fragments from His Life*'.

The figures for '*Bairnsfather: A Few Fragments from His Life*' and '*Somme Battle Stories*' (full details below) show that *The Bystander* was determined to capitalise as much as possible on the virtual monopoly they had on Bairnsfather's work. It may be pure coincidence that the combined print runs of the two books equalled that of the first edition of '*Bullets & Billets*', and were both published within weeks of that volume, or it may have been carefully orchestrated by *The Bystander* to happen that way. So, despite the vast profits they were reaping on the millions of copies of '*Fragments from France*', (and they were vast by any stretch of the imagination - though their 'golden goose' saw precious little from it) their arrangement with Hodder and Stoughton, in respect of these two titles, resulted in a further 50,000 books bearing Bairnsfather's name being brought to the marketplace and on which they hoped to and indeed did, make a very substantial return.

SOMME BATTLE STORIES - The book '*Somme Battle Stories*', as recorded by Captain A. J. Dawson and illustrated by Captain Bruce Bairnsfather, was published for *The Bystander* by Hodder and Stoughton, in November 1916. As has already been stated in the previous information of '*Fragments*' the owners of *The Bystander* were looking for ways to ensure their financial interests in the wake of the anticipated success of '*Bullets & Billets*' due to be published in December. They reasoned, not illogically, that another book, written by an established author, with new illustrations by Bairnsfather, should achieve equal success.

Such was Bairnsfather's popularity at this time that there was no doubt that anything bearing his name, or connected to him in some way, would be a best-selling product. But *The Bystander* decided the book had to be related to the war, and should be written by someone with first hand experience of it. Captain Dawson was the ideal choice. He

had commanded a company of the 11th Battalion, The Border Regiment, in France, and he and Bairnsfather were both attached to the Intelligence Department, so knew each other well. Thus the book was published for *The Bystander* by Hodder and Stoughton in November 1916, no doubt in an attempt to achieve large sales before Grant Richards released what was to become one of the biggest blockbusters ever, a month later.

The original print run for *'Somme Battle Stories'* was 25,000 copies. This was half the number of copies produced by Grant Richards of *'Bullets & Billets'* (for details see *'The Bairnsfather Omnibus'*) but at a time when there was a shortage of paper and other printing materials, it was still an enormous undertaking.

The production costs totalled £821 8s 9d, but Hodder and Stoughton and *The Bystander's* expectations were well met. Within four months *'Somme Battle Stories'* had sold 19,835 copies (505 of which went to Canada). Hodder and Stoughton recorded a profit of £341 13s 10d on the book for the year ending 31st March 1917 - not bad for less than six months worth of sales, and taking into account the £279 1s 8d already paid out in royalties.

However, the public demand for *'Somme Battle Stories'* was short lived. Figures for the year ending 31st March 1918 show only 1,930 copies sold - barely a tenth of the sales of November 1916 to March 1917. A further twelve hundred or so copies were bound up for sale, and this and other costs took Hodder and Stoughton's profit for the year down to £40 13s 11d.

Sales continued slowly, with 1,610 copies sold through 1918 into 1919, the last year for which any sales figures exist. Another 1,691 books were bound up, to replenish saleable stock, and the extra cost incurred in doing this took profits for 1918-1919 down to a meagre £2 4s, against royalties paid of £3 14s 9d. Of the original print run of 25,000, the last stock count recorded by Hodder and Stoughton, for 31st March 1919, showed 709 unsold copies of *'Somme Battle Stories'*.

WILLIAM A. MUTCH - Very little is known about William A. Mutch, Bairnsfather's collaborator on *'The Bairnsfather Case'*. He is believed to have been born in Scotland, possibly Aberdeen, in the early 1880s. Early in his journalistic career he was on the staff of the *Aberdeen Daily Journal* and later worked for a newspaper in Dundee.

In 1919 he was working in London, on the staff of *'Fragments'* - the magazine edited by Bairnsfather. One of Mutch's tasks was helping to sort through the large amount of entries received in the 'Old Bill's Double Competition', which was launched by the magazine in August 1919.

Unfortunately, despite an amount of digging and ferreting about, we have been unable to unearth any further information on the life and career of William A. Mutch. A solitary reference to him has been found dating back to 1932, when he was credited as the editor of *'The Filmgoer's Annual'* for that year, published in London by Simpkin Marshall. The rest of his career, however, remains a mystery. No doubt, somewhere, a member of his family, now several generations on, will be sitting bolt upright on reading this and crying, "I know everything there is to know about great-great uncle William!"

If that is the case, we'd dearly like to hear from you forthwith. Until then, poor old William's only real claim to fame will be his brief association with Bruce Bairnsfather.

VIVIAN CARTER (1878-1956) - Born in 1878, Carter became a journalist in 1901 at the ripe old age of twenty-three, joining the staff of C. Arthur Pearson Limited where he

worked on a number of publications including, *Pearson's Magazine*, and the then recently founded *Daily Express* newspaper. In the few short years that followed, Carter's career developed into that of a 'special correspondent' and saw him travel through much of Europe and the United States.

In 1905 he moved north, to the *Manchester Dispatch*, where he stayed for the next three years before returning to the capital to take the reins as editor on a popular weekly magazine called *The Bystander*, which then formed part of the *Graphic* group of newspapers and periodicals. He was to remain with *The Bystander* through the beginning of the war, until 1916, when he entered military service.

In the early days of 'the great European war' it was not uncommon for *The Bystander* to receive submissions from members of the British armed forces. However, it was not until March 1915 that the editor, then in his late thirties and a seasoned professional, happened across one such submission which was to not only change the fortunes of *The Bystander* beyond all recognition (in the process making its owners very rich), but which was to rocket the artist to international celebrity status and fame. The submission was, of course, *"Where did that one go to?"* and that 'artist' was a fresh-faced young Lieutenant from the Warwickshire Regiment serving on the Western Front - his name, of course, was Bruce Bairnsfather.

The acceptance of that very first sketch showed Carter's editorial instinct at work, for, he readily reasoned, where there was one, there were many and this young Lieutenant had 'potential'. It was not long before the wily editor had secured the services of this boyish soldier cartoonist almost exclusively for *The Bystander*. Indeed it was Carter who guided the early career of the man who was to become the only official 'officer cartoonist' in the British Army, allowing the artist almost free rein in the aptly titled *'Fragments from France'* series of magazines, published exclusively to promote Bairnsfather's work. A book, *'Bullets & Billets'*, followed and Bruce Bairnsfather's life was never to be the same again.

Things, however, changed for his early mentor, for Carter departed *The Bystander* in late 1916 to heed his country's call and to serve as a Second-Lieutenant in the Royal Army Service Corps from 1917 to the end of the war, by which time, putting his journalistic background to good use, he was in the employ of the Foreign Office Press Bureau in Paris. In 1919 he became the Publicity Officer for the Ministry of Labour.

During the 1920's Vivian Carter was heavily involved with the Rotary Club, and was the General Secretary from 1921 to 1928 of the Rotary Clubs of Great Britain and Ireland. In 1922 he was the British Delegate at the International Rotary Convention in America, and again in 1924.

In 1928 he became the Special Commissioner to Rotary International, a post he held until 1931. And during a period when he lived and worked in the United States, he was both editor and manager of *The Rotarian* based in Chicago.

Returning to England, Carter served on the International Missionary Council in London from 1934 to 1936 and spent the next twelve years as a lecturer for the New Commonwealth Society.

During World War II Carter was employed by the Ministry of Information (South and South East Regions) and put his journalist's background to use once more in the cause of his country. After the war, in 1946, he became a member of the Free Trade Union, and in 1950 of the United Europe Movement.

The man *'who discovered the man who won the war'* died on 22nd February 1956, at the age of seventy-seven, and although having had a very long and distinguished career,

he will, perhaps, always best be remembered for introducing Bairnsfather to the world - for which we are all eternally grateful.

A. J. DAWSON (1872-1951) - Alec John Dawson was born in London in 1872 and from an early age showed a talent for writing. By the time he was thirty he had already published a dozen or more books.

Dawson travelled widely, gaining *"in every continent and upon all the seven seas"* at first hand the experiences which were to form the basis for much of his writing.

However, it was not until 1907 (at the ripe old age of thirty-five) that Dawson first attracted widespread attention, with the publication of his book *'The Message'*. The work dealt with the threat of the German menace to Britain, and its publication had far-reaching consequences. A committee was formed to extend its teaching, its message endorsed by, among others, Field Marshal Earl Roberts. The National Service League, and similar organisations, made use of *'The Message'* throughout the British Empire to push their own 'messages' warning against the aggressive Imperialism of Germany. However, despite certain parts of the establishment taking Dawson's warning seriously, the general public, for the most part, trusted to Germany's honesty and good faith and refused to accept Dawson's view of what was to come.

In 1908 Dawson travelled throughout Canada lecturing in all the major cities on causes such as patriotism and unity and 'Duty and Discipline'. On his return to England he launched and became editor of a weekly newspaper called *The Standard of Empire*, which highlighted issues relating to the British Empire. The paper was owned by C. Arthur Pearson (the employer of Vivian Carter from 1901-1905) and Dawson remained its editor for five years. During this period he continued to travel extensively, promoting the interests of the British Empire wherever he could.

Six months before the outbreak of the First World War, he returned to England after a year travelling around Australia, the East, and South Africa. On the outbreak of war he was rejected by the Army because of his age, but he soon found other war work, and launched the Standard Recruiting Scheme, which was responsible for the enlistment of thousands of recruits into the army from in and around London. He also became the first Organising Secretary of the Central Committee for National Patriotic Organisations, which was under the presidency of the then Prime Minister, Welshman David Lloyd George.

In November 1914 Dawson succeeded in obtaining a Commission as a Lieutenant in the 11th Border Regiment where he was promoted to Captain in February 1915, and given command of a company, which he held until being invalided out of the Army after being gassed in trenches near La Boiselle, early in 1916. Whilst on sick leave, Dawson was transferred to the branch of the Department of Military Intelligence dealing with press propaganda, at the request of its Head of Department who had learned of his talents as a writer. Dawson was attached to the Intelligence Department in June 1916. His work included examining propaganda articles supplied by officers on Home Service and preparing such material for publication. Along with another officer he supervised a staff of around twenty writers and journalists. Shortly after Dawson's appointment, Captain Bruce Bairnsfather was attached to the same department as an 'officer-cartoonist' and it wasn't long before the talents of the 'older' writer and the 'young' cartoonist were put together. Both men were dispatched to France together - Dawson to write about the French Army and Bairnsfather to draw it. Bairnsfather also provided the cover illustration to *A Temporary Gentleman in France* - a collection of letters from

the Front from an 'unknown' Subaltern - for which Dawson wrote the Preface, and which was published in November 1916 by Cassell.

The pair collaborated on three further war books, *Somme Battle Stories* (1916), *Back to Blighty* (1917) and *For France!* (1917), the latter based on the pair's joint visit to the French Front in 1916.

In April 1918 Dawson transferred to the Propaganda Department of the newly formed Royal Air Force. Later that year he was promoted to Major. After the war he continued to write, and from 1919 to 1921 was the Director of Information to the Government of Bombay.

During the Second World War, Dawson served in the XXIII (Sussex) Battalion of the Home Guard.

He died on 3rd February 1951, at the age of seventy-eight.

Mark Warby
Editor of *'The Old Bill Newsletter'*
Leicester
November 2000

ACKNOWLEDGEMENTS

In closing this second Omnibus edition it is important that I single out certain people for thanks, not only for their support and contributions, but also for their belief in the 'Bairnsfather' project. My most sincere thanks then to (in alphabetical order):

Chris Boiling (Centurion Publishing - *Legion Magazine*); Dorothy Coggan; Janet Farella; Alex Gigante (Penguin-Putnam, USA); Marie Marino-McCullough (Simon & Schuster, USA); Shirley and Mike Marsay; Margaret and Andrew Pettener; Claire Pope (Centurion Publishing - *Legion Magazine*); Jackee Shillabeer-Hall; Paul Spencer; Rick Sperinck; Tom Stafford and Mark Stephens.

My very special thanks go to **Barbara Bairnsfather Littlejohn**, for her support and encouragement to continue; **Neil Pearson**, our 'artist in residence', for another superb rendition of a Bairnsfather classic for the cover; and **Diane Crowther**, my Senior Editor, for her constant and unwavering support throughout both the highs and lows.

And finally, the biggest thank you of all goes to my good friend and 'official researcher' **Mark Warby**. Mark has been an avid collector and fan of Bairnsfather since his very early teens, and is now considered to be the country's leading authority on the man and his work. That he has chosen to bring his extensive knowledge to bear on the project as a whole and continues to correct the errors and omissions, whilst also loaning material from his own large collection of memorabilia and ephemera, has only enhanced this work. He is primarily responsible for compiling the *'biographies'* and *'notes'*, which add considerably to this work and I am greatly indebted to him.

Mark is the founder and editor of *'THE OLD BILL NEWSLETTER'* which is circulated throughout the world and serves to keep both fans and collectors informed and entertained with material on Bairnsfather, his life and his large body of work. For details of how to subscribe to *'The Old Bill Newsletter'* please write to: 3 Mallow Close, West Hamilton, Leicester LE5 1UY.

BAPTISM OF FIRE
Mark Marsay - £7.99

This award-winning book tells the story of the young men, volunteers from Yorkshire and the north-east, away from home for the first time, who stepped into the breach in the allied line in April 1915 and, alongside the lion-hearted Canadians, brought to a halt the advancing might of the German Army. Despite poison gas, a withering bombardment, lack of supplies and fresh water the Territorials of the 5th Green Howards stood their ground and did all that was asked of them in this, their first action of the Great War. Indeed, such was their fighting ferocity that it earned them the nickname 'The Yorkshire Gurkhas'; a reputation they would live up to time and again as they fought in all the major engagements on the Western Front. Here, together for the first time, is a sterling narrative account of that battle and the thoughts and feelings of the men who fought it. Here too is their poetry, evocative of both their innocence and their courage. Alongside the text are their photographs, many published for the first time in over eighty years, and with them the biographical details of the men the Green Howards are proud to call 'The Yorkshire Gurkhas', the men who underwent their *'Baptism Of Fire'* at St Julien in April 1915.

ISBN: 0-9535204-0-4
Non-Fiction/Military History - 224 pages, black & white - 130mm x 197mm

HAZARDOUS TO HEALTH!
Mark Marsay - £8.99

Set in the 80s, against the backdrop of waning union influence and Tory power gone mad, *Hazardous to Health!* tells it like it was in the gritty, hard-bitten north - where men were men and women were too! Obadiah Jones, a grey, faceless nonentity is plucked from the obscurity of the shop floor to uphold workers' rights by doing battle with Grimes, the power-crazed boss of Consolidated Industries Amalgamated. Out of his depth from the start, Jonesy blunders into crisis after crisis, unleashing a backlash of such intensity it's a wonder he can pee straight. On his knees, with his back to the wall, he fights through blackmail, threats and counter-blackmail, the banner of the oppressed workers held high before him like a shield. Never has the working-class struggle been so desperately fought by such an unlikely hero. Workers rejoice. Bosses tremble. Readers roll on the floor with mirth . . . *Obadiah Jones is here!*

ISBN: 0-9535204-3-9
Humorous Adult Fiction - 416 pages, black & white - 130mm x 197mm

THE BAIRNSFATHER OMNIBUS
Captain Bruce Bairnsfather - £9.99

The humorous autobiographical works of the Great War's most famous cartoonist - *'Bullets & Billets'* 1916 and *'From Mud To Mufti'* 1919 - together in one complete omnibus volume, featuring all the original artwork. With the addition of a specially written 10,000 word biography, and extra material about the books themselves and the publishing records they broke. At last Britain's only 'Officer Cartoonist', Captain Bruce Bairnsfather of the famous Warwickshire regiment, the creator of Old Bill and *'Fragments from France'*, is back in print. A worthy addition to anyone's bookshelf.

ISBN: 0-9535204-2-0
Autobiography/History/First World War - 256 pages, black & white - 156mm x 234mm

These titles are available from all good bookshops, or direct from the publisher, p&p free in UK

BOMBARDMENT! THE DAY THE EAST COAST BLED
Mark Marsay - £14.99

This bestselling book gives the full accounts of the German naval bombardments of Scarborough, Whitby and Hartlepool on Wednesday, 16th December 1914, and their aftermaths. Featuring the personal testimony of the survivors, 36 contemporary street maps and over 440 photographs. Also features comprehensive indexes of the dead, injured, street damage, shipping lost to mines in the North Sea and a full diary of German attacks against the British mainland from 1914 to 1918. The most complete account ever published, now firmly established as the definitive work on the subject.

Now the basis for a major, thirty-minute BBC documentary on the bombardments, featuring archive film footage and interviews with survivors - to be screened December 2000, BBC2.

ISBN: 0-9535204-1-2
Non-Fiction/History - 544 pages, black & white - 156mm x 234mm

BEYOND THE VOID
Mark Marsay - £5.99

When the Universe is threatened with extinction by a race of beings far more powerful than man and the combined forces of the United Confederation of Worlds (UCOW), who are the last people you would want to send in on a diplomatic mission? Captain James Armstrong Custer and the crew of the Starship Erasmus, that's who. Fortunately, diplomacy in this case means forcing the aliens to eat lead. When the chips are down and all else has failed, Custer and his motley band of reprobates take charge of the newest vessel in the fleet, the Conqueror Class Erasmus - a turkey of a ship - and set sail on the Galactic winds to venture into the unknown, through the rim of the Universe and *Beyond The Void*. With the combination of a crew more suited to the confines of a straitjacket than interstellar defence and a ship past its sell-by date before it was even built, mankind might as well kiss its arse goodbye right now! *Then again . . . strange things can happen in space and very often do!*

ISBN: 0-9535204-4-7
Humorous Adult Fiction - 288 pages, black & white - 130mm x 197mm

YORKSHIRES HEROES
Mark Marsay - price to be announced *(available April 2001)*

The thrilling stories, from the archives of the Green Howards, of the 18 VCs and 3 George Crosses won by the regiment since the Crimean War. With full biographical details of the men involved, the citations, photos, and battle histories of their battalions. Features also a potted history of the regiment, through its many titles from Lutrell's Regiment in 1688 to the millennium, with over 320 years of uninterrupted service to the British Crown and one of only two unamalgamated English 'infantry regiments of the line' in the British Army today (2000). With a foreword from the Colonel of the Regiment, Major-General Richard Dannatt MC, and contributions from members of the regiment and a collection of respected military historians and writers.

ISBN: 0-9535204-7-1
Military Non-Fiction/History - details to be announced

These titles are available from all good bookshops, or direct from the publisher, p&p free in UK

WHAT THEY'VE BEEN SAYING
ABOUT THE AWARD-WINNING
BAPTISM
OF FIRE

These Territorials landed in France less than a week before the gas attack on 22nd April; and the immediacy of that experience, and subsequent ones, is brought to life by the quotations from the diary of the author's grandfather. Other personal accounts and contemporary sources are also used to make this a very readable account. Well-produced and illustrated (with some useful maps and many photographs of the men) this book is excellent value and does the 'Yorkshire Gurkhas' much credit.

Ann Clayton - Editor - 'Stand To!'
The Journal of the Western Front Association

I read 'Baptism of Fire' within days of receiving it. It really is excellent and I must congratulate you. I do very much like the balance you have achieved in your historical narrative of the events of the 5th Battalion in the first part, and in the personal accounts in 'in their own write'. It works very well.

Major Philip Banbury - York

The book contains a lot of previously unpublished information, including first-hand accounts of the horrors of war, which will commend it to members of the regiment (past and present), students of military history and collectors of medals to the regiment.

Ian Hall - reviewer - 'Coin & Medal News' - London

I bought a copy of 'Baptism of Fire' and wanted you to know how much I enjoyed it.

Steve Metcalfe - Northallerton

I admire people who tackle local or unit history. I read much of 'Baptism of Fire' and enjoyed it. It is through work like this, set in a wider and balanced context, that a real sense of a community's or unit's war effort can be appreciated. Well done.

Dr Peter Liddle - Leeds

I have just read 'Baptism of Fire' and would like to congratulate you on its publication and to say how much I enjoyed it. There is one line which sums up for me the fact these were ordinary Yorkshire lads, no different from us today. The line is in the letter from Corporal Thomas Little on page 83 which describes the horrors he has come across, but who still tells his family, 'The most needed thing we've wanted is a good drink of tea.' My wife would tell you that when abroad I become quite painful with my complaints that nowhere outside Yorkshire can one get a decent cup of tea. Well done. I look forward to your next publication.

Michael Parkin - Scarborough

I hope your book 'Baptism of Fire' is a success as you have obviously put a lot of research and effort into its production.

David Cox - Beverley

I would like to say how much I enjoyed 'Baptism of Fire'. I found it a remarkable 'read'. I think the fact I found it so enjoyable is that it takes me back to the days when my father related his

horrors of trench warfare (he served with the 5th East Yorkshires).

David Martin - Driffield

I have just read 'Baptism of Fire' and think it is an exceptional piece of research. The extracts from your grandfather's diaries and the letters of brother Territorial soldiers serving with him tell an engrossing tale of those 'Saturday Night Soldiers'. To have included so much additional information, letters, poems and photos must have been a mammoth undertaking. I hope everyone else will be as impressed as I was.

Major D. Whitehead - Bridlington

Your book 'Baptism of Fire' is a credit to you.

Richard Hall - Redcar

I have just read 'Baptism of Fire' and consider it a well-written and well-presented book which I would have no hesitation in recommending to anyone.

Tom Heron - Newcastle-upon-Tyne

I have just finished 'Baptism of Fire' and thoroughly enjoyed it. As a Green Howard and medal collector the references will certainly come in useful.

Kevin Morris - Middlesbrough

The book 'Baptism of Fire' comes alive through the words of the soldiers themselves, with letters, poems, photographs and memories from all over the region, including individual biographical details. Our battlefield tours will now be better informed, and I can use the examples to add a personal touch to my teaching. I recommend this book to all those who want to find ways of adding a 'local', and at times, very personal dimension to their teaching of the First World War.

Keith Melville
Head of History, Scalby School - Scarborough

I recently received your book on the Yorkshire Gurkhas, I must say it was well laid out and very well documented - the last remark was made by an officer of the Royal Scots Greys whom I met on a pilgrimage to my late uncle's war grave. In fact your book brought about the pilgrimage as I followed up the story of my uncle who appears in it. Thanks for the 'push' your book gave me and I am certainly awaiting the next one on the bombardment.

Pete Johnson - Kirkby-in-Ashfield

Through a gripping narrative, based on official records of the battle, supported by personal letters, diaries, poems and archive photographs, Mark tells how these young men faced their baptism of fire with extreme courage; how they fought for seven days on a diet of bully beef and biscuits, sipping water from the puddles in the bottom of their hastily constructed trenches. He tells how they faced barrage after barrage of German artillery fire which not only destroyed but also prevented their resupply. It was the 5th Green Howards' first action and they suffered terribly. Yet they advanced to fill the gap and support the Canadians, and together they stopped a full-scale German breakthrough and sealed the broken front line. It was this first action which earned the 5th Green Howards the nickname the 'Yorkshire Gurkhas' - a mark of respect from their front-line colleagues. I highly commend this work to Green Howards, students of military history and the people of Yorkshire and the north-east.

Major J. Roger Chapman
The Green Howards Regimental Museum - Richmond

BOMBARDMENT!
The Day The East Coast Bled

Just before Christmas I obtained a copy of Bombardment! As one author to another, my congratulations on covering the subject in so thorough a fashion. I am aware of the efforts you have made in researching the book and in assembling the memories of others in a logical manner. The index of German attacks against the British mainland was of particular interest and value to me as it enabled me to place an event my grandmother witnessed as a young girl.

 Stephen Fowler - Author - Surrey

I am thoroughly enjoying both books, 'Baptism of Fire' and 'Bombardment!', they make fascinating reading.

 Peggy Broadhead - Wakefield

I have just taken delivery of 'Bombardment!' and am part way into it. I am very impressed with the thoroughness of your research and surprised that this bit of history is not more well known. Well done!

 Frank Warriner - Ontario, Canada

Just a short note to let you know I am enjoying reading your splendid book 'Bombardment!'

 Dick Bowen - York

I have just finished reading your superb 'Bombardment!' which is a masterpiece of historical research - if I may so, it is the sort of job which would earn an academic a PhD. Congratulations!

 Colonel Geoffrey S. Powell
 Regimental Historian, Green Howards - Gloucestershire

I have been doing a history project on the bombardment of Scarborough at school, during which I have been reading your book 'Bombardment!' which I have found very enjoyable and interesting.

 Ashley Riches - Scarborough

Congratulations on your wonderful achievements with both books. Good luck and keep up the good work!

 Margaret Dickinson - Author - Lincolnshire

Congratulations on your splendid book. It must really be the best researched and definitive book on the subject.

 Aubrey Reeve - Survivor - Scarborough

It is obvious you have gone to considerable trouble to collect all the material for your book 'Bombardment!' Congratulations!

 Stanley Sewell - Survivor - Isle of Man

I am sure 'Bombardment!' will be every bit as successful as your last book. Congratulations. It's just an amazing book.

 Joy Craze - Pickering

Congratulations on another bestseller! 'Bombardment!' is superb. All our guests have been clamouring to read our copy!

 Sue & Tony Hewitt - Hoteliers - Scarborough

Congratulations on writing yet another fine book.

 Paul Allen - Scarborough

Congratulations on 'Bombardment!' it is simply the best book from and about Scarborough published in the last 20 years.

 Andrew Mead - bookseller - Scarborough

Many congratulations on 'Bombardment! - Superb!

 Ray Westlake - Historian and author - Gwent

"Congratulations! It is a most splendid publication. When we initially spoke about this book I have to confess that I was imagining the sort of book that's normally published as a piece of local history, something about 48 pages long . . . this is 544 pages long . . . It's a magnum opus . . . A great work . . . Comprehensive is certainly the word for it. A very significant historical event. Indeed you've got an introduction by Sir Jimmy Savile OBE, and a Preface by Austin Mitchell MP, no less. Let me just say again, congratulations, it really is a splendid achievement.

 Jonathan Cowap - BBC Radio York
 (in an interview with the author - December 1999)

When war was declared in August 1914 a complacent nation confidently predicted it would be 'over by Christmas'. On 16th December they were shaken out of that complacency when the coastal towns of Scarborough, Whitby and Hartlepool were bombarded, resulting in extensive damage to property and the loss of innocent lives.

Bombardment! consists of a full narrative account, with extracts from letters and contemporary accounts, over 400 photographs and 36 maps which bring the incidents vividly to life. It has obviously involved an enormous amount of research as the author has worked hard to separate fact from the myth and legend of collective memory and the Chinese whispers of passed down 'eye-witness' accounts.

In the Preface former Yorkshire Television producer Austin Mitchell MP, who was involved with a 1970s TV documentary on the bombardment, pays tribute to the author's industry and diligence, and the success of the enterprise has been illustrated by the book being an outright bestseller in Scarborough over Christmas and New Year and by the book ranking number 2 in the Yorkshire Post's Top Ten book list for January 2000 - placing it higher than many well-known authors.

Detailed indexes at the end of the book identify the damage and the loss of life street by street and family by family.

I believe this book, with its often poignant personal accounts backing up official documents, is an important addition to the nation's history in its own right.

 Margaret Garbett - Administrator
 British Association of Friends of Museums
 (Reviewed in BAFM's March 2000 issue newsletter.)

The book provides the basis for a special 30-minute BBC2 documentary to be screened in December 2000

COMING SOON!

THE 3RD BAIRNSFATHER OMNIBUS - Bruce Bairnsfather

Captain Bruce Bairnsfather, national icon, international celebrity and hero of the Great War, was the most famous cartoonist of his generation - most of whom found their way to their maker via the mud, the blood and the guts of the Western Front. In this third Omnibus edition featuring work written or illustrated by Bairnsfather are presented, *'Carry On Sergeant!'*, *'For France!'* and *'Laughing Through The Orient'* - the three books spanning the period from 1916 to 1932. The format of the omnibus should by now be familiar to readers, with the works re-set with their orginal texts and illustrations in what has become a popular paperback format. Again Bairnsfather cartoons feature heavily, and the final book in this Omnibus, *'Laughing Through The Orient'* moves away from the subject of the Great War to cover Bainsfather's travels in the early 1930s through the Far East, accompanied as ever on his journey by the truculent and irrepressible Old Bill, that doyen of the trenches and scourge of the barbarous Boche!

ISBN: 0-9535204-8-X *full details to be announced*

UNDER SURVEILLANCE - Mark Marsay

Obadiah Jones is back for a second term in office! Armed to the teeth with regulations and codes of practice, Jonesy once again mans the battlements, single-handed, to do battle with his nemesis and arch-enemy, Grimes, the undisputed boss of Consolidated Industries Amalgamated and leading citizen of Little Rotting. This time, however, the stakes are raised to the ultimate of life and death, as Jonesy is stalked by the ruthless local mob, led by the antique Spats Delaney. Not to be outdone or outplayed, Inspector Patton returns too, his heart full of vengeance, his psychotic sights set fairly and squarely on Obadiah Jones - Little Rotting's number one villain - as he is put **Under Surveillance**. Delilah Jones, Lucifer, Fletcher and Adolf the Doberman, Old Joe the shop steward, Schmidt the works manager and Pilkins the personnel manager are all back, up to their old tricks, each vying with the other to bring our erstwhile hero to his grubby little knees once again. But things are never quite what they seem and nothing ever goes exactly according to plan as all our villains soon discover in this, the raucous, riotous sequel to **Hazardous to Health!**

ISBN: 0-9535204-6-3 *full details to be announced*

THE LOVE COLONY - Mark Marsay

Yes! They're back . . . Captain Custer and the crew of the Erasmus . . . back to save the Universe from the evil machinations of the megalomaniac leader of the Praxus Four mining colony . . . **The Love Colony**. The colony is holding the Confederacy to ransom over trilithium amalgamate - found only on Praxus Four - and used to power the latest generation of starships. The price? The spreading of the colony's religion of love throughout the Galaxy. But it is a price too high. Obviously there's more to all this than meets the eye and Custer and Co. are sent on a top secret mission to restore the Confederacy's supply of the ore - at all costs. It sounds straightforward. It even sounds relatively easy . . . but things begin to go wrong for the crew of the Erasmus the moment they arrive in orbit above Praxus Four, and steadily get worse. Has Custer met his match? Will the most motley crew in Confederate history triumph? Or will the known Universe witness such an outbreak of free love it will threaten the very stability of space and time itself, as mankind and alien alike shag themselves absolutely senseless?

ISBN: 0-9535204-9-8 *full details to be announced*

Get advance notification of publication by adding your name to our mailing list.

PROFESSIONAL PUBLISHING, BOOK DESIGN AND PRODUCTION SERVICE

Great Northern Publishing **does not** accept unsolicited manuscripts, but does offer a fully comprehensive book production service for authors, charities, groups, businesses and organisations who wish to publish their own work. This includes all types of books, magazines, newsletters, brochures, etc. This is a professional service and should not be mistaken for 'vanity publishing' or 'joint venture publishing'. For further details please send an A4 s.a.e. to the address below. Enquiries are particularly welcome from literary societies and groups, authors wanting to see their work in print at a fraction of the cost levied by 'vanity' and 'joint venture publishers', and from other publishers who would like to improve the quality of their finished product. Our books speak for themselves. If the quality of our work appeals to you, then contact us now for free advice with no obligation.

MAIL-ORDER SERVICE AND DISCOUNTS

Further copies of this book are available at £9.99 each, with postage and packing free in the UK, from the address below. Please make cheques payable to *'Great Northern Publishing'*. If you would like to receive advance notification of our books as they are published, please forward your details and we will be pleased to add you to our mail-order list. *Note: once on our mail-order list you will be offered substantial discounts on our books - up to 25% off marked prices in many cases - with postage and packing free in UK.* Discounts are also available for bulk purchasing, and to all educational establishments, museums and archives, etc. Trade and retail enquiries are most welcome.

SALES AGENTS REQUIRED

As our book list continues to grow we urgently require Sales Agents all over the UK (and overseas). As a small, family-owned publisher we do not have a full-time sales team and are seeking alternative ways to make our quality books available to a wider readership. If you would like the chance to earn some extra money and think you could sell our books in your area then send an s.a.e. now and we will send you details of how you can become a Sales Agent. This is a genuine opportunity with no small print, no contracts, no hassle, and no commitment or records to keep. Just a way for you to earn good money on every single book sold. If you have a little spare time and think you have what it takes to sell our books contact us now . . . and start earning tomorrow. Enquiries also welcome from schools, groups, organisations, charities and from professional sales representatives.

GREAT NORTHERN PUBLISHING
'The home of quality publishing in Yorkshire'
PO Box 202
Scarborough
North Yorkshire
YO11 3GE
www.greatnorthernpublishing.co.uk

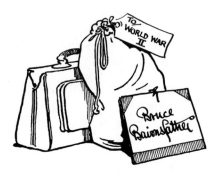

Keep up with all the latest news, reviews and comments,
special offers, current and forthcoming titles (including selected
extracts), and full details about the company and its services at

www.greatnorthenpublishing.co.uk

Add your name to our mail-order list and
be kept abreast of new titles as they are published.

GREAT NORTHERN PUBLISHING

The home of quality publishing in Yorkshire
PO Box 202, Scarborough, North Yorkshire YO11 3GE

Great Northern Publishing wishes to acknowledge its debt to
GORDON RICHARD CROWTHER (1939-1997)
whose generosity made the company possible.